BEYOND EAST AND WEST

BEYOND
EAST AND WEST

Memoirs, Portraits and
Essays

Bernard Leach

FABER AND FABER
London & Boston

First published in 1978
by Faber and Faber Limited
3 Queen Square London WC1
Printed in Great Britain by
Western Printing Services Ltd, Bristol
All rights reserved

© Bernard Leach, 1978

British Library Cataloguing in Publication Data
Leach, Bernard
Beyond East and West.
 1. Leach, Bernard 2. Potters – England –
Biography
 I. Title
 783.3'092'4 NK4210.L4
 ISBN 0–571–11138–6

THANKS AND DEDICATION

My thanks go to everyone who has contributed to the compilation of this book, which I dedicate to my fellow Bahá'í and secretary, Trudi Scott, without whose self-sacrifice, constant spiritual support and practical help, I doubt if it could have been accomplished.

CONTENTS

PART ONE

1. EARLY YEARS, 1903–1909

1903 – my first day at the Slade – friendship with Reggie
Turvey. Henry Tonks. The sounds of London. My father
on leave, sick, sees Tonks. I leave the Slade and art to be at
home until my father's death, before which I promise to
take up banking. I go to Manchester to study for the en-
trance exam. I fall in love with my cousin Muriel –
disapproval. I pass my exam and enter the Hong Kong and
Shanghai Bank in Lombard Street, but in spite of the
compensations of living in Whistler's Chelsea, loathe the
work and resign after nine months. To cleanse my soul I go
to Prestatyn in North Wales and Wareham in Dorset. In
1908 I meet my cousin Muriel again – feelings unchanged.
Parents consent to our marriage. Menton then Italy for six
weeks. The vision of the Italian Renaissance. Meet Reggie
in Paris. Return to Chelsea and the artist's life. Rooming
with Reggie. Meet Takamura at the London School of Art.
Etching under Sir Frank Brangwyn – he tells me to 'go to
nature', and I go to Japan.

Contents

Contents

Southern Japan: With Yanagi, Hamada and Kawai in search of unknown crafts. Himeji castle – Naeshirogawa Korean potters, the hot sea at Kyushu. Flight over inland sea and landing on Osaka river. Exhibition in Tokyo – Kyukyodo – lunch with the old proprietor. Karuizawa in the snow with the Spackmans – round-robin letter to English friends covering travel – the Sakazu pottery – up the Narihira river and Kurashiki. Back to Kyushu and Futagawa pottery. The Sumi family – the *shakuhachi* flute. The best brushed slip in Japan – I re-use the old pigments – brown and green. Firewood catches alight – disaster.

Korea: the beauty of Korean line – exhibition of my work in Seoul – Yanagi's little museum – reproof to my lecture – Koryo pots – the colour of sky after rain – beauty of the Yi dynasty – the land of morning calm. Visiting Korean nobleman's home – curio-hunting – I buy a Yi dynasty porcelain – we sup at a Korean restaurant. North Korea – the Diamond Mountains.

Trans-Siberian to Paris: thirteen days Mukden to Paris – Manchurian hills three days, three more for the Steppes, three to Lake Baikal. We explore Moscow on foot – everywhere Lenin and Stalin but no advertisements. Young artists' gallery. Prince Igor at the ballet. Poland and Europe again – Paris – London.

Article: *Christ in Japan*, written and published in *The Christian Community* magazine (1936).

15. ENGLAND, 1936–1939

Ditchling: a difficult period in my life – decision to marry Laurie Cookes. We buy a caravan – refuge on Ditchling Beacon – our dog Peter – miles of South Downs and friends in the village – autumn berries – the joy of drawing and writing – lecture to women weavers in London Club – Ethel Mairet and other weavers – Gill and Pepler, also the calligraphist Edward Johnston – Ananda Coomaraswamy – the influence of these artist-craftsmen – Philippe Mairet – Mitrivonic – comparative religion.

Winchcombe: with Michael and Mariel Cardew.

Contents

Contents

ILLUSTRATIONS

PLATES

(between pages 128 and 129)

9. Large slipware dish (17 inches in diameter). 'The Mountains', 1929
10. Slipware dish made about 1930, and decorated using open fingers
11. (a) On the South Downs. Brush drawing, 1936
 (b) On Ditchling Beacon. Brush drawing, 1936
12. (a) Hong Kong junk. Brush drawing, 1934
 (b) Plate design. Fishermen, inland sea. Pen and wash, 1934

(between pages 160 and 161)

13. (a) Turkey and hen. In Hamada's garden. Pen and wash, 1935
 (b) California sea-birds. Brush drawing, 1952
14. (a) The furniture-maker Ikeda. Pen drawing, 1953
 (b) Umehara, the best oil-painter. Pen drawing, 1953
15. (a) Sakamoto's kiln, Onda. Pen and wash, 1954
 (b) A Tamba kiln. Pen and wash, 1954
16. (a) Japanese farmer tilling. Pen and wash, 1963
 (b) Rice planters, Japan. Pen and wash, 1953

(between pages 192 and 193)

17. (a) Harvest time. Drying the rice in Japan. Pen and wash, 1953
 (b) Taos Pueblo. Pen and wash, 1952
18. (a) Japanese fireproof storage house. Pen and wash, 1954
 (b) The village of Johanna, Japan. Pen and wash, 1954
19. (a) View from Kazanso Hotel of the valley of Matsumoto. Pen and wash, 1964
 (b) Japanese Alps. Pen and wash, 1963
20. (a) At the Kazanso Hotel, myself with Hamada, Yanagi, and Kawai, 1953
 (b) Kyushu, Onda, with my hosts the Sakamotos, 1954

(between pages 224 and 225)

21. (a) Erosion on Colorado. Stoneware tiles, about 1952
 (b) Winter Landscape. Pine trees in snow. Stoneware tiles, 1960
22. (a) Deer at night. Tile, 1971
 (b) Fish. Brush drawing. 1960
23. (a), (b) Two plate designs. An owl, three fish. Pen and wash, 1966
24. Medieval-style pitcher, about 1935

FIGURES

MAP

ACKNOWLEDGEMENTS

I wish to express my heartfelt thanks to my publishers, Faber & Faber, who in the long years since 1940 have worked so admirably and so encouragingly on my behalf to enable me to publish four books. Most expecially during the writing of this book, I have received from Richard de la Mare, and later from his son Giles, such a welcome as I could never have anticipated. I have no adequate words to convey my true feelings,

To those members of the staff who have worked assiduously for its publication, and in particular Rosemary Goad and Sandie Boccacci, and to Alan Bell, who during the last two years has assisted me here with clear-thinking corrections of the completed text – to all I record my gratitude.

Barnaloft,
St. Ives,
Cornwall

PREFACE

In writing these memoirs, the retrospective of ninety years has assumed unanticipated perspectives and new meanings. It is normal in age to look back reflectively over the lengthening decades of one's life, picking out people, events, and problems.

Thinking over the determining factors of my life I cannot but consider them to have been unusual. First, my having been born in the East in Hong Kong. My earliest impressions, however, were of Japan, where I was taken care of by my grandparents because my mother died when I was born. My father and mother were both of middle-class Anglo-Celtic stock. When I was four years old my father married again and I was then taken back to Hong Kong. By neither marriage were there any brothers or sisters – thus I was a lonely child. At the age of ten I was sent home to England to be educated at the Jesuit college of Beaumont on the edge of Windsor Home Park.

I mention these early days because such were the given conditions which undoubtedly affected the whole of my life. My barrister father had been made a colonial judge in Singapore in 1895. Home on leave towards the end of my schooling, he came to see me at Beaumont to consult the Rector about my future. I had excelled only in drawing, elocution and cricket. It was with some anxiety that my father sent me to the Slade School of Art. To me this was sheer joy. I had found my vocation, my first friends and a real master. Life began to take on meaning.

Reflecting on the past along the miles of lamp-posts, detail is curiously sharper in the distance than in the foreground. Values alter: people and events fall into place: the infinite intensifies: W. B. Yeats called it 'shrinking into the truth'.

This book has been written between two hemispheres – its theme is their meeting. The sometimes rather disjointed recollections, fragments and essays have been placed, as far as possible, in order of sequence, and annotated, to give more coherence. Much concerning my private life I have deliberately omitted. Of the remarkable people I have known, some were in the unfamiliar backgrounds of the Orient. Japan has been my second home and many are the friends who have been with me in spirit for at least half a century. Even those who have gone over the border I do not feel are so far away. Something exists, something continues; their thoughts still work on mine and affection for them lasts as long as I live.

Bernard Leach

PART ONE

Chapter 1

EARLY YEARS, 1903-1909

I remember drawing boats when a small boy, aged about seven, in Hong Kong. I always loved drawing. It was at the age of sixteen that my father sent me to the Slade School of Art, where I studied under the famous Henry Tonks and met my lifelong friend Reggie Turvey, who had just arrived from South Africa.

On my own for the very first time in my life, and feeling very shy and lost, the youngest student in the school, fresh from Beaumont, I must have sensed a similar shyness in him, also the sincere desire for truth and beauty which tempered both our lives.

We stood to easels, drawing at arm's length with charcoal on Michelet paper, from plaster casts of Greek sculpture, from morn till night. For me this was sheer agony, for I had done little else than laboriously copy reproductions of academic pictures such as those by Alma-Tadema or Lord Leighton, P.R.A., with Conté crayon, stump and rubber, almost with the end of my nose.

Reggie was a born colonial. He was English and some years older than me. His ancestors hailed from Bedfordshire, as had mine, two hundred years ago. There is a village called Turvey in that county. A branch of my family, whose ancestors went out to South Africa by ship in the eighteenth century, intermarried with the Turveys and have the same family crest. Goodness knows, but there seemed to have been preparatory roots for our lifetime friendship centuries ago.

Reggie and I walked miles of pavement and galleries, talking art.

Already he had entered the mysteries of oil paint, eating old paint tubes into the night, comparing notes and enduring the lash of the tongue of Henry Tonks – Tonks with his gritty eye and tomahawk nose, tall in shiny blue serge, who had given up his job as house surgeon at Bart's Hospital to use his aseptic scalpel on us at the Slade; Tonks who became a second-class artist in the Impressionist manner, but a good draughtsman and perhaps the best teacher in all England. Often we saw some girl cowering in tears behind a plaster-cast. He spared none; his bitter tongue was fearless and true. Here is tribute and thanks to him. His surgery changed our skins – saved our lives maybe. Tonks, who enunciated 'action, construction, proportion' as the flaming guardians of the paradise of art; who, sitting on one of the student's 'donkeys', after a glance at his drawing, buried his face in his hands, paused long, and then asked, 'Why do you do it?'; and who once said to me grudgingly, 'You may be able to draw one day.' I remember on one occasion he flung open the studio door, stood there in deadly silence, then burst out: 'I want to know whether a day will come when I shall see a sign of art in this room,' and slammed the door behind him.

Tonks was the teacher, but a good painter – and one whom Reggie admired – was Wilson Steer. My greatest admiration went to Augustus John, who had been at the Slade ten years earlier. As to his drawings, Tonks, stern Tonks, was reported to have said of one of them, 'Michaelangelo could not have done it better.'

Outside the windows, yellow London fog and grime, the sound of horse-buses, growlers and hansoms, sulphurous steam belching from the Underground. Sometimes in that high room we heard the cry 'meat, meat, cat's meat', and I was so ignorant and innocent that I believed it was the flesh of that animal which was for sale!

How like the keen but sunny east wind were the enthusiasms of those days. I was alive and flying for the first time. Then came a blow: a specialist told my father, home on leave from Malaya, that he had cancer and only a year to live. It was in a room in Maddox Street that my father told me quietly what the doctor had said. He was but fifty-three. There was a barrel-organ playing in the street below.

Tonks was consulted about my future. He said that I was too young for him to judge, but, with my drawings in front of him, he could not advise my father to let me be an artist with only one hundred pounds

28

per annum to live on. I left the Slade: this was a terrible setback, but my father's need of me at home came first.

Before I left London and went to live in his house in Bournemouth, my father kindly let me go with my two friends, Turvey and Brundrit – who was also at the Slade – to paint in Wensleydale in Yorkshire for a fortnight. How lovely it all was! Brundrit's mother and aunt kept house and fed us well. I still have the impression that the best traditional English food is in Yorkshire. Their high teas!

We three walked miles and painted assiduously, but, looking back, I cannot recall a single picture of mine of any real merit. So far I had been too busily engaged on those three dogmas of Henry Tonks – action, construction and proportion – to give my mind over to the pure delight of beauty. It was not until a couple of years later that I had any genuine conviction of living expression in my own work. Reggie's paintings had always interested me; definitely he was a natural painter with a good sense of colour. We were free-spoken in mutual criticism, as fellow students are. That companionship of the studio and the occasional, if discriminating eye of a sincere teacher, is what the young students most need, rather than the academic years of art schools and their accuracies of technique. Brundrit was skilled and, as we foresaw, eventually become an R.A., but it was Reggie who, although not what I would call clever or a draughtsman, had the real gift of paint. It was hard leaving my friends as well as those moors and dales.

My stepmother was a good wife, but we hardly agreed about any-thing except her cooking. For my father, I had a sort of adoration; not even towards the close of his life, however, could he break through the barrier of silence between us. Later I learned that when he was in Hong Kong and Singapore, he had given help to many a young man running to excess of one kind or another. A few days before he died, he asked me to go the the new cemetery at Parkstone and select a site for his grave. With the words 'In manus tuas Domine' (Into Thy hands O Lord), his stone still stands.

To fulfil a deathbed promise to my father, I planned to enter the Hong Kong and Shanghai Bank, but found out that I was too young by a year to take the competitive entrance exam. My own mother's sister, Edith, whose husband, Dr. William Evans Hoyle, was the director of the Victoria Museum in Manchester, suggested that I should come to them. From her I experienced the nearest thing to a

mother's love. I did not like wet Manchester, but, after the south, I found something more real, if grim, about the people, whether of town or university. It was a literary household, where I met university professors. My aunt and uncle read at Shakespeare groups, and even I was asked to take part. I became attracted by their daughter, Muriel, and one day on Jacob's Ladder in the Cheshire hills, we both became aware of a shared love. On returning that evening, we told her parents. Distressed, they gently but firmly shook their heads because of our kinship. Her father, being an M.D., felt dubious. We took this seriously and parted. I returned rather desperately to London.

Shortly afterwards I began life as a bank clerk in Lombard Street having, to my surprise, passed the entrance exam. For compensation I lodged in the art world of Whistler's Chelsea. It is true that I made a few friends in the bank and even persuaded two or three of them to get rooms near me, or go for country walks on fine Sundays, and share the reading of Ibsen's *Brand* or Borrow's *Lavengro* of an evening. I travelled much in imagination with Borrow, first by coach from Norfolk to London, where I starved with him as he wrote *The Life of John Snell* in a fortnight, and was paid by the publisher in the originally proposed guineas, not pounds! Thereupon he left London and set off on the roads of England, living as a tinsmith with gypsies as companions, before the reign of Queen Victoria. I had often seen the Queen as an old lady whilst I was at school when we were walking in Windsor Home Park, and duly doffed my hat. How George Borrow taught me to love the roads of England! The people he met on them and their racy speech – Petulengro, Isobel Berners, the shepherd at Stonehenge, the man in black, the flaming tinman, and all the others. I read and reread. I even emulated Borrow in walking down to Bournemouth, picking up a couple of tramps en route, sleeping with them, a thin overcoat between us and frost on the ground because we could not find a haystack to burrow in for warmth, rising at 2 a.m. half frozen, and running a mile to get the circulation going: re-waking at dawn and sleeping out in the sun on the chalk downs above Winchester, and again awakened by the feet of people walking to church that Sunday morning. When Borrow walked England, Blake may have still been alive: it was Henry Lamb, whilst young and unknown, who introduced me to these two authors. Such were the associates of my youth. With them I have walked and talked in spirit ever since.

Whilst living in Chelsea, Lamb became friendly with some of those artists and writers who later took part in the Bloomsbury group – the children of Leslie Stephen, Vanessa Bell and her husband, and sister Virginia Woolf, also Lytton Strachey. I believe the Friday Club, a sort of junior New English Arts Club, was their first group activity, and I became a member and was asked to contribute. The first work I ever exhibited with this society was a water-colour done in the hills behind Prestatyn in North Wales, and I was very encouraged when it was picked out for praise by the art critic of *The Times*.

During my nine months at the bank, the only refuge had been an occasional evening in Lamb's studio. There, too, I met Augustus John and savoured the free mind of this adventurous and creative artist. I thought, and still think, John was one of the best draughts-men England has produced.

My family knew the Lambs in Manchester, where Henry's father was professor of mathematics at the university and where, after leaving the Slade, I got to know his son. A natural draughtsman and a brilliant mind, of himself Henry stated: 'I should have been Augustus John'. Nevertheless he stood upon his own two feet from the start and painted that extraordinary portrait of Lytton Strachey sitting in a basket chair with his long legs trailing on the ground – now in the Tate. Like John, he became an R.A. I do not really know why either of them joined the Academy, as both had a real standing in the New English Arts Club, which was, of course, anti-academic.

Lamb, before he came to London, was a medical student in Manchester, but seemed to devote himself to art to such an extent that his father called him to his study one day and told him that he was just wasting money. Henry then put in a month's hard work and came top in his finals. He related to me how after that he told his father that neverthe-less he was going to London to take up serious painting, whereupon his father gave him a five-pound note. He and his girl found cheap lodgings in Paultons Square, Chelsea. This was the artists' poor but lovely area – no roaring buses, the Embankment so beautiful at night, as Whistler discovered. What that couple lived on I do not know, but he went to John's night classes in nearby Flood Street. On his first evening Augustus came in late straight from some party looking well groomed and remarkably handsome, picked up a drawing board, and instead of using it sat behind this new student and watched him for half

an hour. They talked and Augustus invited Henry to his home. These two contemporary artists, in the background of Whistler's Chelsea, were my mental companions. I remember walking the then quiet Embankment, about the time I made a copy of a Whistler nocturne, wondering when and how I could throw him off my back. From him I must have caught some dream of Japan. What Whistler held for me and for many other artists was an unfamiliar asymmetrical Oriental sense of composition and a highly refined taste.

Work in the bank proved utterly alien. I loathed the heartless repetition – balancing to a penny three million or so pounds of duplicate exchange bills per week. This dogsbody routine was generally finished alone in the vaults as late as 10 o'clock at night. My sympathies went to my predecessor, who had also had artistic leanings. The nice old French head of department recounted how this man got so fed up one night that, stuffing his papers into his bag, he walked over London Bridge, paused midway and, looking down on the water, dropped the bag and its contents in and went home with a light heart. Next morning he arrived as usual at one minute to nine, still light-hearted, and settled down on his stool. The bank messenger came along and said, 'The manager wants to see you, sir.' There in his office was the dripping bag and its papers – delivered by the river police! He was dismissed with three months' sympathetic extra pay.

Later, after nine months' hard work, I resigned, much to the annoyance of the manager, but without sympathy. He accused me of using the bank as a 'stepping stone'. Many years later, at a collector's dinner party, I found myself sitting next to the same bank manager – by then Sir Charles Addis. Towards the end of the meal when we were feeling comfortable and mellow, I reminded him of our last meeting, and asked him what sort of stepping stone he thought banking would be for the career of an artist. The mumbled reply was unconvincing, and a chuckle went round the table.

When my stepmother heard of my intention to leave the bank, she wrote to the bank doctor. He took me out to dinner and afterwards told me frankly that my stepmother had asked him to take me out to see whether I was quite normal! This Irishman, Hartigan, was my own mother's doctor and had ushered me into the world, so he had a natural interest in my favour.

Altogether it had been a bad year. I had been thwarted in art, in love,

and I had lost my faith as a Roman Catholic. My first desire was to get rid of the taste of the bank. For companionship I decided to buy a dog. Early one morning I went to Chelsea Bridge under whose arches on the south side of the Thames, lost dogs were kept. Never did I hear such barking – a human voice was inaudible. The brown Irish terrier I bought cost me ten shillings. It had a collar and I was given a piece of rope. Wild for freedom, he pulled me all the way back to my digs in Chelsea. On the way I stopped at a butcher's for sixpennyworth of scraps – a strip of meat over two feet long. The animal was ravenous and grabbed one end of it when I was off-guard, swallowing over half. I hesitated to pull it back out of him and he, in consequence, took a full hour to consume the rest. I began to wonder what sort of dog I had bought.

There was some cause for anxiety: I had planned to take refuge with old family servants at their cottage on the sea road between Prestatyn and Rhyl in North Wales. Arriving in the evening, the dog was shut up for the night, tied to something solid so that he could not reach their larder. We had not reckoned on the length of his body. When I came down next morning to take him to the beach for a run before breakfast, the larder door was open and two pounds of good fresh butter were gone: he must have reached it with his hind leg!

The next adventure was when I took him on to the mountains looking down on the Welsh coast. Suddenly he was over a stone wall full pelt after a flock of sheep. I followed as hard as I could, shouting. Presently, seeing blood on the ground and realizing if a farmer or magistrate heard of it that the dog's life would be at stake, I put on a spurt. Such was my effort that the buttons for my braces broke off, and there was I on top of those Welsh mountains hanging on to my trousers chasing – as I thought – a sheep-killer. Blood was no longer visible and I caught up with the sheep in a half-circle facing my dog. I took hold of him and he was given the beating of a lifetime, but I decided against reporting the incident and took the next path to the plains. After that I avoided the hills for some time, but when we next passed sheep on the road the dog looked the other way and I felt reassured. There was no more trouble of that sort.

In 1908 when I settled down in Northmoor Farm at Wareham in Dorset and I began to paint on the banks of the river Piddle, came the final and tragic adventure with my companion, whom I had called Pan.

33

As usual I took him out with me. He found birds and river life more interesting than my painting and wandered off one evening. Nowhere was he to be found before dark, nor did he come back that night. Next morning I continued searching and finally went to the railway station where we had arrived a fortnight earlier. I was told that such a dog had taken refuge under a goods-wagon the night before – that it had been run over and its mangled body had already been buried. . . . I felt sick.

Taking refuge in my work, I did some paintings and drawings with some signs of vision. I was at least searching for truth in beauty. I walked, rowed, caught a few fish and gradually rid myself of the grubby memories of Lombard Street.

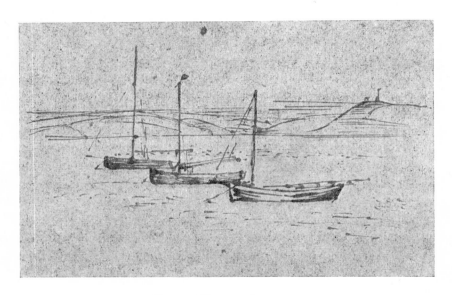

Fig. 2. Three sailing boats

Before leaving Dorset I had an invitation to a tea-party at a country house within cycling range. There, to my astonishment a fellow guest was Henry Tonks. I recall that he helped himself to a spring onion with his sandwich, and I, who had hated onions from childhood, was so impressed that I ate one and liked it. I have liked onions from that day forward. To my former master I said, 'Mr. Tonks, you turned me down on three successive occasions. Nevertheless I am going to be an

artist I'm going to Japan.' He put his cup down, shook me by the hand and wished me farewell and good luck. I never saw him again.

After the summer in Dorset, I returned to London and rejoined Reggie Turvey – now at the London School of Art.

In the spring of 1908 my grandparents returned to England after many years in Japan, and when visiting them, by sheer chance I met my cousin Muriel again. After the long silence, nothing had changed between us, so we put the matter of our shared feelings before her father, Dr. Hoyle, once again. This time both he and my aunt agreed that there did not seem an insuperable reason against marriage, and now that our feelings were clear and strong they would defend our engagement. Joy returned – despite opposition from some of the family. In the summer I made my first journey abroad to join Muriel and her grandparents on the Riviera for a fortnight. From Menton, I went on alone for a six-week tour of Italy. Although I had disentangled myself from Christianity as well as Catholicism, Christian art was in no way alien to me. Thus I was open to Giotto, to the birth of Neo-Classicism in Perugia – founded by a certain Dr. Squarcione – and its development by Perugino and Mantegna. I pursued the high road of the Renaissance – from Rome to Venice with all their famous artists; I was athirst and alone. How can I tell of those pristine weeks in the vineyard hills behind Menton, amongst the seven hills of Rome on the banks of the Arno, in Medici Florence, the untouched walled hilltown of Perugia, on Giotto's walls in Padua, or on the waterways of dream-like Venice?

After my first night in Rome, leaving my guide-book, I plunged into the narrow back streets and emerged on the great open space before St. Peter's. I think he himself must have led me gently toward Michelangelo's façade, up the steps and slowly towards the altar, even to the seated iron figures of himself, legs crossed, one half-foot of iron kissed away over the centuries. I leaned against a pillar and watched a fussy, bespectacled German (surely!) measuring the immeasurable with a footrule, whilst a simple country woman knelt on the hard floor, patient with her burning candle of faith, which she placed in an empty socket, then went and kissed that same iron half foot once more. My allegiance to Rome was gone, but not my respect for her faith.

By the time I reached Paris, where my chum Reggie joined me, I

was overflowing. Presently we took in the Barbizon painters and then, with contemporary enthusiasm rekindled, the Impressionists. We stayed a month before returning to Chelsea and the London School of Art, where we learned something from John M. Swan about paint and tone in a long traditional descent from Velazquez. William Nicholson was persuaded with difficulty to come in one day – immaculate in suède gloves and a swagger cane. He peeled off one glove delicately, sat down on my donkey, with two strokes drew me an elbow and said: 'Simplify.'

When Frank Brangwyn opened a little etching class upstairs, I joined it. Line was my *métier* rather than oil-paint, in which Reggie excelled. He was a born painter and colourist. One of the first plates I made, called *The Coal Heavers*, showed a little Brangwyn influence. I still think there was some life in it. I had Brangwyn almost to myself for an hour or two each week. I think he respected me for asking him not to draw on my plates; at any rate at the end of my second term he said to me, 'How long have you been in art schools?', and I replied, 'Including the Slade, altogether five terms.' He said, 'Enough, get out! Go to nature!'

Ever since I started at the London school, I had contemplated going to Japan in order to try to understand Eastern art and the life behind it. The books written by that stylist who first described Japanese life and culture in sensitive English – Lafcadio Hearn – had aroused in me the desire to return to the East where I was born. On my first day at this art school I had met a young Japanese student, Kotaro Takamura – a sculptor who studied under Rodin. I sought his advice. I remember one evening knocking on the outer door of his studio in the King's Road. He did not answer. I knocked again, louder this time – then I heard footsteps slowly coming down the corridor towards me. The door half opened: very quietly he said: 'Forgive me, I am meditating.' I think he used the word 'Zen'. I apologized. 'Tomorrow I shall explain', he said. The next day I heard for the first time a little about Zen Buddhism. Later, in Japan, Takamura became a well-known sculptor, a good art critic, and poet. He remained my friend all through his life. He was a little troubled about my going to Japan because he foresaw the difficulties I was bound to encounter without knowledge of the language and customs, also the uncertainty of making a living. Nevertheless he gave me an introduction to his father, who was a sculptor

for the Imperial household. I told Takamura that I planned to take my etching press with me and earn a living teaching etching.

In the spring of 1909 I sailed for Japan, third class on board a German liner. It cost me £28.

Chapter 2

JAPAN, 1909–1910

First Impressions

We reached Nagasaki en route for Tokyo in April. My ship had four
hours in port; the spring day was fine, blue and gentle. I walked straight
through the grey-tiled town, all my senses open to first impressions.
Leaving the town I climbed perhaps three hundred feet and came to
open fields, one of which was yellow with *na-no-hana* (mustard
flower): I paused, time stopped; the once-familiar sweet scent of blos-
soms carried me back to childhood. Patchwork fields, conical straw
hats, farmers' brown faces, indigo-blue cotton garments – and every-
thing hand made on a small scale.

Hunger assailed me; stopping a passer-by but knowing no words I
pantomimed my needs: he scratched his head, screwed up his already
thin, flat eyes, grinned hugely and with a 'Ha ha', pointed to a wayside
inn in the distance. There I repeated my performance and was ushered
in. I took off my shoes, climbed the steep stairs, entered a quiet, unfur-
nished room, sat on a flat cushion on the floor and waited. After a while
a maid came in carrying a small, low table; then food. She knelt, bowed
deeply and set out the meal: clear soup in a lacquer bowl with a large
fish's eyeball floating in it like a poached egg; sweet omelette roll;
a pink half curled sea-bream; stalks of raw, pink ginger; some pickles
and a little dish of vegetable resembling chopped boiled cabbage.
This seemed the most familiar, so I took it, using chopsticks, in one
mouthful. I do not know who was the more surprised, the maid or me,

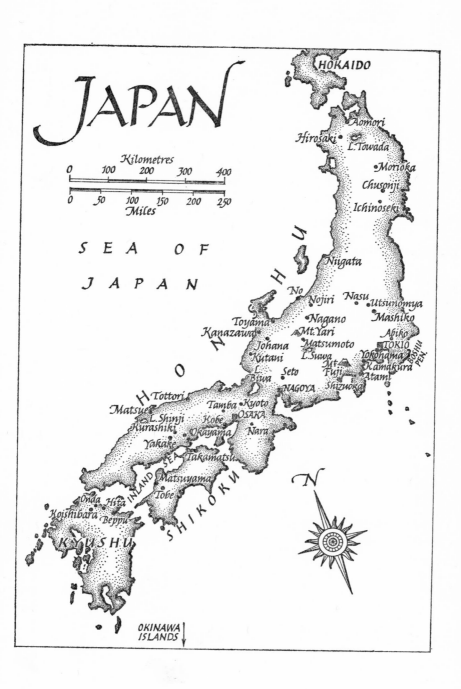

for it was hotter than mustard! She could not restrain her laughter behind a chubby hand – but I was in pain! I found it rather difficult to remove the flesh of the *tai* (sea-bream) from the bones, so she helped. All except for the poached eye of that fish, I enjoyed the food, including *takuan* (giant radish, with a fierce odour) amongst the pickles. Tea and three good bowls of rice went with it. I paid my bill and made my way back to the ship.

Next morning on deck looking at the matchless apparition of Mt. Fuji rising high above the clouds, I gasped and recalled Lafcadio Hearn's words, 'higher, still higher'. Alongside stood an engineer – a matter-of-fact, sturdy Scot who, tired of my enthusiasms said, 'Oh for God's sake shut up – don't you understand you cannot make friends with the Japanese? I know, I've been married to one for thirteen years!' Poor woman!

Later in the day we landed at Yokohama and on the advice of the purser I went by rickshaw to a nearby Japanese hotel. Fortunately a young man on the staff, who spoke some English, helped me. All the maids seemed to make my room their headquarters, plying me with questions.

My first excursion was to Tokyo, twenty miles away, to present a letter of introduction from Kotaro Takamura, my London friend, to his father Koun, the court sculptor. Before I set out the young man at the hotel asked if I would like a hot bath on my return, to which I readily agreed. On reaching the terminus at Shinbashi in Tokyo, I walked up to a sabred, white-uniformed gendarme and showed him my letter. He looked at it, realized I spoke no Japanese, went into a police box, telephoned for a replacement and waited until it arrived before beckoning me to follow him with a downward movement of his hand. We mounted a tram which took us across Tokyo near to Mr. Takamura's gateway. There the gendarme bowed and left me trying to thank him without words. I turned and entered the outer gate, the name and address on which I could not read. The enclosing fence of split bamboo was very charming to the eye. I approached the inner vertically barred sliding doorway. There was no bell; I paused, wondering what to do; then I coughed. Somebody heard me and a maid came, saw me and let me in. She took the card in my hand, and my friend's younger brother, who spoke some English, came to my assistance. Taking off my shoes I followed him in. The guest-room to

which I was taken was almost empty but beautiful in proportion and material; bare wood, well grained, with taut matting. He went out of the room and returned with his father. Polite questions and answers; green tea and cakes. My legs tucked under my buttocks began to ache but I took no notice; this, then was a Japanese home. With the help of the younger son's broken English, we had forty minutes' conversation with the bearded old man; then I thought it was time to leave, I said farewell, bowed, rose to go; but both my legs had gone to sleep and I fell full length! Consternation and laughter amidst my abject apologies. A chair was placed for me on the polished verandah until my long legs recovered their obedience. I returned to Yokohama chastened and full of wonder.

On arrival at the hotel, tea and cakes and many questions from the girls. Then the young man informed me that my bath was ready, so I said, 'Good, ask the girls to retire and I'll undress.' He looked perplexed so I said it again, adding that in England we did not disrobe in mixed company. He muttered something to the maids and they all went off into titters behind their hands and sheepishly left the room. Then I took off my things, put on the hotel kimono and followed him down the corridor to the bathroom. He slid open a flimsy door, showed me where to put the kimono, gave me a small blue-and-white cotton runner for a towel, opened another door and handed me over to *banto San* (the backwasher), who planted me on a very low stool on the wet floor, sluiced me with hot water and then attacked my back with a piece of hair-cloth and deep massage, winding up with sharp blows on either side of my neck and further sluicings of hot water. Then he led me to the large, built-in wooden bath. By this time I could just see through the steam the heads of those inquisitive girls – in the bath – awaiting my arrival! This was too much for my young English modesty: I turned tail and fled to my room, where I cross-questioned that young man about the customs of the land. He assured me that no impropriety was intended and that men and women bathed together in Japan, adding that in his country people saw the naked body but that he had been told that foreigners looked at it. With this initiation I found food for thought and wonder which I have not lost to this day.

Life in Japan

When I landed I had no knowledge of the language. I learn better by ear and at twenty-two, my blotting-paper, so to speak, had not been overused. I had an introduction to Baron Iwamura, who taught English at the Imperial Art School in Ueno Park in northern Tokyo, but in due course he handed me over to his assistant Kamenosuke Morita, who was of great help during those early days and became a friend. Language and accommodation were the first necessities and he provided both, for he lived below Ueno hill on the most northern edge of Tokyo in what was once the village of Iriya, where the great potter Ogata Kenzan first lived in about 1731 when he came to Edo.

Morita offered me his small annexe consisting of only two rooms, which was alongside his own house. I was looked after by an old woman with whom I communicated by signs and the one question 'Nan desu ka?' – 'What is that?' – which I had learned. I received from her the same dull and indigestible food every day – small fish and rather undercooked rice – but it was my first house and I was inordinately proud of it, although as the days passed my digestion suffered. I withstood the pain for at least a month before complaining to Morita who said, 'Oh! You must see my doctor', and took me forthwith. He looked at me, then asked 'What are you eating?' 'Japanese food only', I replied with a touch of pride. 'Go back to bread quickly', he said, and gave me some pills.

I had heard a man calling out the words 'Pan, pan, haikara pan, Rossia pan', which means 'bread, bread, high-collar (very up-to-date), bread, Russian bread.' The old woman bought some for me and upon my word if I had thrown a lump at the wall it would have stuck; but the pains diminished nevertheless, and soon I found something rather more like our idea of bread, gradually extending the range of the, mostly Japanese, diet. Nothing could convince me, however, that the old woman was a born cook, but I had come to Japan prepared for all sorts of sundry endurance. To help me, the doctor had provided a medicine extracted from the fifteen-inch-long, two-and-a-half inch-wide giant white radish.

Walking along the narrow paths between the paddy fields outside

my house I observed farming on the great plain of Tokyo. Towards evening the landscape was punctuated by eight-foot-high piles of washed white radishes, or *daikon*. They are a substantial part of Japanese diet, though, as I had already discovered, when pickled prove highly odoriferous to the foreign nose! My *amah* in childhood must have surreptitiously fed me with them, for I liked this delicacy and its cheesy sort of smell. At any rate it had a chemically useful effect in the process of digesting the rather hard rice.

My immediate task was to establish the first hundred most useful Japanese words. New importations were one thing, but the sounds of old Japanese words had no connection with Western roots such as we Europeans have with French, Latin and Greek. I had been pointing at objects using that one phrase, 'Nan desu ka?' – table, lamp, soap. The old woman replied, '*taburu*', '*rampu*' and '*shabon*'. The first two are easy, the third I guessed to be derived from the French *savon* and was tempted into thinking that Japanese would be easy to learn at that rate. I was mistaken.

Much time was spent of an evening talking to Morita in English, asking a thousand questions and at times going out with him and his cousin to buy necessary furnishings for my simple life. At that period shops were open late at night.

Then came the rains. Five weeks of steady, quiet downpour and overcast skies. It was very humid. My shoes began to grow fungi! Everything dripped! – frogs croaked – even insects took refuge in-doors and produced a kind of music. Human beings also had inclin-ations towards musical expression. I heard a bamboo flute which was eighteen inches long – very woody; sad and poignant; closely in harmony with the atmosphere. Some daughter of a neighbouring house plucked despairing notes from a thirteen-stringed horizontal harp – a *koto* – very melancholy. A group of men sang at night the choruses of *noh* drama in unison – sonorous, with a seriousness reminiscent of plainsong. The induced mood was poetic. I began to read two-lined translations of Japanese *haiku* (seventeen-syllabled poems).

However evocative all this was of Oriental music and poetry, when the sun burst forth at last every thatched roof in view steamed to the opening heavens and the rate of vegetative growth was astonishing. The black, volcanic, sodden soil below – the late June sun above. I think it was then I first heard that the stem of a bamboo grew in height

one foot each day in the following month of July. This was proved by direct observation in later years.

I was engaged to marry my cousin Muriel, and had become sufficiently lonely to desire her companionship ardently, so I wrote to my uncle and aunt suggesting the possibility of marriage if I were to build a house in which we could live. During talks with my friend Morita I discovered the astonishing fact that a house of modest but sufficient size could be built for less than £200! To my great joy this did not meet with blank disapproval. So I set about looking for a piece of land belonging to one of the temples on Ueno hill. Sure enough, I found one. Morita warmly recommended a team of country craftsmen and helped discuss the layout with the master builder. Meanwhile I arranged for some of my capital to be realized.

How interesting that next month was, even though the heat was becoming considerable. Each day I went up to watch the workmen dig the foundations. For every post that supported the construction under what was to be a heavily-tiled stable roof, a hole had to be dug and two or three stones placed one above the other, one always horizontal and the nose of the last just protruding from the ground. The skill of the team, whether using saw or plane in the opposite way to ours, or the adze cutting towards bare toes, was astonishing. Compared with our Western concrete foundations, everything was simple to the understanding yet apparently efficient. In spite of lack of speech, I became on friendly terms with the workmen by sending in shaved ice sweetened with various flavours.

The skeleton of the whole house was erected in a day without using any nails. The unknotted wood was left unpainted – paint is not used in Japanese houses, the material being allowed to speak for itself. Superlative workmanship was assured by the fact that the carpenters spent one-third of their time in sharpening tools. On the following day the heavy roof-tiles were put into place and a flag was raised on the top. We all partook of an uproarious dinner, for which I supplied the beer and macaroni from a nearby shop. It was the one time in my life when, with sufficient persuasion, I joined in the singing, with a folk-song from my own land.

The master builder was able to grasp those ideas which were not according to Japanese custom, but for foreigners who needed greater comfort. I liked the idea of no shoes in a house and the hard springy

tatami mats on which one sat or slept – always spotlessly clean – so practically the only thing requiring alteration was the flooring of the main room. The two central tightly-compressed straw mats six feet by three feet in size, and four inches thick, were replaced by a table-top with short legs which could be raised or set flush to cover a well underneath. When used as a table, our Western legs could slip under it to a lower flooring of wood. This enabled us to have a class of Japanese university students later on – for English conversation. They could sit around this table in their accustomed way on small flat cushions. When winter came, we placed a small charcoal warmer with a protective grille in the bottom of the well to keep our feet warm. I was told later that this idea was taken up and used in some Japanese interior designs.

In my first summer in 1909 before Muriel came, the weather became really hot, and Morita suggested a journey up the mountains. I countered with an adventurous proposal to go up the Sumida river as far as possible in a hired boat with a long stern oar, and camp on board. It did prove feasible and it *was* adventurous, for we were both very nearly drowned within the first few hours! I had not as yet learned to use an oar on a pivot, although my friend was experienced. We loaded up with food supplies etc. and set forth on a glorious afternoon. The great square sails of river-barges – often to be seen in Japanese colour prints – were going upstream.

While I was arranging the luggage, Morita stood sideways with the handle of the eighteen-foot fish-tail of an oar keeping taut tethered by a cord to the flooring of the boat. Grasping the oar with both hands he propelled the boat quite easily with a figure-of-eight movement. All went well until he suddenly shouted, 'The pivot has fallen overboard!' Without the peg the oar was useless. Stripping off his coat, he dived in after it. I presumed that he could swim back on the slowly moving stream, but when about fifteen yards away he raised a hand and, with a cry, disappeared. There was nothing else for it – I dived in after him, but as I swam remembered the danger of being clutched by a drowning man, so I approached from behind, seizing his collar as he came up – but he had swallowed water. Before we went down I took a good gulp of air which brought us to the surface. Again we went down; I had taken another deep breath but something more drastic was required, so as we came up I hit him under the jaw as hard as I could, which ended his struggles and enabled me to shout

45

across the river to where a man was fishing from a boat. Eventually he understood the situation, rowed over and rescued Morita while I swam to the bank. Then he retrieved the peg and finally brought the boat near so I could get on board.

Morita slowly recovered but did not feel very friendly towards me for some time. As yet he could not see the necessity for my hitting him. That came later, over supper. We did not proceed very far that evening and moored to an anchor, hoping to escape mosquitoes. We were vastly mistaken and had a very unpleasant night. Next morning, however, we set off again with him in charge of the oar, and stopped at the first riverside Japanese hotel where we managed to hire a mosquito-net. All day we rowed upstream until the water was so shallow we could go no further, so stripping off most of our clothes we jumped overboard and pushed. Finally we came to a stopping place and moored to an overhanging tree. That night we enjoyed a big meal cooked over a fire on the bank, after which we slept soundly.

Next morning we observed that the food was fast disappearing and considered how it could be replenished. As luck would have it, we espied a man wearing a flattish conical hat making his way along the footpath on the bank side of the river on his way to the next village. From the two ends of the pole over his shoulder hung vertical boxes with drawers full of various kinds of sweetmeats for children, so we decided to be children and bought so much that the man grinned as he went on his way. That served for the time being. The next day we went to the aforementioned village – perhaps a mile away – and seeing some likely-looking birds at a small farm, bought a hen which we plucked, cleaned and cooked. This lasted two days.

I had brought my oils and did a painting next afternoon. Sitting smoking after supper, we saw Japanese lanterns approaching from the village. Two elders asked us if we would be their guests for a hot bath the following evening; they would come again to collect us. We accepted. The next evening we followed them in the gloaming, and felt, rather than saw, a big wooden tub of hot water at least three feet deep and out of doors. I disrobed, sluiced myself down, soaped, sluiced again and then stepped in and squatted up to my neck in very hot water. The moon rose and the tub became visible in the middle of a crowded space between houses. All the villagers had come to see the foreigner having a bath. This time I didn't bat an eyelid! I enjoyed it.

Apparently the villagers enjoyed it too! Morita had his bath, then, shouting our thanks, we made our way back to the boat and embarked under the light of the harvest moon. We took turns, rowing all night.

Upon our return we found the house, consisting of two main twelve-foot-square rooms, two smaller rooms, kitchen, bathroom, etc. and a studio of fair size – all for two hundred pounds – now approaching completion. As soon as my studio was ready and my etching press installed, I advertised in the daily press that I would have a small exhibition and demonstrate etching processes for three days. A university professor who spoke French was one of the visitors. The next day I received a letter from him which read as follows:-

'Dear Mr. Leach, B.,

I wish to send you my thank for you show me method; but I like velly much to say more – thank for the taste of putrid mildness I find in your work. . . .'

I stood still, astounded – completely nonplussed. That letter was in and out of my pocket all day until Sakya turned up in the evening; he was an English-speaking and very kind young friend, the foster-son of an old abbot at the temple on whose land my house was being built. When I showed the letter to him, he raised his eyebrows, scratched his head and said: 'Very curious – I will show it to my priest.' The next morning Sakya came hot-foot to tell me that his priest recognized in these surprising words a Chinese classic compliment. The phrase was in reference to the qualities in certain foods such as the notorious Chinese seven-year eggs; we British appreciate the equivalent in our over-ripe Stilton cheeses or high game.

As a result of this exhibition, a few students came to me, all of whom were members of a new society formed by a group of postgraduates of the Imperial University (see chapter on Yanagi).

One of the saddest things that happened in my life in the Far East was the advent of Kame-chan. A boy of thirteen, fresh from primary school, knocked at the door of my new house and Omiya-san, the maid, came and informed me. Might he see me in the porch? There he stood with a newspaper-cutting in his hands – a review of my exhibition with a reproduction of one of my etchings. In hesitant English he enquired, 'You make this?'

I said, 'Yes.'

'Can I work – anything – for you? I want to be an artist.'

We sat in the house porchway and, perplexed, I considered the matter. He was the son of poor parents: they had no objection to his coming – it was not done behind their backs. I told him I wanted to think it over; could I see his schoolmaster? Could he come in two days' time, with him if possible? I consulted my Japanese friends, and they did not seem to think the idea was altogether unusual; it was even a custom with some boys on leaving school to live in a private household and do any odd jobs required for pocket money and their keep; they usually went on to some other form of occupation eventually.

From the outset it struck me that if he wanted to follow my profession it might be difficult for him financially, especially being trained by a foreigner. He was prepared to do anything. I thought of the garden and the weeding and so on, errands, and, of course, cleaning my studio. His father and mother called on me – simple people, and not very well educated. I saw his headmaster; no objection was raised, so I thought, 'Well, it will cost very little – he may have some talent, why not try?' Then I gave him the answer that he might come, and made the necessary arrangements. He learned English rapidly – so fast, that presently, with the help of a dictionary, he was reading some of my art books – of a kind one would not expect a Japanese boy of thirteen to be interested in: William Blake, Walt Whitman, etc. – stiff for a young lad! He kept the studio tidy; he did jobs gladly and was himself a normal, willing boy, but his heart was really in foreign art. At that stage he was drawing in our Western way, although of course I talked to him about it; but as the months passed and stretched into nearly a year, I grew anxious about his future.

Kame-chan brought his father and his schoolmaster to see me, to whom I explained my anxiety more thoroughly. They talked the matter over and agreed that there were grounds for my fears, so his parents took him home and got him a job.

For about a year I did not see him, then one day by chance we met on the top of a tram. His account of life in a brass factory seemed to me awful. I cannot forget the look of hope in his eyes that I might be able to help him. Later, after another meeting with his parents, we arrived at a compromise whereby he went as an apprentice in a little pottery workshop next door to where Kenzan – who was then my master – lived. All seemed to go well for some time. My wife, Muriel, was always very kind to him and so were the maids, but there was

something odd about him: the biting of his lips (a habit he could barely stop), and an action like constant spitting which became worse.

Eventually we called a doctor who asked a series of questions about his parents and ourselves. Then he explained sadly that the boy had dementia praecox – a form of insanity. I felt stricken. The doctor assured us that we were in no way to blame, but I have often wondered whether if that boy's life had been more ordinary he might have remained within the ranks of normality. Things became too difficult, and after consulting my Japanese artist friends, who too were nonplussed, the doctor suggested that he, Kame-chan, should go into an institution for the mentally defective. There I went to see him and was horrified by the life of the inmates. Very plain food, people of various ages sitting in a darkened room gumming flaps of envelopes all day long, with the exception of half an hour in the garden for exercise. I was appalled: it was enough to make anyone go mad.

My Japanese friends came to my assistance, and helped me to get him jobs in shops, but he couldn't keep any of them for long. The second time I went to Peking he came with us. There I let him go out drawing, which he loved to do with pen and ink. I liked some of his drawings showing the influence of Van Gogh and some of my Japanese artist friends to whom I showed them on our return a year later, agreed with me that he had talent in them. However, he became very difficult, and on our return to Japan from Peking we handed him over to his parents, and on doctor's advice he was put back into the institution.

There I visited him from time to time, on one occasion even taking potter's clay, for which he had asked. Subsequently he showed Umehara, the foremost painter in Japan, and myself, what he had been doing with it, speaking as if it were a masterpiece. (See plate 14b.) I looked at it blankly. Umehara afterwards said, 'I felt exactly the same – no expression of any kind in the lump he showed us, but his intensity made me doubt my own verdict.' I felt desperate, but when we finally left Japan there was no alternative but to leave him with his parents. It was very sad. Sometimes we have to learn how best to balance between joy and sorrow, so I have included this tragic story about the boy who came to me with such hope and eventually, I heard, died at home of consumption. In the etching I did of him I think is caught some of his despair.

By this time I had made good friends with Sakya. He helped me to

acquire two good servants – a maid and a cook. I was really getting ready for the arrival of my cousin Muriel. Her mother – my beloved Aunt Edith – had written to say that she was going to bring her out from England for our marriage.

We met at Kobe and were married in the chapel of the first Christian University in Japan in Kyoto, the Doshisha, at which my grandfather had taught English. Then on to Tokyo and our new house, my aunt staying in a nearby Japanese hotel, which she very much enjoyed.

Strangely, I do not remember much from this period, except that we were very happy. The servants had decorated the house and gave my wife both a formal and a warm welcome, as also did Sakya.

Living was very cheap. We lived that first year on about a hundred pounds. The maids received less than a pound per month, besides their food and clothing. By Japanese custom it was a man's world, and women servants were dependent upon their mistress of the house being their further teacher and friend, and they gave absolute and touching loyalty. How well I remember O Mya San, our maid, flying into a rage of indignation at a boy who had flung a stone into the air over the house, which landed on my studio window, breaking a pane – this in a land where children are treated with utmost kindness.

Neither my wife nor I could cook, so we learned a dish at a time from a book. We had as staples, rice and poor bread aplenty; an ounce or two of always tender beef, fried, an excellent variety of fish, also eggs and milk – all used sparingly but with fearful repetition. Caramel custard I seem to remember being served daily, for months on end. Oh yes, what we did learn we knew how to do for the rest of our lives!

After my aunt had returned to England and we settled down, in what must have been the early spring of 1910, we decided to make our first expedition into the mountains to Mount Akagi, about a hundred miles north, where our earliest Japanese friend Takamura was born. We took a train as far as possible, then from the station a sort of 'diligence' – a horse-drawn country bus, which drove round precipitous curves on appalling roads. At the foot of steepening heights about 3,000 feet below a visible pass, we were dumped down from the midst of equal proportions of humanity and foodstuffs – some of it live fowls. We set out with our light packs to the last village before climbing began. There we were accosted by a persistent young peasant who kept repeating, 'Please teach English.' With the westering sun descending

the sky and that pass towering overhead, this was disconcerting because so patently impossible. He must have been an odd sort of village idiot who toiled up those rocky slopes. Finally he desisted and stood disconsolate whilst we climbed on as quickly as we were able, for we had no idea what to expect when we reached the pass.

The sun had gone down when we looked over the top. We could see many cattle tracks descending towards a lake and a single light to which we groped our way. It was a mountain inn. Bath, supper and sound sleep. Next morning we awoke in our quilts on the floor and a maid brought us green tea and those salted wild plums. How almost stingingly sharp, with the plummiest of all tastes! It certainly had the intended effect of waking one up.

We walked miles up and down the wooded or grassy slopes of what must have been a crater far back in time. This was humanly untouched nature; trees fell when their time came leaving a grey streak of dead wood reflected in the clear water, until we disturbed it with our naked bodies.

The following morning we set off for the plains. Coming down a steep-sided valley barefoot we swung round a bend and there before us, bathed in sunlight, was a mountain of red pines baying at the high moon with the enormous single voice of a thousand cicadas, 'mee, mee, mee – meeeeeeee!' ... The sound came to a pause, then some old bull insect started up again and all the others joined in the chorus of a whole mountainside. Further down we came to reeds and swamps below our path; from them the sound of the Japanese nightingale – a cadence of sound – very sweet in comparison to the roaring insect voice of the mountainside. We walked many miles and eventually reached the town and train, which took us back to our spotlessly tidy home.

In the spring of 1910 my friend Reggie Turvey was due to return from England to his home in South Africa, and I persuaded him to travel by an Eastern detour to visit us and share our Japanese life. We found him a room nearby but he lived with us and used my studio. Summer was approaching, and in the humid heat we began to long for the countryside, or at least coastal breezes. With the help of friends I contrived to hire two or three large rooms in a Zen temple near a fishing village on the large Boshu Peninsula which forms the other side of the Tokyo bay. The mouth of this narrow valley with the morning sun on one flank and the afternoon sun on the other seemed to offer

us an attractive variety of landscape to draw or paint, but our move was planned without foresight or anticipation. We had imagined there would at least be plenty of fish but all of the best catch was sent to the capital by small steamer at 4 or 5 a.m. Vegetables were few, mostly pumpkin, almost no fruit, no meat; even eggs were rare. Then none of us could be called cooks, nor had we learned much Japanese.

When we went out to paint, however remote, the news went round the village like wildfire and a crowd of inquisitive children soon formed a small gaping wall of curious faces between us and our subject matter. My gentle and patient English chum became irritable and asked me to say a few words to shoo them away, but they took no notice whatsoever, not understanding that a Western artist of that epoch drew from nature, whereas oriental artists drew from memory – and indoors. Then came the *buyu*, a horrid little black flying insect the size of a flea, which attacked any bare patch of our richer flesh, dug in and was gone, leaving a stream of blood and furious irritation. We certainly fed and worked under difficulties. When the belated rains came, incessant for eleven days and nights, insect life took refuge under the great thatched roof of our sanctuary. For protection we lived by day as well as by night under room-sized mosquito-nets. Our few books having been fully read, we fell back on a pack of cards apiece at a game called 'racing demon', the ultimate winner to pay for the best possible dinner on our return to Tokyo!

We were hungry; our postal supply of long French loaves from the capital arrived very late and very green. We whittled them until meagre white cigars were left, which we apportioned with scrupulous fairness together with the melted butter.

At last the sun came out and we visited the sea-shore. Muddy landslides from the hills every few hundred yards had made the sea positively yellow.

My wife Muriel accepted our ordeals with fortitude and behaved like a heroine all through, but my friend Reggie opted for his Drakensberg mountains in South Africa. He had had enough. We felt sad about it. I should have realized that his warm English nature was not suited to this kind of life. We returned to Tokyo and prepared for his departure.

Before our visit to Boshu, Reggie had introduced us to Kenkichi Tomimoto, a young Japanese architect, whose acquaintance he had made on his way out to Japan by ship. Tomimoto had studied at the

Goldsmiths' College in London. Much of his time had been spent in the Victoria and Albert Museum, where he had been attracted by crafts from all over the world.

I took to him from the outset. He was a legacy to me from Reggie.

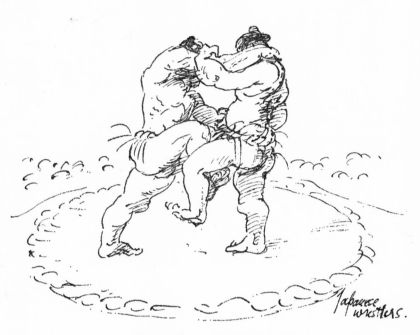

FIG. 3. Japanese wrestlers

Chapter 3

KENKICHI TOMIMOTO

During the years I spent in Japan between 1910 and 1920, Tomimoto and I were like good brothers – we shared everything. We were of an age; young, enthusiastic, open-minded, and gave and received without reserve because we trusted each other's characters. I had come to Japan of my own free will; I think he had been to England for two years in much the same way. Despite differences of race, tradition, philosophy and religion, in each we found common ground and therein an exchange of positive values. I was a draughtsman out of a background rooted in the Italian Renaissance of the fifteenth and sixteenth centuries, born of Greece and Rome. He too was a draughtsman, reflecting the southern school of Chinese culture of roughly the same period. He loved poetry, brush-work, *sen cha* (fine green tea), old classics and, like me, came from middle-class background: it seemed fated that we should become life-long friends.

As I look backwards to those early days of the Meiji period of our companionship, his eager, generous but discriminating eyes emerge from the past; vivid, engaging, sharing every refinement of quality and beauty with his chosen friends. By blood his inheritance seemed to be partly from the South Seas, outweighing the Mongol in his origin, as I as well as he often remarked. His family had lived as land-owners in that same area of Yamato in Nara Province for over a thousand years.

We walked or bicycled over that gentle countryside in the spring-flowering of cherry, peach, and pear trees, sketch books in constant very brief use. Those quick concentrated notes of fern or flower, of

cloud or bird, or building, greatly simplified, were the sources of many patterns we each used in later years on our pots. At first he had no idea of ever making any, although I well remember how he showed me the fine qualities of Chinese *gosu* blue pigment on seventeenth-century Tenkei (T'ien Ch'i) porcelains, and of the corresponding enamelled porcelains of the late Ming period.

After Tomimoto returned to Japan from England, amongst other creative work he had started making wood-block prints. I had my etchings, some of which were done in Japan: we discussed a combined exhibition. The following is written in my diary at that time:

'February 18th 1911. Went with Morita to see the very first independent small art gallery, Gahosha, in the centre of Tokyo, intended for exhibitions by young artists, to see if they would include Tomi's work and mine, to which they gladly assented. This was followed by an invitation to a party where Morita, Tomi and I met some thirty young artists, writers and actors, who, for recreation, were painting pottery. The interior decoration of this house reached the high-water-mark of anything I have yet seen. Not elaborate but in excellent taste and thoroughly Japanese in character; the ceiling of the room, for example, was made of broad laths of partly planed bark and wood showing the quality of the grain of the latter in various places.

'In this large, most beautiful tea-room, brushes, pigments and unglazed pottery lay about on small felt rugs which protected the matting. Someone who spoke English asked me if I would decorate one of them, and for the first time in my life I considered what was appropriate on a pot. It crossed my mind that pattern must be something different from either the landscape or figure-painting to which I was accustomed.

Quite recently I had seen a Ming porcelain dish in the Museum, I recollected, of a parrot balancing on one foot. At the two ends of its stand, small pots contained seed on one side and water on the other. From them at right angles, a framework within the circle of the dish was joined on the fourth side of the square by a handle. Thus a style or formality was created which seemed to have something to do with pattern. This I attempted to paint on my plate, which was then taken from me and dipped into what looked like a pail of whitewash, but when it emerged my pattern had disappeared. For a moment I wondered if my work was disliked, but then observed other people's pots

being treated in the same way. I came to the conclusion that the white-wash was more likely to be finely powdered glass mixed with water. This was not entirely wrong: after all glass and glaze are of one origin.

'The pots were placed around the top of a portable kiln no bigger than a studio stove, to dry thoroughly. This stood on the ground outside the verandah. At the right moment the outer lid was lifted off with a long-handled pair of tongs and we were able to see the inner box with its own cover and red-hot charcoal burning between outer and inner walls. When the inner cover was removed, the colour of the interior was a bright red. The pots we had done were put one by one into the inner chamber, replacing those already taken out. The cover was put back, then more charcoal was added, and the perforated outer cover replaced.

'About three-quarters of an hour later the opening process was repeated and the red-hot pots were taken out one by one and placed on tiles on the ground to cool off. The colour gradually changed, the patterns emerged, and as the crackles formed in the glaze, each made a "ping". To my amazement the pottery withstood this treatment. (Later I discovered that the reason lay in the composition of the clay, which contained at least twenty-five per cent of pre-fired, and thus contracted, powder clay.) After another quarter of an hour or so, my dish was returned to me, not too hot to handle, in a piece of cloth. Enthralled, I was on the spot seized with the desire to take up this craft.'

A few months later, after asking my friends to help me find a teacher, I was introduced to the sixth Kenzan, with Tomimoto as my interpreter.

Shortly after this *raku yaki* tea-party, a national colonial exposition was opened in Ueno Park. On one side of the park there is a large pond full of lotus plants; on the south side I found a shop where visitors could buy unglazed biscuit-wares, decorate them with their own hands, and have them glazed in *raku*. The owner of this temporary shop was a neighbour and a potter, albeit a bad one! Despite this I frequented that shop decorating pots with any suitable ideas which came into my head. I even used patterns taken from my old school's *Green's History of England*, which included some prehistoric English burial wares. I don't think my pots were good but I enjoyed myself enormously, and there was much I learned by observation. There are constant entries in my diary indicating my new-born enthusiasm.

It was at this time I began to think more seriously of how to make a living by some combination of art or craft, possibly with Tomi or Takamura. I dreamed of a shop of our own, but then realized the difficulties involved. I went down to Kenzan's workshop every day, usually carrying a bottle of Ebisu beer which I knew he liked and which we shared for lunch. There, sitting on his hard floor, I began to learn my alphabet of clay, turning a potter's wheel with a stick, making either the soft ware with wet hands, or turning the cheese-hard pots. He said very little; in fact my many questions in very limited Japanese bothered him. 'You have so many "why's" – what is oxidation (clear burning) or reduction (smoky)? Your questions make my head ache.' They may well have done so in my poor Japanese. 'Do what I show you, which is how my master taught me.'

After working with Kenzan for over a year, he said to me one day: 'Would you not like to have a small workshop in the corner of your garden?' I assented eagerly.

This simple little room with the necessary shelves and potter's wheel was soon erected. By the time it was finished, Kenzan had made the kiln, and it too was soon ready for use. I set to work. (See plate 2a.) Not long afterwards I persuaded Tomi to come and throw his very first pot. Naturally I helped him where it was absolutely necessary but was surprised to find that he was able to more or less centre the clay on the wheel and form the inside of a bowl seven inches wide. This I was able to turn when half dried and to biscuit fire it by the following week-end ready for him to paint. He chose plum blossoms and a popular spring song. *Ume ni uguisu, hokekkyo! hokekkyo! to saezuru . . .* 'The nightingale sings amongst plum blossoms once again, hokekkyo! hokekkyo!' I have since discovered that the first Kenzan quoted from the same spring ballad on one of his pots two hundred years earlier. This very pot was later given to me, as was that first pot by Tomimoto. Both are now in the Victoria and Albert Museum.

As Tomi could find no suitable architectural work in Tokyo for his talents he began to yield to my persuasion to try pottery, and presently planned to start building a small kiln on his land four hundred miles away, in the Province of Nara. Meanwhile Kame-chan had gained sufficient knowledge to be useful in helping him to construct it.

Although I liked Kenzan and respected his brush-work, neither

Tomimoto nor I attempted to make shapes in the Rimpa (Kenzan) style, nor to copy any of the traditional pots our master made, but when he introduced any foreign element, the result was poor and he knew it. One evening he asked me to come, saying he wanted to give me the *Densho* (recipes) he had inherited. This was the sealed proof of succession, produced at a Master's death. I clearly recollect how Kenzan explained the manner in which, in the old days, a *Densho* was given by the Master to his successor in a locked house at dead of night, so as to keep it secret and not cause jealousies whilst he was still living. 'Times have changed', he said. 'Nevertheless I would like to give you this document.' Tomimoto later told me that in 1923, after the great earthquake and fires of Tokyo, he visited our Master as he neared his death after nights of exposure in Ueno Park – his house and workshop having been destroyed. Kenzan said that he was dying happy being able to leave us two as his pupils.

Tomimoto and I both loved and admired the first Kenzan of Kyoto and Genroku times. Tomimoto knew him best by his earlier pots, and what has been called his Edo *Densho*, which was really written during 1737. It is dated March 5th in Edo, but was completed at Sano late in that same year, as his diaries describe in detail. There was a second description of his techniques, also written at Sano and its neighbourhood in Tochigi Province which I translated with the help of Hiroshi Mizuo and others in my book *Kenzan and his Tradition*. Unfortunately I was not able to see Tomimoto much towards the close of his life, and could not put all the evidence before him of the authenticity of the Sano pots and notebooks, so that he could take part in the struggle to vindicate, together with me, that fine old artist and potter, whose name we both inherited.

My friend Tomimoto was a fine craftsman and a good colourist, as could perhaps be best seen in his small enamelled incense-boxes and seals. He employed and expanded the repertoire of over-glaze enamels on porcelain, and introduced the use of platinum, together with gold and silver, as no potter had done before. But I would add that on a potter's wheel he was always a bit of an amateur, as I am myself, and even as Shoji Hamada has written concerning himself, adding: 'Any professional potter in Mashiko is far more skilful!' Sheer skill is the result of constant repetition, and in the wrong hands can become the most boring slavery, and result in very bad pots. What is it then that

an amateur may have, and the skilled professional may not? A freer perception of what is alive and true. Some of Tomi's pots were even heavier than mine. I recollect how Yanagi said of some Hamada tea-bowls which were also rather heavy, 'They were better than being too light.' So many people take refuge in superficial catchword judgements of valuation in pots, especially a certain kind of 'collector', and even men of Tea – lovers of Japanese Ceremonial Tea – in a country where above all others, the 'seeing eye' has been most highly developed during at least five hundred years.

To me, Tomimoto was a rare maker of patterns, an originator. All his work was fine and sharp. Pattern – in the old sense of folk-dance, or melody, a few sounds, or movements, or colours reduced to an ultimate simplicity of related and evocative elements has almost vanished with the weakening of the vitality of traditional and close-to-nature country life. Now we have become so intellectualized that this stream of common beauty has dried up. Tomimoto and I were almost the only artists in this field, and yet it was not a world of artists in the modern sense, and to that we inescapably belong. But we were both in love, each in our own way, often overlapping, with that purity and loveliness – like the wind over wild flowers and grasses in Korea, Japan, or elsewhere.

In the early days he called me 'Kappa' (water-sprite) and I called him 'Kappa' too. We even exchanged thought unconsciously. I remember once when I was later making pots at Abiko in my workshop on Yanagi's family estate and I wanted to make a notched pattern on the very edge of English eighteenth-century style twenty-inch plates. With a simple wooden tool I found the work laborious, so it occurred to me that it could be done with a pattern cut into half-dried little clay rollers with a hole for a wire handle – like a garden roller. This I tried at once with immediate success. The drawing of what at that time seemed an invention, showing a wave pattern, on a post-card, was sent off to Tomimoto, four hundred miles away. The next morning I received a post-card from him in Ando – crossing mine – of the same new roller idea, with an almost exact repeat of the wave pattern on it, and the words in English: 'Try this'!

Tomimoto had a fine discriminating sense of form stimulated by Korean pottery of the Yi dynasty and carried out either in porcelain, or semi-porcelain. I cannot describe his pots, in general, as better in

form than in decoration or pattern, in which I feel the stronger and more varied original gift – yet both place him in my mind amongst the best artist potters Japan has produced. Who, since the first Kenzan, has drawn direct from nature such a rich invention of *personal* stylization? That is, no doubt, why he has influenced so many of his contemporaries, not only in pottery but also in metal-work and textiles. I think it may be added that his use of the brush was freer than his use of the potter's wheel.

Tomimoto died in June 1963. Looking back over the fifty years of our friendship, still with a predominant sense of its continuity, tempered by the poignancy of his absence in the flesh, I touch his pots with my hands – *raku*, stoneware, and porcelain; re-read his letters and post-cards, gaze at his clear, sharp brush-work and drawings in pen and pencil, with vivid memories, full of both sadness and joy.

The following is a translation of a poem by Tomimoto from a tiny illustrated book in the commemorative exhibition of his work in June 1964:

To forget myself
And my defeated Motherland
I write these lines.
Like cattle in trucks
We flee to the hills
To eat – to eat beans.
On arrival
Beans are rationed.
No beans –
Only the taste of war.
Each mountain
Has a flavour,
The taste of defeat.
A hundred flowers,
A hundred flavours.
Fish are aplenty
Three times a day,
Back to the coast.
I would eat fish.

Kenkichi Tomimoto

Rough seas, no fish –
The same all over Japan.
I have no kiln,
I cannot make pots.

Written during the War.

Chapter 4

EXTRACTS FROM EARLY DIARIES, 1911-1912

Sometimes discussions between Tomimoto and myself were of a serious or even philosophical nature.

1911. 'January 6th. Tokyo. In a tram the thought came to me that the only source of beauty was the Absolute. We in "its image and likeness", therefore contain an innate capacity to recognize truth. Letters from home.

'January 20th. Leonardo says the soul knows instinctively that it is helpless without the body, hence the fear of death. I cannot help feeling that nothing is lost in this world, material or otherwise, if there be otherwise – only change. Yet let us suppose an artist in the quiet of his studio paints a masterpiece and burns it – the material becomes carbon – the act is registered in his mind – but what happens to the portrayed beauty and its potentiality?

'January 25th. Went down to Kanda with Turvey and bought him some pastels for use on his voyage. Booked his passage to South Africa. This is a strange land; in some ways I do not respect the people and I don't know how much I like them. I cannot speak their language and their thought and emotion is very alien and medieval. I want to go back to England in a year. But I have a home; we expect a child; I have to grasp something of the traditions of old art and I must try to make and save some money. I would like to make a series of etchings both here and, if possible, in Hong Kong.

'January 31st. Went to the Museum . . . Why should not a porcelain vase be as beautiful as a picture? Many in the museum are finer than any painting I have hitherto seen produced by Westernized art in Japan. I daresay there are fifty pieces – such lovely shapes and colours, full of the surprise of beauty.

'February 14th. Turvey packed. He says that when he comes back to London he will find me silly, toothless and inarticulate in an armchair! In the evening Tomi, Turvey and I dined with Morita. He brought one of the art school restaurant chefs to cook and serve the excellent foreign farewell dinner he gave us.

February 16th. How lonely it seems without Turvey. I wonder when and how we shall meet again? Perhaps five years hence in London.

'February 26th. Nearly all the time is spent discussing plans for our exhibition at the *Gorakuden* of young Japanese artists' work into which we are trying to bring fresh life in presentation. A hundred and one details have to be foreseen. Tomimoto is most helpful, as he is thoroughly artistic and has a wide knowledge of decoration. I like him very much – he has a strong sense of humour and loves the piquant. He is nearer the English temperament than any Japanese I have met hitherto, yet he remains Japanese.

'March 3rd. Takamura came to tea. What a magnetism there is about him, his personality compels me. A most lovable character – sensitive, brooding, intuitive, refined, unexpected. He has been passing through a sad time owing to despair over his own country. How horrible it must be for a Japanese to hate all the national tendencies. I hope that he will do much – perhaps not as an artist but as a teacher.

'March 15th. Prospect of O Mya-San's marriage in the autumn. How extraordinary are the Japanese ideas on marriage. So comparatively primitive. They have no concept of our idea of love. The go-betweens for parents determine the "suitability" of the marriage in question and in most cases the "principals" never even see each other before they are inextricably plighted.

63

'March 16th. Tomi is at the Red Cross hospital with a sudden attack of typhoid. I hope to see him tomorrow.

'March 27th. Received a cutting from the *Morning Post* with a favourable comment on the etchings done in Japan which I had contributed to the Friday Club Exhibition in London.

'April 2nd. Went to the Industrial Exhibition in Ueno Park and had three pots baked. I notice in the foreign press *Public Opinion*:

(1) That no Indian soldier can get the V.C.

(2) That no European lady will dance with any native, but that European men will dance with native princesses.

(3) That in no Club between Colombo and Yokohama will a native be admitted. Here is much food for thought!

'April 5th. This afternoon went to Shinagawa and saw Tomi fresh from hospital: thin and white but on the high road to bodily and mental health. We discussed many matters. Details for the exhibition and decoration in general. To my surprise he told me he has five hundred drawings of crafts – mainly pots – made in English museums!

'April 15th. Meeting of 30 artists. The first exhibition of modern artists' drawings in Japan, I think. Everybody pleased. Five of my etchings besides two drawings. About a hundred exhibits altogether.

'April 18th. Pictures selling well and good notices in the press.

'April 19th. Busy every day decorating pots at the Industrial exhibition in Ueno Park with Tomi. Went to see a *Noh* play. They are almost out of my range and very difficult to understand but the music and movement was fascinating. Had a long talk with Tomi about the influence of educational authorities. There is scarcely any chance for the individual and independent artist, sculptor or architect. People cannot get out of the habit of bowing to officialdom. Takamura, Tomi and others seem unable to put up a fight and so want to escape. I would like to see a young revolutionary art group with a high independent standard.

Plate 1 Myself in the garden of International House, Tokyo, 1966

Plate 2(a) My first porcelain pot (4 inches in diameter), fired in Kenzan's kiln, 1911–1912

Plate 2(b) Enameiled stoneware bowl (10 inches in diameter), made at Abiko, 1917

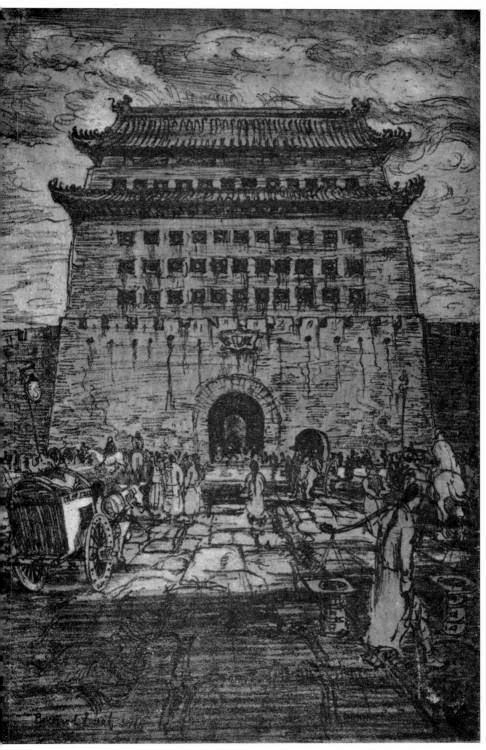

Plate 3 Chen-mun Gate, Peking. Soft-ground etching, 1916 (printed 1918)

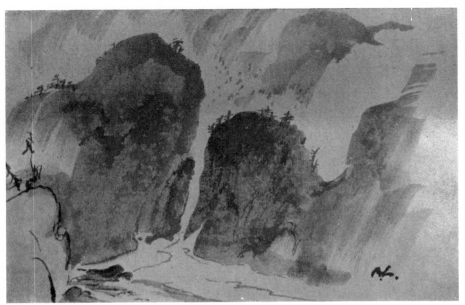

Plate 4(a) Mountain gorge, the plain of Matsumoto. Brush drawing, 1954

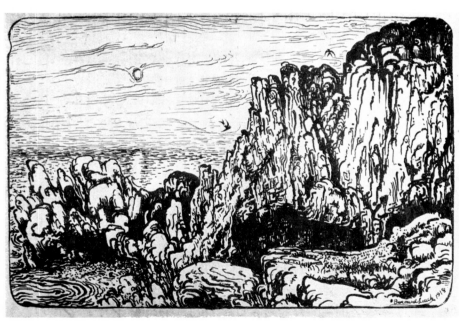

Plate 4(b) Marble Rocks, Pei-tai Ho, China. Lithograph, 1916 (printed 1918)

'April 27th. Tomi goes to the country on about May 3rd to settle and work – I think also to escape the overwhelming influence of official art. We are sorry to lose him. At the exhibition I have sold ten *raku yaki*, seven etchings and two oil-paintings on paper. Tomi sold about forty small prints, one or two plates and one water-colour. About a hundred things sold altogether between us.

'April 29th. Had a long chat with Takamura. He soon is going to Hokaido for freedom and thought, to live on the land and till the soil, to study, be independent and to found his life. The place is newly settled. He goes to escape from the ugliness of daily new Japan to the core of Reality. May God overshadow him. Our child is expected at any time.

'May 6th. Muriel woke me and said quietly, "It is coming." During the day the pains came more and more frequently, till by the evening they were almost continuous. It was an awful night. Poor lassie. She suffered a great deal. I can hardly bear to think about it. About 2 a.m. she slept from exhaustion and I lay down on some cushions by the bed for two or three hours. When I awoke she was groaning and tossing again. I got up and smelt the morning air, damp and rainy as it was, with feeling. The doctors came in and I was sent out. After half an hour Muriel was asking for me, so I went in quickly. I went to the head of the bed and put my arm round my wife's head and waited. They used little chloroform, and that at intervals: in fact when one doctor was called away and all was going well, the other doctor handed me the bottle of chloroform. I suppose an hour passed before the child was born. Never will I forget the first cry of the babe and my first sight of him. For a few moments I feared he was dead, but he soon made it clear he was not! Then came Muriel's relief. They made her comfortable and bathed baby in the next room. Poor little chap – he's not so handsome. About eight pounds with a big head and fairly fat. The rest of the day passed like a dream. I wrote letters, sent a cable, slept, and watched my wife – dear little mother.

'May 11th. Went to the zoo and drew parrots. Came home and painted them on various kinds of Japanese paper in oils, but replacing linseed oil and turpentine with benzine saturated with ordinary candle wax.

This evaporated leaving no fringe of oil in the absorbent hand-made paper, and yet preserving the bloom of the paint. This is an original technique.

'May 14th. Went to the museum in the morning. Made drawings from ancient Chinese bronzes. Noticed the similarity between old Chinese and Ainu designs. It began to dawn upon me in the museum that the Asiatics millennia ago left their footsteps right across the islands of the Pacific to the Americas. In later years I found this to be true from scientists – they estimated twenty-five thousand years of migration from Asia.

'May 24th. Baked all the morning using some early British designs I I have adapted lately.

'May 31st. I am always thinking of a plan for the combined necessary making of a living and the pursuit of art. My present idea is the formation of a group somewhat on William Morris lines by Takamura, Tomi, self and a few others. Painting, sculpture, porcelain, lacquer, etc., to be exhibited in our own gallery.

'June 2nd. At last a letter from Turvey!

'June 13th. Took Muriel for another stroll through the beautiful Buddhist cemetery near our house. When I re-visit that spot, last seen with Turvey, it makes me sad to think that his memories must be so unpleasant. What a mistake I made in asking him to come out. Fate owes him a big debt of compensatory happiness.

1912. 'May. – I have just read an account of Gauguin in Meier-Graeffe's work. My God! Here it is! This natural savage did that which I have been dimly groping after in theory only. So must all sincere men act according to their light. I don't know how people without light in their faces should act, but I do know that a creator, stripping himself nude, must plunge into the ocean of life and swim out and out. It were better for him to drown than to sit on the sand gazing wistfully at the white crested waves. Oh for some courage! He is a poor artist who keeps in his depth.

John Sargent, the most famous portrait-painter in England, said of

Augustus John that he was the greatest draughtman of the age, yet he has received more inches of expert opprobrium than any artist of his generation in England. They said of John somewhat as they said of Whistler – that he poses, that he seems to say: "What the devil is beauty and refinement? Ugliness is agreeable." They do not understand that John is no Englishman but a Celt – primitive, sharp, powerful and rugged as nature. He is not dull and slow-witted like most of them. His broadcast drawings have a wild flame of life in them. His influence over the young men of the day is a better guide. They look to him, as I do.

A friend of mine who had studied under John left him and went to learn painting and decoration under Frank Brangwyn. Late one night in King's Road, Chelsea, he met John, who had been drinking heavily, and called out to him, "Hallo Norsworthy, learned to paint with Brangwyn? Have you learned to think?"

Henry Lamb described to me how on one occasion he went to the National Gallery with John and stood before the famous *Ariadne in Naxos* by Titian. "Wonderful", said John, going nearer; "Rich colour." Nearer still, "Astonishing surface." Then he stepped back again and said fiercely: ". . . but it has no coal – I'm damned if I want to paint like that." '

FIG. 4. Thistle

Chapter 5

MOUNTAINS IN SUMMER

Hakone, 1911–1913

The mountains and lakes of Hakone are just about halfway between Tokyo and Fuji, a hundred miles away. Many lakes in volcanic Japan have formerly been craters. Hakone must have been the result of eruptions which culminated in that matchless, solitary, 14,000-foot Fuji-san. The chain of leaping snow-capped mountains up the northern Rockies towards the Canadian border is magnificent; but this solitary peak in all Japan has a uniqueness of beauty amongst its volcanic peers right round the fringes of the Pacific. My wife and I spent three summers at Hakone Lake from 1911 to 1913.

We rented a thatched cottage at the water's edge in the old village and hired a pea-green dinghy with a single lug sail in which we took our babe, David, out tucked in a travelling basket called a *kori*. Mountain winds over the pass might be treacherous, so naturally we were carefully observant of cloud, wind and wave. When alone I drew and painted, or just sailed for the fun of tacking back and forth. Once when well down in the broadest part of that six by one-and-a-half mile stretch of water, the wind became so strong the running waves were too large and powerful to attempt to tack, so I had to let the little boat run before the wind and steer for a beach and go full tilt up its sand. This meant walking home several miles round the other side of the lake. Fortunately that day we had left David at home in good care. Ours was a simple, healthy life – walking grassy miles, swimming and

getting to know a few other people, mostly English and Americans. Nice, responsible maids were with us, so at least we could make short excursions between the baby's feeds, and David was not a crying child.

The next year some of our friends persuaded my wife to climb Mount Fuji with them to see the sunrise from its peak. I'm afraid I was disloyal enough to say 'No! – for me, such mountains from below!' I wanted to paint anyhow.

I remember once climbing the path over the mountains down to the sea level towards Atami – it must be fully sixty years ago. There the hotel where we spent the night stood on stilts over a stream. Below the slatted verandah we watched carp wave their slow tails.

On another occasion we planned to climb the highest peak of the Hakone mountains, 5,000 feet above the sea. I do not recall what it was about, but Muriel and I quarrelled at breakfast – probably some selfishness of mine. She set off alone and I sulked and fumed for half an hour, then put pride in my pocket, went after her and caught her half-way up. We climbed in silence to the grassy top, where we were attacked by the most astonishing swarm of horseflies I have ever seen. It was unbearable! We dived into the undergrowth for refuge, and with sandwiches and cold tea celebrated comparative, well-bitten peace. Occasionally we raised our heads amongst the stunted oak-leaves, and stared at the astounding vision of Mount Fuji revealed from top to toe, the lake on one side and the ocean on the other. With silver and green pampas grass flowing in the wind, we walked down the flanks of that mountain and home.

Another time we went to a place where we had noticed the apples of a bush called *Cydonia japonica*, which in the spring has a lovely vermilion-red flower. The fruit resembles apples; we were told that, although acid, they are edible, so we took some home to boil, using two pounds of fruit to four pounds of sugar. The result was terrible, so we added another four pounds of sugar and failed again. Two pounds of Cydonia and eight pounds of sugar all to waste!

During our third summer at Hakone we hired a stern-oared Japanese boat, instead of a dinghy; sculling, standing and using the whole body; it was splendid exercise – as it was on the Sumida River with Morita when we nearly got drowned. One night I had a very strange dream. I found myself sitting in a crowded Tokyo tram. Close to me, standing unnoticed, was the Emperor Meiji, incognito. I bowed to him and

69

offered my seat. Undetected by others, he made a slight movement with his hand, declining, and spoke to me. I cannot recall what he said. I was surprised that no Japanese appeared to recognize him. There the dream ended: the next day we heard of his death.

Karuizawa, 1914—1918

The outbreak of the First World War in 1914 found us in another summer resort high in the central mountains about a hundred miles north of Tokyo, not far from the active volcano Asama; the soil underfoot is mixed with its scoria, quickly absorbing rainfall yet sustaining vegetation. The air is clean and fresh. In winter deserted and cold, in summer there are miles of grasses, flowers, and lilies, ringed with distant valleys and mountains – tiger-lilies by day, pale-yellow primroses throng the evening dusk and in September the white feathered seed of a kind of pampas-grass flows under mountain airs and eddies, revealing every ridge and curve of unhampered hills and plains as the winds blow over it, silver on green. A lovely place to dream and draw.

Then came the shock of war; the mud of Flanders. Artists and poets who died young like Gaudier Brzeska, or survived like Sassoon: those who were pacifists like me. When asked by other young Englishmen, practising cricket in the Embassy grounds, if I was going back home, I replied that if I had intended to volunteer I would have already done so. I did not like the Kaiser and his upturned moustache; the heel-clicking and goose-stepping; later I loathed Hitler and his gangsters. I suppose somebody must shoot a mad dog, but hope it does not fall to me, yet I honoured these young men who gave their lives for what they thought was a true cause, but what of all those who gave their lives unbeknown – unsung? In the Second World War, although over age, I was in the Home Guard for five years. Now I would not be prepared, if I could help it, to join in the taking of life.

Under the wise old leadership of Father Kelly, a thinker of the Church of England, who founded Kelham Seminary College in Leicestershire, we walked, and began rock-climbing on the long grassy slopes that end in Prospect Point. There were rocks, one of which was called 'The Giant's Chair' upon which we practised vertical climb-

ing, roping, and learning foot- and hand-holds. These lesser climbs seemed fairly easy to Muriel and myself, but a day came when we went right up to Prospect Point itself; there the formation broke up. The climbing was of a different kind, for the rock changed character. There were cavernous places where a traverse had to be made on a ledge, legs dangling – the weight taken by the clawing of one hand after another at shoulder level on untried ground. That took courage – only one of us dared do it; he also was a parson. I admired him for it but, as we held our breath, thought he was being foolish and that Father Kelly disapproved.

A day or two later when we went again, I was not feeling very well and we came to a point where I got stuck – I could neither go up nor down – I froze. With every second, fear increased. Someone urged Muriel, who was behind me, to attempt it. She reached forward, calmly stepping over my body; then I, the spell broken, followed. I wasn't a specially courageous person. There were days – not many – when I could not face the danger; other days when I could. Father Kelly however did not give up hope, and we even began to ascend precipitous rocks.

One day we crossed those high, flowering plains to where they fell to a valley six miles away. There was one pinnacle full three hundred feet high, up that valley. Father Kelly wagged his head and said that it wasn't possible, so instead I drew it. I used a brush on grey absorbent Japanese paper which yielded texture and was influenced by long observation of Chinese use of brushes in writing characters and by landscape drawings of mountain and water – 'sansui'. My drawing was abstracted out of the scene itself without losing direct emotion, and the abstract was not from a mechanical background but from nature, through ink, brush and paper – the 'three friends'.

The former volcanic core known as 'The Cathedral Rocks' stood six hundred feet high, asking to be climbed. We rested at a vantage point and Father Kelly examined a long water-worn chimney in the rock face through binoculars. 'I think we have a climb there,' he said, 'and today I would like you to try and lead, Bernard.' My heart contracted, but thinking of those men in Flanders, I steeled myself and, after a pause, agreed to try. We made our way to the vertical base and the four of us roped up. The gap in the rock was about twelve feet wide at the bottom, but the hand- and foot-holds were good and I

climbed up perhaps twenty feet and belayed the rope firmly. The next on the line came up and I went on another twenty to thirty feet to where I could span the narrowing chimney and again belay; again the next – a woman friend of ours, followed by Father Kelly, and then, making her first ascent from the base – my wife Muriel. Thus, climb by climb, we ascended six hundred feet in six hours. This was the first time I had led a climb and when I eventually reached the top I lay on the grass, looked into the sky and thanked God.

The most difficult part of the climb had been where a traverse had to be made across a steep grassy slope without much more than a handful of grass to hold on to. Halfway, I recall poignantly, there came a sweet whiff of wild lemon-verbena against which I had rubbed. As I rested on top I realized that this was the very spot where once before I had lain, face downward, looked over the edge, and carefully retreated. At that time my party had climbed up a regular path, with chains to cling to.

Father Kelly, with knowledge and wisdom, taught many young men. He gave the impression of unerringly taking risks. When he used the word God, it was with a quiet seriousness of worship. I think we must all have asked ourselves, 'Why climb – and run risk?' It is one of many ways of learning to face oneself – to face fear – body controlled by mind. At that period I learnt how to look downwards from high places, steadily, as from Prospect Point which, like a broken tooth, overlooks the flat lands of Japan far below.

My favourite hour for drawing on the plains of Karuizawa was between sundown and dark. Then insistent detail eased into a broader vision in which intuition and emotions were released. Thousands of pale-yellow blossoms of evening primroses opened at dusk. Sometimes I was alone with them in mountain mist striving with a reed-pen to evoke patterns of imagination.

Karuizawa lies on a plateau about 2,500 feet above sea level, parallel with the great valley of Matsumoto but on a smaller scale, although its one volcano, Asama, rises to over 8,000 feet. In those days few Japanese came up there – mostly foreigners; but so extensive was that wild upland valley that one could walk for hours in the hills without seeing anyone and, when very hot, plunge into mountain streams.

We spent the summers of 1914, 1917 and 1918 up there, living in borrowed houses scattered amongst fir-trees overlooking the village.

We made excursions in many directions, including one to the ringed crest of Asama choosing an approach away from the belching sulphurous smoke of the live volcanic depths below. The scoria near the rim where we ate our lunch was hot enough to cook eggs buried in it. On the way back we gathered blueberries planted by missionaries years before and still thriving. They were like our English bilberries, only larger and more luscious. From the mountain it was about eight miles back to our wooden house. Most mornings I went out before breakfast and collected the edible fungi – *chanterelles* – growing at the foot of the tall trees. Life was simple and good. The memory is keen of those wooden houses – grey on the slopes of Mount Atago with those tall conifers and the orange-coloured fungi at their bases. It must have been on the last of our summers there, before going indoors to explore the newly rented house with its fine big stone fireplace for the ample wood fuel, that David and I climbed the tallest of the trees, full fifty feet above the ground, and looked out over those miles of grassy plains fringed by unforgettable mountains – the peaks of the high Japan Alps became part of a dreamland which I often drew or even painted on pots. That picture has remained with me all through life.

Chapter 6

SOETSU YANAGI

I first met my friend Soetsu Yanagi in the spring of 1910 at a Tokyo exhibition mainly of German art, arranged by the Shirakaba (Silver Birch) Society. For these students from the Peers School and the Imperial University (the best school and university in Japan), devoted to philosophy and the arts, the objective was the absorption of Western culture. The search at the outset was for truth and beauty in art: in later years through the influence of Yanagi, this search became a Buddhist aesthetic applied to the Western world. Two of their members had started etching in my studio and introduced me to Yanagi, the editor of their magazine, also called the *Shirakaba*. At first I took a dislike to his enthusiasm for German art, which was, I felt, at the expense of the French Impressionists.

The contact with these young intellectuals certainly affected the whole of my subsequent life. Many people would ascribe this to haphazard chance. I have come to the conclusion over the years that we must possess a hitherto unexplained faculty in the subconscious of drawing towards us the occasion, the people, even the ideas, which we need. I recall William Blake's aphorism, 'Desire creates'. Be that explanation as it may, this conviction grows stronger during the retrospective writing of these pages. Certainly the ever-growing friendship and exchange with Yanagi was of this kind. I gave him Blake and Whitman; seeds which fell on fertile ground, for he wrote extensively about both poets. In turn he made me aware of mystics, both of East and West, such as St. John of the Cross, Meister Eckhart from Germany, Lao

Tze, Confucius, and Chuang Tse from China. We dealt authors and artists like playing cards: Sotatsu for Botticelli, Rembrandt for Sesshu, etc. (See *Kenzan and his Tradition*.)

The *Shirakaba* gained status; half a dozen of its writers became well known; Yanagi was always its central figure. As time went on the significance of the Shirakaba thinking became apparent, and is not forgotten at the present time – thus it may be regarded as an historic movement.

I remember one night at a gathering in his house opening a parcel of large and fine German colour reproductions of paintings by Cézanne and Van Gogh, the first to reach Japan. Amazement was followed by excited talk. From that room and the pages of *Shirakaba* enthusiasm spread all over Japan. I, English, and in my early twenties, was en-thralled by the classicism of the one and the burning romanticism of the other.

Few amongst art-lovers of the West knew what was happening in Japan – that paradise of art shut off from the rest of the world for three hundred years. Shakespeare's translated plays were on the stage; Yanagi told me that one of George Bernard Shaw's plays was performed in Tokyo before London. Classical European music was competing with Japan's own music. By the fifties more discs were sold in Japan per year than in the United States. Many decried this overwhelming movement towards the West. In later years when I questioned the conductor Prince Konoe after a concert of English madrigals as to what was happening to Japanese music, he replied, 'Is it the stream which enters the ocean or the ocean the stream?' Forty years later when I heard the children of Shinichi Suzuki, who opened the ears of the tone-deaf child, play Bach's melodies with magic purity, I asked when I met him later on if he taught only Western music. He replied, 'Of course not, is not the world's music *one*?'

Inevitably in a very fast coalescence of antithetical cultures all sorts of exaggerations, misunderstandings and mistakes take place. The marvel is that despite the differences, within a hundred years so much pro-found creative understanding is apparent. The pupil who surpasses his teacher is no longer a pupil. If the West had only taken as much interest in Eastern culture during this period, we would have been the richer for it.

In those early years up to 1914 and the First World War, Hamada

had not appeared. Yanagi, Tomimoto and I had begun to exchange our dreams. At first Yanagi and Tomimoto got on fairly well, but later when Yanagi's ideas of craftsmanship took form in museums and craft shops, a gradual divergence began to develop, partly due to difference of personalities. Yanagi asked me rather belatedly to try to bridge the gap between them; I did attempt to but failed. Tomimoto was impatient: his very sharp perceptive eyes did not always echo Yanagi's verdict, nor did he approve of much in the craft shops claiming to be folk-craft. My friend Tomimoto had a courtly kind of finesse, whilst Yanagi had a religious breadth of outlook.

At this stage of writing in 1974, a bundle of old letters from Yanagi to me has been found of which I am including parts, out of date though they are, because they will throw back an illumination on the period during which the growth of our friendship had become deeper and deeper. I have simplified and corrected his English to make reading easier and have made comments when called for which are in brackets. The first is a postcard written as far back as 1912, when we were both living in Tokyo.

'December 19th 1912.
Dear Leach,
 A tremendous thing has happened. This very evening I received a letter from Augustus John. He is going to send me his works to exhibit here in Tokyo! How my heart beats in reading his courteous words! Let us have some hours to discuss a John exhibition in Tokyo...
 In haste...
(The exhibition never took place on account of insurmountable difficulties, but any magazine with illustrations of his works doubled its sales.)

'May 24th 1913.
 Many thanks for your letter and article. I look forward to seeing your recent works. One must push further one's real thought – that is the only way we can see truth. Let our work be so great that every man is able to love each other in it. Send the following words of Whitman to your wife instead of my congratulory words: "Nothing is greater than to be a mother of man." (On the birth of my son Michael.)
 'Yes, let us work; work is honour.
 Yours ever...

'February 19th 1914.

Dear Bernard,

It was our great pleasure to have a visit from you. I shall never forget the sympathy you have shown me and I believe that our intimacy will cast a beautiful light on my life. Indeed it is my greatest happiness to know you and realize what we are both doing and thinking, for it is my firm belief that the future progress of human beings quite depends upon mutual – Oriental and Occidental – understanding . . .

Your ever friend . . .

'June 1st 1914.

. . . Sometimes I have very much wanted to see you, but the opportunity has not been given. I seldom go out now and am writing and re-writing about Blake. I am very sorry I cannot undertake an article for the *Far East* (a small magazine published in English by American friends); I cannot interrupt my present exciting days with Blake and am uncertain when this will be completed . . . I have written a hundred pages, but for one chapter only out of twelve. . .

'Now Emily Brontë suddenly appears before me. I remember you once told me about her at Mount Akagi (those mountains where my wife Muriel and I first made an expedition after our marriage). My first impression is she is one of the great mystic writers of the 19th century. I am thirsty for *Wuthering Heights*. Tell me again about her when I next see you. Is she not better than Charlotte? I have just read some short account about Emily through the pen of Maeterlinck, which brings tears to my eyes. I love her at my first glance. I am sure she must have been beautiful. If you have *Wuthering Heights* please send it to me. I shall put some of her poems at the end of my book on Blake to make the significance of mysticism clearer . . .

Yours ever . . .

'Tokyo, August 28th 1914.

. . . My mind is not at peace as the world is now in battle. I do not know how to express the present state of my mind. Perhaps the best way to begin my letter is an event which occurred in my dream a few days ago.

'As a soldier I was standing on the battlefield. Suddenly an enemy appeared in front of me. By order I was obliged to shoot him at once. After considerable hesitation, almost unconsciously, I pulled the trigger.

I saw the ball rushing and it pierced through his breast severely. The scene that followed was so dreadful I could not bear it! He groaned in pain, put both his hands upon his desperate breast and fell heavily down to the ground. His pale face turned leprous white. What agony I experienced. I knelt praying and asked forgiveness for this irreparable crime. The dream suddenly ended here. Returning to my quarters I started writing a manifesto against war.

'By all means I hate war. By what authority does our Emperor and government order men to fight and kill other men? Our expected victory is our deepest shame! . . .

'When I finish my book on Blake, I may remove to Abiko with my wife and family, to a new villa which belongs to my sister.

'Abiko. September 11th 1914.
. . . Sorry I left Tokyo before I could see you. I wonder whether you are still in Karuizawa. We, at last, have come to this peaceful countryside to live. My book on Blake is at last finished. I am sending the manuscript to the printer and expect to see its publication early in November. It will be about 600 pages. I am dedicating the book to you as a token of my gratitude for your continual enthusiasm towards my task. I believe it will never hurt your name. It was you who continually stimulated my eager reading and appreciation of Blake . . .

'Abiko. May 5th 1915. Boys' Festival.
'. . . I was delighted to hear you are returning from China. I have both much to say and hear . . . The present age proves that the situation of the nation is far, far, below that of the individual. Man dies and quarrels for the sake of the nation! What more absurdity is in this world? Statesmen declare war, but those who fight are not they themselves, but poor, obedient individuals whom they call faithful soldiers. . .

'Abiko. July 22nd 1915.
Dear friend Leach,

When the great Russian novelist Turgenev was about to die, he wrote a pathetic letter to Count Tolstoy: "Great friend, listen to me again! Please return to your art", was the conclusion of that world-famous letter. Tolstoy however, never listened to his countryman, and continued his career as a rigorous religious reformer. Who was

really right? Turgenev or Tolstoy? I believe both were right. By what work will Tolstoy be remembered? Intelligent critics agree it is by the writing of that great human psychologist that Tolstoy will be remembered as an artist – not (as) a social reformer. Where is the very kernel of his unsurpassable greatness? Without question it lies at the very bottom of his strong and powerful mind, full of moral *and* religious conviction. (Hence no doubt his recognition of the greatness of Bahá' u'lláh.) Turgenev was right in his estimate of Tolstoy, but the latter was right in his crossgrained resistance. Tolstoy's attitude to life was strong and great even in his partial failure. I relate this interesting episode of these two great men because it was with the same feeling that I saw you off at Shimbashi station en route to Peking. Which aspect will your future reveal – you as an artist, or you as one pursuing morality? I don't know; but to which world were you chosen? I personally, as well as affectionately, love you as an artist.

'Abiko. August 18th 1915.
. . . Thanks indeed for your warm p.c. from Tientsin. We are all well here and life has become more joyful. How are your children? My boy grows larger and larger daily. I watch with interest and intensity the realization of human instincts of both child and mother.

'Kame-chan wrote me rather a pathetic letter, in which he describes his life with you in Peking. He writes quite beautifully for his age and learning. . .

'November 8th 1915.
My dear Leach,
The solitary rain has been falling calmly day after day in this quiet country, making everything more imaginative. How often my studies or walks have been stopped by sudden cheerful memories of you. Is the mind not more vital when quiet? Oriental people enjoy the spirit of solitude and the love contained therein.

'Dear Leach, how are you getting on? Through Kame-chan's letters I only learned a little of your life. I hope to hear from you or to see your work; happily my health returns and I have started a new phase on my own, about which I should especially love to talk to you.

'As you already know, I am deeply interested in Christian mysticism, partly from my own nature, partly from studying Blake. I have

lingered for a long time on the problem of dualism, struggling with its division of life – mind and body, Heaven and Hell, God and man, etc. etc. How to escape or reach emancipation – how to unite or organize these dualisms – has been my constant endeavour. When I was first confronted by Blake's thought, the result of which is expressed in my laborious but joyful work on that strange and great world genius, a new life began. I searched for a further answer in Christendom, where the flower of mysticism bloomed so luxuriously. I pondered religious philosophy from ancient times, through the Middle Ages, right up to Bergson. I definitely acquired something, but as taught, God still seemed to remain in Heaven and we below yearning for Him. Christianity teaches the union of God and man, but it is a somewhat unnatural unity tending towards monotheism, rejecting pantheism. Their attitude is "One *or* Many", not "Many *in* One", or "One *in* Many". They reject but do not include. How is monism possible? How is monism within dualism possible? Is all matter? (monistic materialism). No! Is all spirit? (monistic spiritualism). No! Are matter and spirit two aspects of one substance? (monism of substance). Still no! For such, substance is too transcendental and also too conceptual. Is matter identical with spirit? (monism of identity). Still inadequate! Why? It is merely the rejection of duality without its emancipation or freedom: dualism may disappear, but monism becomes impossible. Because there is no unity where there is no variety. No! In duality unity rests! Where two men meet there must be love.' (Here I wish to interpose words that came into my mind fifty-four years after this letter of Yanagi's was written. They are a sort of mathematical proof of the absolute Oneness of God and came to me one day suddenly. 'No one, no two or three, or multiplicity, Q.E.D.')

'By mysticism I mean the religious tempo which claims direct unity with Reality – immediate communion with the One. We can find some marvellous examples of such human experiences in mystics, though their ideas are sometimes very partial and narrow. By *Christian mysticism* is generally meant the tempo which aims at immediate unity of the self with God, usually meaning the *transcendental* God. This I think is the most unfavourable conception for the human being. Heaven and Paradise have the same transcendental meaning connected with this idea of God. Naturally the claim is that God is independent from man and made him in His own image and likeness.' (Here I

think my interpretation from the Bible is not dualistic. It is based on delight on returning to the home I had never really left.) 'The idea of Creation implies the *creator* and the *created* and again it is sharply divided into two. So unfortunately the idea of God itself implies duality. But how is transcendence possible without immanence? This is the question. The world I see is not the creation nor the projection of God, but the manifestation or expression of God Himself. Evolution is Involution. God is not independent from the world, but He must live in this very world. Why then can we not say God is pantheistic as well as monotheistic? It was when I reached these conclusions I met Zen. This was oil to the fire. I have never tasted anything so powerful from the East (I understand this means to Yanagi that the 'Iron Hammer of Zen' represented Absolute Truth.)

'Zen, which I may call oriental mysticism, is the definite grasp of Reality in the self, or self in things. It can be attained through intellectual search with a final profound intuition, through a deeper and yet deeper delving into Reality. Instead of yearning after God so far off in Heaven, the self is dug to the ultimate spring. Zen means the final emancipation from duality and the very grasping of the tap-root of nature. By nature I mean not the phenomenon of nature, but the original nature on which the outward stands. Such aboriginal nature can also be called the will of God. Let our will become that Reality. This is not a simple deification. We should live as the manifestation of such will. Zen – its etymological meaning is "contemplation" – signifies the state of natural peace and unification. I learned from Christian mysticism "what is love", and from the Oriental "what is One". This is shown in the wonderful character of Zen symbolism. Nearly all mysticisms take the negative way (*via negativa*) to reach a comprehension of the final unity. Such endeavours as Asceticism, Nirvana, Self-Annihilation etc. and the words Nothingness, Infinite, Limitless, Absolute, Divine Silence, have been used unavoidably by mystics. In clear language mystic meanings are often beyond the range of words. In the inadequacy of the negative way, men of Zen use the affirmative – the *symbolic expression*. Of course symbolism is well-developed even in Christian mysticism, but its deepest meaning is found in Zen literature. For me this was a discovery. Famous men of Zen not only hear the human voice in themselves, but in the trees and brooks. All nature is a symbol of the self, and the self is yet more.

'I began to study Zen systematically; it really is hard work, because its esoteric side is so developed, but the key once found will open the door.

'Mysticism is not the name of any school, is non-sectarian, and is the very essence of many religions. Quakerism, with which I became acquainted quite recently, is an ism opposed to isms. Man is man the world over – of one identity. ('Ye are all the fruits of one tree.' Bahá'-u'lláh.) Two plus two is four universally: in the same way our mystical nature must be universal. Through mysticism we can embrace all religions because their quintessence is one. Recently I also studied Islamic mysticism – Sufism. Its literature is simply wonderful. Some of their poets intoxicated me and are as profound as Blake.

'Dear Leach, the reason why I devote myself to mysticism will be clear to you. My work on the book I am now writing needs intense endeavour and hard labour as I desire to finish it within three years. I feel sorry that you left Japan without adequately studying Zen. How delightful it would be if I could talk to you about that deep current of human knowledge. Surely even you would cry out! Though Zen originated in India, its renaissance was in China. I don't know of the present state of Zen in China, but I am sure you can learn something about it from Chinese Zen priests. (Unfortunately I never met any.)

'November 19th 1915.

... This morning's mail, to my great delight, brought me your long and intimate letter.

'Dear friend, think of me in writing such a letter in English. I have not suitable words for my thoughts. It is a difficult thing to express delicate nuances in a foreign tongue. The effort makes my back itch! Yet I have been bold enough to write this long letter. What a pleasure it is that we are parallel in thought on the highroad of life! I think your conviction that the present state of European civilization is perverted is right.

'Are you entirely satisfied with Van Gogh's aesthetic? It seems to me that you think as I do and prefer Cézanne, in his quietness, to Van Gogh, but of this I am not quite sure.' (In reply to this question as to which of the two, Cézanne or Van Gogh, I preferred, Yanagi would have been surprised when I say that my own make-up is, I believe, nearer to Van Gogh. Certainly in early life his influence showed in my own



romantic drawing. I am disinclined however, to give preference to either classicism or romanticism, feeling they may be compared to storm-waves in their power contrasted with the quietness of a calm sea, or a statement that mountain is nobler than plain. Art lives by these contrasts.)

'Reality, (God), our Home, our Jerusalem, is one to which we return or make pilgrimage in this life on earth, but the way home varies with the individual and his environment. Here we must realize that there are two aspects of life's journey – Heaven above in its singleness, and earth below in its complexity. Through all its struggle there is an upward thrust. I believe your artistic mind is keen enough to perceive that there is a certain point at which our healthy Cézanne (I say "healthy" – the reason I shall give later) and degenerate Lautrec meet each other, though the routes they took were quite opposite. Van Gogh went through the route of agony, the talented Beardsley through decadence, our dear Blake through that of "mystic vision", our brother Whitman through that of "comradeship" – to the one Reality. Some showed it through moral struggle, some expressed it through pain and torture, for some suns and flowers were the symbol of Reality; nay, even wine and harlots were the revealers of God. We should be thankful for single Reality and plural worlds.

'Here we must face the ultimate question. What is Reality? What are the routes to it? Let me deal with the second question because it is more directly connected with your letter. I think, broadly speaking, there are two kinds of routes, particular and universal. Undoubtedly Lautrec, Verlaine, and Beardsley belong to the former. Their temperaments (mental as well as physical) were particular – their environments (civilization) were particular. Van Gogh, Strindberg and Nietzsche were also particularist. Their tempo and energy were quite unique and inimitable. What are the features of these artists? Great as they were, all their greatness is special and inapplicable, thus individual. Decadence and agony cannot be our ideal. This inapplicability of each particular route originated first from born peculiarity and secondly from the spiritual struggle endured. All were brave fighters and expensive victims of an unbalanced civilization. A world which requires victims is undoubtedly tragic and imperfect. Hence this particular route is unnatural, though the fighters' bravery and sincerity are beyond question.

'November 24th 1915.

The unbalanced present civilization begets martyrs like the deformed born of the dissipated. We, however, are immersed in this world. We have just mentioned one route – the by-pass, but we must not forget the main road, the open road. This I call the common ideal and universal route, which our proper nature claims, and means the balance which must exist in every polarity and consequently is unitive and the will of nature. The "Law of Nature" mentioned in your letter means the same thing. The reason is twofold: the significance of balance in duality (unity), has not been apparent and the artifice in our civilization has made us reactionary. "Not right" and "unnatural" – which is your phrase – must have been unavoidable results under such conditions. I wholly agree with your plea for "naturalness" being the strong necessity in this unbalanced world. It is the universal route – the open road. Thus you will understand why I said I prefer Cézanne to Van Gogh. I didn't mean that Van Gogh was lesser than Cézanne but, to use your phrase, Cézanne was more "natural" than tragical Van Gogh. Similarly I prefer Emerson to Carlyle. Who amongst our artists demonstrates this normality?

'Here I shall enquire deeply into this problem. You mention Blake and his art in your letter, to which I must add a few words. Many critics attack Blake because they think his visional spirituality to be pathological rather than normal – he was called a "madman". "Man's perception is not bounded by organs of perception; he perceives more than sense can discover. He who sees the Infinite in all things sees God." His fourfold visional life was his victory, not his defect. Who will say that our healthy Cézanne was not the two-fold or three-fold visionary also? He actually had the capacity to see Reality in unseen phenomena. "For him the silent bottle danced and the dumb table laughed." I imagine all great religious or artistic experience is marked with mystic vision in some way or other. Their intuitional state is a variety of it. Blake was a thoroughgoing intuitionist. Sometime in the future I believe men will call him a healthy-minded natural artist, though he may not seem so at present. I know he attacked rationalism and named it "spectre", but it is not right to say he was partial (un-balanced). What he actually attacked was rationalism, not rationality, intellectualism, not intellect. He did indeed value intuition (inspiration–

poetic genius) more than intellect, simply because the former is the end of the latter. "What is now proved was once only imagined," he wrote. He wished to emancipate, not reject the intellectual world. He also said, "Without contraries there is no progress . . . Reason and Energy, Love and Hate. . . ." It is quite right when we say that he is far from our present life, but it does not follow that he is not "natural". Whitman and Cézanne were both mistakenly regarded as "unnatural".

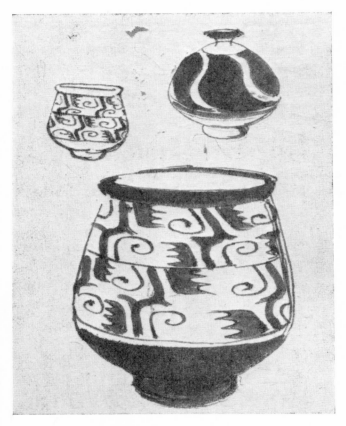

FIG. 5. Three pot designs

'I said mystics are those who experience direct communion with Reality; though the goal is One, mystic ways vary, the favourite being Ascetism, Quietism, *via negativa*. But are these natural and balanced ways? Here I entirely agree with your attitude on life and art, and the adequate expression of this problem will be contained in one of my most joyful chapters. The method "negation of negation" has been used by mystics instead of the affirmative form. I am showing the possibility of the active, positive, affirmative method in mystical principle. This will be the criticism and conclusion of my work. *Principles of Mystical Experience*. The scale seems too vast for my power; the difficulty will be immense. But let me do it in the belief that this is the worthy task given to me.

'I heartily congratulate you on the birth of your daughter. Isn't it a splendid thing to have a babe? How are your two sons? I hope all their futures will be blessed. My own baby and his mother are happily quite well. I did not tell you his name. I named him Munemichi; "Mune" comes from the first letter of my own name, meaning "origin"; "Michi" means "*Logos*" and was the second letter of my father's literary name. I have learnt many things from my baby and become a man of new instinct. I feel my world has become larger and wider. Children in the street who were rather strangers to me beckon me now every time I meet them. How many times I have watched and blessed them. This is my new experience of love.

'The night is cold; the clock strikes one. I must stop this long letter. Blessings to your life and works.

<div style="text-align: center;">

With strong friendly love and affection,
Your friend,
M. Yanagi.'

</div>

(Muneyoshi is Yanagi's personal name in Japanese. Its pronunciation from Chinese characters – often assumed later in life – is Soetsu.)

Chapter 7

NORTHERN CHINA, 1914–1916

Life in Peking

For a long time I had been increasingly feeling the need of a leader of deep and wide perception in art, education and philosophy to focus my own groping thoughts between the Occident and the Orient. I felt that many minds had investigated specific fields, but none of them had seen the similarities and opposites or their successful combinations in overriding wholeness. Such a person I hoped I had discovered writing in the *Far East* magazine in Tokyo to which I myself contributed. Dr. Westharp was a student of the teachings of Confucius, and found in them a basis for a deep interchange between contemporary science, education and the ancient wisdoms of the East. I had read his article and he had read mine. A correspondence started, terminating in a cable from him 'Peking or Tokyo?' This eventuated in my first journey to North China in 1914.

Between 1914 and 1916 I visited Peking three times. On the second journey I took my pupil Kame-chan, and on the third, my wife and sons, David and Michael, as well. When I look back to the exciting life there I hope my experiences will help readers to understand the conclusions reached concerning the meeting of East and West.

Dr. Westharp was a Doctor of Philosophy and Music, a Prussian Jew who had escaped from Germany – more averse to his government than even I, whose country was at war with his. He was highly intelligent, but I cannot say I ever liked him. Certainly I weighed his often

revolutionary thought and although I was deeply interested in the Confucian philosophy to which he introduced me, as well as all forms of Chinese life and art, nevertheless it astonishes me today to think of the time and energy, not to mention the amount of money, which was spent on those three journeys. During the first two, I sacrificed my way of life for his. My respect for the 4,000 years of China's mainland culture grew. This was more than book-learning. I lived on native food and loved it – the clothes, the script, the Southern School of Chinese painting, the pottery (still produced even now) and the stern architecture. I liked Westharp's servants and later on, our own; the people, too, and their sense of humour and practicality. Everything seemed to have, indeed had, those years or more behind it. Surprise and discovery were never-ending.

In the spring of 1914, by arrangement with Dr. Westharp, I arrived from Tientsin at Peking station late at night expecting to be met and taken to the temple in the Southern Chinese section of the city, outside the Tartar walls, where he was living. Nobody was there; nobody came; I had a visiting-card with his name and address written in Chinese which neither I nor my rickshaw-runner could read. He found someone who could help but we seemed to pad along miles of walled, dusty, narrow and almost empty streets before we finally reached a monastery and were directed by a group of old priests. The big gates of its sub-monastery were opened. I was ushered into a large room prepared for me, but no Dr. Westharp. The room papered white, patterned formally with mica, was warmed by a handsome brass three-legged stove fed with balls made of powdered coal mixed with wet clay. The inner portable stove was only brought indoors when red hot, producing a blue flame rather like a bunsen burner, and when properly burning was smokeless. The furniture, sternly noble, was made of heavy hardwood from Burmese forests and the brick floor was covered with large-sized reed mats. Tea was brought and eventually after about half an hour, with a rather lame excuse, my host arrived – not too auspicious a beginning.

I slept well that first night and awoke after dawn wondering where on earth I was. There was a small, high window in the brick wall. The sky was a hard, pale blue. A strange whistling came down from away up in the air, first on one side and then on another of the north, south, east and west foursquare building. I looked at the fine lines

of the furniture; one style pervading all. I thought of that rather formidable man I had come far to meet. The whistle returned and glancing up I saw through the window in the early sunlight the curved flight of a dozen pigeons – with aeolian harps attached to them. Then other sounds of street vendors – all strange; brass on brass, wood on wood, mingled with the many street cries of an awakening Chinese city. Presently a blue-clad Chinese servant entered, clasped his hands, bowed from the waist and proceeded to remove yesternight's burnt-out stove, which he replaced with a fresh one. I got up, washed in cold water in a large brass pan rather than a basin, then sat down to a breakfast of rice gruel, half a salted goose-egg and some pickled vegetable. Not British, but quite healthy and filling for all that. The taste depended, I found by degrees, on what the goose had fed upon – sometimes it was fishy and not so good. The egg looked just hard-boiled and was cold but unlike any other breakfast egg I have ever eaten. There is, it is true, another kind of preserved duck's egg notorious amongst the English as the 'ancient eggs of China': a raw egg packed to tennis ball size with a coating of, I believe, salt, rice husks and kaolin, or perhaps lime. In about three years this alters the whites to the appearance of clear coffee jelly and the yolks to an ochreous olive unguent. These have no smell and once prejudice is banished are quite delicious. The Chinese say of their varied foods that they have one thousand dishes, the Japanese five hundred and the French two hundred. English food is not mentioned!

I talked a great deal with Dr. Westharp, went on explorations often alone, and came to know a school-teacher friend of his, Chen Fu-ching, who had translated most of Dickens for an appreciative Chinese public. I often wondered what the translated Victorian flavour was like, remembering varied early presentations of Chinese classics in English – not only in literature but in other directions as well; for example the blue and white willow-pattern dinner plates, printed from engraved transfers with a curiously European stylization instead of the Chinese brush-work.

The long centuries of manual skills seemed to meet every contingency with unexpected ease. When my small 2,500 ton steamer from Japan had been warped within ten feet of the wharf at Taku, the narrow riverport city of Tientsin, the blue-clad dock-workers stuck their iron hooks into a long baulk of timber, and, rope over their shoulders, all

together inched its weight over the wharf edge. As the beam protruded, labourers leapt onto the butt end so that the tip could span the gulf over which a line of dockers immediately crossed. A gangway was winched from the ship side and the friendly Japanese purser carried my bags over to where a semicircle of rickshaw-runners standing between their shafts converged towards me with shouts and screams. With difficulty a tall policeman halted the rush with truncheon blows on the head of the foremost man, who, with blood running down his face, backed his rickshaw out. In horror I thought he was knocked out of the fray – not so; he whipped round the edge and was back again, undaunted. A hard competition for life!

The dockers worked two hours for very few coppers, gambled for food by taking a chopstick out of a bamboo cylinder and looking carefully to see the number marked on it which indicated the quantity of cakes or other food they had won; then they lay in dusty gutters, head on sleeve, for two hours' sleep; thus all through the day. If they had not accumulated say sixpence for a doss-house, yet another frozen body or two might be found by the police at dawn in wintertime. Hundreds of millions of people for so long packed together – so hot in summer, so cold in winter: however well cultivated the land, life was bound to be down-to-earth and hard. The people by and large were patient, long suffering and humanist, but they also laughed, gave loyalty, and loved our English Dickens. Englishmen liked them and used to say their word was their bond. The Chinese had traded so widely and for so long with the Romans on the Silk Road, all across Asia, that like the English they learnt early that honesty in the long run paid. In the eighth century 40,000 foreigners and 4,000 interpreters lived in the Southern capital, Loyang. They came from the Southern Seas, India and from all over Asia – even Persia. Hot water was supplied through wooden pipes on some of the great thoroughfares of that twelve-mile-square city.

One morning at breakfast Dr. Westharp announced an impending removal of all his furniture from the temple to another house, and this was done on the following day with the early arrival of a horde of some forty hungry indigo-clad 'coolies' – more or less casual workers, led by Dr. Westharp's head 'boy'. Without food they could not work. A large dish of pastry-like dumplings and hot tea were obtained for them from street vendors. Then they were shown all the furniture,

crockery and luggage, and instructions were given to carry them to a large house on the North side of the Manchu city, six or seven miles away.

The method of conveyance was so simple. For example, a square table was turned upside down, four chairs placed one in each corner right way up, then four wrong way up, the whole lot roped criss-cross together and the load lifted onto a man's back with the weight resting on a staff in one hand, rope-ends in the other. At the leader's word the caravan set off, stopping at intervals for a short rest; thus padding right across the city in the dust! We arrived late in the afternoon with some trepidation but found everything spick and span – not only was nothing broken but most things were in their appropriate places.

There were no trams and few motor cars in Peking at this time; one took a rickshaw, and this experience was as interesting as choosing a meal at a restaurant. The Chinese habit was to walk along the road until one approached a halt for rickshaws. As you came nearer the runners hailed you saying, 'Where to?' You remained nonchalant and heard them say 'Is it such and such?' Then with one word you would indicate your destination. This produced an excited competition for your fare and meanwhile, out of the tail of your eye you assessed the condition of the runners and their rickshaws. You were supposed to take in the condition of the tyres, the cleanliness of the rickshaw itself, the weather, the time of day and the bid. Then stepping into the rickshaw you had selected, off you went. Thereafter, you said "north", "south", "east" or "west"; that was fairly simple but sometimes it happened that you picked a runner who was tired or hungry and he, without any consultation with you, would shout out to the next group of rickshaws, 'I want someone to take this man to such and such a place. What bids?' They would haggle with him and you paid him off, or perhaps protested at the quality of rickshaw offered.

If you had no change in coppers the man would run you a little bit further and stop in front of a wayside money changer. There the drama unfolded. It was safe to take for a dollar 100 cents packed in sealed paper, then presumably having seen in your English newspaper the current copper value for a dollar that day was 137 cents, you would continue to hold your hand out. The very gesture began to collect a curious and expectant crowd. Probably twenty cents would be counted into your hand; you would pocket that and put your hand out again. The crowd

would get quite amused. You received another ten cents; still you held your hand out, then they began to laugh. You knew too much – you could not be fooled. By this time you had 130 cents and were still demanding. Loathfully you were given five more but you held out for the last two, at which the crowd roared. You transferred to the other rickshaw and paid the balance when you arrived at your destination, or of course you may have been a dumb fool and done none of these things. There was always a bit of expostulation at the end, but you tried to behave in the established way and walked away ignoring the racket.

In such ways life was full of entertainment of an unexpected kind. How strange, for example, to see at sundown, men coming in from a hard day's work in the fields; one might be carrying a song-bird carefully tethered on a stick which when it sang entranced the labourer and his friends. Or the shop-proprietors came and sat outside in the cool of the evening and made music with flute or other instrument. Music after the day's work. There was camaraderie about, quite different from that found in the quiet of a Japanese temple or Tea-room.

For a month or so I hired a private rickshaw and coolie at a very moderate cost. Being employed by a foreigner and treated, I hope, kindly, he always had the rickshaw clean and polished and the spokes shining. He ran like the wind. One day in the more crowded Chinese quarter where I had purchased a fine old jar, he began to show off his running and unfortunately the right-hand hub of the wheel, projecting as it did some four inches, collided with the hub of a rickshaw going in the opposite direction, and sent me flying head over heels into the street, hugging the jar. Neither I nor the pot was seriously damaged, but his pace decreased slightly for a time. I recall one day some other Chinese rickshaw-runner felt challenged by my man's pride, or speed, or both and they began a race, with more regard to the suitability of the road for such a purpose than for my intended direction! I was patient for a short time, then shouted to my man, 'Wang tung' (turn east).

Occasionally Dr. Westharp and I went out to an old-style Chinese restaurant for dinner. I am inclined even to this day to place Chinese cookery at the summit of epicureanism. I remember Dr. Westharp describing a certain soup consisting of chicken stock, very fine-cut Chinese white cabbage and dried shrimps. This he pronounced some-

what pompously as the 'soul of China'! In spite of its variety and finesse of cooking, my digestion was never upset by Chinese food.

The Temple of Heaven, which I visited outside the city, was where the Emperor of China annually offered prayer and praise for the whole people. This had two parts, one for the Sun, symbolizing the positive male order; the other for the Moon, the female. The ground-plan of both was circular, but the Sun had roofs in three tiers and the Moon but one. The tiles were deep blue, the carved steps and railings were of marble; everywhere grass grew between the slabs. I did a soft-ground etching of the Temple of the Moon. I also made one of the great Southern Gateway of Peking, Chen-mun (plate 3).

Perhaps I may give my impressions of going to an ordinary theatre in which the purely Chinese music was popular but astonishing, and the behaviour of the audience astounding. It was more like the Globe Theatre in Shakespeare's day, when the spectators almost seemed to take part in the performance. The stage stood foursquare with a roof of its own, amidst a crowd which ate, talked and expressed its approval or disapproval with considerable vehemence. For the first half-hour I could not give my mind to what took place on the stage. The weather being hot, there was a constant demand by the audience for fresh, clean (?) steam towels with which to wipe the sweat from their semi-naked bodies. From four vantage-points, two below and two above the stage itself, attendants hurled bundles of perhaps a dozen steaming towels knotted together, from end to end of the theatre. These were adroitly caught by men who distributed them amongst the audience for a copper apiece and returned their dirty towels which were also knotted and hurled through the air back to the distributor. I never saw the like before in any theatre.

After this prelude I gave my mind to the appalling din of brass on brass and hardwood on hardwood which produced a terrific constant repercussion. Threading its way through this din, the see-saw of the two-stringed fiddle with the horsehair of its bow between the two strings produced an unceasing rythmic melody as a background for a single falsetto voice which brought a hush over the audience like the effect of a kite over a field. If the melody was sung well the applause rose with one united shout of 'Hao, Hao' (splendid, splendid), while men spat and children relieved themselves almost indiscriminately on the turf below. On the stage itself parades of male actors only,

representing victories or defeats well known to all present, intermixed with gymnastic displays, went on for hours. Doubtless this was an art in decay, and yet it was full of vitality and fed the audience with something which they wanted. Many of those standing were soldiers in uniform and I was told that the ill-paid soldier was apt to get out of hand unless he enjoyed this entertainment, free for him, at least once a week.

By contrast with this popular music, I recall a dinner in spring, on the roof of a Peking restaurant with Dr. Westharp and our friend Chen Fu-ching, and a player of the one ancient instrument still in use, a seven-stringed horizontal lute, quiet by comparison. There was no din at all or cacophony; the enjoyment was poetic and musical. The last piece the old man played after we had eaten was concluded without a note struck, just the sound of the player's fingernails touching the wood gently to arouse the imagination of the hearer. Starlight was overhead and young willow-leaves hung their tresses from the only trees in sight.

I returned from Japan for the third time and with my family in the full heat of the summer of 1915. Peking is a city of walls and they positively radiated heat at night. We stayed in that second house of Dr. Westharp's until we received word from him that he had secured a separate furnished house for us in the village where he lived, near the Summer Palace. This meant travelling about twelve miles on donkey- or mule-back, or by palanquin. The boys loved this of course, but my wife, who was expecting our third child, used the palanquin. The house and garden were quite Chinese in style and furniture, but on arrival we were pestered with more flies than I have experienced anywhere. Kame-chan and I attempted to rid one room of these prior inhabitants, but even when we killed a thousand it still seemed to make no difference. The next day I rode back to the city and bought silk gauze, with which the room was made impervious.

When Michael became ill with some digestive trouble, Chinese medicine having proved ineffectual, I rode into Peking with him on the saddle in front of me, to a French Catholic nuns' hospital, where I left him. I was getting a little anxious about Muriel. Within a few days we received a message that Michael had recovered. This, I was told by a kind nun, had been brought about by a diet of good Chinese grapes. As my wife was normal again and able to be left, Dr. Westharp and I,

with a couple of servants, made a mule-back journey by night, risking attack by brigands, some eighteen miles to the valley of the tombs of Ming dynasty emperors. Arriving safely we rode up the central ritual way of the dead. Flanking the road were rams, camels, elephants and other actual or imagined creatures, as well as men of all ranks, carved life-size in marble. The great gateways over stones were incised with fine memorial Chinese characters, and a clean stream ran alongside secondary valleys with a temple for each emperor at the ends, some of them with whole trees growing through the tiled roofs. Up and down the heights, occasionally precipitous and stepped, went an unceasing enclosing wall, twelve feet high and twelve feet wide, a roadway on top; I think visible from the Moon with a powerful telescope.

We returned safely by day and found my wife well but getting anxious about the time of approaching birth. I felt we should return to Peking, where there were the foreign doctor and a nurse. Dr. Westharp had offered us the empty part of his house which we had previously inhabited. We made the move without incident and then received a peremptory note from him telling us to be out in two days! This was too much and our friendship ended there, but without any open quarrel, for which I was thankful.

I did manage to find, furnish and move into a suitable Chinese house in the centre of the city just outside the legation quarter. Then began a happier period of independence. We acquired a head boy, a male cook and, for the expected baby, a middle-aged *amah* who had tiny little feet three inches long – she had in childhood suffered the traditional binding of feet imposed by the conquering Manchu on the defeated Chinese.

For a few pence each I was able to buy stoneware pots, beginning with kitchenware made at Tz'u-chou, almost as good as they were in those Sung days six hundred years earlier. When my cook took me to that shop I was pleased; looking at them in the quiet of my room I was astounded. Seen within that setting the uniformity of style became apparent and explained why it was only isolation that revealed its full beauty. The fact was that the stylization of Chinese life was unexpectedly powerful, though severe. A chair was rectangular, a table circular or square, shoes were the same, right or left, and for us rather painful. The tiling of the imperial yellow palace was uniform with that more modest unglazed grey of our own roof. The fact was that in Peking

it was possible to see a whole capital clothed and decorated in a style so similar as to be almost unnoticeable! To see a city like Bath at its height, together with its eighteenth-century Chinese-influenced furniture, would probably have produced the same reaction. In such a setting the advent of waving soft lines of young green spring willow in Peking was lovely in its relief.

An understanding of the Chinese attitude towards money took time to acquire. I noticed at first that the commonest word one heard was 'ch'ien', meaning money, which evidently had an additional significance. Something beyond a financial transaction seemed to take place, involving loyalty; people could be hired who gave more than mere money's worth in return. When I went out with the cook to buy our kitchen ware, I noticed that he pocketed about ten per cent on the prices quoted, without a word said; to save his face in public I waited until we got back to the house before asking him to put on the table the money he subtracted from the price I had agreed to pay. He did so protesting, then, half by sign language, I gave this ten per cent back to him indicating that I was willing to pay what was customary but needed to know what I was doing. His understanding smile implied the establishment of a human relationship, which indeed proved to be the case.

We had just settled into comfort when the signs of impending birth set in. A nurse for Muriel and an English doctor had been engaged when needed. All went normally and to our delight a girl was born, whom we named Edith Eleanor. I must have been through a considerable strain with the additional tension and uncertainty between Dr. Westharp and myself, for about this time I was attacked by a plague of boils which lasted for about three years, refusing to yield to any treatment. In spite of this attack, however, we enjoyed life in our own house making friends – both English and Chinese.

Later on we engaged a boy of about thirteen. There was some difficulty in obtaining the co-operation of the staff with the employment of a boy of whom they knew nothing. I told them his father was a curio dealer, from whom I had bought some antiques, at which they shook their heads in disapproval saying, 'Bad class, no good.' Having seen the boy and thought he was all right, I asked please would they try him for one week? Grudgingly they agreed, but thereafter accepted him. He looked after and played with our two boys, taking them for

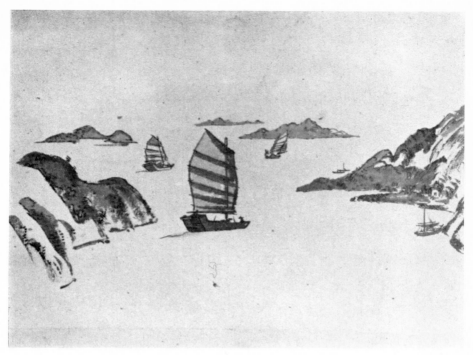

Plate 5(a) Outside Hong Kong harbour. Pen and wash, 1934

Plate 5(b) Pei-tai Ho. Soft-ground etching, 1916

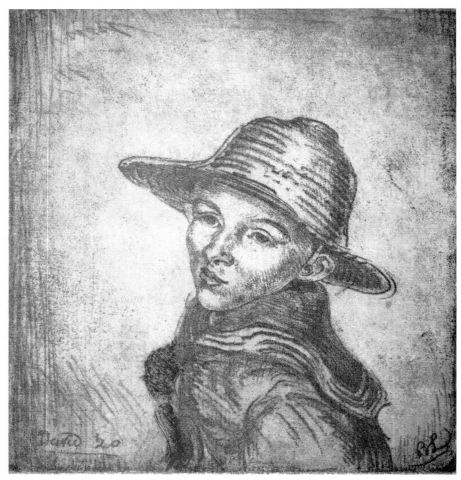

Plate 6 My son David, 1920

Plate 7(a) David Leach kneading clay in the
Japanese way at St. Ives, about 1940

Plate 7(b) Portrait of Old Fishley at Fremington
Pottery, about 1912

Plate 8(a) Discussion group—Bernard Leach, David Leach, and students
during the war

Plate 8(b) Opening of first joint kiln at Hamada's Mashiko, 1934

donkey-rides along the broad top of the sixty-foot Tartar walls of Peking. The walls of the palace grounds were on the far side of the lane where we lived. Our corner middle-class house, as customary, faced north, south, east and west and consisted of a paved yard about twenty by thirty feet, surrounded by one-storied brick buildings, two or three rooms to each building.

Winter brought cold; everything was frozen solid for three months, but dry and exhilarating even with the thermometer far below zero. When summer came we took the main railway towards Mukden which skirts eastward the northern edge of the Gulf of Peichili, where we had rented a bungalow on the coast at a small foreign colony called Pei-tai Ho. (See plates 4b and 5b.)

Upon our return to Peking a most welcome letter from Dr. Yanagi awaited us confirming his hope, 'I am dreaming of coming to Peking.'

'July 28th 1916.
... It is with great joy I tell you both of my decision to go to Korea and China. I leave Japan on the tenth of August. I shall come to Peking (via Korea). Please telegraph me when you will be returning. To see you in China means a great deal to me.
<div align="center">Yours ever ...'</div>

One of the first things we did together was to make an expedition to the Great Wall of China, by train and donkey. The last part of the approach was on mule-back with a guide. We were deeply impressed by that great wall which curved about the bare mountains as the similar but smaller wall had encircled the Ming Tombs described earlier. We actually walked on the top of that Great Wall. Thousands had died in the building of it, and I was told that their bones lay within. Time passed, the sun descended and suddenly as it got dark our guide disappeared and we were left to find our way back to the station in the dark. We struck out over fields towards a small light which came from a cottage, from whence we were directed to the station and caught our train back, leaving the mules to be collected, for which I think we must have been fools enough to pay at the outset. But the memory of that ancient wall winding over those bare Manchurian hills, with a lowering sky and moving sunlight across it all, will never leave my inner eye.

We made several excursions, one to the Summer Palace from which the famous Dowager Empress had ruled. There I remember we saw in all solemnity a father teaching his grown son how to walk along a canal bank; also we watched three men naked to the waist practising an exercise which consisted of one throwing to another a sort of marble dumb-bell of some pounds' weight to be caught in twisting flight. These men appeared to have been educated attendants to the late Empress.

Yanagi and I explored Peking together and visited the old imperial collection of pots where we could see examples from the twelfth-century Sung dynasty – not single examples, but rows of pots as they came out of one kiln, enabling us today to compare the variety of effect so obtained, in comparison with our own. Sometimes we were confirmed about the difference of temperatures and at other times made discoveries about old glazes or the method of packing. The firing was less controlled if anything than ours, so there were hot or cold corners, or too much reduction in some areas, all of which we call 'accidentals'.

We loved the street-cries, the food-sellers, the food itself, not perhaps quite as much as Hamada, whom I regard as the expert – but oh, we enjoyed it! – and the temples, especially the temple of Confucius. As we went by rickshaw south to the Chinese quarter through the great walls of the Tartar city we noticed, with horror, the demolition of the double walls surrounding all the gateways of the city to permit a hideous but convenient tramline.

Yanagi stayed with us for a month, during which I poured out the conflict I had continually experienced with Dr. Westharp. His answer was, 'Come back to Japan, you have followed a mistaken leader – you do not need him. I have seen the intuition in your drawings. Come and build a kiln on my family land at Abiko and join our group again.' How welcome was that invitation! We accepted and began making plans to return before autumn turned to winter, when even the sea froze.

The discovery of Chinese shadow plays was the last exciting event of our stay here. Our 'boy' Wang told us that a group of players had come to Peking and that we could hire them for a night's performance for a very reasonable payment, which we did. Half a dozen of them came and set up a stage in the middle of our courtyard, which proved

to be ideal background. The construction was made of indigo-dyed cotton with a profile of a single Chinese building like our own, but on the side facing the audience a window formed a white screen about four by three feet, upon which the coloured images were projected by a light from the back. The whole effect was in perfect proportion. Sitting on the steps with our own stove, our party of a dozen or so was enthralled. One of them was half-Chinese, half-English, and able to provide just sufficient commentary on a historical drama which dated back two hundred years. The flat, translucent, painted donkey-skin figures were manipulated by bamboo sticks attached to their hands and feet. These images were moved by two trained puppeteers hidden in the corners of the stage, facing each other, to both sung or spoken words, produced by four musicians sitting on benches with a glowing Chinese stove between them. I felt this 'theatre' as never before – a stirring of the imagination, exotic, although understood only in part. Mere facts became secondary to make-believe, as when the scene called for these impossible figures to run from a house on fire behind that paper screen. I was so carried away that I wrote an illustrated article about it and sent it to that man of the theatre, Gordon Craig – Ellen Terry's son.

As the weather was already cold and we feared that we might get locked in by ice on the way out from the port of Tientsin, we began to pack up.

A farewell stag-party at a real old-fashioned eating-house was planned for me. There were about eight of us, including the half-Chinese who had provided the commentary upon the shadow plays. We sat round a removable circular table-top six feet in diameter, until it was a mound of small dishes brought in one by one, piled one upon another. I have never eaten so much in any two hours of my life. We seemed to run the gauntlet of all Northern Chinese cooking. My friends evidently wanted me to understand and remember China through my stomach as well as in other ways. At, or beyond, the point of excess, I was offered a bowlful of rice-porridge and groaned, 'Not that!', whereupon the whole table seemed to unite in assuring me that the long history of China had taught them more than the Romans with their peacock-feathers ever knew concerning epicureanism and gluttony! I gave in, took two or three spoonfuls of the soft wet rice and to my astonishment finished that bowlful and asked for another. Comfort

had returned; the interstices within were filled. Once again the wisdom of 4,000 years emerged! As we were assisted into our rickshaw a great basket of garlic was passed around; at that point I refused, probably unwisely, yet I had no ill effect from overeating.

Fig. 6. Magnolia

Our date of departure approached, but the work was delayed by one cause or another and finally we had to take the train for the river port of Taku, trusting our servants to get the luggage off by the following train. When we reached the port, contrary to information Cooks had given us, the steamer had not even arrived, so we had three days to wait in an hotel. I was so worried about that luggage I jumped on to a returning train and reached Peking station towards midnight. There seemed nobody about, but by the dim light of a blue bulb I could make out close by a six-foot pile of familiar-looking packing cases. Whilst turning one over I heard a sleepy voice from the top. It was the Chinese boy who had played with and taken care of our children so well. Thinly clad in cotton, though the weather was freezing, he was hanging on to our property grimly though he never expected to see us again.

I was deeply moved. Early next morning in a comfortable bed at the Wagon Lits Hotel I reflected that in China one could buy loyalty and love with money.

(This was written before the victory of Communism in China. The change after the Republic established by Dr. Sun Yat-sen in 1912 to the Communist Revolution of 1949 I ascribe to the desperate need for order, which China had increasingly lacked for centuries.)

Chapter 8

CONFUCIUS

With a certain deliberation I have reserved this chapter to the end of our time in China. It is in the nature of a postscript concerning the meaning of Chinese philosophy at this vital period in time.

The first thing I had done for Dr. Westharp was to type, with one finger, a book he had written called *China Anti-Christ*. Although at this period I was not a Christian I did not like that book and was glad it was never published. He believed in the importance of science to the Eastern world and decried the formalism into which Confucian profundity had decayed. He thought the former could restore the latter and tried to persuade the government, such as it was at that time, to adopt the progressive educational concepts of Dr. Montessori, but this did not have any success. Yet today some of the happy enthusiasm of Chinese education as depicted in films has seemed to me to indicate the employment of some similar principle.

Here I would like to go deeper into the Chinese philosophy with which I found myself wrestling during my first visit to Dr. Westharp. I read and contemplated the *Chung Yung* (Middle Way), that volume of central thought by Confucius, which we discussed, weighing the difference of approach to life proclaimed therein. I agreed with Dr. Westharp that Ku Hung-ming's translation of the *Chung Yung* was by far the best either of us had come across and one began to comprehend why the religious philosophy it contained had had so profound and prolonged an influence in the East. At that time I was too engrossed to balance my impressions sufficiently by studying Lao Tze's more

spiritual and imaginative concept. Fortunately I have kept a copy of a letter I wrote to Ku Hung-ming before returning to Japan, which indicates my thought at that period.

'Dear Sir,

Five months ago, in Tokyo, I bought your translation of the *Chung Yung* and commenced to read and ponder over it with increasing interest and respect. Today, I feel I do not take a liberty in writing to thank you for a great gift after having lived here in this city, where every Chinese detail speaks of the organic stability of Confucius.

'Since I ceased to be a Christian some seven or eight years ago, I had not found any clear central belief upon which to base my thought and life. "To find the central clue to our moral being which unites us to the universal order, that indeed is the highest human attainment." (From the *Chung Yung*.) I notice that at the end of your introduction, you say that in the recent writings of our best European thinkers are to be found affirmations of the main moral ideas of Confucius. As a modern artist I can confirm this, for it is a confused idea of this same self-realization which gives to contemporary European art – the counterpart of that literature of which you speak – a vitality which has aroused Europe with a sense of regained liberty.

'At present I am only in Peking on a visit, but that which I have seen has been sufficient to determine me to come back as soon as possible, probably during next month, in order to gain a deeper insight into that Chinese civilization of which Confucius is the Pole Star. (It seems to me now in 1974 that what I then called a single Pole Star was in fact a double, and that these two philosophers, Confucius and Lao Tze, more than any others polarized the inherited traditions of Chinese wisdom from an earlier era.) I believe that the first man who has the insight to grasp the wisdom of Confucian educational thought and our own Western progress with a view to combining them is Dr. Westharp. Last year in Tokyo I gave a lecture entitled "Revolution in Art". In it I spoke of the necessity of including the researches of varied opinions and discoveries of Orientalists such as Fenollosa, Okakura Kakuzo, Havell, Lafcadio Hearn and many others. Thus, when I discovered three articles in the last *Far East*, dealing in such a way with Confucian thought and certain Japanese problems, I was surprised and delighted to find someone else with the same convictions

but better qualifications than I possess. It was through Dr. Westharp's
advice that I bought your translation of the *Chung Yung* and it is with
great regret that I gather there exists some kind of misunderstanding
between you and him. This appears to me, more or less an outsider,
to be nothing less than tragic, for I have no connection with him
other than a deep interest in and respect for his ideas, although I have
been staying with him in a Chinese temple. It is discouraging at such
a time as this, when foreigners begin to collaborate, when China is
seriously threatened by the same hideous process of quasi-European
and utilitarian "progress" as has inundated Japan, that men like you
and Dr. Westharp should be unable to work together to stem the tide.

'I have lived in Japan six years during which I have come to recognize
that this process, although drastic, was unavoidable there. Dr. West-
harp's publications enabled me to perceive the possibility of a completely
different development in China, and through China a modification
of what has taken place in both Japan and even India. He regards
the method of education started by Montessori as the first scientific
system in which can be unmistakeably seen the meeting of extremes –
intellectual or objective Europe, and moral or subjective China. . .

'May I ask of you that if after reading this letter, you feel a sufficient
degree of sympathy with its contents, would you give me the oppor-
tunity of meeting you, not only for my own sake, but also to bring
Dr. Westharp and you into closer touch. What I have seen in Peking
makes me feel strongly that unless those who venerate the greatness
of China work together to preserve it, the world might lose that which
could become the very bond between East and West.

'In your introduction you say that "The Chinese civilization and
Chinese social order combine to form a moral civilization and true
social order and cannot, therefore, in the nature of things, pass away";
yet it seems to me that the latter may take place, in fact has already
begun to take place owing to decay. It would seem that the rebirth of
Confucianism might even take place in the Occident. Sir Hiram Maxim
(the inventor of the machine-gun) has recently written that "uncon-
sciously there are more Confucianists than Christians in Europe":
Dr. Westharp insists that spiritually the West has much to learn from
the East, and my own experience in various branches of art confirm
this in great measure. But because the Occident might from now for-
ward begin to appreciate Confucius, is it not a suitable time to lay

aside all small differences? Is it not of value to have European art and science as weapons to withstand this inundation of secondhand Europe and to preserve not only the spirit but also the life of your great Chinese thinkers here in their own country?

'Believe me,

Yours sincerely . . .'

(Fifty years later we can see what has actually taken place in Communist China, probably owing to an underestimation of the resentment against centuries of bad government in both China and Russia.)

I received no reply to this letter but after my separation from Dr. Westharp, he did ask me if he could use my guest-room for a meeting between himself and Ku Hung-ming. I put aside my pride and agreed, but never heard the outcome.

An article which I wrote in 1916, published in an Anglo-Chinese friendship magazine illustrates another approach to my thought during this period.

Chinese Education and the Example of Japan

Not only were very divergent opinions on the respective merits of classical and technical education put forward at the after-dinner debate of the Society, but some confusion was also raised by ambiguity as to what constitutes the one, and what the other. Moreover it was never quite clear whether the question was general, or particular to China. However, taking the voting to indicate the latter it was surprising to find an easy win for the classical side. This I think can only be explained through the fact that the classical had been made to stand for the spiritual and moral, and the technical for the merely material. I did not feel that many present would have voted outright, either for the one or the other form of education to be put exclusively into use in China, or indeed that many felt that the two could rightly be separated. This has encouraged me to write the following pages upon the possibility of discovering and using a spirit-governed technical education combining Chinese tradition and modern natural science. Presently I shall try to indicate how the essence of Chinese tradition and European technical

capacity show signs of converging to a meeting point, and how valuable that tendency could be.

First however it is pertinent to question what is education? This has been asked with increasing insistence year by year in all progressive centres in Europe and America by such men and women as Froebel, Rousseau, Pestalozzi, Locke, Spencer, Le Bon, Ellen Key, Edmond Holmes, Dr. Montessori and many others. It is thus obviously far more important to ask it in the East where the issues involved are both more pressing and more complex. More pressing in so far as the whole future development and progress and even existence of states like China and Japan depend upon the way in which the rising generations are taught to think and act; more complex in so far as the methods evolved must enable them to suddenly face the international life of today and tomorrow competently, without eliminating and destroying all that is strong and true which they inherit from their past.

Everyone who has lived in the East for any length of time must realize some at least of the innumerable and taxing questions raised by this meeting of East and West, and the necessity of going down to bedrock to find solutions. The question of the education which will become compulsory in China within the next few years is the most fundamental, as I shall try to show by the example of Japan, so I ask first, what is education? The obvious way to get a true answer to this is to enquire what the best educationalists, psychologists and scientists of Europe say, on the one hand, and what the Chinese classics say, on the other, and to strike a balance. This will at least give indications of what the progressive education of China could be.

What then are the underlying principles of modern European educational reform? I think these can broadly be summed up from the time of Froebel to Montessori today, as a steadily growing appreciation of the tremendous and neglected value of the spontaneous initiative of the child, and a corresponding depreciation of the use of force and repression in education.

This evolution began with the abolishing of corporal punishment not only on the principle that 'prevention is better than cure', but also with the conviction that repression only produces revolt. It showed itself in the improvement in conditions of school life, greater attention to individual students, the presentation of facts in a more acceptable form, a new voluntary system of classical education, the training of the

senses and talents, and so on. I actually made a wooden tile about three inches square with the strokes of a Chinese character raised, which I carved. Blind children were able to use this as a toy while learning to write. To those who, like myself, were educated in the old way, this new educational approach seemed to belong to another and happier century.

These educationalists have discovered that liberty does not necessarily imply abuse of freedom, that outflowing natural energy along lines of talent produces incomparably the best work – the work of love, *self-expression*; and finally that this self-sought joy-work alone awakens the mind to full controlling activity. This is called in the *Chung Yung* 'consciousness from sense experience'. (Now in 1974 it would appear that education in the West is suffering from an over-degree of freedom but allowance must be made for the fact that the interplay of thought by means of television and radio, for example, is bound to produce indigestion. Everything is presented to the young and the result is a desire to experiment in every direction, to question past values and to endure the resultant malaise. It is so easy to be wise with hindsight.)

The new belief is radically upsetting our old ideas of teaching and giving us instead a fresh and quite opposite way of procedure. Instead of forcing abstract knowledge into the heads of boys and girls, like nails into boards, the new education endeavours with care, tenderness and scientific exactitude, to provide healthy, natural conditions and ample stimuli for the senses and talents, so that the young life grows and opens out even as a plant in the hands of a good gardener. The only difference between the plant and the child lies in their respective degrees of evolution, the life-force in the plant hardly yet being what we call instinctive in animal life, and certainly not conscious in the human sense. Nevertheless the botanist respects that life-force and feels that it is his privilege to reverently study its requirements and provide conditions for growth, flowering and fruitage. The educator should be still more reverent, for the life which he tends has instinct, intuition, inspiration, and intellect, wherewith to guide itself. It is only with the young arrogance of this latest acquired human faculty, i.e. the power of mechanical reason, that we have dared to curb the older manifestations of life-force, and against this folly the best minds of Europe are protesting in philosophy, psychology, science and the arts. But in spite of this no connection has been clearly, or scientifically, established between the First Principles of life and the technique of the

new education. Turning to the principles of Chinese tradition, not to traditionalism, do we find anything to fill this gap?

Unfortunately at the present time there are few if any voices to explain in modern terms the real meaning of Chinese traditions amongst the Chinese themselves. Mr. Ku Hung-ming is one of the few and I am indebted to his fine interpretation of the *Chung Yung* for the following phrases: 'Truth means the realization of our being: and moral law means the law of our being . . . truth is not only the realization of our *own* being: it is that by which things *outside* of us have an existence. The realization of our being is moral sense. The realization of things outside of us is intellect. These, moral sense and intellect, are the powers or faculties of our being. They combine the inner or *subjective* and outer or *objective* use of the power of the mind. Therefore with truth everything is done right.'

Here we have religion, or the moral law, defined as self-expression, or self-realization, by Confucius himself. Here is the basic principle of Chinese civilization, both spiritual and practical. Here finally is the feed-root of the strange series of parallels between quite modern European philosophy, education and art, and the old Chinese thought, existing even today under a thick crust of formalism and decay.

The moral law in China is a natural law. It puts the divine or most spiritual force within the individual, saying: 'Where does a man derive his power and knowledge except from himself? How all-absorbing is humanity. How unfathomable the depth of his mind. How infinitely grand and vast his divine nature.' To the Chinese truth is not abstract, it consists in the action of man's divine nature. *Reality* lies in the accomplishment of the moral law, in the unification of spirit and matter. Through the practice of this self-development and self-realization alone 'the central clue to our moral being which unites us to the universal order' may be found. But that infinite universal order, Confucius is content to leave unexplained, saying, 'The principle in the course and operation of nature may be summed up in one word: it exists for its own sake, without any double or ulterior motive. Hence the way in which it produces things is unfathomable.'

(Looking back on this from 1974, I would add that this corresponds to the Biblical description of God, equally unfathomable: 'I am that I am'. When it comes to the quotation of other phrases from the *Chung Yung*, it may be observed on scrutiny that Confucius does go

beyond the non-religious philosophical concept, and is very close to the Buddhist, even to the Biblical Christian understanding. The essence of Life is to be found in the realization of that spark of Infinity which lies within every one of us and in all else besides. This content of the *Chung Yung* is very different from the dryness as it comes to us today of the Analects, the rules of behaviour from Confucius's time of about 500 B.C.)

I know of no country where the divinity of man's own nature, and its 'realization' as the basic religious principle, have been taught and acted with equal intensity. To it I attribute the organic quality which is stamped on every Chinese product, and the stability and unity which, in spite of all outward appearances, still underlies Chinese character. In order to solve any Chinese problem it seems to me necessary to start from this first principle, this bedrock. The idea is not entirely unique to China, for in Greece was written, 'Know thyself' and in India, 'Self is master of self', but nowhere, as far as we know, has it been lived as in China, nowhere has it been the basis of a civilization for several thousand years.

I may arouse the disagreement or ridicule of many Europeans, for we have the habit of putting things before thought, and of realizing money or ambition before the Divine self.

(1974: This does not mean that art in the West was not produced, but that gradually faith was more and more replaced by mundane values. Thus we come to the assessment of what has taken place in China and Russia. The Divine fruit of culture ceases to exist. What is the fruit of Communism? To this day we are still far from acknowledging the Divine nature of the individual as a centre from which life radiates.)

But if China were to begin solving her problems through the control of the outer world by the inner spirit, there is a possibility that instead of being absorbed, the process may be reversed. In education it would mean the ability to adopt modern science without loss of Chinese spirit – a moral control of all future activity, such as we so badly stand in need of in Europe. The importance of this will become clearer when applied to practical life, for it signifies that the outward form of Chinese religion would be good work, work which is self-realization – technique controlled by Chinese spirit. In plain terms it would mean that every Chinese worker, whether craftsman or engineer, inventor or poet,

educated on these principles, would produce with the enthusiasm resulting from self-expression and that his products would be the outcome of his own and his national character. Such work would mean a revival of all national industries with scientific organization, but without the scourge of materialism. Further it would mean the exploitation by China of her rich natural resources of wealth, power and independence. The materialism of Europe which has inevitably culminated in the present world disaster, had its roots in an unmoral, unspiritual, mechanical use of intellect and power over 'things outside of us'. Almost all the work of modern Europe is characterized by a hitherto unknown mechanical perfection, lacking in spirit. The introduction of this kind of work to Eastern countries like China is destructive. Long before science found its way into the baker's shop it was written that men could not live by bread alone; today this is doubly true.

Fig. 7. Flower

To our Western ears this may sound like a Utopian dream, and perhaps for Europe it will remain an unattainable ideal for a long time, but in China the means are immediately to hand. Unless these means are used, the loss to humanity will be incalculable and the value to both East and West of their meeting will be postponed indefinitely. There is

no choice between absorbing and being absorbed. Unless the compulsory system of education renders a large body of Chinese students capable of grasping, and demonstrating, the theory and practice of the underlying truths of Chinese tradition in all branches of work and thought in a clear scientific way, no amount of feeling and sentiment will prevent her from being absorbed.

We need to recognize from Confucius that in placing the centre within man, he also climbs towards Infinity.

Such were the ideas with which I left China in 1916. Revolution swept first Russia and then China. To the latter at least it brought much-needed order at the price of China's ancient wisdom. What reaction will ensue remains to be seen.

Chapter 9

JAPAN, 1916–1920

Thus back again once more, and, oddly, of all those journeys back and forth I now only recall a single incident – a talk with the Japanese purser who told me of his previous crossing when the small steamer ran into a typhoon and passengers and crew were knocked about: many were violently sick, amongst whom was a Zen priest. The purser asked him why he did not have recourse to deep meditation! The priest bowed to this reproof, forthwith took the approved position for contemplation, preserved it, swayed with the movements of the ship and was sick no more.

Stopping en route to Tokyo, I spent the next two or three weeks with Tomimoto at his old home. I cannot remember what Muriel and the children did, but I feel she must have gone to stay with English friends in Tokyo. Tomi asked me to share the kiln with him so I set about making pots which were fired with his. All went well until the day of the cooling. To cover our impatience he had proposed a fishing expedition up the stream beloved by his father. We set off on a grey morning loaded with rods, bait and *sushi*, the Japanese equivalent of sandwiches – rolls of cold boiled rice containing perhaps a cooked vegetable, some pickles and covered with a thin slice of sun-dried seaweed or raw fish. Tomi marched ahead making short cuts on the narrow paths between the wet paddy fields. He strode in silence for some three miles, then turned back, brushed past me and without a word walked towards home. Puzzled, I nevertheless followed him.

He went straight to the the two-chamber kiln and, taking out the

stopper of a spy-hole in the first chamber, pushed in some newspaper which caught alight, illuminating shining pots on the saggers (boxes) and shelves. Very hot air surged out, but when Tomi began to pick away with a spike at the brickwork of the kiln door I was alarmed both for his pots and mine. Recognizing the inclination towards hysterical frenzy to find out what fire had done to a month's concentrated design and execution, I begged him to be patient, but even my tempered counsel seemed to increase the already fierce gleam in his eyes!

All that morning we slaved with bars, tongs and burning cloths, to get the saggars out with his or my pots inside. Actually in this battle few were broken, nevertheless when he levered over the last half of a bung of those fire-clay saggars, in order to see some pot of his at the bottom, I made a mental determination *not* to share kilns in future. Obviously if a man gives his all to creative work he must be allowed broad margins! We did not quarrel; our friendship was too deep for that, but I remember once when I praised the quality of the glaze on one of his somewhat matt and slightly underfired jars, he snapped at me that he hated underfiring. I thought otherwise and made another mental note. I think we were both right from our own temperamental points of view. He liked quality, clean, bright and hard; I preferred something warmer and gentler, and in glaze surface this is obtained by either adding refractory materials to the glaze mixture or not firing quite so high.

Questioning him about marriage one day, Tomi shook his head and took me up on to the ridge-top of his house. Pointing over the flat cultivated fields to a cluster of trees and a larger house in the distance he pulled out a wallet from his broad belt, then showed me a photograph of the daughter of the landowner. The marriage go-between employed by his family had recommended her and several others, after discreet customary but nevertheless precise investigation as to family health and wealth. Tomi swept them all aside, looked me in the eyes and expostulated, 'I do not wish to marry in the old way – I have lived in your country, England.' He continued, 'I am the eldest son and my family is distressed at my delay; I may have to resign my position in favour of my younger brother.' Financial adjustments were made and in due course this took place so he felt a freer man.

One day he was painting with Chinese ink when the manservant quietly announced that a guest who wished to see him was waiting in

the porch. The servant pushed a man's large-sized visiting card to-wards the master of the house. Tomimoto glanced at it and said, 'Oh, take him into another room. Give him tea and say I shall come when I have finished this painting.'

Some time passed and the servant came again excusing himself, coughed in a certain manner and whispered, 'Please look at the card again, sir?' Tomi did so and realized that the address given was that of the leading 'Women's' journal in Tokyo.

'That's odd', he said, 'ask him to come in here.' Tomi continued to paint as someone entered behind him. Presently he turned round and to his surprise faced an unusually tall woman. No doubt she explained that she had used her pen-name on a man's sized card. She had come in admiration to make his acquaintance. They became mutually attracted, but there was then nowhere to meet without causing scandal, so when I told my wife we offered the use of our house. Thus they came to know each other and became engaged. The stages of this progression he confided to me. Looking at me along his Malay nose, head thrown back, he said, 'I can beat her in anything except drinking!'

The marriage took place in the Seiyo-kan, a foreign-style hotel in Tokyo. Japanese food was served at one side of a long table, Western food on the other, with the principals at the end, very solemn. The daughter of a well-known painter who looked more like a wrestler than an artist, she was rather swarthy, with a painted white face and old-fashioned hair style to suit her white bridal kimono. The chief speaker, a government official, started off low and level, and went on speaking interminably with a gradual increase of pitch and volume. I could understand only a little. I stared at my plate, and glancing down the row of heads, saw an astonishing assortment of set expressions. Oh, I thought, a real Japanese bore! Two Paris-trained artists, whom I knew well, sat opposite me. I heard one of them titter, then the other. This was too much; I dropped my napkin under the table, pursued it and stayed, biting my lips hard; surfaced, again heard that uncontrollable titter and again disappeared, beyond control. It was disgraceful; in the old days *hara-kiri* would have resulted!

My wife and I had found a nice house in Tokyo with some garden and even a slightly separated Tea-room, where I slept. This was pleasant because it was not far from a particular area of that vast city where some of my wife's close English and American friends lived. Once

we were settled in, I called upon my master Ogata Kenzan, who agreed
to let me purchase his old kiln to be re-erected on Yanagi's land over-
looking the long, reed-bordered lagoon of Teganuma, twenty-five
miles eastward at Abiko.

Abiko

In this way began perhaps the happiest year of my life. My master Kenzan
VI came out to rebuild his stoneware kiln; the excellent village carpenter
constructed a nice workshop next to it with a tin roof over the kiln
itself. A small conical hill separated Yanagi's house and his studio on
stilts. I often heard his wife Kaneko singing – she had the finest con-
tralto voice in Japan, and became the country's most famous exponent
of lieder. The week-ends I spent with my family, and from Monday to
Friday lived with Yanagi and his wife, consolidating my Japanese
friendships, making exchange and thereby expanding whilst taking part
in the early days of a movement in art which is still rippling round the
world. It has in fact merged into something greater – the prelude to
marriage between the two hemispheres. Such is the only possible way
to rid ourselves of the role of dualism. If the meaning of the word is
obscure, let me add that it is the most universal criticism levelled
against the Occident by the Orient and is therefore vitally important.
Yanagi said that the basis of dualism is the Western separation between
the concepts of God and of man – God above, man below. When we
look back at ourselves we call the Victorians moral hypocrites; I feel
the Oriental thrust is deeper still – the rule of the inner by the outer.

There were many discussions at night between Yanagi and me or
with Naoya Shiga and Mushanokoji, of the Shirakaba group – two
novelists of growing reputation who lived nearby, and often with
young men from Tokyo. To me, by then able to follow and even join
in most of the conversation, what an epoch of life that was in give-and-
take, in the expansion of thought. This was seed-time for ready soil.
The dreaming eastern miles of that long lagoon are still at call behind
my eyes.

The first firing of Kenzan's small cubic-square-yard kiln was disas-
trous, for I refused his offer to come out and help. I was too anxious
to learn – even through my own mistakes. I had never fired a kiln

at high temperature and was inexperienced in the struggles and skills required to raise the heat so much higher than the bright-red 750°C of *raku* ware. Thus it was not surprising that even after thirty-five hours of incompetent stoking I had to give in. I thought we had ample dried split red pine. We started in the evening with larger, slower-burning, quartered eighteen-inch pieces, in order to heat gradually. By the following evening the big wood was getting short, so we began to use thinner pieces. This burnt brightly and fast; the temperature rose to perhaps 1100° by midnight, then the embers began to choke, the chimney under the tin roof of the shed became red hot, a six-foot flame from its top and a column of black smoke rose towards the shining moon high in the sky, breathless in the heat of the night. Here is Yanagi's vivid description written at this time.

'It was a hot night in August. Leach was covered from head to foot with soot and sweat, and no one knows how many cups of water he drank that night. It was a regular battle with the heat. By this time the wall of his workroom was too hot to touch. A hundred pieces of wood would be entirely consumed in less than five minutes, and feeding the two firemouths alternately did not allow a moment's rest. From time to time he anxiously peered into the kiln to see how the colour was getting on, and I well remember the troubled look in his eyes as he sat despairingly by the side of the kiln, staring at the smoky flames with the look of one who had given up all hope of the result.'

My friends gathered to help; they even cut down Yanagi's bamboo fences and brought household coal, and their wives helped to split wood. Like a fool I went on doggedly over-firing, my hands bleeding from wood splinters. Hundreds of moths gathering to the light of that great torch were scorched and fried on the tin roof and its supporting beams caught alight. Water did little good, so we threw scoopfuls of liquid clay at the chimney as we fought what appeared to be a losing battle. The last wood almost gone, we awakened a woodcutter and persuaded him to bring another load, but it was not absolutely dry and with this continued 'smoky and reducing' method of stoking – acting upon Chinese twelfth-century records of how celadon glazes were fired, we never got beyond 1200°C. By dawn I could no longer stand: then, through a spy-hole a gleam of reflection from half-melted glaze was seen on some of the pots. . . . I gave in. They took me to the deep wooden tub in the bathroom; I stepped in up to the neck, squatting,

with my head over the edge and fell asleep. I was rescued from drowning.

For all that blood, sweat and obstinacy, the reward was half a dozen semi-glazed celadon pots – but of the reduced and blue-green effect produced only by the smoky method of firing. I learnt my lesson however, and old Kenzan did come and help me with the next firing. He admitted that it was a difficult kiln so we enlarged the exit holes from the hot chamber to the chimney to increase the draught. (See plate 2b.)

Many strange and delightful things happened during that year, but this book is not intentionally an autobiography. On the whole I have been extraordinarily what is called 'lucky'. With increasing age the conviction has grown strong that many apparently external events, thought of as matters of pure chance, are in truth subject to the subconscious mind which draws or rejects even outward happenings. Some would ascribe such events to the watchful help of a guardian angel, others to a merciful God Himself. That may indeed be so, but here I would be humbly content with the subconscious explanation, as far as it goes. Certainly science is coming more and more to admit the existence of much that seems inexplicable.

One weekend when the workshop being built by a master carpenter to my design was nearing completion, my wife Muriel and the children came out to Abiko instead of my usual journey to them in Tokyo. As we sat with Yanagi in his library looking eastward down the lagoon, I heard a sharp cry from David who was playing outside with Michael. I ran to his aid immediately and found him crying, holding one hand by the other, with Sato the carpenter examining it. He had been stung by a hornet. Sato said, 'Please let me help; I can cure.' I let him: he took David on one knee and said, 'Be still.' Then he repeated the words of a *sutra* (Buddhist sacred text) and wrote its Chinese characters – with one finger in the air! Turning he said, 'Now all right!' He was!

During the heat of July and August in 1917, we went up as before to the cool dry air of Karuizawa. This was the summer when the yeast finally healed my plague of boils. Or could it have been the air and relief of mind? It may well have been both but several of my friends have taken my advice about yeast and been cured from similar ailments.

In the spring of 1919 I planned to include in my annual exhibition

117

in Tokyo textiles and furniture which I had designed, some of which I had made myself. One day early in the morning after a previous twenty-five hour firing I was awakened by banging on the shutters outside my window and the voice of Kaneko Yanagi crying, 'Leach-san, Leach-san, your workshop is burnt down!' Half-clothed I ran round the mound which obscured it from view; to my horror nothing was left but the stark kiln. I stood numbed. My recipes and notes, books, tools, old specimens, designs, textiles for the exhibition – all gone...

Searching for a solution, I borrowed the ferryman's spare punt, poled it to some quiet spot amongst the skirting reeds, and lay on my back dejected.

The weeks that followed brought letters of sympathy which included information that I had given to others, and much more besides – particularly from Tomimoto. Presently with fresh knowledge of glaze recipes, I knew more than before the disaster. With this compound interest I took heart.

At this juncture the proprietor of my Tokyo gallery, a Mr. Seigo Naka, came out to see me bearing a proposal from his former master Viscount Kouroda, who in our no longer feudal times had studied art in Paris and was a leading painter in oils. I had met him only once. He, evidently concerned by my loss, sent Mr. Naka to enquire whether I would consent to him building a new workshop and kiln for me on his parkland not far from my own house in Tokyo, on condition that he might use it himself after I left Japan, which for some time I had been planning. I was quite taken aback by such generosity and told Mr. Naka that I must talk the matter over with Yanagi, who said at once that I should accept. Such a proposal was fully in accord with old custom, particularly amongst upright elderly sons of Edo (Tokyo). I gave thanks, drew the necessary plans, then, as usual in the hot weather, went with my family up to the mountains at Karuizawa to draw and to paint. When we returned not only were the workshop and kiln complete, but a trained potter and a young assistant had been engaged as well. Everyone concerned attended a Shinto ceremony to beseech the God of fire to be kinder to me in future!

Nothing untoward did happen – on the contrary, all went exceedingly well during that last year. First of all the contents of that last kiln at Abiko came out excellently and I was able to hold the planned exhibition after all. Secondly the trustworthy and experienced potter

who managed my new workshop and kiln so admirably, demonstrated by his behaviour the right relationship between artist and artisan. Thirdly and most important, was the entry of Shoji Hamada into my life.

It was in the spring, I think, of the year in Abiko, that a letter arrived from Kyoto asking if he might come and meet Yanagi and me. He described his education, more especially at the ceramic technical college in Kyoto, where he had had a thorough training after deciding to give up his original desire to become a painter. This he told me, was after seeing the pots which Tomimoto and I were making, and exhibiting in friendly rivalry year by year. Hamada and I struck up an immediate friendship. He knew the chemistry, I the day-to-day workshop practice, also I had the advantages of art-school education. For two days on end we talked and then he returned to Kyoto. Later when he heard that I had been invited to start a pottery in Cornwall, he asked whether there was any possibility of coming with us to England. I wrote, asking Mrs. Horne, the financial partner I was to have at St. Ives. The reply was in the affirmative. Thus began a flow between Hamada and myself which has continued without pause to this day.

I met his quiet Buddhist father and two of his cronies, one the head of a house which made the best painting and writing brushes in Tokyo, the other a Zen priest turned lawyer, Iseki, whose penetrating and forthright speech caused Hamada's smooth brow to wrinkle. It would not be altogether wrong to call him Hamada's mentor. Undoubtedly they came to see with what sort of a man the young Hamada proposed to help start a pottery on the other side of the world. In later years Hamada told me that Iseki's last words to him were, 'I would have thought you would prefer to go to China. If you change your mind during the voyage, don't hesitate to come back.'

With the coming of 1920, our life in the Far East was drawing to a close, as I felt my children needed an English education and I had decided to see with my own eyes our good English pottery tradition. We were just able to book an extra single cabin for Hamada on the N.Y.K. *Kamo Maru*, leaving Yokohama for London in June, and to hold a final exhibition of pots, drawings and etchings, to sell and in some cases give, leaving me with a balance of over £1,000 with which to start a new life. (See plate 6.)

Two articles written during this period in Japan are still in my hands,

and, I feel, are of sufficient importance to be used here in full, with very slight alteration. The first, published in 1918 in the *Tokyo Advertiser* in English, deals with the reception of Impressionist and Post-Impressionist art in Japan; the second makes comparison between Japanese and Western Pottery.

Japan's Response to Post-Impressionism (1918)

Before attempting to describe how and why the influence of the Post-Impressionist painters has taken hold of young Japanese artists, it is necessary to have a clear idea about this revolution in European aesthetics. If these contemporary artists have no real message for mankind, their clatter will soon die away. On the other hand, if the outcry which their works cause is due to an unusual amount of creative thought, then by all means let us consider them.

The primary and highest function of art is communication between the spirit of man and man. This function is common to all arts, though they deliver their respective messages through different channels of sense. The purpose of the visual arts is not, as most people suppose, to merely reproduce the appearance of nature – for example, as in the pre-Raphaelite movement. Drawing, painting, form, colour, proportion, may all be unlike nature; the question is whether the spiritual communication is expressed. Almost without exception in the history of art, each fresh advance, particularly in painting and sculpture, has been heralded by a storm of abuse against the innovators. They are accused of being insulting – 'flinging a pot of paint in the public's face', as was demonstrated in the famous libel court case of Whistler versus Ruskin in 1878. This kind of blind opposition has been shown to many artists including Rembrandt and Van Gogh, as well as Monet, Augustus John and Whistler. Fewer mistakes would be made, less injustice perpetrated, if it was generally understood what art is and what art is not.

The outstanding character of revolutionary art today is to eliminate all that is not entirely essential – the traditionalism of the schools, the dust of the centuries. James McNeil Whistler, with his spareness and asymmetric sense of interior decoration derived from Japan, stripped the walls of the Victorian drawing-rooms of their unnecessary bric-à-

brac. It was he more than anybody else who first introduced Japanese taste to the West – certainly to England. The change from Impressionists to Post-Impressionists only reached our British shores about 1914 through the influence of Roger Fry and a few others. Amongst the most important figures of the Post-Impressionist movement were Cézanne, Van Gogh, Rouault, Matisse, Braque and Picasso.

(A note added in 1975: over and beyond the birth of Cubism, out of a mechanical epoch, there is also in Picasso an element of ceaseless inventiveness – 'You can't catch me, I'm the gingerbread man'. I cannot regard him as a good potter, but he is the greatest acrobat in the history of art.)

It was Picasso who introduced us to primitive art, which as with the art of children consists not so much in the attempt to represent what the eye sees, as to put a coloured line round conceptions of the seen objects. Like the primitive artists, pictures children draw are often extraordinarily expressive in this way. The influence of primitive art – here we are dealing with adults, not children – is a cause of the abandonment of representationalism of past centuries. That the revolution is profound, marking the end of a probationary period, can only be denied by those who put the Post-Impressionists down as fools or charlatans. To accuse these artists of being fools is absurd, for no set of fools could have set the thinking world by the ears as they have done, and to say that they are charlatans is merely to descend to abuse without making an effort to understand.

An analysis of changes in the conditions of our civilized life during the last two centuries – the spirit of enquiry in art parallel to that in science – was bound to show its effect. Not only has hand-craft been ousted by machinery, but folk-art – that delicious expression of genuine and naïve feeling – has silently departed. Practically all pattern has hitherto been the product of the folk, and now that it is gone, we needed something to take its place – Cubism hardly does this. Although Post-Impressionists are driven to emulate primitive or childlike expression, they are often self-conscious; their work is parallel to what we often hear in modern music and poetry – synthesis, asymmetry and discord are now included. The squares, angles, abrupt curves, sections – the very cubistry which could not have been conceived in any other epoch, owes its origins to the forms of our post-industrialized society.

By contrast, European art today – at least many aspects of it – owes much to the Japanese inspiration first felt at the exhibition of 1873 in Paris. This contribution came at a time when Japan had only recently thrown off the feudal system of government and opened her doors to the world. Their colour-prints were part of the expression of the rise of the merchant class, and the impact upon the European public was considerable. Decadent ceremonial tea-bowls, which were also exhibited, had an effect upon the French, and a movement amongst potters in Paris, and elsewhere, developed.

The world of thought here in Japan is in a very chaotic state. Nothing is concrete or very definite: change follows change in waves, and it all seems to uncertain purpose. The religious background of Confucianism and Buddhism has to a considerable extent dried up at the very time that Zen was first arresting the thought of the Western world. Shintoism plays no progressive part, and the presentation of Christianity cannot escape from critical scepticism. The influence of every movement in modern art is quickly to be seen in the exhibitions in Tokyo. Education has been retrogressive. The thoughts of such teachers as Tolstoy, Nietzsche and Bergson, although unfamiliar to most Japanese, are well known and appreciated by the eager young-minded intelligentsia who will be the leaders of tomorrow.

Around 1913 a wave of naturalism swept over Japanese literature – previously romantic in tendency. Unlike the naturalism of Europe, it was decadent, being influenced by such men as Baudelaire, Verlaine and Oscar Wilde. In spite of the obvious unhealthiness of this principle it nevertheless penetrated rather deeply as an inevitable reaction against the feudalistic concepts of native *Bushido* (chivalry). The result was a further degradation towards neo-dilettantism which was still present when Post-Impressionism was first introduced some three years ago. Now though Post-Impressionism may be abortive in some of its manifestations, it certainly is not decadent, and thereby offers an attraction to those disgusted with the frittering away of life which dilettantism implies. The direct contact with nature and life, the spontaneous and natural quality in those primitive-like paintings, the organic and truly classical quality of Cézanne, the burning fires of the later work of Vincent Van Gogh and the conscious naïveté of Matisse, have rudely shaken the conservatives everywhere, as much in Japan as in the West.

It is always a matter of curiosity to nine Europeans out of ten that the Japanese should be influenced by European aesthetics, and it is an additional surprise that the most modern work has the greatest influence. Japanese thought is chiefly engaged with problems which have arisen from recent intercourse with the West. New ideas from Europe strike root very easily – so much so that the present movement has been accepted sooner and more readily in Japan than in America. A few square apples of Cézanne's; the flames of Van Gogh; strange Tahitian women by Gauguin; together with magazine articles were sufficient to sow the seed. Artists were first attracted and certain of them, before long, formed the *Société du Fusain* for the encouragement of such art in Tokyo, and have recently been holding their second exhibition. It contained many superficial works but some which showed real insight, notably the pictures by Mr. Ryusei Kishida. Certainly there seemed danger ahead for young artists who might do good executive work and trust themselves too readily to borrowed wings.

(Seen from the present in 1975, three artists stand out whose work is likely to be remembered beyond this century. One is Kishida, who not only drew upon Post-Impressionism, but even from such other influences as Dürer and William Blake and, later in life, Chinese painters of the Southern School, digesting them and developing a style of his own. The second artist, Ryusaboro Umehara, a fine colourist, is still alive and has been the doyen of oil-painters in Japan for no less than forty years. He started working under Renoir and after his return found his own expression reflecting Impressionism and Post-Impressionism in a Japanese way. The third was the outstanding woodblock artist Shiko Munakata, who died quite recently. He was just as original, but the Buddhist background in his work predominated. All three were my good friends.)

The exhibitions and those organized by the Shirakaba Society consist mainly of reproductions of contemporary Western paintings interspersed with a few originals, and have had the effect of converting at least sixty per cent of young Japanese artists to Post-Impressionism. During the few months after publication in England of Lewis Hind's book *The Post-Impressionists*, three hundred copies were scattered in Tokyo, and it was even adopted in a certain school as a textbook.

The Shirakaba Society is playing a very important part in the development of young Japanese minds. This group of art-lovers has

amongst its adherents some of the most hopeful painters, potters, writers, musicians and students of philosophy – incidentally providing food for thought to the yearly increasing number of people in Japan who feel the need for other than material progress. The exhibitions are the first independent attempt to yield aesthetic stimuli; for officialdom has done little in this direction.

From the foregoing it might be concluded that the Shirakaba Society, together with other progressive Japanese groups, may be swallowing an overdose of revolutionary culture from the West. It is difficult to foresee how far these reborn Eastern nations will leap into the arena of Western progress, taking part in a worldwide forward movement. The ultimate result is bound to be compromise, but of what kind we cannot yet foretell. At all events our Western civilization must be tested properly and it is quite evident that so far for the general public one side only – the material – has predominated. The weakening of national character in art and thought generally is not limited to Japan; it can be seen internationally – for example in the work of Whistler, an American, who has his French, Spanish and Japanese facets. The Shirakaba and other societies should neither be blamed nor thwarted in their enthusiasm, for as such they are valuable, creative, and a sign of the times. All that need be said further is that this expression of expanding creativity has become part of an evolving world movement. It frees the Japanese from the necessity of long, laborious, historic studies, and in this respect even gives them an advantage over us Europeans chained to our past.

Ceramic Exchange East and West (1918–1919)

Pottery is ceasing to be a living craft in Japan – it has become a trade.

This is the answer to the question I am continually asked: 'Why do the Japanese imitate ugly foreign wares instead of preserving their old and beautiful traditions?' If during a steady development of applied science, we have banished our Western folk-arts to the hamlets and hills, it should not astonish anyone that in the half century of this country's galloping modernization, a similar process should have taken place in Japan. The change centres round the factory and the struggle between capital and labour, such as it did in England a century or

two ago. The leap from the past to the present cannot take place without the profoundest effect upon art, particularly the directly useful arts such as pottery. It *was* a native craft, it *is* an industry. Forces far greater than anyone anticipated have been set in motion.

A proportion of those foreigners who lament the passing of Eastern crafts perceive that the nation's life is best recorded by its arts, which, like flowers to the tree, are its guarantee of continuity. If industrialization is a main factor in modern Western civilization, it is clear that Japan, in joining the ring of nations, inevitably follows suit, but why do Japanese and indeed all Eastern craftsmen, whom one would expect to have extraordinarily good taste, imitate bad models? Artistically, Chinese, Korean, and Japanese pottery of the great periods has never been equalled by Europe, but on the technical side, in theory and in exact scientific knowledge we are far more advanced, and this is the main reason why – except for the new type of artist-potter – Japanese craftsmen potters have blindly followed in our footsteps, adopting foreign fuel, foreign kilns, colours, glazes and labour-saving machinery, producing economically a much larger output for export, which to them as with us is essential. The good taste we would expect the craftsman to employ in adopting Western science is non-existent, except for the artist-craftsman. It did exist in the past, but by late Tokugawa times it had degenerated, and in any case was quite inadequate to contend with the whole avalanche of Western materialism. Towards the close of the nineteenth century at the middle of the Meiji era, Japanese master craftsmen, with rare exceptions, were traditionalists, inheriting a thin technique and design which they passed on just a little thinner. It is difficult for us to grasp the extent to which Eastern hand-craftsmen have depended on traditional thought – the result of long-established belief – tradition rooted in Faith. It may sound simple to combine old traditions with new knowledge, but the combination of extremes is always most difficult because mutual understanding is requisite and time must be granted. In the past crafts have been the art of the folk; now they have almost vanished – in the future they will be replaced either by machine-made goods or by artist-craftsmanship. Craftsmen will be creative artists and the machines will fulfil their true democratic purpose by reproducing designs for wide and cheap distribution.

There are two main tendencies in Japan at present which constantly

overlap – country conservatism, which still preserves numerous small local potteries working on old lines with steadily weakening vitality, and big-city progress on Western commercial lines. The more artistic work naturally comes from the former, but it rarely has that spirit of fresh growth essential to any vital art and cannot possibly supply demand.

The commercial products which come from the great Nagoya and Seto factories are in the main cheap and nasty. Poverty of design is partly due to the causes I have already indicated, but it should also be borne in mind that the designs are carried out by workmen who have already lost their traditional feeling for Japanese form and pattern, who are not as yet at ease with Western life, and sometimes do not even know for what purpose the article is to be used when exported.

(At this point in 1974 I recollect a 'potty' story told me by Tomi-moto. He was talking to a workman who was making a familiar bed-room article without the slightest idea of what it was used for. He looked up innocently and said, 'Do you know what foreigners drink out of these rather large cups?').

Good work can only be achieved in the machine-shop through sensitive co-operation between artist-designer and worker. There is no getting away from the importance of intuition. Too often I have watched the best workmen miss all the essential points of good foreign designs and colours, by merely measuring, even when they had models before their eyes. We in the West are just beginning to emerge from our slavery to the machine, but Japanese workmen are in the early stages of the process. So thoroughly have we separated utility and beauty, we have come to think of handicraft as a charming if unpractical pastime – as a frill round the hem of industry. In the Middle Ages it was otherwise; then handicrafts were the basis of trade; refinement was for the few. Man and nature were at one.

It is difficult to put the true end or object of labour before average people in a convincing way because they have got so accustomed to living without beauty that it is no longer recognized when seen. Personally I have never become reconciled to the thought that the majority of people will be permanently satisfied with this modern kind of slavery. In some respects we do still know the comparative value of the hand-made, the home-made and the joy-made; every housewife who is worth her salt scorns mechanically produced goods, though perhaps

she does use them for convenience or cheapness. The product of the factory is not good enough because the conditions of manufacture are determined by economy first and last, and quality is continually sacrificed to quantity by capitalists who do not directly feel a moral and aesthetic responsibility as does the good housewife. Only a few years ago each manipulation in the production of a pot or other hand-craft was intimately controlled by the living spirit of man, whereas today it is the dead hand of the machine. In Japan the kilns always used to be fired with red pinewood which gives a long, gentle, caressing flame, expecially when the wood is without knots, well cut and thoroughly dried. Stoking was done by hand with consummate skill and the temperature gauged by eye. At present coal is being used as it is cheaper, but it is not easy to adapt the native wood-kiln to this new fuel; discolouration of whiteware takes place because of the presence of sulphur in coal. Moreover, coal burns with a short, fierce flame. In abandoning the Japanese kiln and fuel some of the subtleties dependent on primitive methods disappear.

Also, in former times blue underglaze colour came from China; it was a carefully picked oxide of impure cobalt, yielding a delightful sleepy blue which was ground by hand with a pestle and mortar for long periods – months, even years – a laborious task. I have seen old women grinding colour, breaking off to make tea for the workers, reading the latest newspaper aloud, and doing all the small jobs that keep a workshop alive, without any sense of real monotony. Today machine-ground foreign cobalt has entirely taken its place. Apart from the fact this is less satisfactory to paint with, the colour is so thoroughly purified by scientific methods that it becomes a hard and staring blue with which we are all too well acquainted. So it goes on right the way through – one change leads to another and can eliminate the heartbeat in work. If the worker has no joy in his labour, how can the public receive any?

Anyone may ask, 'Why are machinery and beauty in conflict?' The answer is that the machine is essentially a duplicator, and precise repetition eliminates choice, variety and pleasure. When machinery is used to multiply faithfully reproductions of originals for wide and cheap distribution it serves its purpose, although the result is that much less alive.

The standard of Japanese pottery has fallen mainly through contact

with the West, and it is quite clear that the whole tendency is towards Western methods and ideals. With few exceptions the examples for study at present from the West are so poor, one cannot be surprised that imitations are yet worse; they should be replaced by the best obtainable, and the finest Japanese pots put beside them for comparison. To collect and exhibit samples of the latest developments in good utilitarian pottery would seem to be a straightforward matter, but I would go further and say that the only Japanese equipped with the right insight to collect good examples of European pots and introduce them to industrial conditions in this way, are those men (mostly artists) who understand good design in both hemispheres. They are familiar with Western refinement and would be able to direct potters to use foreign shapes, designs and colours, and at the same time recognize those old techniques which could be preserved.

Here I would like to quote from a lecture I gave at a UNESCO conference in Paris in the 1960s called *Potter's Voices East and West*:

'For Tomimoto, Hamada and me, pottery was a vocation in which we sought truth of contemporary expression as artists and as craftsmen, inheriting traditions not only from our respective native backgrounds but also from the other side of the world. We knew that we stood on new ground with an unknown journey to make. At that stage we were not even fully aware of the social need which gave birth to artist-craftsmanship in England under the leadership of William Morris, as a reaction from the effects of the Industrial Revolution, and we certainly knew little or nothing about the European craft movements to come. We made pots because we wanted to make pots. We saw new possibilities of shape, pattern and glaze in good traditions of hand-craft still extant in Japan, mainly in the country potteries.

'Japan is a potter's heaven: all the waves of Far Eastern culture have broken upon its shores. Pots are understood through the senses: from the outset people bought even mine. The background of Zen and Tea provided a highly developed perceptivity of truth and beauty, and there was no hard dividing line between arts and crafts. Lying behind Japanese cultural life were magnificent achievements of Chinese and Korean potters of the Sung, T'ang and Yi dynasties, setting the noblest standard the world has known. These pots first emerged in quantity from Chinese and Korean tombs during the construction of

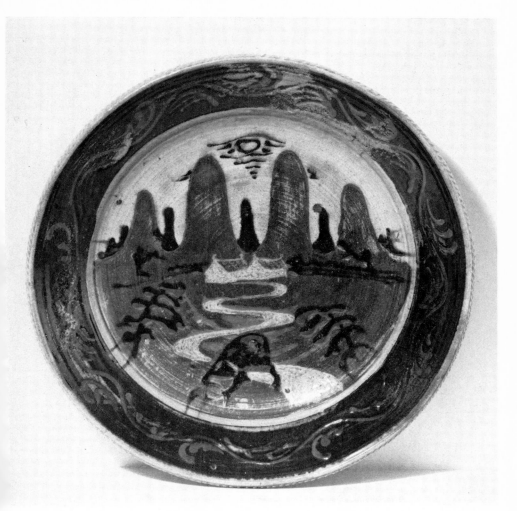

Plate 9 Large slipware dish, 17 inches in diameter. (The Mountains) 1929

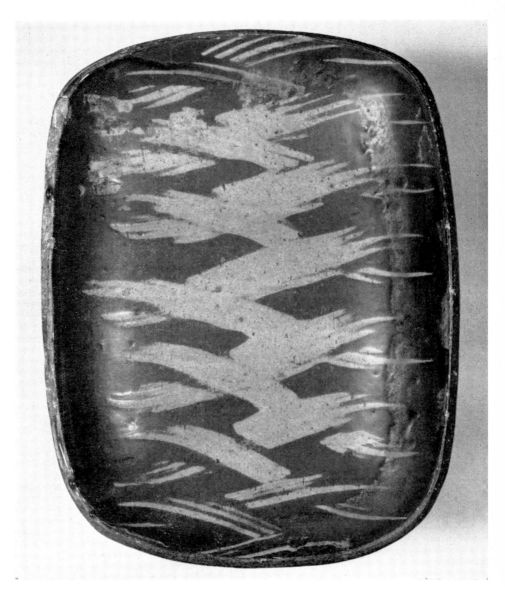

Plate 10 Slipware dish made about 1930, and decorated using open fingers

Plate 11(a) On the South Downs. Brush drawing, 1936

Plate 11(b) On Ditchling Beacon. Brush drawing, 1936

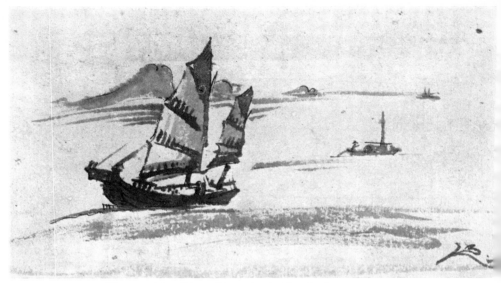

Plate 12(a) Hong Kong junk. Brush drawing, 1934

Plate 12(b) Plate design. Fishermen, inland sea. Pen and wash, 1934

their railways in those years which I spent in the Far East. It was from them that we obtained our main inspiration, and in later years it was from this original source that the contemporary and international "stoneware movement" derived. Sooner or later great achievements are recognized, raise standards and open the way to new creative work.

'The discovery of the real folk-art of Japan and Korea was due pre-eminently to one man, Soetsu Yanagi, who, with Hamada and the potter Kawai, founded the Japanese Craft Movement in 1930. During my year at Abiko the principal subject of conversation did, however, concern both folk-art and artist-crafts.

'My belief is that we are slowly feeling our way towards a criterion of the good pot corresponding more or less to those unwritten principles by which we judge other forms of art. There is a tacit, although never static, understanding by which we take music or literature for example, seriously, but that cannot yet be said about pottery. Nothing, in my opinion, is so important as such a clarification at this period of expansion and interblending. In this century the potter for the first time in history is stretching his horizons from village, or town, or country, to the whole world. That is our inheritance of today. We move towards an unprecedented richness and unity of mankind.

'Our English historian, Arnold Toynbee, has written to the effect that people in the future will look back to this our epoch for its main significance, as the beginning of the deeper understanding and exchange of values between the two hemispheres.

'Human beings want belief and love and the play of imagination in their homes, or they become starved. All the cogwheels and electronic brains cannot give it to them. They need more than functionalism. A pot is more than a vessel to hold food or liquid. People whose sensibilities are not too dulled want to enjoy their cups and bowls and plates as they eat and drink from them. Such is the fundamental and historic approach to the making of pots.'

Before we left, some half a dozen of my closer friends and I published in English and Japanese a small book called *An English Artist in Japan*, lithographed on hand-made paper. It contained memories and tributes; the first by Yanagi – an appreciation of the work I had attempted during my eleven years in Japan, Korea and China. Rather than use it as an

introductory preface, I felt it should come here at this period when it was written. The text of the translation has been slightly shortened and freshly edited.

Leach as I Know Him (1919)

The other day, as I was talking to Leach by the side of his new kiln, he told me, reading from a letter he had just received from England, that he was soon leaving Japan. When the full understanding that we must part for a long time was borne upon me, I realized how much affection I felt for him; though he is a foreigner, he is the best friend I have. We moved in the same world, although our work lay in quite a different field, and very often spirit and comprehension were identical.

It was in the summer of 1915 that Leach packed up all his goods and departed to China, without any expectation of returning to Japan. This migration was the natural result of wishing to imbibe the spirit of the East as deeply as possible, and no doubt his two years' stay in China was not without profit. Even if it was not a period of reconstructive work, it was a time of reflection and impulse and his ideas developed accordingly. When I visited him in Peking in September the following year I spent several weeks at his house at Tung-tan Pai-low; days crowded with many memories. I made the most of every opportunity of seeing the art of China, and his understanding explanations helped me to a closer perception of the beauties of our great neighbour. I have him to thank for being able, on these journeys, to enter into the wonderful national spirit of the Chinese people. Many a new suggestion and stimulus flashed across my mind at this time, but more than all, the warm beauty of the art of the T'ang and Sung periods came to both of us like the revelation of another world. The specimens of Sung pottery we acquired too gave us much room for shared thought. We would go on talking so that the time flew by and we often heard it strike two or three in the morning. One day he received letters from England telling of the illness of his aunt, of whom he was very fond, for she had been as a mother to him. Soon afterwards came news of her death.

The many difficulties he had encountered with this strange Dr. Westharp during the past two years he discussed with me. His leaving China to escape this oppressive environment in order to concentrate on his

own constructive work seemed a very wise decision. I persuaded him to come and live with me and set up a kiln at Abiko. He was attracted to the quietly beautiful scenery and the presence of our friends. He arrived in Tokyo with his family in the winter of 1916 and after a good deal of preparation built his first kiln at Abiko, with an adjoining workroom constructed to his own design in a mixture of Chinese and Japanese style. With the view of Teganuma lagoon spread out before his window, he set to work with high hopes. He thus became one of my family: how glad I was! He was always hard at work and when especially busy would scarcely stop for meals.

With what hopes of success, not unmixed with anxiety, did he essay his first kiln; preparing, filling and firing it all unaided. We celebrated this his first day as an independent potter, but we shall never forget what befell, though probably all potters have a like experience at some time or another.' (1974: I doubt it.) 'He started the fire just about sunset; the first night passed with the kiln growing hotter and hotter and by the following evening the firing should have ceased but the required temperature was not yet reached. Whenever he looked in at the spy-hole the colour was still unchanged and thirty hours had already gone by. Wood was flung into the furnace in feverish haste, but the faggots only flew like the hours and still the temperature would not rise. The shed almost denuded of pine-logs, he sent a man post-haste to the village to search for more. There was nothing for it but to split up wood which was not yet fully dried and feed the fire with that, but however much was used nothing but smoke resulted and the colour would not budge. My wife and I were both helping him to split the wood and carry it to feed the fire in the broiling heat. That night really was one fierce fight against the odds!

After forty hours we saw the glaze begin to melt. Leach sprang up as though he had risen from the dead, threw in the last of the wood and closed the kiln. Covered in dirt he staggered away to a bath, then fell into bed and lay prone for the next day and night. When the time came for that most happy moment of a potter's existence, the opening of the kiln, he was unable to wait and broke it open while it was still too hot to touch. Unfortunately a good deal of ash had marred the best pieces. The only thing that cheered and encouraged Leach was the colour of some celadon, the beauty of which in old times, he reflected, was obtained by a 'reducing fire', or smoky flame. Defective though the

results of this firing may have been, he learnt valuable lessons; the study of this rediscovered 'reducing fire' he has concentrated on for years. . . Many times when I have seen him downcast over some unhappy failure I could read his thoughts, even if no words were spoken.

On the twenty-sixth of May this year 1919, he had finished firing his eleventh kiln and was sleeping soundly as usual after the effects of the necessary vigil, when entirely without us or the village folk knowing anything about it, his workroom quietly burnt itself out from top to bottom through the night (the fire had started on the roof). All his notes, which could not be replaced, on the mixture of earths and glazes, all the rough jottings of the many experiments he had made, all the labour of many years, besides countless drawings and volumes of precious books, several fine specimens, not to mention unglazed pots and various potter's tools, together with fine pieces for the next exhibition – all destroyed leaving hardly a trace!

Aroused by the cry of 'fire', Leach came running out after us. When the sudden shock of the sight struck his eyes he stood as if turned to stone. His face grew pale as he gazed at it. Even now, as the scene of that moment rises before my eyes, I have no words to describe it. As he sat dejectedly in his chair all day, doing nothing but reflect on his loss, it was a sight to move anyone to sympathy. 'What shall I do now?' he asked me in a dispirited voice. It was a day of silence for all of us. Leach's face did not light up until he opened the kiln in which was the rest of his pottery, and I could only be thankful that this last kiln was such an unqualified success; for his spirits were raised again. He moved to Tokyo to use a kiln in the grounds of Viscount Kouroda at Kogei Cho, Azabu, where he has since been hard at work, turning out some seven kiln-loads between January and April.

I believe his pottery is going to hold a distinguished position in the artistic world of today. Who is there amongst our present-day potters who can be called an artist? One craftsman only in Japan, Kenkichi Tomimoto, who has a great admiration for Leach's work. Leach has a depth of feeling that goes beyond mere technique, the character of an artist who will be satisfied with nothing short of work that is alive.

The example of etching done in 1918, entitled 'Lagoon', is one of the scenery of Teganuma, a place full of memories for me; I think it is one of his finest efforts. I well remember how he made the sketch for it one evening in autumn, as he stood by the side of the lake watching

the setting sun; his thought can be read very clearly in the feeling of the line. (This etching was the one given by Her Majesty Queen Elizabeth to the Empress on her visit to Japan in 1975.)

'The end of Summer', an example of his pen-drawing, was done at Karuizawa in 1917. The line and shade mystically represents his vigorous expression of beauty.

1

此小冊子は吾々がリーチとの長い交友を紀念する為に編
纂されたのである。
リーチはいつも吾々の親しいリーチであった。彼程若い日
本の人々に愛せられ、又理解せられた外国人は稀であり、又
彼程若い日本の吾々を心から愛した人は無いであらう。
彼は真に吾々の一人として此十餘年の月日を日本で過ごした。
彼程若い彼との交りは、まさしく彼を送らねばならぬ凡ての友に
親しい気持ちを起させてゐる。もっと日本にゐてほしい〜誰し
淋しい気持ちを起させてゐる。去り難い吾々の思出として、茲に小
思ふ。彼が帰るふら、
冊子を編んで、リーチ自身の感想文や詩文や、又彼の作品

序

FIG. 8. Title page of Japanese section of *An English Artist in Japan*

I believe in his character, his art, and his future, and that the day will come when he will realize this period spent in Japan as one of deep meaning. Many people fall in love with Japan and come and visit us, but few are able to live here in the spirit of our country. His understanding of Japan is not that which is born of observation, or of the solution

of theories, much less is it a mere criticism from the point of view of preconceived ideas; it has soaked into him through the experience of entering deeply into our inner life. The power to understand another country does not come through politics or theories, but in my opinion, through pure artistic intuition. In what other way can a country like Japan, the aesthetic treasury of Asiatic beauty, be understood? Like Hearn, it is from Old Japan Leach drew inspiration for his work, but more than that, for us, the deeper meaning is that he understands the needs of New Japan: he shows in his art what they are. Living with us he has felt our yearnings, our thirst, our struggles and our labours: if he had not had such experience how would he be able to understand our innermost needs, or our position with regard to our old ideas, or our respect for the religion and art of other countries, or our self-awakening, or the ideals we embrace, or the things we try to realize?

When he leaves us we shall have lost the one man who knows Japan on its spiritual side. I feel very sad that he is going, but I hope when he returns to his own land he will be able to represent the East in a more just way than has yet been done, and that not only in words will he be able to show his affection, but in his works. I consider his position in Japan, and also his mission in his own country to be pregnant with the deepest meaning. He is trying to knit the East and West together by art, and it seems likely that he will be remembered as the first to accomplish as an artist what for so long mankind has been dreaming of bringing about.

Soon we must bid him good-bye; but I secretly believe that the day will come when he will return once more to this, his second native land.

PART TWO

Chapter 10

RETURN TO ENGLAND, 1920–1928

On 28th August, very soon after our arrival, Jessamine and Betty, our twin daughters, were born in Cardiff. All being well, Hamada and I soon afterwards went down to St. Ives, where we found a house awaiting us in Draycott Terrace overlooking the harbour.

The very first thing we did was to walk over to Carbis Bay, a mile away, to call upon Mr. and Mrs. Horne, my future business 'sleeping' partner and her husband. I felt a little nervous, but found her elderly, charming and enthusiastic regarding craftsmanship. We discussed sites and asked many questions. What were the clays like? Was suitable wood available for the kilns? What assistance could be found? The best china clay – even exported to Japan – and feldspar, were locally obtainable; wood was a problem as the wind was too strong on the north side of the peninsula for new growth. Most had been cut down for pit-props. Pine was scarce and so, too, were woodcutters. Searching the countryside on foot, spying out the land with a pair of binoculars, Hamada and I did discover a pit of plastic red sand and perhaps a hundred dead fir trees – enough to start with. After discovering not only the plastic sand, but smooth low-temperature clay which had once been used as an impervious basis for the granite quays for Newlyn fishing boats, we continued searching for a high-temperature variety. (This was eventually found at St. Agnes and used by us only since approximately 1970.) Cornwall seemed at that time to produce exclusively good high-temperature china clay, but it was almost non-plastic. To make a satisfactory mixture we obtained smooth high-firing ball clays either from Devon or Dorset.

One day on the flank of a hill called Rosewall, we sat down to eat our sandwich lunch, after which, whilst smoking a cigarette, I poked a tiny pebble into a half-inch hole – it disappeared but we did not hear it fall. I thought to myself: 'How odd', and tried again: after a second or two we heard a little tinkle far below. We both realized that we were sitting on the edge of some old mine-workings of considerable depth and moved rapidly to a safer pitch – I had heard occasionally of untoward happenings of a like nature, such as the sudden fall of a half a room in some cottage built over forgotten workings.

For the pottery buildings a hundred-yard strip was chosen between the Land's End road and the stream called The Stennack, which drained the old tin-working valley through the town to the sea three-quarters of a mile below. The whole area, including Penzance – approximately the toe-piece of the map of England – goes by the name of West Penwith. The moorland hills on the tin-lode were honeycombed with the workings of old tin-mines whose chimneys punctuated the landscape like the giants of old tradition (Tom Thumb and his friends). Almost bare of trees, some valleys in West Penwith however are sheltered from the power of the north-west wind; clipped Cornish elms, oaks and sycamores bend toward the south-east, so that in a mist or fog a man could get his bearings from them as well as the flow of the grass. For some, the bare landscape – folded hills and stern cliffs – may seem sad and lonesome, but to others with perhaps Celtic blood, fierce and grand in winter storm and cold; how tender the flowered paths of Cornish spring below granite bastions. This land grows upon aliens like me with some Welsh ancestry.

The first friend to whom I bore an introduction was Robert Morton Nance, whose forbears gave sanctuary to John Wesley, a century and a half ago. The word 'nance' means 'valley'. He was rather a recluse, but an authority on old sailing ships as well as on the Cornish language, having written the first Cornish dictionary and several delightful playlets of life and speech hereabouts a hundred years ago. He founded the Old Cornwall Society, and later became the second Grand Bard of the Cornish Gorseth. Our sons and his grew up together. His second son, Dicon, married my daughter Eleanor. Thus I am tied to Cornwall, not only by long life and work but also by blood-relationship of grandchildren.

Mrs. Horne introduced us to a Mrs. Podmore, known to all the Irish

poets as 'Dreolin' (the wren). She was tiny; a cloud of pure-white hair over a head full of sensibilities, romantic Celtic dreams and enthusiasms. Both Hamada and I fell under her spell. She told us of the carved mermaid of Zennor Church and took us to see it. The mermaid is said by legend to have enticed the curate of Zennor under the waves of the sea. Dreolin was full of ideas for the future of the pottery, but she was not physically strong, and of a sudden one evening she was whisked away to Switzerland to be treated for pernicious anaemia and never came back. We were sad for her lonely death but have never forgotten her. I made a slipware dish taken directly from one of her scribbles in memory of her after her death. That tiny wren with the puff of white hair and dark eyes kept both Hamada and me alive in those early days.

It was through an old family friend, Mrs. Skinner, that I originally decided to come and start a pottery at St. Ives. She knew Mrs. Horne, who wished to include a potter in the Craft Guild she had started. Mrs. Skinner had written to me in Japan urging me to apply for the post. I did, and got not only an opening for myself but also an agreement to bring Hamada with me as my assistant. Mrs. Horne was a kind and sensitive woman and I could not have had a better partner. We just managed to pay the interest on the capital she and her husband provided, and eventually bought the property from her.

When we started in Cornwall neither Hamada nor I had any experience of crafts in England. Our ideas were more or less bounded by conditions of craftsmanship in Japan. The conclusion we came to was that making and planning round the individuality of the artist was a necessary step in the evolution of crafts. So at St. Ives, at the outset, we based our economics on the studio and not on the country workshop, or, for that matter, the factory.

Hamada and I laid the foundation for an Oriental climbing stoneware kiln – the first of its kind in the West. Whilst the kiln shed roof was being slated, and his mates were not present, a casual labourer, George Dunn, took pity on us and came down to demonstrate how to use a long-handled Cornish shovel, with the haft over the left knee as a fulcrum.

When building the pottery workshop in the autumn of 1920, we left a small corner area for a bedroom, which was first occupied by Hamada and later by Michael Cardew. There Hamada slept, looking after himself, cooking and eating at the large open corner fireplace in

the workroom – the only heating we had at that time. It was lonely, but he quickly made friends and always speaks of the following three years with nostalgic gratitude, for there it was that he found himself and the sure pathway of his life.

The pottery cottage was built just about the time when granite ceased to be used and concrete was replacing it. We all noticed how dead the surfaces seemed in comparison. Some of the blocks were made of mica and quartz refuse after china clay extraction and mixed with cement but the repeated imprint of the moulded edges was so monotonous that it crossed my mind after having seen the way in which these blocks were made, that the surface might be varied by the kind of sand and pebble mixture found on some beaches, thus presenting a more natural varied appearance to a wall so constructed. This started off quite well, but evidently the Cornish workmen felt 'it didn't belong to be' and made a silent protest by putting in the bottom of the mould which faced the eye spare tops of cigarette tins, bang in the middle of the block. I did not discover this until these shining protests were embedded ten feet up in what was to be the wall of the showroom. I believe they are still there, covered by several coatings of lime or waterproofing! Thus I began to learn why I must then have been dubbed as a 'furriner'. The Cornish have their pride.

Later that year, I noticed an advertisement in the *St. Ives Times* for the sale of a count-house in Carbis Bay. These houses were the account and storage buildings of the tin-mines, where the mine-captains lived – 'Providence Mine' in this case. To learn something of local property values, I went to the sale and was surprised at the low price—together with an extra piece of land it sold for £750. I had immediately taken a liking to the roomy old granite house standing a hundred yards back from the main up-country road from St. Ives, and wished that I had been prepared and able to bid, so I instructed our solicitor to let me know if that house and land should come on the market again. At the beginning of 1923 this did happen, and I eventually bought the property for £1,100. We never regretted that purchase, although my wife's parents, fearing damp or dry rot, were justifiably afraid of my inexperience. Damp rot was there right enough, but the builders instructed by our architect dealt with it effectively, and at the same time put a second gable replacing the long old sloping stable roof, giving us four extra rooms. Selling some of the land at the other side of the road helped to

pay the cost of all this. In the first winter the whole house smelt of eucalyptus. Dr. Havelock Ellis, our predecessor, had planted a tree, the roots of which threatened to move even the two-and-a-half-foot thick front wall of that granite building – it had grown as high as the chimneys. But notably we caught no colds! Eventually we met and made friends with Dr. Havelock Ellis himself through dear Dreolin Podmore – but after her death. The fourteen-roomed house, with wild open moorland in the background, capped with acres of rhododendrons up the hill to Knill's Steeple, has been home and homeland to my family these fifty years. The building is now divided between two of my daughters.

Whilst we were still living at Draycott Terrace we became anxious about my daughter Betty. We took her to a specialist in London who said the trouble was that she was born a spastic and would require a special upbringing. He foretold that she would have a happy nature as a compensation, and this proved true throughout her childhood. My wife looked after her until her own death in 1955. Since then Betty has lived in homes for spastics, spending her holidays with one or other of the family, but she still thinks of the Count-House as home.

At last the day came when Hamada and I walked up from the town expecting to find the pottery building finished and empty, hoping to set about internal carpentry. Standing in the gateway, arms folded, was the barely five-foot George Dunn, mason's help, ex-miner, ex-fisherman. Surprised, I said: 'Hallo George, what are you doing here? I didn't expect to see you.'

He looked me square in the eye and replied, with an extended hand: 'Cap'n, I'm staying put.' I took his hand with all that he had to give.

When the roof of George's house threatened to fall in, I had another cottage built for him at a nominal rental – with a bathroom. The bath, however, he filled with coal. Baths were evidently considered new-fangled in the countryside, but coal was precious. He had never conceived of anyone building him a house, and his loyalty sometimes showed itself touchingly. There is a local word 'scubma', which is the equivalent of 'finding is keeping', well-known on the Cornish coast. One day a great round lump of iron obtained from the neighbouring Consuls Mine and weighing probably two to three hundredweight had been levered into our wheelbarrow with obvious labour and skill and triumphantly deposited at the gate. George was crestfallen at my refusal

of his finding – 'It must go back – this is not an ironmongery; I can't see you chopping wood on it either, with our axe.' If any of his numerous children helped themselves to anything from our premises, George took off his belt to them!

The building complete, we set about getting or making tables, benches, damp and other cupboards, shelving etc., with George's outside and willing help. We bought second-hand fire-bricks from local gasworks and with these made a small temporary kiln in which to fire blocks made mainly of impure china clay from the first preliminary diggings of the newly formed Porthia China Clay-Works two miles away, which cost us nothing. This was no doubt mixed with some Devon or Dorset ball clay for its binding and strength. Nevertheless the mixing was so poor that the first kiln gave way in the hot wall between the first and second chambers after two years' use. I was almost able to put my hand right through a bulging crack.

After Tsuneyoshi Matsubayashi, an old fellow student of Hamada's, joined us in our third year, he most carefully rebuilt that three-chambered sloping kiln. Some of the good brickwork is still *in situ*. Matsubayashi was a kiln specialist, but more about him later. At any rate, Hamada did get some good glaze-tests out of that first kiln, the best being in the last firing. Besides the twenty-foot-long one, we built a small round kiln for biscuit as well as *raku* ware. This we began to use for Thursday afternoon demonstrations of very low temperature *raku* pots, encouraging the public to come and decorate their plain biscuited purchases and see them glazed and fired while they waited. Year by year people returned, doing their dreadful décor on our pots, from which they certainly gained pleasure, but we doubted whether our dwindling finances or reputation were much helped.

As time went on we found the need for a secretary. Although I had spent a not too happy nine months in the Hong Kong and Shanghai Bank in London, I never mastered the principles of double entry. Edgar Skinner, the husband of the lady who originally wrote to me in Japan – himself a kindly, retired banker with a love for art, now offered his services at a very modest salary. This was a godsend – it left me to do happier, more congenial work, with Hamada as a boon companion. G.D., as we called George, was mainly outside, sawing or splitting the two hundred tons of wood we had purchased from the G.W.R. for twenty pounds. That was a bit of unwonted cunning on my part, for

I foresaw that in cutting or dragging the sixty or so dead pines in Tregenna woods from the necessary clearing through the dense rhododendrons below, much more dead wood could be obtained.

For some years our main revenue at the pottery came from enthusiasts and collectors in London and Tokyo. We worked hard, but with an irregularity of mood. We destroyed pots, as artists do paintings and drawings when they exhibited shortcomings to our own eyes – what Hamada called 'tail' (this means self-consciousness – he once said 'I shall get rid of my tail, but not before forty.'). These pots we stood on the keel of one half of an old pilchard-boat and threw stones at them; when we heard the crash of the pot in the river below, a sense of inner cleanliness returned. Pilchard-fishing had ceased some years earlier and not being wanted for other purposes we had bought a whole boat for a pound and paid another to have it brought up to our yard, where we cut it into two halves for keeping wood dry.

We only turned out two to three thousand pots a year between the four of us, and of these not more than ten per cent passed muster for shows. (See plates 9 and 10.) Kiln losses in those days were high – quite twenty per cent, so the best pots had to be fairly expensive. What was left over was either sold here or went out on that usually unsatisfactory arrangement of 'sale or return' to furnish craft-shops up and down the country. Nevertheless our work became known, students arrived, critics were kind, my Japanese friends held repeated exhibitions of my pots and drawings and sent all the proceeds to help establish this pottery in my own country. Neither Hamada nor I, nor Edgar Skinner, ever took more than one hundred pounds per year, and George Dunn, our clay-worker and wood-cutter, to within a year of his death was easily the best paid as an unskilled worker.

In 1920 Hamada was 25 and I was 33: he had not yet exhibited whilst I had been launched in his country as an artist and potter for ten years. He had had a scientific training, but I had made mistakes and thereby gained some experience. Like his own pots, he was well ballasted. For three years we shared a good partnership. The background of thought which we brought to the undertaking was that of the artist turned craftsman; or at least of the educated and thinking man perceiving the simple beauty of material, workmanship and general approach to work which had preceded the Industrial Revolution. His desire, as was mine, was to recapture some of the lost values through the use of his own

hands. So it was with William Morris, Gimson and Edward Johnston. East or West, this is the counter-revolution, the refusal of the slavery of the machine. The Industrial Movement started here in England. The return wave of artist-craftsmanship from Japan had a character of its own – it had gained richness, a reflection of other and different philosophies and culture.

The very first showing of my pots was in Conduit Street, London, in a group show at the Artificers' Guild. There I first met the potter William Staite Murray. We stalked each other round a show-case in the middle of a room before making acquaintance. Eventually the friendship broke up – we were doomed to become rivals. I still feel that his Scottish dourness and seriousness of purpose made him a leader amongst British potters who helped educate the public to recognize us as artists and pay more fitting prices for our pots. I think it should be stated that when we came upon the scene he was already making stoneware pots which, he said, were fired at 1650°C – this I found difficult to believe. Such high temperatures were unnecessary – if indeed possible. Hamada's knowledge of Chinese glazes fired at 1300°–1350°C helped Staite Murray a great deal.

An American collector, Henry Bergen, by profession a lifelong student of Middle English, became our first patron and friend. He was an expert in Japanese art, especially pottery, and not content with collecting Oriental art on a modest income from the Rockefeller Foundation, used to come down to stay in St. Ives, solemnly model and cut *raku* pots and also take a full turn at firing kilns during long, hot nights. Bergen was good company, learned and enthusiastic, and he introduced us to museum people – Hobson of the British Museum, Rackham of the Victoria and Albert, and especially to the greatest collector in Europe, George Eumorphopoulos. A group of collectors began to buy our pots as well as those made by Murray, Charles Vyse, and others.

My first 'one-man' show was at the Cotswold Gallery in Frith Street, Soho; Hamada's was at the Paterson Gallery, 5, Old Bond Street.

To the £2,500 capital with which the Hornes financed the Pottery, I must have added from legacies as much again. Nevertheless, despite the fact that we were receiving money from exhibitions of our pots sent out to Japan, and that the first exhibitions here did moderately well, there were at least two periods when bankruptcy loomed ahead. On the

first occasion I appealed to this group of collectors promising a selection of the year's work in return for whatever they cared to invest in the Pottery. Without private funds, however, and help later from Leonard and Dorothy Elmhirst of Dartington Hall, we would not have reached security. Strange as it may seem, that only came in the early 1930s.

In 1922 we were joined by Tsuneyoshi Matsubayashi, engineer, chemist and craftsman-potter of the thirty-ninth generation of a well-known family of potters. Hamada returned to Japan in 1923, and Matsubayashi in the following year.

At this early stage we were making a lot of rather uneconomic experiments in the Japanese low-temperature faience, *raku*, in middle temperature English slipware and in high-temperature Oriental stoneware and hard porcelain. We were still using wood, and there were many occasions when the beginner's struggle with the unforeseen, without the experience and advice of old hands, made me realize the truth behind the friendly warning that in Japan twenty years were regarded as about the time requisite for the establishment of a new pottery. I remember one firing in about 1924 which lasted twice as long as usual – 72 hours. In all that time I had only two hours off, and could hardly stand up at the end. It must have been during this firing that I beat a wall with my fist saying, 'Why in heaven's name did I take up this maddening craft?' The fire-bars below the mass of white-hot ember became choked with mixed ash and a flux from saltpetre with which, unknown to us, some of the wooden railway sleepers we were using as fuel had been saturated. Eventually, raking desperately at the fire-mouth, I drew out long streamers of slag-glass, freeing the air passages once more, and the temperature soared.

It gradually became clear to me that the precincts of Bond Street were too expensive, so we moved to the Beaux Arts Gallery in nearby Bruton Street. We also made an experiment in Church Street, at the Three Shields Gallery, and joined with the important group of craftsmen at Ditchling in Sussex at the New Handworkers Gallery in Bloomsbury. From there we published a small series of craft pamphlets printed by Pepler at the St. Dominic's Press. Mine – *A Potter's Outlook* – was my first attempt in England to formulate faith and ideas. That was in 1928.

At about this time I was elected to William Morris's Arts and Crafts

Society, which held triennial exhibitions in London. During the 1920s I also became a member of the Red Rose Guild in Manchester – which may be regarded as the northern branch of Morris's counter-industrial movement. In this case it is remarkable that activities started with the support of a liberal-minded firm, the Royal Lancastrian Pottery. In its early years exhibitions were held annually in Deansgate and later transferred to the Whitworth Gallery, with its fine collection of early English water colours – a more suitable background for exhibiting artist-craftsman's work drawn from the whole country. A director of the Lancastrian Pottery, Margaret Pilkington, was in charge – herself a sensitive water-colourist. Her outlook was both liberal and generous towards arts and crafts. The artists themselves came together at these exhibitions, selling to the public directly and exchanging thought with one another. This activity continued until shortly before Margaret's death in 1974.

Meanwhile our pots had been shown at various national and international exhibitions – Wembley, Paris, Milan, Leipzig, etc. At the invitation of a group of Harvard university students I joined with Murray, Hamada, Cardew, Bouverie and Braden in a combined Anglo-Oriental individual potters' exhibition. It was spoiled however, by delays and rough handling in the Customs, but I think it worthy of mention because of the newness and breadth of the idea.

When the remnants of this show went to Japan, rather hidden among the bouquets, I found one penetrating, disconcerting criticism: 'We admire your stoneware – influenced by the East – but we love your English slipware – *born, not made.*' That sank home, and together with the growing conviction that pots must be made in answer to outward as well as inward need, determined us to counterbalance the exhibition of expensive personal pottery by a basic production of what we called domestic ware.

Chapter 11

EARLY STUDENTS

One day in 1923 a handsome young man looking like Apollo – straight nose and forehead, with curly golden hair and flashing eyes – burst into the Pottery! Just down from Oxford, Michael Cardew had come on from Truro where he was visiting an aunt, and, as an afterthought, came on to us to see the new Pottery of which he had heard. Here is his recent description of what took place:

'I reached the Pottery at nightfall and met George Dunn, the pottery watchdog and general factotum, who said Hamada was in but not "the Cap'n." I talked to Hamada and very soon questioned the possibility of working there. He was sufficiently impressed to walk the two miles with me to the Count-House where Leach was with his family; en route talking about Ethel Mairet, the fine weaver. There I met Leach and his wife and the children – David, then about twelve years old, Michael and the three girls. We ate a meal, using plates and cups of grey stoneware, with decoration in a reserved blue-black pigment. When he heard I wanted to work in the pottery, Leach said to me, "Before I give you an answer, let's see what your ideas are." He then produced a lovely fluted twelfth-century Chinese bowl. "What do you make of that?" he asked. Of course I didn't make anything of it. I had seen and admired some exciting sepia-painted Tz'u-chou pots, which then were beginning to appear for the first time in London but I had never seen anything like this bowl before. Luckily I had enough sense not to say something stupid. I felt myself to be (and still to a great extent am) a "Western barbarian". What Leach began to teach me then, I am now beginning to learn.'

147

As a boy Michael had known and even worked with Edwin Fishley (probably the last vital peasant potter left in England) during his holidays at Fremington in North Devon (plate 7b). Michael came again to see us at St. Ives. I recollect driving him up-country on my new motor-bike and sidecar, taking two days over a long drive to Saunton in North Devon, in order to see if his family approved.

Cardew's father was a civil servant who liked old furniture and good music, as did the whole family. The first evening at their country house was spent between lobsters, Bach, Mozart and Haydn; the family quartet did not at that stage include Michael. From the first Cardew showed definite character: he galloped on impulse, then pulled up to think. He could also reach red-heat and fury in a moment – even throw a pot at some offender! But Michael was lovable. I can see him taking his first slipware pots out of the third kiln-chamber – having waited with barely hidden impatience whilst we unpacked the first two, glance at them and in immediate dislike send them flying in an arc into the Stennack stream behind him; also him wading in the water to retrieve them later that afternoon! More than with most people, these two aspects of Cardew's personality were difficult to marry. When it did take place the result was astonishing. Those large and apparently clumsy hands with which he made his pots, in turn mastered first the recorder, then the clarinet, and in good time classical music burst forth from him. From the very first his pots expressed the man. I do not believe anyone in this country has made such warm, honest, more or less traditional English slipware, and with so much life.

One weekend he took time off to go and visit Ethel Mairet's weaving workshops, called Gospels, at Ditchling in Sussex. He came back a week later engaged to the auburn-haired, handsome daughter of W. W. Jacobs, the writer, and brought her to the harbourage of our Count-House in Carbis Bay, where she continued to weave. To please her, Michael marched down to Fore Street and ordered the stoutest possible suit of corduroy, which was in due course delivered to the pottery and unpacked. The trousers stood up on their ends – defiant! The rising colour of Michael's neck was marvellous to behold. Enraged, he seized the coat and trousers and plunged them into a barrel of slip – there to mature!

Michael was casual about clothes and often out at the elbows; yet he was so handsome he focused every girl's eyes – it was embarrassing

to walk with him in St. Ives on a Sunday. He did not attend to his shoes either; his front soles were always flapping.

Once Michael and my second son, his namesake, and I were invited to make a journey in a herring boat called *The White Heather* right round Land's End. There, where all the seas meet, we became very sick and although sitting in the bows, our condition was seen from the bridge. My son and I were dragged below and put to bed, where we slept soundly in spite of the thick and hot atmosphere caused by the almost red-hot stove. We revived and were presented with a mackerel apiece fresh-boiled in the sea water with a lump of sugar in it. Never was there such mackerel! Fortified we went back to the bows, only to be sick again. Eventually we reached Newlyn harbour and limped our way to Penzance esplanade where we laid ourselves out on seats at daybreak, whilst Cardew went flapping over the hill towards St. Ives.

Michael was a good talker, illustrating his points with broad gestures, flashing eyes and a fine row of white teeth. He could laugh with the best. He wrote with a firm, clear, masculine hand, expressing himself in forcible language and well-phrased athletic English. Later under a kerosene lamp in tropical Nigeria – at Abuja, where he was Pottery Officer for the whole country, he wrote for wandering modern potters a good book on geology and chemistry. At his best the two sides of his character came together as in a single coin.

Such was my first, and best, student.

Katherine Pleydell-Bouverie was next to arrive. An aristocrat, she had a very telling and communicative laugh like the neigh of a horse, especially if she disagreed. She was nicknamed Beano. And it was during her period at St. Ives that Matsubayashi came from Japan. Matsubayashi means 'pine forest': we soon called him 'Matsu'. He had worked with Hamada and Kawai at the potters' technical college in Kyoto. Well trained in kiln-buliding and chemistry, as we have seen, he rebuilt our large kiln on the basis of the three-chambered climbing kiln which he had constructed for his family pottery near Kyoto. A dedicated and talented young man, he shared his knowledge with us as he built a first-rate kiln with the fire-bricks at which he chipped away for months. He scorned my ignorance, and I have belatedly been told that I too showed my scorn for his bad pots.

Beano settled with a friend in an empty miner's cottage in down-at-heel Halsetown a mile along the old Penzance road, studying wood-fired

kilns and ash glazes, which she put to good use later on. A serious
student, she worked away hard at chemistry and potter's engineering
under Matsubayashi, with us all. Sometimes she burst into irrepressible
laughter at his unusual but expressive English. We laughed with and at
him, and so did he, taking advantage both ways. She scolded me justly,
I expect, but I can still see a wicked gleam in her grey-blue eyes
behind a good powerful nose and tossed forelock.

Beano etched thumb-nail vignettes of her friends brilliantly, wrote
a good letter, and occasionally an excellent article, one of which,
published in *Essays in Appreciation* – a small book compiled by potter
friends in New Zealand in 1960 prior to my visit there in 1962 – I
quote with her permission.

At St. Ives in the Early Years

I met Bernard Leach for the first time at one of his earliest shows, in
1923. It was the first show of modern stoneware I had ever seen, and I
thought it was wonderful. Bernard, a long spidery man, giving a
curious impression of shagginess in a Norfolk jacket and an extensive
moustache, appeared to be about eight feet high and much older than
he was: he must in fact have been about thirty-five. Moved by a sudden
impulse I asked him, if he ever thought of taking a pupil, to think of
me. But he, not unnaturally, took a poor view of that; he said hastily
that he had Michael Cardew coming to him shortly and did not want
anyone else. I left him my address in case he should change his mind,
and went away sorrowful like the young man in the Bible, but for
different reasons. I don't think he ever did change his mind; but the
St. Ives Pottery was going through a difficult time just then; and it
occurred to his secretary, Edgar Skinner, that it might be worth while
to collect a paying stooge. So I was allowed to join the party for a
fortnight on trial; and the fortnight must have gone all right, for they
let me join up for a year, a month or two later, in January 1924.

The team at St. Ives at that time consisted of Bernard, Skinner,
Michael, Shoji Hamada, Matsubayashi, and an elderly ex-fisherman
called George Dunn, who lived in the pottery cottage at the end of the
garden with his wife and a rabbit-warren of young Dunns. He was like
something out of a book about buccaneers; stocky, very short, in-

destructibly good-tempered and devoted to Bernard. If 'the Cap'n' had taken an illicit fancy to any of his neighbours' goods he would undoubtedly have found them on his doorstep next morning; for what Dunn did not know about wrecking, looting and smuggling would have gone in a nutshell. When he approved of anything he said 'handsome'. When he disapproved he spat.

Hamada, rather silent, quick moving, with an air of always knowing exactly what he wanted to do and being determined to do it at all costs, went back to Japan soon after I arrived. But Matsubayashi stayed on all that year. He was a precise little man, a member of a well known Kyoto pottery family that had been making pots for thirty-nine generations, and a very competent chemist and engineer. His pots were rather terrible; and Bernard looked on them with a withering contempt which he was at no pains whatever to hide. It seemed a little hard on Matsu, who made him a beautiful kiln and quantities of very fine saggars, lavishing on his building all the artistry that he never got into his pots. But Matsu, wrapped in a cloak of complacency that was so impermeable as to be comic and rather endearing, remained quite unperturbed by all the things that Bernard said.

Michael . . . was learning Chinese. He was subject to attacks of sudden fury that were extraordinarily funny, appearing like thunder out of a clear sky and usually disappearing as suddenly. There was one splendid occasion, which I unhappily missed, when, moved by some unspecified irritation, he solemnly threw twelve large bucklers into the pottery stream. After which, with equal solemnity, he walked into the stream and threw them out again. It is recorded that nobody laughed. He and Matsu lived at the pottery, sleeping in two minute rooms upstairs. Each room had a rather beautiful Japanese bed, but there the resemblance ended; for Matsu's room looked like the bed-sitting room of a Victorian spinster with Oriental accretions, and Michael's like something out of Mürgers' *Vie de Bohème*.

Skinner had, I think, spent his youth in a bank and his age in Italy. The bank had given him a sense of order that must have been very useful to the pottery, and Italy had added a philosophical outlook that was undoubtedly very useful to himself. Kind and polite, a painter of water-colours upon which Bernard cast a baleful eye, he trotted in and out of the sheds, wrote the business letters, and usually cooked the midday meal which we all ate by the big open fire in the main shed.

My chief memories of these meals are of curry and rice, interminable arguments, black treacle and Bernard making sauces over the open fire. When not making sauces he drew pots on a large blackboard or made them in his corner of the shed, throwing and turning on the stick wheel which at that time he almost always used. 'There is no drudgery in pottery', he pontificated happily, slapping the clay down on the wheel. Michael, kneading at his bench, Matsu, hand-making special bricks for the fire-mouth of the new kiln, Dunn at his sieving and I, grinding cobalt, felt a bit less dogmatic about it; but anyhow there was plenty that was not drudgery and on the whole it was very good fun.

At intervals Matsu had us all round the table taking notes while he lectured about kiln construction, chemical formulae or the plasticity of clay. 'Velly important the cray should have the plasty,' intoned Matsu, who never learned the difference between the letters L and R, but shook them up in a bag and took what came. 'For which put in tub with water till smell bad, yes leally strike your nose too much, when have the plasty and perfect condition for make the cray body.' The lectures were full of good sense whenever it was possible to disentangle their remarkable English; and I think it was memories of them that started Michael off long afterwards on his researches into potters' materials.

St. Ives in 1924 ended at the Pottery; beyond it were fields and farms and heathery moors looking over the sea. Very occasionally on one of the rare sunny days of that characteristically wet year, we downed tools and picnicked on the cliffs. But for the most part we worked rather steadily; and gradually the big kiln took shape until the day came when it was fired for the first time to stoneware temperature. The stoking, after a slow fire of – I think – coal overnight, was all of wood; great logs in the fire-mouth and, towards the end, sky firing with split sticks straight into the chamber. If all three chambers were used the second was side-stoked up to stoneware temperature when the first was finished, and the raw ware biscuited itself in the third meanwhile on the waste heat from the other two.

The first firing began, I remember, with a ceremonial offering of salt on the fire arch. And gradually, through the long day's slow stoking, an atmosphere of tension developed that would have been quite suitable on a battlefield. The rate of firing increased and the kiln grew hotter. So did we. There was a great deal of black smoke billowing out of the

chimney, making an acrid fog in the shed. We got blacker. Night came, and in the flickering light of what Matsu called the 'bro holes' (blow holes) and the crackle and flare of the logs in the fire mouth we moved about like creatures out of one of the more sinister creations of Hierony-mus Bosch. And then, in the grey dawn, something began to go wrong. Matsu took out a spy brick, and as the wicked little flame that jumped out at him died down, peered into the incandescent kiln and let out a ghoulish roar. 'Oh-ho-ha-ha-hay – awful sings happen', sang Matsu with every appearance of enjoyment, as a six-foot bung of saggers leaned slowly forward and collapsed on to the front wall, blocking up the draught.

I shall always be grateful to Bernard for letting me be at St. Ives that year. It was a great experience and he was very kind, ungrudgingly generous with information and suggestions. He did not know the meaning of the words 'trade secret', and I have never known anyone who would give his time and attention so completely to another per-son's problems. I shall always remember how he came to us at Coleshill when we got into a muddle with a kiln, and sorted out an idiotic error in construction. 'Your chimney is too small', he said. When Matsu said, 'Chimney ten by ten inches, but a round one is best', he meant a twelve inch diameter tube, not a ten inch. Well, of course. But it was Bernard who spotted it.

I think it was during Matsu's visit to Beano Bouverie at her once famous house, Coleshill, built by Inigo Jones and later destroyed by fire, that he one day initiated her mother into the intricacies of a Japanese Tea Ceremony. He preceded this by dressing in best formal Japanese clothes and going out into the rose gardens to select two or three blooms as a background for the ceremony. Looking at them with a calculating eye as they grew, he squatted first on one foot and then the other, quite unaware of the tiptoe curiosity of the gardeners peeping over the hedges at his antics!

The magnificent old drawing-room was the last place to think of as a background for Japanese Ceremonial Tea. He proceeded to arrange the old furniture to simulate a small Tea room, with a very low entry for the poor dears to crawl in humbly on their knees and in their English skirts. They took their positions sitting on their heels, whilst he ponti-ficated with boiling water, rinsing out each of his bowls, emptying the

water into some receptacle, then wiping them ceremonially. He then opened a *cha'ire* (tea-caddy), took a couple of bamboo teaspoonsful of powdered green tea which he emptied into a bowl, and over which he poured a bare cup of boiling water. This brew he then frothed with another fine tool, a bamboo whisk, before presenting the front of the bowl towards the principal guests whom I presume had been invited to nibble a special Japanese sweet to enhance the austere flavour of this peculiar drink. Who the second or other guest was I do not know. I think almost surely Beano's elder sister must have been present – she also surveyed one with a rather wicked, perceptive eye! My mind boggles at the thought of those English ladies composing their faces to this solemn ordeal presented by the Master. They must have experienced difficulty in knowing how to use those Tea-bowls without handles. At any rate, this must have been a poignant contact between two hemispheres.

From Coleshill I think he went to Paris. I have two letters written during this period.

'c/o Madame Sarrazin,
12 Rue de la Grande Chaumière,
Paris.
September 7th 1924.
. . . I am rather regret say which I am suffering some difficulty out of my pronunciation which impossible to pronounce their word of L or R by Japanese. One day rather too kind Frenchman very kindly took me to the one of Hospital when I asked on the way to get Grande-Chaumier to him because he does not understand which I said grande is grande or glande and the French word of glande means the boil and I haven't any boil in my all over body whatever and it made me more difficult to get there . . .'

'September 22nd 1924.
. . . I don't think you can have a good successful exhibition in Tokyo in the future five years time because they are building the house or to to get furnitures are more nesaselly than ornamental pots and the population of the Tokyo much smaller than "Osaka" so many people are not rich enough to educate their own boys and girls to the school because their all fortune are has been losed since grait earthquake . . .

'I am very unfortunately hearing news of Japan is all terribly bad. The weather does not wet whole last summer even a drop of rain and everything dried up and no water at all even for the drinking and it is graitest dried weather since last seventy years addition to having awful heavy earthquake everywhere.'

Hamada was still with us at St. Ives when this appalling earthquake almost totally destroyed the biggest city in the world in 1923. At that time his relatives lived in Tokyo, and at the Pottery we received no news of them for three months. His father had a small factory and when the building began to rock he told all the employees to be sure to put on footgear before running into the streets, because, with the great fires which had started all over the city, there were bound to be red-hot embers flying from the burning houses. They took refuge on the one bridge crossing the Sumida River, which was undamaged. Thus their lives were saved. That river corresponds to the Thames in London and relatives on the other side saved their own lives by standing in the water up to their necks and protecting their heads with wet cushions from the great heat coming across the river. In later life I knew a priest whose life was preserved, although he lost one hand, because he was six bodies deep in a crowd in a large open space ringed with fire. How quickly we forget these far-off disasters – even those on the grand scale.

The next student to come was Norah Braden, preceded by a letter from Sir William Rothenstein at the R.C.A. saying, 'I am sending you a genius.' I still think there was some truth in this estimation, even though the frustrations of life forced her later into teaching rather than potting itself, except during the years she spent with Beano Bouverie at Coleshill after she left us. Norah was perhaps the most sensitive of all the students who have spent time at the Pottery. She drew beautifully; she played the fiddle and had the sharpest eye for any falsity in art or character I have ever known.

During this period my son David joined us feeling that he could make a better contribution to life helping me rather than going to university. At that time he did not think of himself as an original artist, but he certainly had the makings of a craftsman. (See plate 7a.) It was he who brought in a local ex-primary-school lad, aged sixteen, William Marshall, who is still with us after thirty-six years and who, without

further education or private money, and with little travel, has through contact with various students, learnt not only first-rate skill as a craftsman, especially as a thrower on the potter's wheel, but has gradually become quite an expressive potter – one of the best in the country. Now, in my old age, he has been my right hand. A born lover of nature, he used to read very slowly, but take in, the contents of such a book as *The Compleat Angler*. He also made his own gunpowder for shooting snipe, but this sometimes blew up in our chimney – when a spark caught it the explosion was marvellous to see.

There were about a dozen or so other students preceding the war. Gradually from all over the world we must have had nearly a hundred students, but there was never any attempt to start anything like classes, as done in schools and American universities. Periodically I talked to them as they learnt their alphabets of clay – its qualities – its innate demands on a potter – its form and decoration – kilns, slips, glazes, etc., encouraging them to stand on their own feet, both technically and aesthetically, insisting on right standards, but avoiding rules. It caused some hardships, no doubt; but no real harm, nor did it quench enthusiasm. (See plate 8a.)

Chapter 12

EARLY FAMILY LIFE

A year or so after we had settled in the Count-House, my friend Reggie Turvey arrived from South Africa, with a young slip of a wife called Topsy, literally in his arms, for she had appendicitis and had to be rushed into hospital. He eventually built a house opposite mine in Carbis Bay, from where he painted mainly Cornish landscape for ten years, and where his two children, both boys, were born – Geoffrey, who died in my arms of croup of all things, and John, who now lives in Rhodesia.

For our children's education we eventually sent our two boys to the same non-denominational school in Wiltshire – Dauntseys. It was Michael who took an interest in pottery first: on one Speech Day we found he had constructed a small kiln and was making pots as a minor demonstration. On Speech Days the custom of that school was for all the boys to engage in their normal occupations for their parents to observe. With afterthought, we felt that with their different personal characteristics it would have been wiser to have sent them to different schools. David was quick at games; Michael was more of a student and passed his exams for Cambridge, specializing in biology, long before he could go up. Two of my daughters, Eleanor and Jessamine, both went to Badminton School and were happy there. Later they both trained in dancing, and were in my opinion talented enough for the stage, but marriage and children won. My third daughter, Betty, being a spastic, required special training, as I have mentioned, and was finally sent to one of the best homes in England, where she still is.

How I looked forward to games with them all during the school holidays, either indoors – racing demon, up Jenkins, or head, body and legs – or French cricket in the garden – or sardines in Tregenna's rhododendron woods. Neither of the boys sought an art training, I left them free; nevertheless they both eventually followed in my footsteps as a potter.

FIG. 9. Young frogs, spring 1935

I do not like praising one child above another but perhaps my most vivid memory is of my daughter Eleanor being the youngest child amongst a thousand folk-dancers in a large field, being led and adjudicated by Cecil Sharp, and of her stamping her foot in mounting rage, shouting 'Dance, will you!' because her schoolmates were wide-eyed and absent-minded. She can dance and teach others to dance and can originate her own mime.

I cannot remember who introduced us to Bernard Walke, the vicar of St. Hilary, about ten miles from St. Ives. The wife of this priest of the Church of England was a fellow student with me at the London School of Art. It may have been curiosity that took me to his church because of his repute as a fine preacher and pacifist. At any rate I took my family

over one Sunday and we were all so impressed that we continued to go there for several years. The sincerity and holiness of this priest bending over his mainly farmer congregation with a searching humanity, always brought to me a mental picture of St. Francis of Assissi. That face leaning over the ledge of the pulpit touched our hearts with Divine love, nearer to Heaven than any other I have seen. When he spoke it was not only with love but with courage. That courage showed most clearly during the war when he addressed a group of people in Penzance on pacifism and the message of Christ. The congregation was enraged and two Tommies fresh from the trenches leapt on the stage saying, 'You'll have to deal with us first.' Father Walke was carried to safety by his friends.

The inside of St. Hilary Church looked more as it must have before Henry VIII and the Reformation – a Catholic church – but then, so it once was, and so great was our family need of unity that we joined it. The Stations of the Cross hung round its walls, a light was always in the sanctuary, candles and incense burned. On Sunday evenings when Father Walke carried the Host round the church in Benediction his face *was* that of a saint in adoration.

At Christmas and at Harvest the church was decorated with large branches of trees, and great silver balls eighteen inches in diameter hung down the arches flanking the aisle. Certainly not Protestant. One day I asked him why he was not a Roman Catholic. He replied, 'They will not admit me, nor the validity of my Holy Orders, nor my religious experience, hence I cannot join the old Roman Catholic church.'

Yet the people loved him and many came, like us, from afar. Year by year the Nativity was enacted by farmers, and broadcast. But there was in the congregation a handful of 'no Popery' protesters: some were imported and settled there to make trouble. Eventually they drove him out. I do not know how he finally squared his conscience: for a time I had quietened my own by the thought of Catholicity, the Wine of God and the Staff of Life in remembrance of Jesus.

In the village there was a home for the children of London's Magistrates' Courts, sent down for Father Walke to heal, and that he did. I asked him if he ever failed; he smiled and said, 'There was one, a boy, whom it took five years to reach.'

Father Walke had a donkey which he loved and on which he rode

about. It became too old and reluctantly he had it put to grass five miles away. He paused in telling this tale, then said very quietly, 'One Christmas Eve I came into this room and in the dark across the lawn there stood the grey donkey, his fur sparkling with frost in the moonlight.'

Father Walke died in the arms of Rome. With him gone and my marriage on the rocks, the High Church, because of its departure from the purity of Christ's teachings, did not quench my thirst.

Plate 13(a) Turkey and hen. In Hamada's garden. Pen and wash, 1935

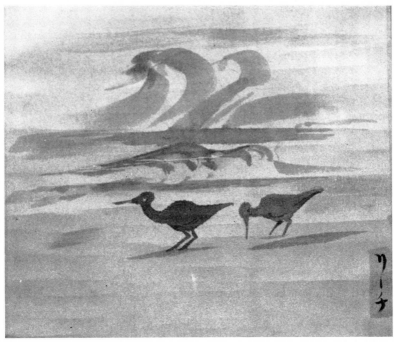

Plate 13(b) California sea-birds. Brush drawing, 1952

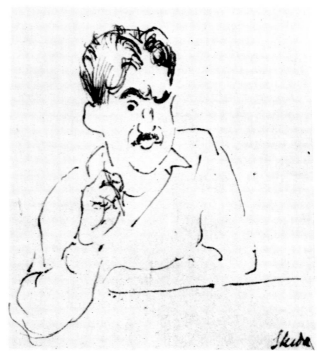

Plate 14(a) The furniture-maker Ikeda. Pen drawing,
1953

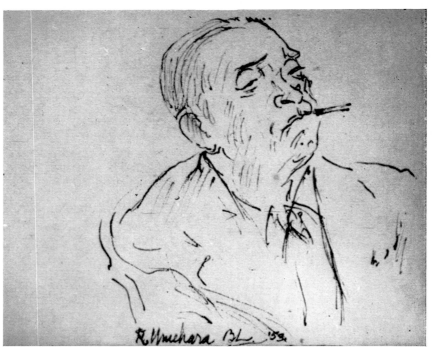

Plate 14(b) Umehara, the best oil-painter. Pen drawing, 1953

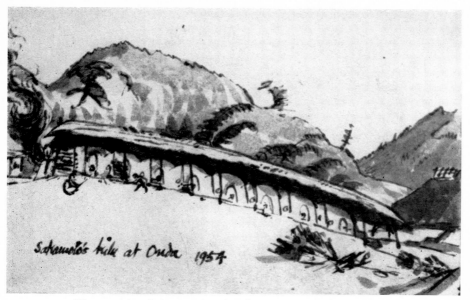

Plate 15(a) Sakamoto's kiln, Onda. Pen and wash, 1954

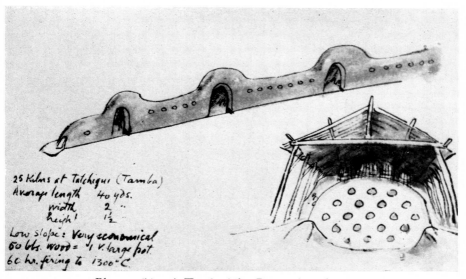

Plate 15(b) A Tamba kiln. Pen and wash, 1954

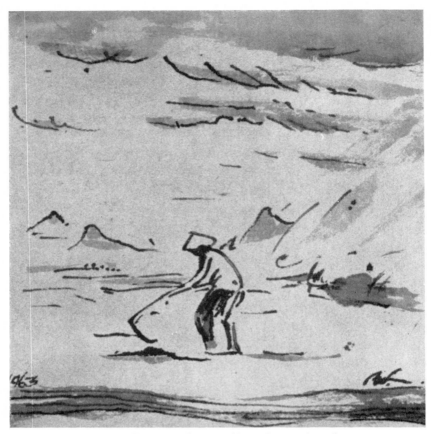

Plate 16(a) Japanese farmer tilling. Pen and wash, 1963

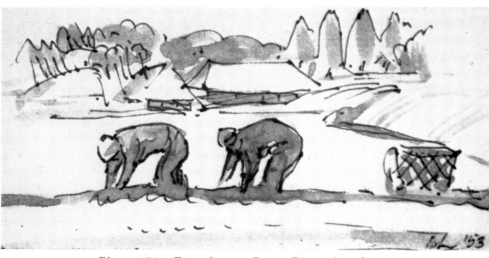

Plate 16(b) Rice planters, Japan. Pen and wash, 1953

Chapter 13

DARTINGTON, 1927-1934

We first heard of the concept of Dartington from Leonard and Dorothy Elmhirst in our old Count-House drawing-room in Carbis Bay. They had driven down to see with their own eyes how we were attempting to draw East and West together in the making of pots. There followed an invitation to come and visit Dartington Hall in its early beginnings.

It was in 1927 that my wife and I first drove up a grass-grown road, passing the site towards Dartington Hall upon which the Foxhole School was later built. Leonard and Dorothy were at this time in residence in part of that beautiful old unfortified mediaeval building; repairs were going on all round the great quadrangle. The Banqueting Hall itself was not yet re-roofed, but the plans existed and were eventually well carried out, using timber from the estate. Leonard and Dorothy talked about their ideals with quiet enthusiasm, but it was not until later that I came across a moving account of the source of these ideals, which originated from the advice of the Indian poet Rabindranath Tagore. Leonard had formerly met Dorothy at Cornell University in America in 1921. Later when he went as agricultural adviser at Tagore's university in Santiniketan they met again. They decided to marry and use her wealth for what turned out to be the most remarkable decentralization of culture in England, developed by the advice and inspiration given to them by Tagore. The following are his words, quoted by Leonard himself in a Dartington Hall newsletter; they speak for themselves:

'We have no right to deprive growing children of direct access to nature and to all the beauty that nature lavishes upon us; the most beautiful place will not be too beautiful for your school. Why not look for a site in Devon? When you settle there you must open a craft-school of your own and be sure that your weavers and potters always keep in touch with your artists. The practical work of craftsmen must always be carried out in partnership with the divine spirit of madness – of beauty – with the inspiration of some ideal of perfection. Try to attract some budding poets, some scapegraces whom no one else dares to acknowledge. Never mind how small the flame may be, provided they have enough of a gift to light the lamp.

'The process of the cultivation of the land has a stability all its own. Gradually its scope widens and its organization becomes complex. Art on the other hand is an independent thing. Each artist has to pursue his own separate orb of light. These artists then are bound to be opposed to the stability of your agriculture. For this very contradictory reason these forces should learn to live alongside one another and be gathered together in one place.'

Later when Tagore came on his first visit to Dartington, Leonard took him round the estate and even in a boat on the surrounding waters of the River Dart. Before he left, Leonard asked, 'Sir, will it do?'

'Elmhirst', he answered, 'it *will* do.' Thus was the lamp lit. Many artists, dancers, musicians and craftsmen have emerged from this start, singly or in groups.

A letter I wrote to Leonard Elmhirst in 1931 contains the following:

'I have been more and more driven to the conclusion since my return from the East that it is only by a return of the artist into normal life, into production, that on the one hand *he* may hope for normal health in his work, and on the other *we* may hope to buy and use furniture, textiles, pottery, etc. which will satisfy at one and the same time our bodies and souls. For the moment I am thinking of the artist in the broad sense who, as Eric Gill says, makes things as well as they should be made, or as Phillippe Mairet puts it "as ends in themselves, not as mere means to an end". That is the responsible craftsman. To make pots of that kind it is necessary that there should be a close alliance between the artist, the scientist, and the businessman. That is the rub!

The man of commerce comes first, the works manager second, and the designer a bad third. I would reverse the order. It seems to me like a race between the two possibilities. The conception of work as responsibility and enjoyment has to be regained. We have sold that birthright. Is not this an essential part of that new order? Our world will not in any case tolerate industrial serfdom much longer. The will to enjoy life deeply cannot be held in check indefinitely. This is where quality as well as reasonable quantity in work is socially significant. And this is where I believe the craftsman has an important role. But the necessary amalgamation between science, machinery, organization, distribution and the capital necessary, even for a small experimental venture, cannot be expected of the hand-craftsman working in comparative isolation. At Dartington, there is the best environment I have seen, if you want to work in this direction. As well as the community to be supplied, the next generation has to be brought naturally to understand the problem, a sympathetic and progressive spirit must keep the workers keenly aware of contemporary thought and need, organization, various experts and allied craftsmen and scientists involved, and an indirect publicity of a valuable kind prevails. The knowledge of a century could be gathered round the new craftsman – the factory to him instead of him to the factory.'

I came up from St. Ives more than once, finally in 1932 to teach pottery at the newly built Foxhole School. At first I was installed in a room in the great quadrangle. Then I remember Leonard taking me over the estate and saying that neither he nor Dorothy regarded themselves as dictators, and it was up to us whom they had chosen, to determine the future of Dartington. He introduced me to the Heads of Departments and then to Mark Tobey, the resident American artist. In the courtyard Margaret Barr was still in charge of dancing but was replaced by the Jooss Ballet in 1934. Races and backgrounds were mixed, mistakes were inevitably made and had to be rectified; change was in the air and speech was free – sometimes cruel. Yet Dartington as a whole was a magnificently generous and far-sighted effort upon which to spend great private wealth for culture in a rural setting.

We knew this and appreciated the possibilities, despite intermittent cynicism. All the problems of modern life seemed to be concentrated in that loop of the River Dart. For me, most fundamental was how to

reach a unity of purpose within a group of, let us say, a thousand people – one in which a higher contribution of individual talent and goodwill could be blended into a whole. There, within the soft fringes of democracy, it seemed to me, was where the difficulty lay, for what applies to oneself applies to the thousand.

Reggie Turvey and his wife Topsy came up from St. Ives later, to join me, and to take part in any activities, though not on the staff. His house, quite near Shinner's Bridge, was built for them under the control of an amateur architect – who ran into difficulties – much as I had at St. Ives, for Reggie's wife had no idea of the relationship between the inside and the outside of a house, and the consequences were to some extent, disastrous. Moreover the cost was important to them – the roof may have been economical, but it leaked, was re-covered, and leaked again. However, the difficulty was eventually more or less corrected.

A warm friendship with Mark Tobey began, which grew closer over the years. We talked of everything – all arts, all beliefs, and especially that one to which he adhered through all vicissitudes. He spoke of a Persian Prophet, Bahá'u'lláh (The Glory of God), who declared Himself in 1863 in the garden of Riḍván in Baghdad, and whose claim was no less than that of the return of Christ. After my loss of faith at about the age of eighteen, following a long period of un-certainty, this was more than I could take. Yet I read the books Mark lent me, and often went to the meetings of Bahá'ís – followers of Bahá'u'lláh. I was deeply challenged. Buddhist thought and life in Japan, and ten years inter-religious thought through Mitrinovic in London (not to mention the writings of mystics both East and West) had certainly widened my mind.

Of His Message of unity Bahá'u'lláh wrote, 'A new life is, in this age, stirring within all the peoples of the earth . . . the fundamental purpose animating the Faith of God and His Religion is to safeguard the interests and promote the unity of the human race . . . the well-being of mankind, its peace and security, are unattainable unless and until its unity is firmly established. . . So powerful is the light of unity that it can illuminate the whole earth.'

As well as coming to Mark's classes, Reggie, with his wife, shared my interest in Mark's religious conviction and went to all the Bahá'í gatherings. Both he and Topsy accepted this Faith some years before

I could. Looking back, the quiet strength of Mark's belief had its effect, but the idea of a new revealed religion was too much for my acceptance whilst he remained at Dartington. It was not until after he and I made our journey by ship to the East in 1934 that, left to my own judgement, I later realized that the Central Figures of the Bahá'í Faith – the Báb, the Forerunner, Bahá'u'lláh, the Founder, and Abdu'l-Bahá, the Interpreter – were totally without egocentricity. I found myself convinced, almost against my will, that the absence of self implied the presence of Truth – the Universal 'I am that I am'. This new apprehension was like the click of a ward in a lock. A door opened, not only between Buddhism and Christianity, but also between East and West. I asked a knowledgeable Persian believer if it was sufficient for a seeker to consider Bahá'u'lláh as a spiritual genius. He paused; then said, 'Yes'.

'Then', I said, 'I believe.' Perhaps his pause may have indicated that this was a minimal part of the reflection in the Mirror of God which is our concept of a Manifestation.

This volume is not intended to be what might be called a 'religious' book, but to be silent about one's gropings for meaning and truth is certainly not my intention either. Throughout life, friends – living and dead – have been my educators, opening the doors of perception. Mark Tobey was one of a succession all down the years. How fortunate I have been!

The following is quoted from a paper by Mark which he read at his first drawing class at Dartington in 1930:

'What I am seeking in you, and endeavouring to help as much as I can, is the furthering towards the realm or identity of being; so that we may be better equipped to know of what a real unity is composed – not uniformity, but the unity of related parts. I have no hesitancy in including philosophical colourings, any more than I would hesitate to say that back of any person, and I mean each person, there must be his or her metaphysics.

'First of all, I want the desire to create; for therein lies the will to continue to live in a new way – to add to your house more vistas of being. For I believe that back of all great achievement is a richness of being.

'There will be for all of us in this class – and myself not excluded –

periods of disintegration and of integration. Many avenues will open up, all at once. Perhaps there will appear too many before the bewilderment of our astonishment will cause us to integrate in a new way.

'For me, a person is constantly being educated – at home – with friends – on journeys – alone with oneself – at all times and at every odd moment that he may be conscious. We are constantly receiving many impressions – some of which we can become conscious of and accept, or exclude, as the case may be. What is the foe to our finding a voice of our own? I should say fear. Fears, governed by public opinion, by ideas of friends, by accepted patterns of traditional modes of thought. From where can the release from all this rigidity of pattern come? To me, it must come from the Creative Life. That life, which, drawing upon the vital forces within us, gives us power to begin to think and to feel for ourselves, in our own individual way. The beginning of the creative life is the beginning of faith in oneself; the will to experience and order the phenomena about us.

'Now, why should a class like this – a so-called Drawing Class – enable us, in any way, to do this; or set us on the road? I think, firstly, because we are taking the creative point of view, however puny or weak the results – and to me, the immediate results should not be dwelt upon too long – they are like steps on a ladder, experiences through which we grow and move onwards to the next stage.

'Many are afraid to begin; but the start must be made somewhere – some time. How subtle the forces are that pull against a keeping of our vision clear. I am sure that if we were able to look deeply within ourselves, as well as to observe the effect of many things and people upon us, we should reach for the first weapon available and try to clear away these obstacles that prevent us seeing with ever greater clarity.

'Again, I want you to feel that in this class you are, through making an effort to express your ideas on paper, freeing yourself – opening up greater powers for living the life of the artist within us all – that can see and know greater subtleties of colour and of form and wider experiences in other dimensions, than you have ever known before. To me all the phenomena we observe should result in a heightening of consciousness, day by day. How much substance is there to the past? Things touched and known in the past have now become the phenomena of your consciousness – of your imagination; you can recall

them, touch them, hear them and see them, but they are in a world far more subtle than the one immediately around you. The future, as soon as you have experienced it, will, may I say, become the raw material of your consciousness.

'No doubt, I am seeming to some of you to be far from the object of your presence here. Very well, but the things you create here will in the end help create new and other states of consciousness within yourself.

'I may perhaps have travelled a little further than you on this particular road, but I also am undergoing similar experiences to your own and I am attempting to readjust this mechanism of my own so as to let in more light; for that, to me, is the object of life, the enlargement of consciousness; and without light and more light, how shall we see?'

Mark's work as a painter about the time when we first met was mainly representative of what the eye sees – man, landscape, house or tree, or even still-life. He told me he started as a realist portrait painter in New York, but as the years passed over our heads he weaned himself away from appearances and wove into his work a representation of inner meanings and significations which most people would describe as abstract. He disliked this word. Looking back at his work in a long life, I have sometimes compared his evolution with that of Picasso in the wide domain of exploration, despite completely different temperaments. All through, his stylization is individual, by which his character can be read, but as he grew older and wiser the clothing of the mere personality became translucent and the spirit appeared.

That Mark was a marvellous teacher of art was apparent at Dartington Hall. Twenty to thirty chose to come to his free drawing class one evening each week – artists, dancers, musicians, housewives, servants and gardeners – both the élite and the simpler-minded. Those who came never forgot. Mark did not teach by any ordinary standards, yet he taught everything, even by silence. In particular I recall a summer evening when he did not appear during the first hour. Everyone set to work at a long table with a board, ink, pens or chalk, silently seeking some private expression. The fine weather had kept a few away. Suddenly Mark entered quietly and stood in the open doorway. We glanced up. He paused, then said: 'I too have been out for a stroll, watching some of you move freely in the sun on the tennis-courts,

not stuck with your noses on drawing-boards. Is there a pianist? Play, for God's sake! Now leave your boards – dance! Let go! That's better – dance, you emotionally tied-up English! Now stand up and dance with your chalk on your drawing boards!'

I remember another night when we were drawing under electric light; it must have been winter. I had chosen to make a study of an anatomical cast. I was drawing the muscles of a man's thigh when Mark came and sat beside me and began to chat about the way the light played over the limb, then he went on about the discovery of the use of light down the centuries and how it revealed form, from the earliest Renaissance right on to the present time, in which the abstract barely uses it at all. He took my soft charcoal and drew on Michelet paper in the manner of Leonardo, searching light and shadow and again reflected light within shadow as it rounded the white limb. Then he dusted off the charcoal and drew as El Greco would have done, the same exercise, but with his peculiar attenuations and accents, inevitably showing the strange personality with which he must have been endowed. Again he dusted the drawing off and drew as Rembrandt drew, revealing light on form in space with the insight of a great humanist. What tender discoveries! And so to *plein air* and Paris – Manet, Monet and Renoir; then, too, the Post-Impressionist Cézanne, then Picasso, and not least, the one who brought the humanities back into the dance of life, light and colour – Van Gogh.

Towards the end of 1933 I received an invitation from Yanagi and his craft friends to revisit Japan in the spring of 1934. In this connection Dorothy one day asked me to tea with her and Leonard, in his study. Suddenly Dorothy looked over her teacup searching my face and said: 'You and Mark are great friends, aren't you? Would you like him to go out with you?'

Astonished, I said: 'Very much.'

She smiled, 'We shall see to it.'

Leonard took me to one side and added a warning: 'If you do travel on the same ship, have cabins at opposite ends.' I thought this unlikely, and in fact there was just one double cabin available. Mark is a night bird and I like to be asleep by 11 p.m. Around midnight I would awake with a poke in the ribs, the cabin in a complete cigarette smog and out of it Mark saying: 'I want to talk to you, Bernard.' After a few days this got on my nerves, and one early morn, sitting on stanchions in the

very bow of the steamer we had a flaming row, telling each other off in no uncertain terms. Mark suddenly paused, laid his hand on my knee and said in humility: 'Do we really want to do this?'

I too paused, then answered: 'No.' We did not quarrel any more; I was beset with a private sorrow and tension and had the more need of Mark's companionship.

With hindsight, the years at Dartington were of thought and exchange of thought and friendships, a time of enrichment and expansion for which I am deeply grateful. As a potter, trained in the Orient, they provided a counterbalance of European birthright, in form, pattern, colour and texture. I feel I have not the wisdom to answer the basic Dartington problem. For me personally, the years there provided a pause in my life, between East and West, during which I had the opportunity to assess its basic values.

Dartington was and is a brave effort, worth all the cost, but I saw the need for an overall and inclusive vision of the meaning of life, for mankind as a whole, a touchstone, a meeting point between East and West, a creative hope for the future. This is my faith, as a man and as a potter.

Chapter 14

THE JOURNEY EAST, 1934-1935

When Mark and I left England in the spring of 1934 I was exceedingly sad at the parting and stood alone in the stern of the cross-Channel boat saying farewell. I did a drawing of the Seven Sisters, those receding white cliffs of Dover and the veering seagulls, full of the growing sense of separation. We sailed via Aden but did not land there. The next port of call I remember vividly was Colombo. I cannot recall what Mark did, but we had agreed to separate, partly because I wanted to be more alone; time in which to think. All my thoughts were back in England and fraught with tension and sadness.

I had been put in touch with a parson who lived, I should think, five miles along the coast towards Mount Lavinia. I must have telephoned to him and he replied that a death had taken place of a noted Ceylonese, whose funeral he must attend that day. Would I care to go to a Buddhist funeral taking place at the back of the public gardens? Somehow this fitted with my mood, and I said 'Yes' and went to his house in a *gari* (horse-carriage). After that we joined Indian people walking through flowering bushes and trees with tropical scents. We came to an open grassy space where a crowd with many priests robed in varying tints of yellow stood awaiting the ceremony. Some distance behind them, the body of the dead man lay upon a ten-foot pyre of wood. Speeches were made about the life of the deceased. The English parson was able to translate some of what was being said: eulogies and reminiscences of the good acts of his life; prayers for the future of his soul. Quite a few of those close to him spoke. The scented time

passed by. Then the pyre was lit: flame and smoke blew across the colouring of the tropical sunset. Flame against flame. A strange passing of a man from this to another world.

My next memory is of parting company with that Christian missionary and instead of returning as I had come, I made my way down to the beach, where coconut palms leaned towards the ocean high above the thatched roofs of fishermen's huts. The sand was firm as I tramped all the way back towards Colombo and our steamer at anchor. Solemn and sad – halfway between East and West. The colour struck me in the street among the native bungalows, combinations differing from ours. I remember black, puce, and vermilion. The plus and negative of colour was unlike that of the West, exciting, pungent. When I got back to Mark I found that he too, as a fellow artist, had noticed this same phenomenon. That night we sailed for Hong Kong, the place of my birth.

Hong Kong harbour is formed by the island of Victoria, less than a mile from the mainland of Kowloon. The rather difficult airstrip lies like a tongue in the middle. Ships enter and depart through narrows at each end; it is a harbour well protected against all storms except typhoons, which are fearsome! I remember once when I was a child, my father was shooting snipe with friends on the mainland and a typhoon approached. It was not until the third day that a telegram sent from him – 'Safe' – was delivered to my stepmother in our house on the peak top by men roped and coming from the post office on all fours through the wind. A neighbour had his whole roof blown away like a kite.

Mark and I left our ship and put up at a roomy Chinese hotel in Kowloon. This gave us quick access to the harbour and to Chinese impressions, mainly pictorial, during the all too brief week which followed. It was also cheaper than in the city of Victoria opposite. We drew constantly. He was fascinated by the vertical signboards outside every shop – characters, black on white, red on gold; I was absorbed by the beauty of the hand-made, brown-sailed Chinese junks tacking across the land-locked harbour amongst the varied ships of the world. We sauntered, or took a sampan in the harbour from which I drew the shapes of those unique Chinese boats against the peaks of the islands of Hong Kong – in my heart a lifetime's memories of childhood. (See plates 5a and 12a.)

Hong Kong is very beautiful. In the street we were both struck by

two things; first, the quiet, orderly behaviour of the busy crowds, secondly, the Chinese clothes for young women – slit-sided skirts, close, silken trousers, trim Oriental collars and hair styles. A new style, but still Chinese. Clearly they preserve a creative ability to stylize – more than may be found in Japan. This may seem strange to a Western mind, but in fact, under the impact of mechanized Occidental life, few races retain this inner power. Behind China lies a continuity of at least 4,000 years – spirit and matter.

One day we decided to go up and look at my father's house and the Matilda hospital, named after my great-aunt Matilda Sharp, and look down on the most beautiful harbour I have ever seen. I presumed Mark would come with me on the funicular railway 1,200 feet up the hills, but not he! 'Then', said I, 'we can walk slowly together up the zig-zag road.'

'No', said Mark, 'I have no head for heights, we'll take a cab.' We drove twelve miles circuitously before arriving at the top terminal of the railway, then he told the driver to wait (three hours) saying to me, 'We might not be able to phone for another', although there was a hotel just behind us.

Mark had certain inhibitions; I don't know why – it was his temperament. He told me that in New York he would sometimes walk three times or more round a block before he could get himself to enter his hotel. But I knew from experience that when he did he was treated as an expensive man of the world by the staff, who immediately began to swarm round, offering suit-pressing, smooth shaves or breakfast in bed! Something in him attracted attention.

It was out of his experiences during that week in Hong Kong that Mark Tobey drew his inspiration for the 'white writing' style of painting which gave him his first international reputation as a creative American artist. He was not to be caught in a net however, and first changed his extraction from Chinese calligraphy to 'black and white writing', later developing a kind of brush-work weaving over big pictures, using a small sable brush, in which all the form and colour of his past is included. For any verbal description only a musical term such as symphony is possibly adequate.

From Hong Kong we took another ship for Japan via Shanghai. It anchored in the great roadstead of the Yangtze, amongst other steamers and larger, heavier junks. I noticed one being manoeuvered

down the river tide by a huge fish-tail stern oar manned by four people all with their hands on the long, pivoted handle. Their figures bent forward across the flat stern deck and then pulled right back in an arc so that the back of the boy's head at the end almost touched the deck in a wonderful human rhythmic movement.

Early in the voyage eastward we had discussed the issue of whether Mark should get off the boat at Shanghai to visit and stay with his old artist friend, Teng Kwei, whilst I went on to meet Japanese friends and prepare a programme for him. As we got closer to Shanghai, the decision became more urgent, but Mark could not make up his mind and was still uncertain when he left the ship and went off with this friend. The matter settled itself when he stayed ashore with him, throwing streamers at our ship as we slowly steamed away from the quayside. We were both torn apart! The reason I had advised delay was because I visualized him in Japanese rooms, cross-legged, unable to understand a word of what was being said. After fourteen years' absence I questioned my ability to translate the fast flow of talk for him whilst trying to understand it myself.

Japan Again

As my ship from Shanghai was edging into the quayside at Kobe I scanned the crowd looking for a familiar face – not one! My heart sank – I felt sure that Yanagi at least would be there. Something was passed by hand to the ship's purser, and he brought it to me. The press and others came in with a rush as well as my friends and we went into a quiet corner. I opened the parcel and with a shock realized that it was my biography in Japanese by the psychiatrist Dr. Ryusaburo Shikiba. Overcome, I could not speak for a few moments. I almost felt as if I should be dead.

The next few days were spent in Osaka, where we received a great welcome by a large group of craftsmen at a glorious Japanese meal on the uncomfortable floor. Talk, talk, talk. I congratulated myself that Mark Tobey was not with me, for the reasons already stated. Another meeting of old friends in Kyoto and then four hundred miles north by main line to Tokyo. Here I lived alone in a house Yanagi had persuaded a friend to lend me near his own. This was furnished in foreign style.

Most meals I had with the Yanagis but I lived without the feeling of overcrowding or disturbing them.

I recall one evening wanting to get an impression of a newer Tokyo and I went to its 'Piccadilly', the Ginza, taking with me Yanagi's youngest son of about nine years old, with his father's consent. I wanted to give him an English tea, very much as I might have done in London itself. I found a shop serviced by waitresses dressed as in England and we ordered cakes and tea. At the next table to ours I observed a strange phenomenon: a well dressed Japanese mother in a kimono etc. and two daughters, one of whom also was dressed in the then fashionable Japanese style and another young woman, presumably her sister, dressed entirely in Western costume but with the behaviour of a prostitute. The fourth member of the party was a student of the Imperial University; this I noticed from the shape of his cap. I talked to Yanagi's boy about himself and all sorts of things he might be interested in, but I was filled with curiosity by the ménage close by.

We returned home by tram and after supper at the Yanagis' were joined by some Japanese artist friends and, puzzled, I described what we had seen in the afternoon and asked for an explanation. They were much amused by my suppositions and assured me that I was quite mistaken and that the young woman was merely trying to behave like a young English lady imitating the style from American films. Expounding this, they said, 'The cinema is now the educator of young Japan – more than all the schools and universities put together', I thought to myself, 'Is this happening all over the world, and is Hollywood responsible?' Blunder on blunder!

My visit to Mashiko, seventy miles north of Tokyo, is taken from my diary at that time.

'May 3rd 1934. On Thursday afternoon Hamada was waiting for me at Utsunomiya station and we drove off to call on the governor of the province and other officials: tea – reporters – photographs. The Mashiko town doctor came with Hamada and two of his boys – Ryu (dragon), the eldest, and Atchan (Atsuya), aged three, who enjoyed himself hugely, spilling tea and crumbs all over the place – Hamada managing him all the time, leisurely and with perfect good humour.

'Friday and Saturday have been spent in and out amongst the potters

and their lovely kilns getting my bearings generally. Again and again I have wished all my students and pottery-workers were with me to have their eyes opened. Half a dozen workers fill a kiln about ten times the size of our large one at St. Ives, twice a month. No mechanics.

'Yesterday we went to the pottery experimental school to watch the last genuine traditional painter of Mashiko patterns, Masu Minagawa. By request I gave a serious talk . . .

'Next morning: we had a concert last night with my English gramophone records – the Hamadas, their children, maids, father, uncle and pupil. They enjoyed especially the solemn Gregorian chants and the negro spirituals, they gave themselves to the music. During the records, fat little Atchan did a curious solemn little dance impromptu, then came and planted himself in my lap. I really felt taken into the family – it is a happy one.

'The house and landscape are a dream, but of this earth – earthy. Old English pots and furniture look so perfectly right in their substantial Japanese farmer background. (See plate 13a.) Heavily thatched roof, the house construction of *keyaki* wood (to Japan what oak is to us), with the inside exposed right up to the thatch – polished daily within reach; delicate paper and wood sliding doors. The flooring, as in all Japan, covered with four-inch compressed straw and taut matting, and with much more space than the town houses. Everything is very open and free including terrifically hot baths – the lavatories too are very unhidden but there is never a hint of coarseness or impropriety. The Japanese are a lesson to all people in many kinds of refinement and real politeness.

'Here and there among little pine-clad hills a cloud of smoke rises where a kiln is being fired. A forty-foot pole on the lawn outside flies lazy cotton carp twenty-five feet long, in bright colours, to celebrate Boys' Day, May 5th – one fish for each boy – the eldest, the biggest fish. In the paddy-fields below young green rice plants are being transplanted by women knee-deep in brown slush, moving rhythmically to old folk-songs taken up by each bending figure in turn, in strange wavering cadences; their indigo-blue clothes touched with white spots and a red band – conical straw hats repeat the volcanic hill lines. Lovely plumes of tall bamboos and sounds of busy early rising people and innumerable frogs.

'Several visitors included old Masu Minagawa, with whom we had

a most interesting conversation; I dare say the only such meeting and exchange which has ever taken place. We sat down together on the clean mats each with a little table, ink, water, brushes and paper supplemented in my case with bamboo reed pens, freshly cut. Minagawa had cards with stencilled red outlines of her familiar Mashiko tea-pots and at my suggestion, drew the patterns of an era elsewhere lost – lightly and with amazing swiftness and impersonal beauty of traditional touch. Thin black lines first, a pause for them to dry whilst I filled another tea-pot outline with extemporized pattern, then she took a fat brush, tipped it with dark Chinese ink – fresh ground – tried it on a rough piece of paper, after which she dabbed two or three graduated light tones over her former bamboo, plum or 'sansui' (mountain and water) outlines. I added my dabs using a similar brush, but noticed that her patterns were conceived flat whereas my brush-work inevitably tended to add form and depth. I copied her once or twice, but, despite her praise, failed to get that beautiful, nonchalant, almost accidental calligraphy, the quality of which she was almost unconscious of, and for which she has acquired fame, rather to the disgust of local potters who say, "Her nose is growing upwards!" '

In the Province of Tochigi at that time there were about sixty kilns in a town of less than 10,000 people. Pottery production in Mashiko itself is relatively young, starting sometime in the first half of the nineteenth century, but the traditions are far older, having worked their way up the length of Japan from as far away as Karatsu in the south.

Hamada's house lay half a mile beyond the town on a slope of bamboo and pine-clad hills which bent to the flat paddy-fields and provided fuel for the kilns. I was introduced to Hamada's father – now old and retired. Hamada's delightful wife, Kazue, reminded me of a gentle seventh-century sculpture of the Buddhist Boddhisattva of Compassion. Hamada's family were *Edo-ko* (children of the capital). They were not farmers as I had previously supposed, but makers of quality cakes for high-class society. I do not know what Hamada's father did when he was young, but at the time of the great earthquake in 1923 he owned a small factory making inks on the Sumida riverside in Tokyo. In his retirement, living with his son at Mashiko, he occupied much of his time laboriously writing out and illustrating by hand a great 'pilgrim's progress' chart – the broad and narrow path of Budd-

hist vices and virtues – reminiscent of Bunyan in England. Certainly the path he followed was governed by *Tariki* (the Other Power), in contrast to the *Jiriki* (Self-Power) of Zen. In other words, he was a man of pious act and a sincere Buddhist. In warm weather he carried and distributed these charts wherever he went, as a penniless pilgrim, preaching the law of Buddha. His delight lay in looking after caged birds, of which I made many drawings.

On this my first visit to Mashiko, a wheel was placed in one of the two rooms which formed the two sides of the thatched long gateway. I slept in the other room. A young thrower from the village came when required and threw the large pieces under my direction. The clay itself was, as Hamada pointed out, not specially good and not very plastic. The local technique for dealing with large jars was beyond my skill, so I made the smaller pieces. During my stay I made a considerable number of pots and joined in the daily life. The descent from table-level to floor-level is always uncomfortable for a European, even if he is pliant, but I was young. The food was easy, especially in that household where the mistress was so excellent a cook; with the freedom of the Japanese bath I was already well acquainted. Footgear, of course, also presented problems – no shoe ever enters a Japanese house. Unlike the Chinese, traditionally the Japanese did not wear boots. Out of doors they wore wooden clogs – still more unsuitable for the inside of their scrupulously clean houses than even the best leather boots or shoes.

The first firing of my pots was shared with Hamada. The pots fired well and on the day of opening about a hundred people came including a bus-load of businessmen from Tokyo and, of more interest, the governor of the prefecture with some of his party. This surprised me because in England an opening day was the one occasion on which we hoped to be left to ourselves. However everyone behaved with remarkable tact and left us to unpack the hot chambers without getting in our way or constantly asking distracting questions. It was hard, hot work, and I had to back on all fours into the low chambers. For hours the nice governor and the crowd stood well away on the slope of the land watching the pots emerge one by one and listening to our remarks almost in silence. Occasionally one or another would quietly take a worker aside and give him his card to put in a certain pot indicating that he would like to have it reserved if possible; there was no mention

of price. Photos were taken by the press and sent with reports attached to the legs of carrier pigeons. Off they flew to Tokyo in time for publication the next morning. (See plate 8b.)

Behind the scenes Mrs. Hamada had sent off for food and assistance. Most of the people were fed seated on matting on the lawn. After eating, the governor stood up and asked Hamada and myself what we considered to be our best pots and to have them put out for all to see. I looked at Hamada: he looked at me and as far as I can recall we both said one to the other, 'You choose mine and let me choose yours.'

The governor stood still, then said, 'Today I have seen something I never hoped for, a Japanese and a Westerner on such terms of friendship and trust.' A murmur ran round the crowd.

It was about this time that Hamada reminded me of a very strange man of whom he had often spoken at St. Ives in the old days. This Mr. X had been trained from youth in the manner formerly employed for traditional spies – highly skilled men who carried secret messages or obtained information for their feudal lords. Hamada had heard that he was in Tokyo and might be willing to meet me with my friends in the room which I had come to regard as my headquarters in Tokyo. My curiosity having been re-aroused I said, 'By all means let us try.' Mr. X agreed to come to my house and on a fine afternoon talked to some fifteen of us for two hours. No other foreigner was present and my guests were mostly literary men. Mr. X said that he began his training at the age of six when he was selected from other child candidates. There were two tests; one was a silent crossing of a room covered with crumpled paper, the other was to keep his head under water for two minutes.

Mr. X was a short, rather tubby man, but when after talking for a quarter of an hour or so describing his further training, he threw off his kimono and stripped to his drawers, we could see a very neat, well developed body – when he drew in and extended his abdominal muscles the range was quite unusual. The first thing he did was to light a cigarette, put the butt end into one nostril and with a finger on the other, inhale deeply. Then he drank from a glass of water and only subsequently exhaled. This slight beginning rather astonished some of us, even though Hamada had told me long ago that this man had cultivated quite extraordinary abilities, such as climbing walls at right angles

without foot- or hand-holds, by using arm- and leg-pressure against each surface.

The next thing he did was to take some women's Victorian six-inch-long hat-pins with black or white glass knobs at one end. After wiping them with alcohol he opened his mouth wide and slowly pushed first one right through his cheek from the inside in one direction and then another in the opposite direction. It was at this point I began to take a sixteen-millimetre film, with his permission, in the bright sunlight of my large room. Mr. X even went on talking with these hat-pins protruding and exhibited no signs of either pain or bleeding. Then he calmly withdrew these weapons slowly, thrust forth his tongue and holding the end with one hand, pierced a third hat-pin through it, the point emerging on top. Thus he went on speaking, then after withdrawing it he requested another tumbler, which I provided. He examined it, then put it well into his open mouth and bit out a piece at least two by one inch which he proceeded to crunch between his jaws for a minute or so, then he gulped down a mouthful or two of water from that first glass, and went on talking normally. This was astounding! There he stood alone amongst us, and I have the visible record as well as the memory of hearing further crunching of small remnants of glass whilst he went on lecturing.

Anyone might ask, 'What was the use of such revolting tricks?' I assure them there was no trickery, and the use of them saves life or puts off suspicion when in a tight corner. Between the age of six and twenty this man had been trained to jump six feet in height and over twenty feet in length. He could run or swim twenty miles; he could eat poison and suffer no harm, get drunk on water and remain sober after a couple of pints of spirits – so my friends told me. The knowledge of dogs' language enabled him to call them at any time and encourage them to fight amongst themselves.

What I saw him do next was to gather in one hand the rings from five- to ten-pound steelyard weights totalling about seventy pounds and repeatedly throw them at arm's length in the air and crash them on his chest. There was no mark nor sign of pain. His explanation was that though the training was part physical it was mainly mind over matter. One may well ask, 'What is its limit?'

He talked volubly and answered questions freely. To wind up he asked me if I had a sharp knife. I thought for a moment and replied that

a few days before I had bought a very sharp pruning knife, which I took out of its sheath. This he examined, said it might do, bared his arm and giving a piercing cry, made as if to cut himself by a thrust, but observing carefully, I saw there was a gap between blade and arm of four inches. Nevertheless, after each cry and criss-cross cut on his wrist a mark of blood clotting showed under the skin! Then, picking up a newspaper, he rolled it, put one end to his mouth, blew down and produced sounds very much like the well-known *shakuhachi* flute — the result would have deceived somebody in an adjoining room. I questioned the object in doing such things. His answer was that in a crowd out of doors he could call dogs to fight to distract attention and, in the other case, pretending to be amusing yourself in a restaurant with music and wine would also disarm suspicion.

Hamada had two particular friends at Mashiko — one was a young man called Sakuma, whose father was an established potter with his own kiln, but who for a long time disapproved of his son To-chan making acquaintance with Hamada when he first arrived. The people of Tochigi province were stand-offish and afraid of any innovation; for years they regarded Hamada's influence as a danger. Nevertheless the friendship between To-chan and Hamada developed. It would perhaps be more accurate to say he became Hamada's pupil. I got to know him quite well — despite his strong local dialect. I recall once when I saw some religious figures modelled by him, asking Hamada what one of them signified, with arms and hands clutching his chest. He said To-chan explained that the hands were on the way to prayer. (The position of joined hands was very much the same as with Christian believers.)

The other friend was Dr. Suzuki, the head of a small local town hospital. This good doctor had a lovely sense of humour and delighted in sharing the incidents of provincial life with someone of wider travel who enjoyed oddities of local behaviour. One day his short, fat figure came running along the narrow paths across the paddy fields in a great state of excitement, buttoning up his braces as he ran. He told Hamada that his miserly neighbour farmer had summoned him in great pain. Upon enquiry this farmer said that he had on the way home the day before, observed what he believed to be strap seaweed — much eaten in Japan — which had fallen off a cart, had picked it up, taken it home and instructed his maid to wash it, cut it up and serve it raw for supper.

With great difficulty the maid did this – with greater difficulty the farmer tried to chew and swallow some of it. It turned out that it was not seaweed at all, but the inner tyre of some car! What the doctor did is left to the imagination. The farmer recovered, however.

All this time I had heard nothing from Mark Tobey, but at last came a letter announcing his approach, written from a Zen monastery where he was staying somewhere in southern Japan, practising meditation. By now plans had been made, chiefly by Yanagi, involving many other people in different places, so it was only possible to fit in meetings with Mark in Tokyo and Mashiko. He must have seen the exhibition at the Matsuzakaya Department Store in Tokyo of my pots, many of which were English slipware, made at the request of my Japanese friends and for which they have great affection. When Mark and I met, we talked endlessly, and I have a pictorial record on film of him watching Minagawa decorating pots. It became clear to both of us however that the life I was living in Japan was not suitable for his needs – certainly not at the tempo of life imposed – so, after a week or two together, he decided to go home to America.

After the exhibition, the five of us set off to Kuriyama, the remote mountain village behind Nikko – the only one in all Japan that had no electricity. We left Mashiko together in a car, passing the area called Oya where a building stone is quarried deep in the mountainside and taken to Tokyo. The Oya stone is also used powdered at Mashiko to make *kaki*, the basic red-brown iron glaze. We were interested in this stone being increasingly used for architecture – quite unusual in Japan. Suddenly down an avenue we saw a building made of it and called the driver to stop. On examination we discussed the possibility of it being transported by cart or lorry and used for the construction of the Mingei-kan (the folk-craft museum) being planned by Yanagi in Tokyo. (In due course this was actually done.) We went on by car as far as possible and then continued on foot until nightfall. Half-way up the ascent we found a wayside hotel, where we spent the night.

The next day we climbed over the pass where 900 years previously some of the Heike Clan escaped from the forces of the conquering Genji, and followed a stream down to that unique village, Kuriyama (which means Chestnut Mountain). The buildings were of the Tokugawa era – old and thatched, sometimes of three stories,

on both sides of the clear mountain stream. Telegrams had been sent ahead by the governor of the Province to the proprietor of the old-fashioned inn who awaited us sitting beside his fireplace, smoking a little Japanese pipe. As soon as he saw us he leapt to his feet crying to his sons to go and catch fish for our supper with cast nets. They passed us one by one with the nets slung over their shoulders, returning within the hour with fine mountain-trout. These were grilled over the charcoal fire whilst we sat around and listened to an ancient speech elsewhere unheard – echoes of courtiers long dead. How good the air was at that altitude!

At dusk we were led to a natural hot spring at the very edge of the stream. As we sat up to our necks in that water under the thatched roof with its four wooden pillars and no walls, I remember how we dipped our hands over the side of the stone bath into the icy water of that clear cold stream. That night we slept soundly. The next day we were provided with horses for our precipitous return journey downhill, but one bullock was chosen to carry my larger size. It had no harness beyond a rope for its nose and with a borrowed, seven-pound, Bell and Howell sixteen-millimetre cine camera under one arm I held that rope hopefully as we descended a steep mountain pass, lurch after lurch; when I really felt myself about to fall I pressed one or the other foot against a horn of the animal. Nothing untoward happened, and we finally got back to level land and paddy-fields again.

On July 19th 1934, having made a thousand or more pots at Mashiko, I took the train to Kyoto to work at Kawai's, in what is known by foreigners as 'Tea-Pot Alley'. There I lived as one of the family. I made quite a number of pieces, mostly in porcelain, many of them pressed from beautiful moulds made for me by his assistants. By night I saw various Kyoto friends – in their homes, in restaurants and sometimes at Kawai's house. I was made an honorary member of a fruit-testing society, supported partly by doctors, at which the standard of the fruit was appraised. This was part of a national effort to improve the quality of new varieties of fruit. Modern Japan had realized that its peaches, for example, although they looked beautiful, were considered – at least by foreigners – to taste like wet blankets rather than the fruit. Since that time some of the best peaches in the world have resulted from a cross between Chinese and Japanese stocks; similarly with other fruit, such as apples, pears and grapes. There is, however, at least one

kind of Japanese fruit which by its indigenous nature is the best – the persimmon.

At breakfast one morning Kawai announced that a certain doctor was coming to supper. His daughter Ryoko danced with joy and said, 'Do you think he will bring his needle?' At this I pricked up my ears because I had heard of acupuncture.

Kawai said, 'I don't know, you can ask him.'

So after supper that evening Ryoko, who was about twelve years old, came in and gaily enquired of the doctor, 'Have you brought your needle?'

Eyebrows up, the doctor felt in his pocket, smiled at her and said, 'Yes I have.'

'Will you treat us?' she asked. I had a premonition. He asked Kawai if he would like a treatment. Kawai nodded and slipped back his kimono baring his neck, while the doctor laid out his needles, small hammer, cotton-wool, bamboo ring, and a bottle of alcohol. He disinfected the area round the backbone above the shoulder-blades, then pressed the little ring of bamboo a couple of inches long against the flesh between the vertebrae, placed in it the needle, the butt end of which was embedded in an inch of cane. This he tapped lightly with the hammer, which he then put down and slowly pushed the needle in a couple of inches and then again slowly backwards and forwards several times. Kawai did not flinch or show any expression on his face.

I felt myself being trapped. The doctor made six punctures on one side of the spine between the projections of the vertebrae and six down the other side. Kawai thanked him. The same operation was undergone by his wife, followed by Ryoko, who enjoyed it. Then I was politely asked whether I would accept the same treatment. Cornered, I agreed. The sensation was not exactly pain until about the tenth puncture. I found it easy to keep my countenance and then it became rather like an electric shock as the needle went back and forth. I was thankful when it was over. The next day I felt no effect whatsoever, but then I had had no need of any treatment! Many Japanese evidently enjoy such minor torture, but there is no doubt, however, that extraordinary things such as major operations are now done by aid of this very ancient Chinese procedure, and with no pain.

The sloping yard at the back of the house belonged to Kawai, and upon it stood his steep 'climbing kiln'. The best part of the first two of

the eight chambers he kept for his own work. The rest were hired out approximately by the cubic foot to a group of other local potters, each of whom had a locked wooden shed containing their own pots and saggars, for which a rental was paid according to the value of the anticipated resulting firing. This sharing of large kilns was an old custom of Kyoto potters. Certain secrecy was observed and when the kilns were cool enough to be unpacked, the resulting wares were covered with cloths, partly to enable them to be removed in carriers safely and partly to give as little information as possible to their neighbours. They were carried in two large, flat baskets hanging from a shoulder-pole balancing each other. The men who did the wood-cutting and actual stoking fired a group of such kilns for a small neighbourhood of potters and were certainly expert at their job, knowing the idiosyncracies of each of the kilns they looked after. It was to be noted that the slope of the chambers was steeper than in most parts of Japan because a greater proportion of the wares were porcelain, and this procedure enabled the higher and reduced temperatures necessary to be reached more quickly and readily thereby. Kawai's kilns, now that he has passed on, are preserved as part of the museum into which his establishment has been made; they are beautifully kept and well worthy of a visit.

Despite the fact that I seldom liked his pots, I did admire the man. It was impossible to hide my reservations about his work, but he never allowed this to interfere with our long friendship, although I could see that it hurt his loyal wife. Many years later, when he was dying and no longer able to speak, I sat by his bedside for a quarter of an hour holding his hand; finally I stood up and raised mine in farewell; he lifted both of his as I walked out of the hospital room in silence.

Matsue

On the north-west coast of the main island of Japan, Matsue straddles the entrance of the twenty-mile or so long salt-water Lake Shinji. This feudal town is where Lafcadio Hearn wrote, giving us a first impression of Japanese, life and where he settled down, married the daughter of a samurai, took Japanese nationality and observed life from within. This he recorded in fine writing and with sympathy.

Undoubtedly he gave the pupils he taught their first love for English prose and poetry. Although half a century after his death, when I visited Hearn's middle-class Japanese house, I found it preserved as he left it. Next door was a funny little museum in a sort of nondescript foreign style containing his scant furniture – his desk, a chair and a most curious row of little metal thimble-sized Japanese tobacco pipes. Forty thousand visitors still come in memory of that lonely writer every year. A launch named 'Herrun' in memory of Hearn was moored opposite my hotel. My friends took me in it for a trip.

Matsue, the capital of the province of Shimane was also the home of the Matsudaira clan. Centuries ago the daimyo Fumai Matsudaira owned the most famous Tea-bowl in all Japan – the Kizaemon O Edo Tea-bowl. (My book of Yanagi's translated writings, *The Unknown Craftsman*, published by Kodansha International, Tokyo, contains an illustrated chapter on this Tea-bowl.)

The Tea Ceremony is still practised, and I remember one occasion when I received a visit from a little old gentleman who had shown me over his old-fashioned *sake* brewery some time earlier. He said he hoped we might enjoy a little ceremony and converse together. I was surprised but delighted, and told my room-maid to prepare all that was needed. The maid brought in his *furushiki* (a square of fine cloth for wrapping and carrying) containing a travelling ceremonial Tea-set. A bowl smaller than that usually employed, was easier and safer to carry about. I did enjoy this quiet, almost silent, drinking of Tea, as I looked out over the long expanses of that lake watching the fishermen.

On wet days with my *shoji* (paper door) open I could see the lonely fishermen, each with a peculiar net hinged on the stern of his anchored boat, which he raised and emptied again at intervals. (See Fig. 10.) They huddled for hours under grass raincoats, waiting. How strange the endurance and patience of fishermen everywhere, escaping to reverie at once removed from daily life. I enjoyed the whitebait, nevertheless.

I recollect an 'All Souls' commemoration night when, after supper with my friends, a couple of boat loads of us put off into the smooth dark waters of Lake Shinji and wrote poems or painted messages to the dead on Japanese lanterns. These lanterns acted as sails on the model boats, one for each of us. We launched our little fleet on the still waters and watched it drift further and further into the darkness.

Whilst staying at the Minami Hotel I asked the proprietor if there was, in the town, an old-fashioned Japanese garment-vendor dealing in silk, linen or cotton, as in some cities I had visited. Also if there was a good mounter of *kakemono* (hanging scrolls). He replied that there were both and I asked him first to call the latter. When he arrived I showed him some of my drawings, especially several of junks done in Hong Kong, and asked him if he would be willing to consult with me about mounting my drawings for exhibition in the traditional manner, making border proportions, allowances etc. for the difference of eye-level between Japanese and foreign rooms. He readily agreed and also offered to help me to select suitable old materials. We had a further consultation together with the old garment-seller at which I agreed upon perhaps ten pieces of fabric in natural dyes, or in indigo, at no more than two shillings each. Then the mounter and I set to work determining materials, colour, and proportions suitable for each drawing.

I have always found it delightful to work with Japanese craftsmen in this wide experimental field between two cultures. Both parties have to be prepared for a give-and-take, dependent upon mutual intuition more than strict acceptance of old traditions. To me the Japanese were always ready for experiment and highly sensitive. Frequently intuitive solutions emerged simultaneously from both sides. I enjoyed these adventures enormously. Yanagi and I both employed Japanese proportions, colours and textures not only of woven materials, but also of good hand-made paper. To some extent I followed his proportions of space above and below the painting or drawing. It should be well noted the Japanese allow far more blank areas above than below the painting or drawing, whereas we incline to greater space below. Who would have thought that the eye-level when sitting on the floor would make so great a difference? Later at the Fujina pottery I made and decorated pottery roller ends for such *kakemono* scrolls.

Amongst the craftsmen in this vicinity was a paper-maker called Eishiro Abe. In his village near Matsue the clean water was particularly suitable for the making of Japanese paper, and he was the guiding spirit of his village craft. Hand-made paper made from mulberry-bark is still produced – lovely absorbent paper which I have used most of my life for drawing. Most Europeans imagine Oriental papers as being made of rice; such is not the case, however, although the Chinese do make

a wafer-like material on which a kind of popular painting can be done.

The two- to three-inch diameter mulberry stems are ringed with a knife, then cut vertically, and the bark peeled off in strips. These are soaked in clean running water until the skin separates. The bark itself is then pounded and boiled in large iron baths, to which is added a slimy siccative which is obtained from the root of another plant. The bark dissolves into a fibrous, thick soup, this is then cooled and poured into a rectangular wooden bath of suitable size for the required sheets of paper. As I recall the depth of the liquid was only a few inches. Hanging above this bath is a tray not more than two inches deep, which is dipped into the soupy liquid and half filled. The bottom of the half-filled suspended tray is covered with fine slivers of bamboo, which act as a sieve when the tray is shaken. A thin liquid pours down into the bath leaving just a wet skin of fibre clinging to the bamboo sieve. The swinging line at each end allows the sieve tray to be accurately reversed, each load of wet fibre being released on a pile of perhaps a hundred layers. Each pile is then covered with boards and put under pressure to get rid of surplus liquid. The layers are just firm enough to be peeled off and lightly stretched either upon large wooden boards or on heated iron plates which dry the sheets quickly. The boards may often be seen leaning against the local houses, with paper drying in the winter sun; the grain of the wood makes a slight but beautiful natural pattern on one side of the paper.

These hand-methods need time and thought but they yield quality, engage the heart and give joy both to maker and user. Yanagi and his Mingei Society saw the human need for keeping such villages alive and provided an outlet for sales of this craft. Laborious hand-methods have almost been entirely abandoned in the Western world, but a craftsman is not worth his salt if he makes no effort to preserve this natural joy in labour.

I had first crossed Japan in order to work at the old Fujina Pottery on a lovely promontory some three miles down the southern coast of Lake Shinji. It is run by the Funaki family of whom I have known three generations. Both Hamada and Yanagi thought I could help them with the techniques of lead-glazed English earthenware. The use of lead as a flux was part of a local tradition and hardly used elsewhere in Japan. In fact after he returned in 1923, Hamada had introduced some of our St. Ives methods which he, Michael Cardew and I rescued before the

eighteenth- to nineteenth-century English tradition was entirely los
Here then I was given a warm welcome.

The Funaki property extended to the extreme tip of the land, when
on my first visit I observed two slender rods of young bamboo frond
crossing and bowing to each other across the open spaces of the broa
waters, their further side running away in diminishing hills to a lo:
distance. I liked the theme and did some drawings.

At the workshop, several men put aside their normal duties to suppl
me with clay, copy my shapes and generally help assiduously. Ever
morning one young potter arrived before eight o'clock, havin;
bicycled twenty miles from the other end of the lake where a sma.
hamlet of Buddhist farmers – the Shussai Brotherhood – had taken uj
pottery in their spare hours. I noted the all-out concentration of thi
young man.

Michitada Funaki became my friend. His rather high-fired slip
ware had a flavour of its own, part English, yes, but underneatl
Japanese. I have been to Matsue at least four times over the years an
on the last but one Michitada was ailing. When we parted we botl
knew it was for the last time and he asked me to keep an eye on his soı
Kenji who would take his place, which I promised to do. Kenji eventu
ally came to England for a year and worked well and happily with m
son David in his pottery at Bovey Tracey in Devon, concentratin;
upon mediaeval lead-glazed earthenware.

Here I want to return to the Shussai Brotherhood and the connectioı
between Yanagi, Kenji and myself. Before Yanagi died in 1961
he begged me to go and re-visit this group of humble Buddhist potters
as he feared that faith in Amida might not solve their problem iı
making true and beautiful pots. Knowing his thoughts as I now d(
better, after his death, he felt that since they were not traditional potteı
they could not be expected to make a marriage between two cultura
roots without the assistance of an artist-craftsman. Yanagi stated quit(
clearly that the real function of artist-craftsmen at our stage of evolu-
tion was to act as pilots because, being educated and informed, sucl
people can make use of the more intellectual faculties of the mind.

Years earlier I had visited the hamlet of these pious men and wa:
moved by the communal effect of their faith in Amida (Buddha)
When in 1961 I went once again, I experienced the same warm greeting
and a meal on the floor with them, surrounded by their selected pots oı

shelves. They plunged forthwith into the problems concerning which they sought my help, approximately in this way: 'Leach-sensei, we have lived hitherto in the compassionate Faith of Amida and have been helped except in the ability to make good pots; can you advise us?'

This was the very question I had feared because I did not know the answer to it. 'Surely,' the spokesman went on, 'you must have some idea how "Other Power" and individual artistry can work together.' Hamada had already been asked – they were distressed and at a loss because his reply was similar to mine. I said it seemed to me that leadership was called for.

'But,' he answered, 'none of us are educated leaders.'

'Could not one of you be elected as a sort of Abbot?' I asked.

'No, no, not one of us has any such authority.'

Quilts were laid out and we all slept on the mat floor. Early next morning I awoke to the sound of their chanting Buddhist sutras. I wished they had asked me to join them although I cannot sing. We breakfasted together and they begged me to bring my sketch-book and criticize their pots as they worked. This I did. Many of the pots were more or less English types of handled jugs. I showed how the handles should be 'pulled' and attached; how the lips should be made to pour etc. etc.

In the midst of these operations Kenji Funaki arrived on his bicycle, jumped on a spare potter's wheel and asked me to criticize his pots in the same way. A fair-sized English pitcher was nearly finished when I came to his wheel. The Brotherhood left their work to listen to our conversation. I looked at his pot as a whole, then said, 'It rises well to the good round belly and shoulder, but then the change from convex to concave of the neck is uncertain; one does not help the other as it should in oppositeness; the vertical neck comes to no rim, or lip; try capping that last movement with a flat conclusive rim.'

As Kenji did these two corrections the whole group unanimously exclaimed with excitement, 'It has come to life!' – before I had even perceived it myself. I stepped back in wonder . . . another Power was at work; not mine; nor Kenji's skill; not even the clay or good wheel, but the absence of any self-assertive ego to hinder the birth of a congregate good pot made for its own sake. My only contribution was what I had learned from mediaeval English traditions of form.

The problem remained who could help them in the future. I made the

suggestion that if Kenji Funaki could spare them even one day a month something might result. The questions raised are not only important in Japan and the Orient, but also to potters the world over. On the one hand the death of all that vast inheritance of traditional communally produced hand-work; on the other the birth of so small an output of beauty either from artist-craftsmen, or, for that matter, from industry. Am I then writing as a pessimist? No. I believe that eventually mankind will discover how to release creative pleasure in work once again. Not for a moment do I think this can be brought about quickly by any slick magic. The advances of science have been so fast that the young are suddenly faced with the whole world's history and knowledge to digest and assimilate. Yet I write as an optimist.

FIG. 10. 'On the edge of Lake Shinji' in letter of 1935

Southern Japan

Later in 1934, after Matsue, I joined Yanagi, Hamada and Kawai to make a journey southward from Kyoto, to collect examples of remaining country crafts for exhibition in Tokyo and Osaka. This was at the request and expense of the Takashimaya Department Store. At last Yanagi's Mingei Movement had begun to make a dent in the attitude of these large stores regarding the preservation of traditional crafts. Hitherto it had been assumed that the only way to preserve them was to send out smart up-to-date young foreign-style designers to persuade craftsmen to change their products to suit a new progressive public. This time we were going to collect genuine crafts. Our sponsors spent £1,000 on our journey and ordered some 20,000 articles, which were all sold in their Tokyo headquarters in three days. They forthwith ordered another 20,000 objects for a receptive public.

We travelled south by rail stopping at various cities or centres all the way down to the southern island, Kyushu. The feudal castle at Himeji was fantastically beautiful, but our objective was the finding of hitherto unknown examples of fine country crafts. At the village pottery of Naeshirogawa we found a population of Koreans whose ancestors were prisoners after Hideyoshi's invasion at the close of the sixteenth century. Many potteries in Japan were advanced by this influx of Korean art. In my experience, this village was the only one which preserved its original Korean character in food and dance as well as pots.

We received a particularly warm welcome. Pots filled an open field, some over-fired, some under-fired – all varieties of plain black but nothing personal or decorated and not a bad one amongst them. The villagers were touched by our praise and performed their ritual dances for us at night. The further south we travelled, the more we endured the fierce heat. At the most southern tip of the lovely island of Kyushu we bathed from a beach which toasted our bare feet, and plunged into a semi-tropical sea where the water was heated in patches from volcanic hot springs. From the frying-pan into the fire! Somehow we survived.

From Kyushu we flew back to Osaka over the Inland Sea of Japan at a fairly low altitude. A thousand isles and islets lay below us on a crinkled blue sea with as many white-sailed schooners fishing between the seemingly unmoving waves, yet there were plumes of white foam from every bow. The patterns of each island were like agates. Behind parallel white rollers the sea faded to pale green, then to deep blue. Shoreward the beaches were yellow crossed by grey boats, drawn up, then grey-tiled roofs, then pale-green rice-paddies, then dark-green pine-trees climbing upward to the rocky summits. We were in the air for less than two hours, intent upon that Inland Sea which has haunted my dreams throughout my life. (Plate 12b.) Suddenly we found ourselves above the hollow factory chimneys of Osaka – looking, it seemed, for a place to land. In a moment we were in and out amongst the shipping of Osaka's broad river, and I only then remembered that this was a seaplane. We glided to a river bank and a huge crane swung us slowly up to the terminus platforms. Buses took us to our express train northwards to Tokyo.

At last the pots made at Mashiko, Matsue and Kyoto were assembled at the Kyukyodo Gallery in Ginza for an exhibition on the first floor.

The day before the opening I had lunch with the nice old proprietor and he mentioned he had kept in the basement the pots which had been broken in conveyance, made by Michael Cardew, Katherine Pleydell-Bouverie, Norah Braden and myself. He wanted me to see which might be gold-lacquer mended and sold as such. I had not known about this, for the proper price had been paid to me in England, but I agreed and made the selection, remarking that I supposed the insurance company had been informed and had duly paid up for the breakage. I noticed a curious look on his face, and with diffidence he said 'No', the claims had not been made. Taken aback by this, I pointed out that heavy insurance had been paid at our end. He then said slowly, 'Old-fashioned Japanese, like me, do not like insurance.'

'Do you mean that you paid for the damage out of your own pocket?' I asked. He bowed low, saying it was the old custom of the Edo-ko (children of Tokyo). I was astounded and said so, humbly, I hope, and offered to repay him, but with quiet pride he refused. Thus have I been treated again and again by Japanese friends.

Early in the New Year of 1935 I went by train up to the plateau of Karuizawa to spend a week with old friends, Harold and Winnie Spackman, a rail climb of about 2,000 feet into snowy mountains. This now almost deserted summer resort was where we spent three summers up to 1919, walking, climbing and drawing. The effects of snow were magic, the pine-woods and rivulets full of visual surprise, and the air crystal clear. When we trudged in the snow up to the pass above their warm wooden house, the 8,000-foot smoking volcano Asama lay to the right about ten miles away. On the left, sixty miles distant, the peaks of the Japanese Alps, that long screen of glittering heights, high in the winter sun commanded by the 'shark's tooth' of Yari. Indoors we sat by a long fire, thinking and talking of friends in common; of my wife Muriel, with whom we learned to rock-climb on those good volcanic rocks.

Re-reading our Christmas mail I thought of what I had left behind and of that to which I would return. I had undoubtedly put work before human relationships: but felt driven by a powerful wind. Sooner or later, consequences, like bills, have to be met; there is the rub.

Now, years later, I look back in the long perspective. This is not just an autobiography, nor do I intend to deal with the more private side of my life more than is necessary to preserve a continuity of events,

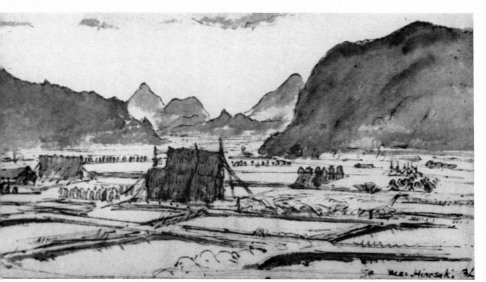

Plate 17(a)　Harvest time. Drying the rice in Japan. Pen and wash, 1953

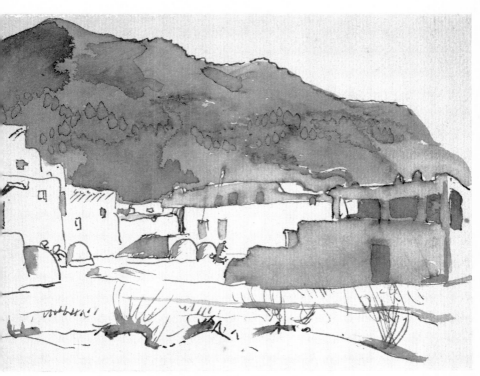

Plate 17(b)　Taos Pueblo. Pen and wash, 1952

Plate 18(a) Japanese fireproof storage house. Pen and wash, 1954

Plate 18(b) The village of Johanna, Japan. Pen and wash, 1954

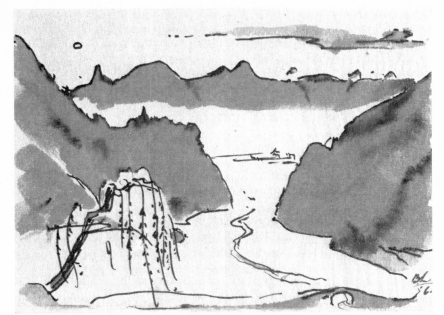

Plate 19(a) View from Kazanso Hotel of the valley of Matsumoto. Pen and wash, 1964

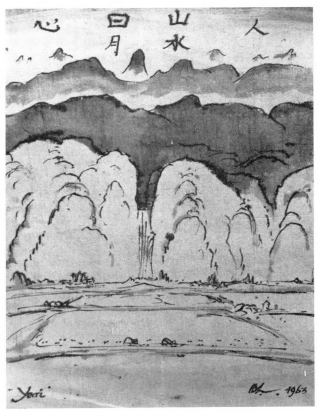

Plate 19(b) Japanese Alps. Pen and wash, 1963

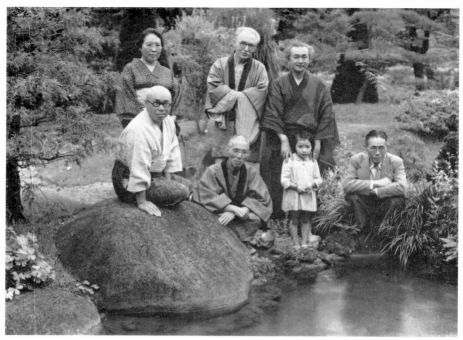

Plate 20(a) At the Kazanso Hotel, myself with (*left to right in front row*) Hamada, Yanagi, and Kawai, 1953

Plate 20(b) Kyushu, Onda, with my hosts the Sakamotos, 1954

people, and problems. They emerge, as accurately as possible. Here perhaps it is enough to say frankly that with my own hindsight I admit and I regret deeds which I cannot defend. And yet it is difficult to see even now what better alternatives could have been found. Suffice it to say that at this point I was in the early throes of the breakdown of my first marriage, and thought was serious and painful in the silent snow with those good friends.

The following letter written in February, 1935, was copied and sent as a round-robin to thirty or forty of my friends in England. It has been preserved and is introduced to take the reader back as vividly as possible to my thoughts and experience all those years ago.

'February 17th 1935.
My dears,

Here I am in a shaky second-class carriage of a train which takes eight hours to cross Southern Japan from Kurashiki to Tottori, South to North, Inland Sea to the Sea of Japan. The train winds along between hills which are getting higher and higher following the valley of the Nariha River. Presently we shall come to snow; on the train are several youths with skis. All young Japan skates and skis and plays baseball, tennis, golf, football etc. today.

'I'm very sleepy and rather exhausted after five strenuous days and nights at Kurashiki. You won't know the name of the place and will wonder what took me there. Well of course Yanagi and his group arranged it. It is a nice little town about twice the size of St. Ives and is situated in a lovely background, near the Inland Sea – moderate mountains all round the horizon and a heavenly river – this Nariha – in long sandy reedy stretches sweeping round Kabuto Yama (Helmet Hill) where I worked at the Sakazu pottery for three days and made seventy pots. We poled across the shallow stream each morning and evening a quarter of a mile, dodging the rocks and shallows and swirls between low reedy islets. We were: my host Mr. Takeuchi, the curator of the excellent local art gallery, belonging to our millionaire friend Mr. Ohara who is a sort of wise lord of the district and a man of great taste and ability, and myself, sometimes accompanied by local craftsmen or gentry. On the other bank the Okamotos awaited us, and carrying every trifle of mine, conducted me to their private sitting-room and a potter's workshop where everything was laid out for my

day's work. The Okamotos have run this local pottery for three generations and there was a huge climbing kiln on the pine-clad slope. The soil was clean, crisp, hard, reddish and quartzose and the winter sun quite hot on the pine- and bamboo-thickets when the keen snowy wind stopped blowing down the valley from the high hills.

'We have reached the snowline.

'At the workshop at Sakazu I got used to being watched silently and intently by groups of potters, and my own comparative clumsiness on the wheel did not trouble me any more – it is secondary – and the intense desire to learn and to understand outweighs it. What has taken longer to accept has been the universal recognition that I am a *sensei* (master), and that no trouble taken on my behalf is too much. At Kurashiki I have been treated as a *tono-samma* – a feudal lord. Sometimes it is overwhelming – every detail of trains, cars, accommodation and food to the number of seconds I like my egg boiled for breakfast is passed on ahead – the brand of coffee – the hot milk – who is to meet me or travel with me or whom I had better meet – those to be fended off, and so on, everywhere I go. It is amazing! It isn't that I get a conducted tour without freedom, I've only got to express the slightest desire and the way is made easy – I have lived in the homes and life of this people as never before. And as to the *sensei* business, besides being flattering and pleasant, I have no difficulty in accepting the role when it comes to craft itself simply because excepting two or three – Yanagi, Hamada, Tomi, and to some extent Kawai, who are also *sensei* – I feel able to teach, explain and show the way confidently to this younger generation and to the half-attached world of connoisseurs and art-lovers who are mostly very confused by the complexities of intercontinental art and life. Moreover, when I don't know, I say I don't know.

'Out of the window the river has become a stream – clear and brownish and gushing and we are boring through the hills with glimpses of snow and larch between.

'At Kurashiki I had a house of my own those last days next to the Takeuchis with whom I met, he being the curator of the art gallery. An odd house, a mixture of China, Japan and Europe, built by Mr. Ohara for an artist, now dead. Solid and comfortable. I was able to array all my drawings and materials I have picked up here and there for mounting them as *kakemono* – and my letters, amply for once.

Also I did a certain amount of Chinese character-writing last thing at night. I'm getting more the hang of it artistically though of course I'm making no pretence to learn the meaning of the characters. I find the pure brush-work fascinating and helpful both for manipulation, as well as an exercise in rhythm and balance.

I have come to understand thoroughly how and why the Chinese, Koreans and Japanese value good writing so highly. The extent and variety of character gives ample opportunity for expression of innate personality, and is so stylized, universally understood, graded, and historically punctuated with the high standard of masters that it contains the very essence of abstract potential beauty. Our own is young and inexperienced in comparison. I find myself able now to recognize what Orientals consider fine and why, and to obtain similar emotional and intellectual reactions to theirs. Takeuchi is a lover of calligraphy.

'On the third night at Kurashiki after a steady race (successful) to finish handles, slip decoration, turning etc., I was rushed to a large foreign-style dinner party for which we were cheerfully three-quarters of an hour late. Twenty-five people and then speeches. I was introduced very warmly by a relative of Ohara's, he being away. This Mr. Ohara said they had all known my work for years and some of them possessed it, and that they were delighted to meet me personally and hear my modern views on craft pottery, especially on the problems underlying it and my criticism of the contemporary Japanese movement which I had initiated twenty odd years ago, and which has grown up under Yanagi's wing. He particularly asked me to try and explain why even the best of modern pots fall far behind the standards of the past, especially that of the Sung era in China and Korea. I talked away freely for half an hour when Takeuchi whispered to me that I'd better cut it short as there were some forty people in the next room waiting to hear me!

'I thought I'd got to the meat, but no, I had to start again. This I did and carried on for about another hour. Then followed a whole series of questions from various people covering a very wide field. Characteristics of East and West, similarities and dissimilarities, with many examples. A picture of Japan as the great experiment in the blending of the two extremes of Eastern and Western civilization, a reference to her first absorption of Buddhist culture, the process of digestion

involved, examples of indigestion (and Heavens above, they are plentiful), the discarding of Oriental culture and its values in work, especially for export today and the shortsighted folly of much of it, the roots of Japanese aesthetic culture – Lao Tze, Zen, Tea, script, flowers, incense, poetry, pottery, painting, architecture and interior decoration; how to deal with peasant craftsmen – the leadership of factory design by artist-craftsmen – the acute problem of the half-peasant, half-artist type – European food and customs in Japan – imitation etc.

'It was all very alive, keen, frank and often amusing. Sometimes I could not get the clear meaning of a question and had to have it simplified by Mr. Takeuchi who very quickly got the hang of my vocabulary. Generally now I can follow half to two-thirds of the speech. Seldom do I have to stop to think and plan the sentences of a reply, and I find I am understood without difficulty. Well, that was not the end! My cinema projector had been packed hastily into the car and we wound up by cording up to the electric light, turning through two reels (700 ft.) of my Mashiko and craft travel photos. Bath and bed at one a.m. very tired and with my voice nearly gone.

'The next day I breakfasted rather late in Takeuchi's delightful house – everything in fine Japanese taste, every pot and utensil good – local, old Japanese, Korean, Chinese – his wife silently serving us, my socks darned in various stitches (finely) and colours (!) with wool, cotton and silk (!), returned with much diffidence, and so off to the Art Gallery. There I found old Egyptian pots and sculpture – Turkish – Persian – and a large room of paintings – El Greco (five), Millet, Chavannes, Segantini, Hodler (originals of course), de Segonzac, Matisse (two good ones), Besnard, Bonnard, Renoir and other moderns. Quite a good display – better than provincial art galleries in England can boast of! Thence to an industrial school to inspect and advise on basketry and cane-chair making. I made a large sheet of designs and suggestions, praised what I found good and explained how and why the curly Victorian tradition, which still held the field, was bad. Then to a factory where they make quite good Kurashiki carpets. There I made a series of practical suggestions about colour, design and durability. The following day I wrote letters.

'We have crossed the divide and come down to the other coast along which we are skirting, with the snowy lower slopes of extinct Dai-san away on our left, its seven-thousand-foot crest lost in hori-

zontal grey cloud. It is colder this side but not three feet deep in snow as I was led to expect. There is no snow at present, but it may come any moment by the look of the severe sky.

'I am going to Tottori for five days to start the craftsmen there on some work – furniture etc. – then back to Kurashiki for a two-days' exhibition and so on to Kyushu by the 25th. After that Matsue and again Tottori. Travelling is very cheap and my expenses low. Imagine! I got a three-month ticket from Tokyo via Kyoto to Tottori for ¥8.50 (the equivalent of 50p.) second-class, a distance of about four hundred miles.'

It had been arranged that I should visit the pottery village of Futagawa in the north of Kyushu. There I stayed with the owner of the traditional pottery – a middle-aged, quiet man of some culture of a family called Sumi. He had a grown-up son who, to my delight, played the *shakuhachi* wind instrument. This is a twenty-inch vertical flute. I know of no other instrument more woody in tone and so close to nature. The music scale is different from ours, and this fact is a barrier to many of us, but that strangeness passes as one enters into another world of music; it is even a voyage of discovery with its own delights. This I found when I heard that young man playing sometimes after nightfall.

The pottery's thatched buildings reminded me of Devonshire – in the open space between there were ranks of shelves on trestles with pots still wet with slip, drying in the wind. I watched a man putting this liquid clay on with a broad brush from the inside of the lip to the middle of a pot centred on a banding wheel. By the time the flat brush reached the centre it was just about emptied of the liquid clay and a little thin and dry. There was reason – a little quartz sand was scattered between foot and centre between pot and pot when packing in the kiln, which prevented them sticking to one another. This quartz could be knocked off eventually – a little rough but pleasant because people in old Japan used wooden chopsticks, not silver, which becomes scratched. No harm was done to the wood.

That particular white slip was the best I came across in all Japan – whiter although apt to scale off the exteriors of pots – that was why it was applied with a brush on to the softish clay, to make the slip grip better. Two colours were available apart from the brownish clay and

the white: the transparent iron-brown and the green copper, but I was told they had not been used for fifty years. The skills of the old patterns had gone with the passage of time, but they dusted the old containers and reground the colours for me as I was an artist and enjoyed using them freely.

When I went into the throwing-room I watched a potter preparing the balls of clay for the wheels. Kneeling on the damp earthen floor, with palms down he rolled the clay into sausages three feet long and two inches in diameter. These were placed close to the wheel ready to use. They were laid on a slowly revolving wheel and with a wettish rag in each hand, the potter pressed inside and out on to the previous coil, nicely calculating that the length of the sausage would make a circle above the one below, thus forming the wall of a large jar by a coiling process. At first I did not observe how the wheel revolved, but looking under it I found a man lying on his back on straw, paddling the bottom of the wheel with his two bare feet. I had never heard of such a thing and was astounded.

The pots, moreover, were steaming and drying as they were being made because there was a fire burning on one side – charcoal I would think, throwing off the reflected heat from a suspended holder. The standing potter went on calmly between two activities and when he had closed in the lip of the jar to the shape he desired, the whole big jar, perhaps two and half feet high, standing on a round removable bat, was seized by two men and taken out into the open square to dry. Before nightfall it was then placed – already considerably hardened – on a rope in a figure of eight, just where the two loops crossed; the upper part of the loops went over the shoulder of a man on each side, and they staggered away with the pot between them and put it out under thatched cover. It was all very surprising to me. So free!

I think I spent about two weeks at the Futagawa pottery. One day that young flautist took me off to a small restaurant by the seaside where the noblest oysters I had ever seen were provided. Two made a full meal, briefly semi-cooked over charcoal in their shells and eaten with a piquant soya-bean sauce. Delicious! The proprietor said that he had been trained in Paris. Naturally I came back again once or twice.

As I remember I made a series of large decorated bowls, but never possessed one myself as they were fired after I had left Japan, for the reason I shall now recount. Whilst I was at work, to make sure of

having fully dried wood ready for the firing before I left, the many chambers of the kiln were stuffed with somewhat greenish wood and a small bonfire was kept burning at the entry to each full chamber. Whilst we were at work a sudden cry arose, 'Fire!' Somebody had carelessly allowed the bonfire to catch the wood inside the kiln alight and it was a case of all men to the rescue. But no water could stop the blaze, though the fire brigade arrived on the scene as well as a crowd of would-be helpers.

I took the opportunity of talking to Sumi San the elder. I said, 'It's hopeless, you cannot put it out. The only possible thing is to close up all the inlets and outlets of the kiln.' But even that measure was ineffectual because although it stopped the flame consuming the wood it turned it all into charcoal, which being of soft wood was only of secondary use. They had to get a new lot of wood and dry it before the pots could be properly fired. It was only on my next visit to Japan that I saw a few of those pots in the Japan Folk Art Museum in Tokyo. Yanagi had snaffled the lot!

FIG. 11. Okamoto climbing kilns in letter of 1935

199

Korea

I had visited Korea for the first time with Yanagi in 1918, before the occupation by the Japanese. We landed at Pusan in the south and travelled on to the capital, Seoul, by train. I recollect the strong impression gained on this earlier brief journey. I seemed to have the sensation of already knowing something of its unique beauty, not only in the pottery, which continues to this day, but also in the lines of its ancient granite hills behind the Imperial Palace gates; the curved roofs lifting to the mountains behind; the strange black horse hair hats of the married men – raised an inch above their heads on bamboo frames to provide a flow of cool air in hot weather; the lilting shape of the foot gear; women beating washing on flat stones in the clear flowing water of river-beds, the lovely line of dark hair resting on the napes of their necks. In warm weather, cool, light linen clothing. Everywhere beauty of line, neither Chinese, nor Japanese. There was however some kinship with old Persian beauty of perhaps the tenth or eleventh centuries of which I do not know the explanation. The emotions were poetic; I did not want to leave; memories are still nostalgic.

After the annexation I came again in 1935 and by invitation held an exhibition of my work in Seoul. The government had allowed Yanagi the use of a small building at the old palace to be used as a museum – a meeting place where Japanese and Koreans could enjoy love of beauty without rivalry or politics.

During my exhibition I gave a talk in Japanese. Remarking on the sad loss of beauty in the things of everyday life. I praised Yanagi's brave attempt to preserve some of the exquisite 'arts of the people'. I was silenced by a courageous young Korean student who dared to stand up and reprove me for pleading for beauty when life was at stake. This was unanswerable. I hope nothing untoward happened to that young man, for the Japanese army was ruthless.

I recall once when I was standing on the fringe of the open space in front of Peking station. A short Japanese stepped out of his rickshaw and threw down a small silver coin for the panting Chinese runner who expostulated, as usual, at being underpaid; the Japanese slapped his face hard. The movement of the crowd stopped in dead silence with hatred and fear of further invasion in their hearts.

I remember with what enthusiasm I saw the imperial collection of pots in Korea before they were dispersed by war. The ones I at first loved most were celadons of the twelfth and thirteenth centuries, many delicately inlaid with white and black patterns. These were famous, even in China, where their grey-green was described as 'the colour of the sky after rain'. These quiet pots were made for a cultured Buddhist society of the Koryo Dynasty. In later years the pots I came to love still more were white, or blue and white porcelain, influenced by distant Mohammedan Ming China. Yet as in all things these pots are of a different ethos. The quality of blue pigment on the porcelain itself and the form spoke of that beautiful countryside, not of China, nor so insistently of court taste. It did not aim at thinness, translucency, or ornateness. Why should it? Why should the seeing eyes of the Japanese men of Tea have selected the rice- or soup-bowls of Korean country potteries to set the highest of all standards? What is the uniqueness of Korea, 'the land of morning calm'?

Northern China elongated towards southern Japan, which, together with Okinawa and the Kurile islands to the north formed the eastern outline of Asia prior to the melting of the last ice-cap – perhaps 15,000 years ago. Everywhere in this peninsula I found a lonely, poetic beauty. From the first if my concept of China has been of form, that of Korea has been of line, whether in landscape, hats, shoes, pottery or poetry. The calm ideal of Korea may be due to Buddhism – there was in the air a sense of loneliness, isolation and sadness. The wrinkled peasants on the plains almost certainly endured a hard life, redeemed by nature and poetry. Once when Yanagi and I were climbing fast from the plain to a mountain monastery, the sun sinking towards the horizon, we came upon three old scholars who had been sitting enjoying nature, poetry and sipping wine – as in so many Chinese and Korean paintings. They greeted us, drank last cups and toddled away down to their village homes before dark, whilst we climbed steeply against time to our mountain monastery. The memory of Chinese classics, philosophy and poetry pervaded all.

During my exhibition in Seoul we were invited by an old Korean nobleman to come as a party to a midday meal at his village guest-house in the countryside. We drove some miles by car and got out on the green banks of a clear, fast flowing river. The elderly gentleman and his entourage of men and women stood awaiting us on the other bank.

I wondered how we were going to cross. Palanquins with a couple of strong countrymen both fore and aft came through the breast-high water to ferry us over one by one. Some of the Koreans spoke in Japanese. We were introduced and welcomed. The whole party was ushered up a curving slope to an old style guest-house standing under pleasant trees at the top of the little hill looking down to the river on one side and over the grass roofs of our host's village on the other.

As we entered the long room, a low table right down the middle, laden with food in lovely Yi dynasty porcelain bowls and dishes greeted us. We sat on flat cushions. Next to me was a beautiful girl, who spoke fluent Japanese, and all through that delicious meal I took to be our host's daughter. The food was not unlike Chinese or Japanese, but different as was everything else. I enjoyed the salted pickles most and noticed that Yanagi did also. This is the Korean method of preserving vegetables through their severe winters. Small onions, garlic, pine-kernels, cabbage, sundry other raw vegetables and even cut-up pears and apples are put into great and beautiful jars half-filled with brine. Fresh contents are added when in season to replace what has been eaten and the family and guests seem to pick and choose by preference and date from the preservative salt and well-flavoured water.

The well-educated and charming beauty next to me talked mainly about music. I must have been fascinated; perhaps I was, as when a chance came, one of my friends whispered in my ear, 'She is a *kaesan*, you know.' The equivalent in Japan is *geisha*, meaning professional entertainer. That she was – and I thinking her to be our host's daughter! Inwardly I laughed. I would not have made that error in Japan. It was a delightful day – a rare experience of old Korean life to which I had indeed lost my heart. I think we were all sorry to make our way back to the river crossing and to the farewells from bank to bank.

On the last, and first, free day before Yanagi and I travelled north to the Diamond Mountains, a small group of friends, both Korean and Japanese, took me around the antique-shops of Seoul. I wanted to buy some examples of old Korean pottery. We found both large and smaller plain Yi dynasty pieces. These I have and still use with increasing pleasure to this day.

I also spotted, in a dusty rack out of doors, a small incised Koryo twelfth- to thirteenth-century wine-cup with a reduced 'grey-green' celadon on one side turning to a yellowish tinge 'oxidized' effect on

the other. The gleam of gold lacquer told me it must have been prized and mended in Japan. My friends said they would have these things sent to me in England, but amongst my purchases was a very large pickle jar, for which we found a fine iron-bound chest in an antique furniture shop, large enough to protect it within a packing case. It did arrive safely and I still have that Korean chest in the room where I write these lines.

Tired and hungry after hours of search we were taken to a real Korean restaurant. We entered a large room where a few groups sat on the polished floor at low tables. My friends felt the floor until they found the area with the most pleasant warmth before we all sat and ordered ox-head soup, followed by pickles and of course, plain boiled rice. The food was excellent. When we had finished Yanagi asked for permission to show us the kitchen where the soup was made. There I saw an iron cauldron as big as a full-sized bath, simmering over a fire with eight bobbing heads of oxen in it! It was rather shocking but we had enjoyed the soup!

The method of warming the floor of that restaurant was the same as that employed by the Romans: the hypocaust. From end to end of the ground-floor buildings, underfloor stone passages carried heat and very little smoke on a slight rise from an external fire at one end, to a mere two- or three-foot external chimney at the other – most economical against the bitter winter cold.

Before parting with Yanagi to go to Mukden he and I spent a few days in the Diamond Mountains in northern Korea, walking, talking, so enjoying the crystal-clear streams, and the curved temple roofs, lifting so beautifully to those granite peaks 4,000 feet above.

Since landing at Pusan, Yanagi and I had driven all the way through the core of Korea right up to the capital, prior to my boarding the Trans-Siberian Railway to Mukden, en route to Paris and London. My most enduring memory was of natural furrowed faces of Korean peasants, browned and wrinkled by summer sun and winter frost.

Trans-Siberian to Paris

Thirteen days by Trans-Siberian from Mukden to Paris. I travelled second-class with an old Scottish missionary who had lived many years

in Korea. He was a pleasant companion, but most of the time I spent meditating on the events of the last eighteen months and contemplating the life to be faced upon return. Three days of the sparsely clad, repetitively small hills of Manchuria were soothing, but contrary to the travel agent's assurances the food was awful, and I became sick as our train began to cross the vast ocean of reeds bending like waves under the prevailing wind. The engine-smoke trailed across the expanse as from the funnel of an ocean liner; occasionally a blackbird rose from the expanse of water-reeds and was lost in the unmitigated distance. Every three hours we stopped at a small, low, red-brick or wooden station to pick up water or fuel, but I do not recollect a single village. No place to live. The stomach pains grew worse and I feared that I would have to be left in hospital.

Six days and nights had passed before we ran into flat forest land; pines and silver birch; every so often a clearing of perhaps a square mile and in it a village, and large bottles of milk for sale. I bought some, which when sterilized was returned to me watery, with chunks of cheese curds and whey. I ate and drank nothing else and gradually recovered. Maps showed that for hundreds of miles north and south, these woodlands following the Russian Steppes were almost uninhabited. It must have been about the eighth morning when we found ourselves rounding Lake Baikal and saw people and settlements. By that time our train was two days late. Once at a prolonged stop we got out, walked ahead round a bend up the line and came upon a couple of moujiks with picks, leisurely tightening the stone ballast under the sleepers. Everything in Russia seemed to be sleepy.

We arrived at Moscow three days late, in the early morning, then had to wait about two hours for any food. As we were not due to continue our journey until midnight, my companion and I set off on foot to explore the city. There was no other method of transit. My companion did not know more than twenty words of Russian. I wanted to smoke and had no matches. I stopped a pedestrian, mimicked my needs and entered a shop which had no signs – only everlasting Lenin-Stalin photographs. I pantomimed again and showed a coin, but was waved away because it was not in tourist money. I shrugged my shoulders; the man behind the counter showed humanity and pushed over to me a box of matches!

At Red Square we had a look at the famous church, the domes of

which looked too much like pineapples for my taste, then we joined the queue and eventually viewed Lenin through glass – pale, emotionless, and in type almost commonplace. By means I cannot recall we found a young artists' exhibition, where the woman curator spoke English. Noticing that I had written 'artist' as my occupation, she turned to me and said: 'As you are an artist I shall leave you to form your own impressions. Would you care to tell me afterwards what you think of our young painters?'

We looked at the pictures, then called at her office where I said that we were hesitant to express our opinions as we did not wish to give any offence. Her sincerity reassured us, then I said, 'The revolution does not seem to have taken place here in art! The pictures seem to be either "hammer and sickle" or second-class academy.'

Brightening up, she responded: 'Ah, our own leaders are troubled about this.'

We made our way to the Russian ballet and enjoyed 'Prince Igor'. During the intervals we walked round the foyer smoking and observing how every detail of foreign clothes, shoes, jewellery etc. focused envy and admiration. We forget their long deprivations.

Back on the train, it was only when we entered Poland that we felt we had returned to Europe. It struck me with surprise at Berlin station that the crowd was but little different from that in Paddington; the similarity was even closer in Paris at the Gare du Nord. Thus home to England.

Soon after I returned I received a letter from a friend called Leo, a follower of Rudolph Steiner, in which he asked me about Christianity in Japan. Here is my reply, written whilst staying a few months at Michael Cardew's. It was published, still in letter form, in *The Christian Community* magazine.

Christ in Japan

'Winchcombe, November 11th 1936.
Dear Leo,
 You have asked me to write on Christ in Japan. I feel some natural diffidence since I do not call myself a Christian, and I do not think much of the greater part of missionary work in the East because

there always seems to me such a difference between the teaching of the Christ who emerges from the four Gospels and the formalization of the churches. I have moreover frequently heard my Japanese friends express similar views. But because I have lived intimately among the artists, craftsmen and writers of that country, and because you have widened the issue from sectarian limitations to the breadth of Western spiritual values, some of my observations may provide your readers with food for thought.

'Very few people in England realize what modern Japan is like. In the first place, they have no experience of a critical conflict between two cultures with their own national future dependent on the issue. It has been Japan's fate to bear the brunt of this internal strain even more than it has been India's or China's, for the simple reason that she has undertaken the task voluntarily and in self-preservation.

'For sixty years Japan has absorbed the West at breakneck speed with the whole energy of an active, proud, undefeated, island people. Year after year battalions of her best brains have been sent out to gather knowledge of the latest and best in matters military, naval, commercial, educational, scientific, artistic and philosophic, all over Europe and America. They have returned, organized and applied their knowledge, and the world is beginning to fear the results. China, Russia, and the League of Nations have been defeated by her soldiers and diplomats. We are being undersold in the world's markets, and even in England; we are being ousted from the Far East, and there is a threat over India and Australia. On the plane of materialism it is diamond cut diamond. But has Japan gained no more from the West than what a Chinese statesman called the "outside in" values? Or has she a vision of life "inside out" informing her energies?

'To the last question one can, I am afraid, only answer broadly "No", though this might give offence to many simple-minded Japanese who believe that their Emperor is the direct descendant of the Sun Goddess, Amaterasu, and that the whole spirit and structure of the State radiates from that divine source. I do not wish to give offence to such, nor do I desire to attack any Japanese spiritual beliefs; on the contrary, any criticism which I offer is of Occidental material values disturbing and displacing them without sufficient compensation of our own inheritance of the spirit.

'The second point which I feel needs stressing to English readers

is the hopeless confusion which exists in their minds between China and Japan. They have no clear picture of the deep temperamental and historic differences of the two peoples. The patient unsentimental realism of the continent contrasted with the romantic and hot-blooded idealism of the island folk: the age-old commercialism and anti-militarism of the one, the new western commercialism, and the keen-edged fighting spirit, inherited from remote sea-Dyak ancestry, of the other.

'Antitheses might fill pages; I hint at them, because the dynamic energy of the Japanese has crossed the Straits of Tsushima to Korea and Manchuria and is running like fire and quicksilver at this moment down the valleys of the Yellow Empire. Japan, after the former threat from the West of being colonized, seems to be trying to turn the tables on China. History is being repeated with differences and the chief of these is that the force of this Japanese energy is borrowed European materialism. The question is, what will temper it?

'Thus we come to the question of what influence we have had upon the Japanese in depth of understanding of life, in truth, in love and in beauty. Any thinking Japanese would admit that it was profound. The people are scientifically minded upon a German model, and I well remember university students strolling past my first Japanese house of an evening thirty years ago, shouting "Deskansho, Deskansho" – a catchphrase from their studies, meaning Descartes, Kant, Schopenhauer.

'Japanese Christians of all denominations put together form no great part of the total population, nor do dispassionate observers think that they ever will, but in a broader sense something of the spirit of Christ is touching the soul of this people. Not long after I arrived in Japan in 1909 a young man who has since become a noted critic, sculptor and poet, said to me, "Why do the English say 'plucky little Japs' because our soldiers beat the Russians in Manchuria? Do you know that whilst the poor Russian moujiks were being killed by us every household in Japan was reading the words of Tolstoy? We understood Christ through him more than through the missionaries, and the spirit of Russia, through Tolstoy, was the real victor." It was the spirit of Christianity in Tolstoy which won their hearts.

'Possibly we do not observe the workings of this concept of life in the subsequent military, political, or commercial acts of Japan, but what of our own? How little of our outward history has been truly

Christian! I cannot forget how, during the Great War, the Japanese marvelled at the capacity of the Christian Churches on either side, to claim Christ's support for the slaughter. Any cynicism on their part towards our present politics can, to a quiet observer, hardly be a matter for surprise. But below the surface of this Westernization of the Far East a ferment has been at work – the spirit of Western man – the culture of Europe – a rebirth through the essence of Christianity.

'I have asked Japanese who were not Christians what they thought of Jesus, and they have said, "He is one of the Great Teachers." In a country which is mainly Buddhist I often wondered what He had to offer, and found my own answer, occasionally among actual converts, but more often in the personalities of my non-Christian friends. A great measure of human love and warmth had entered their lives indirectly, and they were far more individuated than their fathers, grandfathers, mothers and grandmothers. In spite of Buddhism the individualism of the Western mind comes with new and compelling force to the philosophical, quiescent East. If I talked to Japanese or Chinese of the old school on any question of principle I was baffled by the un-self-conscious, un-probing, un-analysing mentality of their tradition. New Japan has altered profoundly in this respect and my belief is that this is due to Christianity behind the more direct causes of Western science and education.

'A change in the relation of sexes struck me more forcibly than anything else when I revisited Japan recently. Women are emerging from the handmaid seclusion of centuries, and men are just beginning to seek them as personalities and friends. I have watched young Japanese men returning from Europe refusing to bow to the family and tradition and marry the unknown and unloved bride chosen by the parents. Japanese modern literature is full of drama of this kind.

'The family system is inevitably broadening and deepening. Behind Japan's practical need of adopting our ways in order to preserve her independence there has been an unexampled enthusiasm to experience all those modes of thinking, feeling and acting, from which history has debarred these hitherto inviolate islands.

'The capacity to enter into another person, to be that person, to see and judge as he or she does, surely implies human sympathy, tolerance, affection, the allowance of fifty-fifty which is Christian.

'You asked me what form of Christianity I thought would be most

acceptable in Japan. My answer so far tends to show that no external form is likely to be widely accepted. Missionaries are liked individually but not as doctrinal teachers. The Japanese are sick of being taught by those who do not know and respect Buddhism, Shintoism, Confucianism and Taoism. A more inclusive and tolerant Christianity might make an appeal, but never accompanied by any element of coercion or Occidental superiority. Missionaries must go to Japan to teach prepared for a full exchange.

'The spirit of active love is contagious. Tolstoy, Dostoyevsky, St. Francis, Rembrandt, Van Gogh, even Blake and Whitman move Japanese without doctrine. It has been said that the religion of Japan is art. Might we not *even* say art is also religion? So widespread is the love of nature and of beauty that to us Europeans, so long inured to the divorce of art and religion, this love is like adoration, which indeed is the truth. I remember, with a sense of opportunity lost, the ugly chapels and churches, houses, clothes and hymns of Christian missionaries. We never seem to think that things which are not beautiful are at worst evil, at best incomplete.

'In speaking of the deeper influences of our culture in Japan I have purposely stressed its Christian root, but it would be quite misleading to suggest that Japan is not being attracted by Western thought which is un-Christian or even anti-Christian, but with that I shall not attempt to deal now.

'To conclude, I would like to give a picture of two Japanese friends out of the background of the Japanese Craft Guild, the one Tonomura, a Methodist minister, the other Asano, a Buddhist priest. Both have parishes and are sincere and devout men; both give a good deal of their time to art. The first weaves and dyes beautifully, employing some of his maimed parishioners to work with him in happy co-operation; the second has collected lovely examples of living craft in his house and is now setting about building a modern temple to be a thing of beauty. Tonomura regards his weaving as part of his mission; beauty is also an essential part of Asano's concept of life, but the accent is different. With Buddhist Asano the atmosphere is still and inward. From Christian Tonomura there radiates an active love which warms the life of all who associate with him. Love on the one hand, insight on the other.

'There is no conflict, but a difference.'

Chapter 15

ENGLAND, 1936-1939

Ditchling

Back in England, many unforeseeable things happened. This was a very difficult period in my life, culminating in a decision to marry Laurie Cookes, who had been my student and secretary at the pottery, as soon as possible. We bought a caravan from the makers just outside London, had the fittings fixed according to our instructions and motored down to Ditchling in Sussex, where we found a hidden pitch half-way up Ditchling Beacon looking over the flat land behind the South Downs. There we lived a quiet, rather remote, but healthy life, walking miles of grasslands and visiting friends in Ditchling village.

Laurie and I had a wire-haired fox terrier, Peter; he and I shared dog-language and endless fun together. What a companion! His behaviour to other dogs to whom he took an immediate dislike, even at fifty yards distance, was tiresome, but his spirit and courage were grand. When I drove alone with him beside me, he stared ahead, tongue hanging out, for miles and miles, intent upon the possibility of seeing a rabbit. If the side window was open, he would be through and after it in a flash; he never did succeed in catching one, but neither did he give up hope.

We gathered mushrooms, yellow wild raspberries and plums in a deserted garden. We watched autumn come with berries and deadly nightshade, hips and haws, traveller's joy, and picked a bunch of dwarf thistles no more than three inches high, which we kept for years

as winter decoration – rather like golden-tinted 'everlastings'. We explored those grassy, rolling downs all the way between Lewes and Chanctonbury Ring. That was a happy life, ideal for both drawing and writing. (See plates 11a and 11b.)

I recall the view from our caravan one evening as the sun went down between a low set of barred clouds, its beam racing across the fields as from a great lighthouse, picking out spires and elms on the purpling plain of Sussex. During the night the rain tattooed heavily on the thin shell of our caravan.

In April 1936, I find by my diary that I gave a lecture at the Portsmouth Club in Grosvenor Place, to the Association of Women Weavers, to whom Ethel Mairet, who lived in Ditchling, must have introduced me. Dogs were forbidden, but we had Peter in our car and did not like to leave him there, nor was he accustomed to that sort of thing, so he pleaded his way in. Never were we so proud of him. He walked his way down the aisle of assembled women as cool as a cucumber, bowing to right and left, behaving like a perfect little gentleman!

I also remember visiting Havelock Ellis with Laurie at Wivelsfield, about seven miles north of Ditchling. He was sunning himself in a revolving garden outhouse – being cared for in old age by a charming French companion.

It is strange but I cannot recall any details of my first visit to the English weaver, Ethel Mairet, at her house and workshop called Gospels, except for the warm smell of the dyed hanks of wool. The village of Ditchling lies about a mile short of the South Downs and some ten miles from Brighton and the sea. At least two groups of people lived there who focused the crafts of England; the spinners and weavers, and the letterers and printers. Of these the most widely known was Eric Gill, who had the advantage of the good hand-printer Douglas Pepler to publish some of his forceful writing and woodblocks on hand-made paper. I think that Gill's best work was his lettering rather than his sculpture.

There was also Edward Johnston, a recluse, who sometimes gave lectures at the Royal College and Central School of Art in London; from his quiet retreat, he changed our outlook on writing and printing in England, even more than his pupil Gill. It is said that his little book *Calligraphy* revived writing for Europe. Both Hamada and Yanagi

said he was the most remarkable man they had met in England. No one taught by him forgot his timeless purity. Once I called to see him, and his wife Greta came to the door, a finger to her lips. Leading me to the drawing-room she whispered, 'Edward is engaged with two children and the room is darkened for an experiment with light.'

There he lay on the floor, the children's heads beside his, looking up a divided beam of sunlight through a prism, falling like a rainbow on a sheet. 'There you see all the colours together go back to white light if you look at them in line,' he said to them, as he puffed the smoke of a cigarette upward. I remember when I stayed with them there was peace in that house. Twice I talked with him slowly until the small hours of the morning. Everything he said had meaning.

Ethel Mairet was a remarkable woman. She was first a musician – a pianist. When she married Ananda Coomaraswamy, the Indian art critic, she went with him to Ceylon, where they stayed for four years. There he, and the Orient behind him, must have awakened her. I think that it was upon their return to Chipping Campden that she began to weave and express her love of colour in the warm textures of vegetable-dyed and hand-spun wool. For many years she had followers all over England and to some extent, in Europe, and even in Japan.

Those 'candles' lasted for fifty years, but now they are dimmed. Although when carried away in conversation she often said the wrong thing she invariably proceeded to do the right. When Coomaraswamy left her she married Philippe Mairet and moved to Ditchling. Philippe was editor of the *New Age*, following upon Orage. Orage pursued Gurdjieff as his religious Guru to his school of wisdom at Fontainebleau.

Philippe and Ethel were interested in another spiritual teacher in London – Mitrinovic, a Serb. He had been a music and art critic in Italy and had quite a following of intelligent people at his headquarters in Gower Street. A man of spirit and insight, I learned from his wide understanding the relationship of many religions within the wholeness of Truth.

Winchcombe

Enclosed in my diary of 1937 I have found a poem, undated:

England, 1936–1939

Red hip,
Black sloe,
Bound alike
By hoar.
Sweet spring
Come slow,
For we may
Come no more.

I recall those hips of the autumn of 1936 on the South Downs at Ditchling. Also multitudes of sloes growing near the Winchcombe pottery, handfuls of which we stripped from the branches of that toughest and most astringent of wild plums. It was a phenomenal harvest. Mariel Cardew made the best sloe jam – stones and all – I have ever tasted. I recollect the matter-of-fact way Michael spat out those stones. We fixed up our nice caravan in the apple orchard for a month, and enjoyed their warm and stimulating companionship.

After he left St. Ives in about 1926, Michael had resuscitated that old English redware pottery with the excellent and appropriate assistance of one of the former hands, Elijah Comfort, thankful to come back to his original occupation. I think Michael's fiery leadership gave the new pots more vitality than the old ever had. I once put his great rose-bowl, now in Hanley Museum, next to very good mediaeval English pitchers and found it in no way put to shame. When it and his other pots of that period were shown at a Bond Street gallery, I cannot forget how, when their first beautiful child needed feeding, Mariel so naturally suckled him before the assembled crowd. I could have shouted for joy!

Years later, in the autumn of 1969, when I had just escaped death in hospital, she came to sit by my side. With her still beautiful eyes on mine she asked, 'Do you remember what you said to Michael and me?'

I whispered, 'Ah! You must mean "Why don't you two get married".' Looking her full in the eyes, I ventured, 'How has it been?'

She unhesitatingly answered, 'Look at the children!' I do not forget either how she told me that after their wedding at Winchcombe Church they travelled to Erin on honeymoon, kicked off their shoes and walked barefoot into the green countryside. When people eyed them with suspicion, Michael would pull out his Dolmetsch recorder and all began to dance.

In some ways Michael is like Mark Tobey: both men of force and originality, they each suffer from curious fears. Michael was afraid of both dogs and fire. The dogs knew it and informed him of the fact! Fire was stronger than Michael, and he had an unholy fear of its burning power. He was not always rational (thank God!). Once I walked into the middle of the round bottle-necked chamber of his up-draught kiln to see if I could find out why on earth it took something like seventy hours to reach about 1,000°C. and incidentally why his lovely rose-bowls and pitchers were thereby so beautifully smoked. The dome of the old chamber had sunk and was horizontal, or even slightly lower in the middle, where the flames gathered to a single hole about twelve inches in diameter, surrounded by perhaps a dozen square one-inch holes. I was pushing a walking-stick through one of these and found it choked when Michael came on the scene. 'I don't want to be the death of you', he shouted, which might have been the case if the dome had fallen. It never did.

He attributed these firing problems to the fact that the sweet-makers at Cheltenham, from whom he purchased some old packing-cases to use as fuel, had given up the full use of cane sugar and were using saccharin instead. This was really funny! The kiln should not have taken more than twenty hours at most and the smoky or reducing flames were simply due to overfiring and choking of draught at the outlets of that old chamber. Yet without this smoked overfiring that rose-bowl in Hanley Museum would not exist.

Shinner's Bridge

Following Ditchling and Winchcombe, we made our headquarters at Dartington. I continued to teach senior children in the pottery. When some of the more casual, or rampageous, boys or girls began to sling pats of clay about my work-room, punishments being unheard of, I pushed them out and off and settled down to making a rather higher-fired lead glazed slipware by myself.

The Dartington estate proper comprises a thousand-acre loop of the river Dart, in which there are salmon. The best I ever ate came from its waters. The fishing rights are let out expensively. A week or so after Laurie and I settled our caravan thirty feet above Shinner's Bridge we

took our wire-haired terrier for a walk round the edge of that river. As we approached the steep rounded bank I picked up a long piece of wood and threw it well out. Peter ran to the crest and head up, like a hunter, jumped twelve feet out into the stream. That dog had courage! It is true that he loved a good fight, but usually his opponent was larger than he was. Some dogs he could not stand the sight of, and if he picked a quarrel with those, the bigger the better – more noise than wounds resulted; he never angered against man or child.

Although I was launched into a difficult period with the Second World War years, life at Dartington was rich with interesting people and activities. Farming – the traditional as well as the most progressive kind; a sawmill, forestry, gardens, rural economy and even town-planning – all basic; on the other side of education all the arts and many crafts, of which mine was one. Here then was Leonard and Dorothy Elmhirst's dream, under Tagore's advice, taking shape. By this time I was placed directly under Dr. Slater of the Central Office, who wished me to uproot from St. Ives and settle at Dartington. Further, he wanted me to take the advice of a Cornishman who directed the pottery section at Heal's in Tottenham Court Road, as to what to make. I thought that commercial adviser had done enough damage to rural potteries already, and declined. During the war, this same scientist asked me why I was not using my knowledge of Japan and its language. 'You mean as a spy?' I asked. 'I would rather be shot.'

He said: 'I believe you mean it.'

'Yes', I replied.

After about eighteen months of caravan life next to a bird-sanctuary, Laurie and I obtained permission to build a wooden cabin, and this we did with the help of an old carpenter, at our own expense. Here in a lonely, quiet spot, with one good-sized comfortable sitting-room, a bathroom, etc. we could spread ourselves. Eventually we added a bed-room to the cabin and then sold the caravan.

Mark Tobey was in America and his place had been taken by Heine Heckroth, a German artist attached to the Jooss Ballet at Dartington, to which the Elmhirsts had given sanctuary from Hitler. Heine was a good teacher too: he was the designer for *The Round Table* ballet. Mark's absence left me with an inheritance of thought about life on a deeper plane – a challenge. Who am I? Who are you? What is a Prophet? I had continued to meet Mark's Bahá'í friends. The claim

of the Founder of this religion was no less than to be the focal point of all religions. I came to realize the totality of this challenge, about which I have written in another book, *Drawings, Verse and Belief.* Here it is sufficient to say I became a believer once again.

During these years my eldest son, David, played an increasingly important part in my life. In 1930, instead of going to university, his preference to help me was his free choice, and I was delighted as I had not pushed him at all. I needed the particularly practical help which he gave, and in 1937 he became manager of the Pottery. This enabled me to live at Shinner's Bridge and keep a foothold in St. Ives. Whilst I had been in Japan in 1935, a letter from David told me that Leonard Elmhirst had urged him to take a scientific and industrial course at Stoke-on-Trent. I wrote a long letter to Leonard trying to persuade them both that David's greater need was a period spent in Japan by himself, after introduction by me prior to my return, in order that he might find his own balance between East and West – and a deeper perception of what was best in pots. I still think that it was his greater need, but he feels that his gain was beneficial.

Whilst he was away at Stoke, Laurie and Harry Davis held the fort. Harry was the only fast, well-trained thrower on the potter's wheel who had ever studied with me. He had been a trained at Bournemouth Art School, and was I think the hardest worker we ever had, which made it tough going for his workmates. It was part of his temperament. Whatever he undertook, he attacked with an electric frenzy. I also felt a moral drive within him. Nevertheless I often wished that his early training had had more depth. David was a good companion and became an excellent craftsman and teacher. I took him into partnership in 1946. We worked well together for twenty-five years. He had not been to an art school, nor back to the East. Inevitably my shadow fell heavily across him: I wished that he had taken my advice to spend some time in Japan.

I had often during the fifteen years since I returned from the East, felt the need of a book which might help the kind of students who had come to study with me. I had read what books were available on the subject of non-industrial pots, but they did not contain much information about either the ideals or the methods of Oriental potters. I felt there was a gap which I might be able to some extent fill, and that it should not only cover techniques, but also the Oriental approach,

in contrast to that which we inherited from our industrial past. It was the friendship with Henry Bergen, Hamada, of course, and for part of the time Staite Murray, which made me aware of a necessary interchange. I saw the need for interpretation, and with the hope of assisting young English potters, began to write *A Potter's Book*. Fortunately I had always kept diaries and notes, and thus had the means to make a start, covering standards, methods and ideals. At that time I had no idea of the wide response the book would receive.

FIG. 12. Turkeys, 1935

Chapter 16

THE WAR AND AFTER, 1939-1946

The clouds of the Second World War rolled across Europe, and broke upon us in September 1939. Although I remained a pacifist during the First World War living in Japan and China, in this one when the threat of invasion became real, my hatred of Hitler and his gang, and the rousing voice of Churchill was too much for me, so I walked into Totnes one day, gave the shotgun over my shoulder up at the Police Station and joined the Home Guard – now best known as 'Dad's Army'. I could not bear the thought of England being overrun by the Nazis. In my present frame of mind I would rather have taken part in non-destructive service, but my first thought then was of defence.

In retrospect, those five years seem to have been largely a waste of time – marching about, shouldering, or presenting arms, as obscurely as possible, crawling about the coast around St. Ives or keeping watch on the Dartington hilltops at night and seeing the bombing of defenceless Plymouth twenty-two miles away, the sound of explosives taking eleven seconds to reach us. In the distance we saw half the German planes turn northwards to Bristol and Coventry. After the last bombardment of Plymouth hardly a house was left standing within a central square mile. In the Home Guard headquarters at St. Ives the nights were interminable; glaring lights, iron bedsteads – without mattresses at first – and boring stories told by sergeants. I made one close friend, Denis Mitchell – now a well-known sculptor – but when the War came to an end, how thankful we were.

As the War went on the number of workers at the pottery dwindled

until I was eventually left with a single lad: those were the rough years for us all. In addition there was the question of how to make ends meet. At the Government's request but at our own expense a committee gathered monthly in the National Gallery in Trafalgar Square to do what it could for the remaining craftsmen of England, for the sake of the future. The present Crafts Centre is the residue of those efforts – originally under John Farleigh, C.B.E., and later Sir Charles Tennyson.

Twice when we were short of labour I appealed successfully to tribunals for the direction of young art students who were genuine conscientious objectors. That decision helped. One, the late Richard Kendall, became a good teacher at Camberwell College of Art and eventually married my daughter, Jessamine. The other, Patrick Heron, is now an internationally well-known painter and art critic.

On one of my journeys to Shinner's Bridge I called out on arrival, and hearing no reply walked into our pleasant hand-made living room and found Laurie contemplating a little boy of two years old at her feet. She said, 'There is no other home for him out of a large family. I do not believe the doctor is right about him. I am sure he simply needs love. Will you let me give him a home?' His family, living on the borderline of London, had slept in the Underground for six weeks before coming here as evacuees. With heart in mouth I consented. A few days later I watched that untrained boy reach for a spoon and fork after a meal, crawl to the kitchen and put them in the right drawers as he had seen Laurie do. I felt reassured, and time proved her intuition wiser than the doctor's knowledge.

We gave Maurice a sound education and a home. He eventually became a good wood-worker, carpenter and joiner, and is happily married to a nice girl who was at school with him. They emigrated to Perth in Western Australia, but neither of them liked the less cultured life there. Maurice worked hard, sometimes taking risks. He managed to build his own home and sell it, before they eventually returned to England with their four children and bought a house and workshop in Somerset, where they still are.

Back at St. Ives in January 1941, when I left the Pottery one evening after work, I noticed a somewhat unusual plane circling overhead and wondered what it was looking for. I drove over to the Count-House at Carbis Bay and awaited David's return after a meeting of the air-raid wardens at the Pottery. Sitting upstairs, I wondered why he was so

long. It was after nine o'clock. Suddenly there was a terrific explosion. I rushed outside with a flashlight, thinking, like many neighbours, that we had been hit by a bomb. We came to the conclusion that it must have been a German bomb aimed at the electricity works at Hayle. Time passed; David still did not return, so I phoned to find out why and heard his excited voice at the other end, panting, 'Don't you know we've been hit?' I raced round through the town in our car and found the whole area of the Pottery crowded with air-raid wardens, police, firemen and people – all with flash-lights. I could hardly get into my own place.

A half-ton land-mine had fallen into our vegetable-garden about thirty feet from the upper end of the Pottery cottage, alongside the Stennack stream. Desperate measures were taken to fill the gap with surface soil and stones from our roadside boundary wall to prevent the water from overflowing down the road; there was a horrible mess and confusion. George Dunn's cottage was half-destroyed and his wife sustained a broken collar-bone. Someone else had a severed artery, but no life was lost. All the neighbouring houses had their roofs off. A large fragment of the bomb was found on the tennis lawns half a mile away.

Next morning when I arrived, Air Force officers were examining the parachute in our gateway which had held the bomb and told me that they thought the plane was one which belonged to a flight which had strafed a military airfield further up the North Coast the night before. This plane appeared to have been delayed and circled St. Ives instead of St. Eval for a long time before dropping its two half-ton bombs, aimed apparently at the football field and grandstand. The other bomb had fallen on soft ground and did no particular damage.

Our Pottery cottage was roofless and uninhabitable for three years whilst I fought against red tape to get permission for repairs, for which we had the material and old men's labour, rather than the country having to pay the cost of complete rebuilding after the war. Local authorities, Plymouth and then Bristol, all said 'no'. Indignantly they asked why I should be favoured when less damaged houses in Plymouth were condemned. I replied that they seemed to prefer that we, as well as the houses in Plymouth, should be treated in the same way; no reconstruction in either place. Obstinately I persevered and eventually won the case when the local Liberal Whip took the matter up with

the Minister. I was called up to Whitehall and the matter was settled in half an hour. Meanwhile we lived first in one cottage and then in another in the hamlet called Hellesvean a quarter of a mile beyond the Pottery.

Living was rough for four of us – Dick Kendall, Margaret Leach (no relation), an ex-fisherman from Newlyn who worked at the Pottery, and myself. Two of my students, who had grown beards, were promptly thought disloyal by Cornish neighbours. We were even accused of signalling to the Germans with our kiln-fires, even though our kilns had not been used for months. This may have been during the roofless period when we contrived to borrow a showman's canvas tent, which gave us sufficient protection from rain, to fire the big kiln under it successfully.

David was called up in 1941. He was a pacifist, but somehow had not registered properly, so he was sent to the camp of the Devon and Cornwall Light Infantry at Dorchester. There he twice refused to put on his uniform and was consequently imprisoned. On the third occasion he was sent to the rigorous imprisonment at a 'glasshouse' and his ordinary clothes sent home. Again he refused. So they sent him back to his regiment wrapped up in a blanket. On arrival the Tommies cheered and shouted 'Here comes our Gandhi!' (whom he did resemble!). I think this experience changed his heart, for he later shared with me his inward thought 'Can't a soldier be a Christian?' At any rate, he put on his uniform and trained recruits for the rest of the war.

My second son, Michael, after studying biology at Cambridge, was also called up, put into the Pioneers and sent to East Africa where his connection with pottery was discovered, and he was required and able to build and start two potteries with native labour making the then unobtainable mugs etc. for the troops.

Back in England we could sell whatever useful pots we made during the dearth of the War. People were no longer buying collector's pieces, but because of shortage of manpower in the potteries etc., distributors in London were selling hand-made pots for use; thus conditions of war to some extent caused us to change course. The relative demands of necessity won the argument, at any rate for the time being, and we began to make more of the standard ware which we introduced before the war. I made the prototypes, drew them on cards with measurements attached, and these were handed out to whoever was making

221

cups, saucers, beakers, bowls, jugs, etc. Naturally the price of our plain household pots was less than for those we had supplied to art galleries, so we had to take steps to increase production. In long retrospect I think this was a very healthy change because it preserved a useful connection with the demands of life itself.

During these years every period of school holidays ensured the appearance of an unusual pottery student, Dorothy Kemp. Teaching difficult boys history was her profession. A keen downright north-country woman, she loved pots so much that she used to place a favourite at the foot of her bed so that it was the last thing she saw before sleep came and the first on awaking. She worked humbly but assiduously at repetitive designs. One day I came round and saw a board of twenty cream-jugs which, although standard ware, were also Kemp; the lesson was learnt and the character of the maker apparent. Such are the days of recognition I have always looked forward to. Part of the time she taught at Saltash to be within easy travelling distance during holiday-time.

Kemp did not become an individual potter any more than a good cellist becomes necessarily a composer, but a cellist is a musician and who should decry either one or the other?

Later on she became a teacher at a good girls' school and started a pottery club amongst the staff, much to their surprise, followed by delight. Margaret Leach, a contemporary student at the pottery whose work was sound, became her friend. Another was Aileen Newton, whose husband was a leading art critic. When she separated from him, she took up pottery at the age of sixty, for solace, and made some good pots before leaving us.

There was another woman potter who came down from London to see us about this time, Lucie Rie. A young Austrian artist of great sensibility, already with a reputation in Vienna, she was trying to find a niche in England. She did not become a student of mine in the ordinary sense and her pots do not show any of my influence, although she says I slaughtered her at Dartington, where she came to meet me just before we entered the war, and that I changed her course. I must have been employing some of Henry Tonks' methods, having suffered and learned thereby. There may also have been a lingering prejudice against Viennese arts and crafts.

She was and still is a very good potter. Today I think Lucie Rie's

pots display the great and persistent elegance of a fine woman artist. Her shapes are feminine, but clear and firm, sometimes austere and always expressive of her natural character. She still works alone in that little house in the blind mews, which used to look down on tennis-courts, trees and an archery, almost on the northern edge of Hyde Park, close to Marble Arch. How did Freud's architect son find it? How did he fit in her hand-made Viennese furniture as though it was designed for this London home and workshop? During the war it became known as 'Lucie's hotel'. I often arrived at Paddington on the night train from Cornwall and walked along to her flat through the shrapnel and broken glass on the pavement and, sometimes a bed hanging out on a third- or fourth-storey window looking over the Park after a night of bombing. This Austrian potter did find refuge, the love of many English people and a new home. I am proud that she was honoured by the Queen with an O.B.E.

My first meeting with Muriel Rose was in 1924 or 1925 when she was helping Dorothy Hutton in her Three Shields Gallery just off Church Street, Kensington, and where I showed my first lead-glazed notched dishes and jugs while at the same time exhibiting stoneware pots at Paterson's Gallery in Bond Street. The stoneware naturally showed more Oriental, the slipware more English, influence. It must have been about this time that Staite Murray's and my pots began to be called 'Anglo-Chinese'. The leading art critic of *The Times*, Charles Marriot, praised our work and perhaps as much as anyone, was responsible for such pots being regarded as works of art. Michael Cardew and I were certainly the first to go back to the English eighteenth century, and later to the thirteenth-century English traditions for inspiration. It should be clearly stated, however, that we never copied them any more than we copied the Chinese, Korean or Japanese pots.

Following an exhibition at the Little Gallery of traditional textiles and other crafts which I had selected and sent from Japan during my journey in 1935, a show of Hamada's and my pots was held. I remember Mark Tobey came. At a subsequent exhibition of my pots in the Little Gallery, Charles Laughton bought many of my best pieces, and Muriel Rose and I were invited to dinner with him and his wife, Elsa Lanchester, in their flat in Bloomsbury. Laughton had an intuitive appreciation of beauty; he recognized the incomparable quality of

Hamada's work, and purchased many pieces. He was making a Rembrandt film, and the room was filled with large photos of details of that great artist's paintings. What a depth of study! He told me that of all his work, Lincoln's Gettysburg speech from the film *Ruggles of Red Gap* was his favourite. How well they foiled each other, he and his wife; how delightfully and spontaneously they proceeded to act and play the fool round a sofa in that room! I showed them the sixteen-millimetre films I had taken in Japan, including the one of the old-fashioned Japanese spy mentioned earlier.

The Little Gallery came to a close as a result of the outbreak of war in 1939. Henry Rothschild later opened another craft shop quite nearby, Primavera. It was quite different – a man's enterprise. For years, nevertheless, it and the Crafts Centre on Hay Hill were the headquarters for craft lovers. We exhibited at both. The Crafts Centre was the outcome of the wartime committee of which I have written. These were the galleries we have known best; since then there have been many more in London.

Of my individual pots, the first exhibition following the war was held at the Berkeley Gallery in Davies Street in 1946. I recollect making a number of nine-inch-square mounted and framed decorated stoneware tiles. Almost all the plain or painted tiles I had hitherto made were four inches square and intended for fireplace surrounds and hearths. Of these we made many. Occasionally I have enjoyed making larger ones, even in composite sets, purely as wall decoration. The technique has always been brushwork in iron – black to rust – sometimes sharpened with sgraffito. Often I dreamed of making a large set, hard, austere and enduring, suitable for a church or cathedral, but the opportunity unfortunately never came. A photograph of my relations, friends and students was taken outside the gallery before we all went off to a Chinese lunch in Soho, and then to a film of the St. Ives Pottery shown for us at the B.B.C.

I recollect that during this first exhibition following the War, three other remarkable shows took place at the Victoria and Albert Museum: first, the Henry VI sculptures from Westminster Abbey taken out of their safe-keeping during the bombing of London; as fresh as when they were chiselled in the fifteenth century; secondly, a memorial room of Edward Johnston's wonderful calligraphy; thirdly (and surprisingly), a great roomful of Picasso and Matisse paintings. When I

Plate 21(a)　Erosion on Colorado. Stoneware tiles, about 1952

Plate 21(b)　Winter Landscape. Pine trees in snow. Stoneware tiles, 1960

Plate 22(a) Deer at night. Tile, 1971

Plate 22(b) Fish. Brush drawing, 1960

Plate 23(a) An owl. Plate design. Pen and wash, 1966

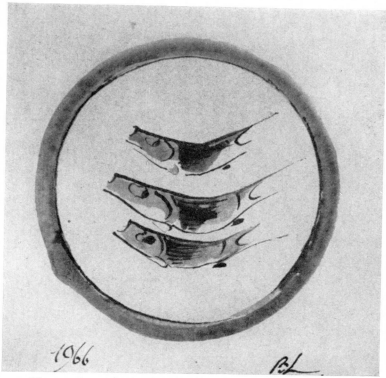

Plate 23(b) Three fish. Plate design. Pen and wash, 1966

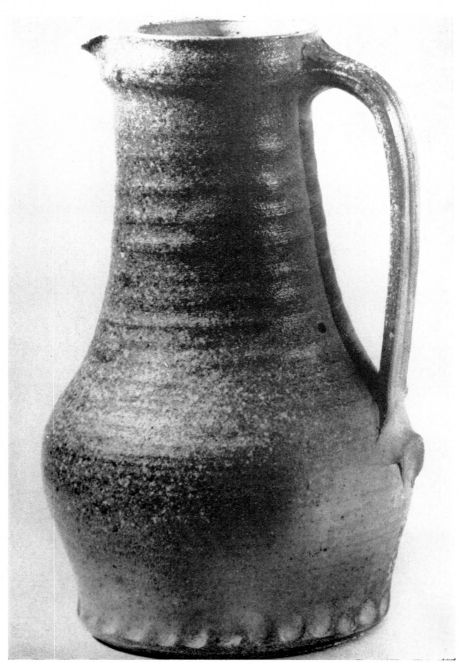

Plate 24 Medieval-style pitcher, about 1935

saw that central room crowded with excited people I gave up hope of studying the paintings and, instead, watched my countrymen, like a pack of hounds in full cry. I remember a retired admiral mopping his red neck, resting on the shoulder of his anxious little wife who was saying, 'Dear John, be calm, be calm – if you're not you'll have an attack of apoplexy.' The previous day the daughter of Holman Hunt, the pre-Raphaelite, had jumped upon a table, haranguing the crowd with a stout umbrella in her hand – I have never seen the English public so upset by art!

In the last fifty years there must have been fully a hundred exhibitions of our pots in England and abroad, including a retrospective of fifty years of my work, sponsored by the British Council, in 1961. The catalogue contained two articles by my Japanese friends Tomimoto and Yanagi, and one by Dr. (now Professor) J. P. Hodin, who wrote with the breadth of a European mind.

The following article, written in 1946, reflects thought born during and after the War and carries the reader on towards the fifties.

Joy in Work

I will attempt to write about a Movement in which I have participated both here in England and in Japan, which started about the year of my birth – 1887 – with Carriès in France – and a little earlier, I believe, with the Martin Brothers in England, and is part of a counter- but not necessarily anti-industrial revolution which finds expression in artist-craftsmanship in many countries besides England. It marks the beginning of the return of creative and responsible enjoyment in fine workmanship.

A new kind of studio- or artist-craftsman has sprung into existence. He belongs neither to the peasantry nor to industry. In many cases, as in my own, the training has been that of an artist and has been preceded by a reasonable degree of education and possibly culture. The result has been a great widening of outlook in the world of pots and the consequent birth of personal synthesis in form and pattern.

In ceramics the sensitivity of the artist-turned-potter has found stimulus in the work of every age and country from Neolithic bone-smoothed wares of prehistory, black and red with the smoke and flame

of primitive open fires, to the height of perfection of form, pattern and glaze in the Chinese T'ang and Sung cultures; or to the delicate 'sky after rain' celadons of the hermit Kingdom of Korea; or to the 'white of of the moon', thick carved porcelain, with pale and sleepy blue pattern, when the Korean Koryo dynasty gave way to the Yi period.

When I left England in 1909 the museums of the Western world held but few specimens of such pots. Most of them have since been disinterred from old Chinese and Korean graves. For centuries we have been accustomed to the comparatively artificial perfections of a late Chinese court taste. Elaborately enamelled porcelain, imported by the English and Dutch East India companies, stimulated our own sophisticated court circles and caused widespread emulation of Chinese porcelain to take place all over the West. For centuries fantastic efforts were made to copy this hard, translucent, white substance, the secret of which was only revealed through the letters of a French Jesuit, Père d'Entrecolle, from Ching tê Chên in the early eighteenth century.

When, however, I returned to England in 1920, Sung wares had been given the place of honour in the museums of Europe and America where, prior to my journey Eastward, the wares of Ming and Ching had held sway. This change of values in ceramics was as great, or even greater, than corresponding reassessments which occurred about this time in our painting and music. It was greater because we had no European pots comparable in refinement and nobility of conception. Beyond the discovery of yet another field of delight for the spirit of man was the apprehension of a supreme epoch of culture expressed in clay. Herein the West has begun to perceive the complementary value of the East perhaps more keenly than in any other direction. Those Sung pots in the Chinese Exhibition at Burlington House in 1935 gave us in England the seismic tremor of great art. The proof of the depth of an impact lies however in its outcome – what we actually do as the result of being deeply moved.

At this point we may consider the English potters. How many of us have there been since the beginning of the counter-revolution started by Morris and Ruskin? And what have we achieved? Behind half a dozen or so well-known names stand two or three times as many younger men and women who are clamouring for an adequate training. These people come out of the bitter destructive experience of War. I

am told that there is a still larger proportion of young Germans and French who gropingly seek a means of positive and expressive life-work in the making of pots.

And the achievement? We who live in smallish islands off the coast of Europe, and our Japanese confrères who live in corresponding isles off the coast of Eastern Asia, were the natural repositories of the cultures of a continent. These two countries have been better equipped to absorb and assimilate the varied stimuli offered by evolving circumstance and it is for this reason that I think they have produced the best modern pots.

(1974: Here it is not necessary to repeat what has already been included in the earlier part of this book. The only emphasis required is a statement that I was the only foreigner to receive an Eastern training, and that the advent of the first-rate potter Shoji Hamada with me carrying these traditions to the West has undoubtedly led to the new and widespread interchange of aesthetic values.)

It is an odious thing to praise oneself at the expense of others but this is not a judgement of personalities, nor will any informed person accuse me of race-prejudice. I love the French and I have a great respect for the way of life evolved in Scandinavia, but the pots which come from these two sources strike me, and most of my fellow English and Japanese potters, as lacking life, for all their smooth and conscious control.

In France pots have not been produced with the same flow of national and international genius as have pictures, partly perhaps because of the artificial barrier created by the over-distinction between *beaux arts* and *arts décoratifs*.

In America there are many individual potters but it appears to be too early for their mature cultural expression.

Again, in Russia, pottery does not seem to have been at any time a national form of art, and it is difficult to see how hand-crafts fit into its present economic pattern.

China has suffered too much decay, disorganization and invasion to show comparative modern expression.

It is not inappropriate that in Europe, England which was the birth-place of the Industrial Revolution should also be a source of counter-revolution.

This brings me to the necessity of speaking from my own ex-perience as a link between Japanese and British potters, because the

influence of each upon the other has been remarkable and has contributed vitally to this modern Movement. The War hit British craftsmanship hard. The thread of continuity upon which traditions of right making depend has worn very thin during these six years.

Crafts such as pottery are sustained, as it were, by a slow passage of time: the gradual transfer of the bodily knowledge of the right usage of material and the intimate co-operation of small groups of workers. Break those threads, disperse the men and their tools, and an heritage is lost for ever. This is one of the contingent tragedies of total war and it is the more poignant because craftsmanship in its essence is the counterbalance of mass-production and the conscious craftsman is the type of fully responsible worker, without whose love we reach death.

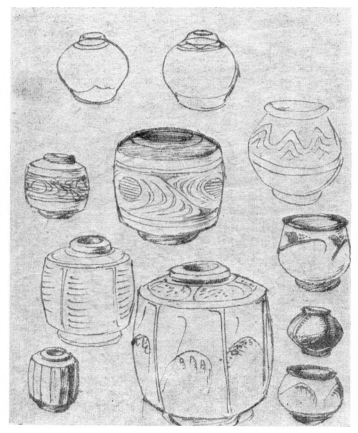

FIG. 13. Eleven pot designs

Chapter 17

NORTH AMERICA, 1950-1953

I have spent four periods of about three months each in America. The first, when aged ten, on my way to England for schooling, in the care of my aged and sick great-uncle Granville Sharp. How vast that land as seen from childhood – I remember unending sage-brush plains passing the windows of the train carrying us from San Francisco to Chicago. I was lonely and very bored – my uncle was shut in a compartment to himself. I had no one to talk to and nothing to do. In Chicago our horse-drawn carriage rattled over the cobblestones–which may surprise American readers today. I recall very little else except the terror that overcame me and has haunted my bad dreams ever since – when my aged uncle got out at a train stop to buy something and I feared I would be left alone on that seemingly endless plain.

Early in 1950 I was invited by Robert Richman, the director of the Institute of Contemporary Art in Washington, D.C., to visit the United States. He had organized a series of what I found to be called 'seminars', in which for a week I was to demonstrate and lecture to groups of potters in various centres. I stayed with him and his wife, from whom I received kind hospitality and helpful advice about the long journey. An exhibition of our work at St. Ives travelled independently to museums all over the States.

It may help at this point in time to record a few impressions formed during this second visit to America. That incredibly tall New York! Friendly? No. Exciting? Yes. The man-made canyons of architecture. I felt particles of dirt hit my face. I could not love it as I loved London,

or Paris, or Rome – each heart-warming in its own way. I craned my neck out of the taxi on the way to the station but was unable to see the tops of the buildings we passed. On the four-hour journey to Washington I wanted to read, so at the station news-stall I put down a quarter as I had watched other people do, took the top fold of the New York Times and turned away, but the chap in watchful charge said, 'You've left more'n half behind' and handed me a great wad of newsprint – making a total of about seven pounds in weight. In London during the postwar period any newspaper was but a single sheet.

On the Pullman the man sitting next to me started a conversation, 'Say, that pad you are writing on is sure Japanese paper, isn't it?' So I explained how I came by it. He told me that after the occupation he had been in charge of re-afforestation in Japan, to replace the ravages of war. We talked, discovered people we knew in common, Japanese characteristics and so forth, with some interest. Then each fell to writing letters. But at some stop suddenly he was gone without a word. This incident took me by surprise and I later recounted my experience to an American friend in Washington, who just shrugged his shoulders and said, 'Big country, you know.'

I noticed how those enormous plank-like American cars which I so disliked in England looked somehow right in the wide open spaces of America. Kindness and generosity abounded; nevertheless I missed the old, tap-rooted inbred intimacies of a small country. England has sailed the seas for centuries; it has fought and sometimes lost, and thereby learned. For me the question was had America produced a potter as it had given birth to a Walt Whitman, as a poet singing with the voice of a new continent?

When I came to teaching in Washington I did not find a standard by which their contemporary pots rang true and beautiful. Nor did I discover it at the chief centre of pottery-teaching in the United States, Alfred University, in up-state New York. That a pathfinder will emerge as have poets, prose-writers and some artists, is my greatest wish not only for America but for all the newer countries such as Australia, New Zealand and South Africa. So far the only pots which express the land and the people have been native pots, 'born, not made'.

How dare I be so arrogant? Am I? I don't think so, but neither shall I defend myself. This is a matter far beyond personality. It is the question for us all – what standard is true for the whole horizon of a

round world looking at itself for the first time in history? It will inevitably be found by perceptive people everywhere, from the best achievements of the past. In large measure this has been found in the pots of China of the classic Sung dynasty, and were it better known, I would add those of Korea.

It appears to me inescapable that if there is difficulty in discovering a standard whereby the true and beautiful may be fairly readily distinguished from the false and pretentious in the background of old cultures, surely there is no need for surprise or offence if this proves yet more difficult to attain in the newer countries. The issue is urgent and will determine the directions of our endeavours not in arts alone, but in the very nature of work itself. America stands at the crossroads of Eastern and Western thinking. The two World Wars have caused New York to take the place of London as the world's financial centre; to that extent the British future lies in America's hands. What other country was in the position to assume leadership which was as rich, as generous, as desirous of peace? War had almost beaten us to our knees. Here then, is the place where the greatest world wisdom is called for, *now*. Here then let us observe and take counsel for humanity's sake.

Upon arrival at Alfred University from the capital, I was met by Charles Harder, the successor of Charles Binns, an Englishman who had originally started the serious teaching of pottery both commercial and artistic. Mr. Harder showed me round the old red-brick buildings, introduced me to staff, and found me good accommodation for the night. Next morning I made my way up the narrow hill valley to a simple canteen and awaited breakfast. A sleepy-looking undergraduate, with a woman's feathered hat on his head, came in. He weathered my surprised gaze with a lowering eye as solemn as an owl; no word! Presently in came another odd fellow with a ribbon round his waist attached to a small pram containing a doll. They grunted to each other. A scanty hum of converse went on amongst the otherwise fairly normally clad and behaved young people. I ate in silence.

When I joined Harder for an evening meal at his house I asked him and his nice wife what this performance during breakfast meant. He explained that this was a sort of selection by a month's 'hazing' of freshmen as to their suitability for a popular Alpha, Beta, Gamma or Delta fraternity. These unhappy lads had to pretend that such behaviour

was perfectly normal – and without protest! This and subsequent happenings caused me to wonder if the freedom the emigrating Pilgrim Fathers sought was all that free after all. Behaviourism seems to be governed with a heavier hand here in America, almost a religious aftermath. It may even explain, by a reverse process, why the stoneware pots I found everywhere showed some recognizable oddity, like a special coloured glaze in the hollow knob of a sugar-jar, rather than a convincing truth and beauty of form. Bottles with enormous balloon-like shapes and tiny necks were popular . There was even a period when the word went out that the 'one of a kind' potter was not self-respecting in his 'creativeness' if he condescended to leave any opening whatsoever to his balloon!

The set-up at Alfred was wonderful – better than in any school I had seen elsewhere, but living pots were absent. Wealth, technology, books and the consequent variety of choice placed before the young may twist their growth. Are these the signs of a huge indigestion or of something more serious? I am but a potter, some sort of artist, raising, out of long life and wide experience a cry of protest and warning.

The following American diary written during my travels at this time may help the reader to accept or reject the conclusions I reached.

'March 25th 1950.

I am riding in a train skirting the southern shore of Lake Erie between Buffalo and Cleveland – the lake comes to a flat land edge – solid and frozen. The comfortable voice of the Negro train attendant breaks in to ask if he can do anything more. This widespread land and its open-handed, generous people; he has been told that I am just out of hospital, which is true to the extent of three days – I was in the excellent nursing home attached to Alfred University with a bout of fever and its associated aches and pains. This I must have caught from Robert Richman, with whom I shared my room when he came up from Washington to give a lecture and catch up on my movements. Unfortunately, I was booked to give two talks on the day I began to feel sick, one at the request of the chaplain at Alfred on the significance of what I have been trying to bring home to the students – the necessary interplay between East and West in the culture of the future – and an overall religious approach to life; the other was my paper on the con-

temporary studio-potter, given at Rochester, seventy miles away over snowy hills.

'These were too late to be put off, so five of us drove over and I managed to get through and back again, and then more or less collapsed. The local doctor insisted on hospital for me forthwith: three days' complete rest, pills of all colours, two shots of penicillin in my behind, and here I am, shaky but just fit to travel and on the mend. It is a 'flu germ which is rampaging around – sharp and short. They were so kind in the hospital and the students sent in flowers and presents and messages, coming in themselves when permitted – I almost felt like a maternity case! I have received continual kindnesses – anything I seem to lack has been supplied, from handkerchiefs to hand-made tools, a hundred slides of various photographs for lecture purposes – rare pigments, kiln designs, etc. etc.

'In the mornings I demonstrated with stoneware, porcelain, slipware and, at the last, even *raku*. In the afternoon, I had an hour and a half of talk and discussion on one or another aspect of art and pottery – letting them choose. In the audience were Japanese, Chinese, Negroes and varied European Americans, men and women, aged twenty-five to thirty-five, and quite a few potters, besides a very keen staff. Charles Harder, his wife and son – very nice – warm and sincere. My closest contact was with Warren Gilbertson, who wrote to me some time ago and then went to Japan and worked with Kawai for two years, and later had an administrative job in Korea and really lived the life of the East.

'I enjoyed many meals with both students and staff, including one grand Japanese supper, a more formal dinner with the president and deans, an English tea-party, and finally the yearly jamboree – St. Patrick's parade and grand ball – all the men in tuxedos. The students paid $1,200 for a band from New York – crooners and music hall combined, and a young, dark, handsome, hard-faced girl sang with a voice that would shatter a brass gong! Either terribly slow shunting dancing, or wild fast jitterbugging. Every man had a girl – and how! I felt frozen and awed – critical for a time, but then relaxed. The transformation of the girl students from casual and untidy slacks, slushing about in snow-shoes, to the gorgeous creations of that night, was almost unbelievable. A couple of nice married women took me in hand and made me enjoy myself. Is this all going to my head? No, I think not: such sincerity and affection keep one humble.

'I wish I could convey the beauty of that winter landscape in snow – the "wine-glass" elms – the hills like marching Cotswolds raised a thousand feet. There was a six-inch fall of snow one night – temperatures were well below zero several times.

'Today is Passion Sunday. I got to Toronto at 9 p.m. last night, very tired and shaky, and slept late this morning in the hotel flat which had been booked – breakfast was sent up – food excellent – got my slides and paper ready, telephoned the Toronto Museum director who came with his wife and another friend, and we all lunched and then went to the museum with its fine art gallery. The city and people are closer to England than America – quieter, steadier, more Victorian. But the arts and crafts are behindhand and rather lost. The best American are better, and the worst similar. I stayed in the University Club as the guest of five associations, to whom I talked at considerable length. In the Central Technical School about fifty students daily – all very keen – some coming from as far as 1,200 miles. I have to broadcast presently and then to the Royal Ontario Museum amongst the T'ang pots with Mr. Spenlove who is in charge of the Eastern section and is a Bahá'í. He arranged for me to give a Bahá'í talk concerning East and West.

'April 8th.

Train from Chicago to Wichita, Kansas. Here I had the outstanding experience of being one of three judges selecting crafts for a local national exhibition. It had the advantage at least of avoiding the lowest common denominator of a large committee. Prior to the judging I was rather nervous, but in fact found that we hardly ever had a disagreement, never got angry and were united in choosing Tony Prieto's ceramic sculpture for the national prize. Since Toronto and Columbus I have gradually recovered from the 'flu which ended my time at Alfred, then Detroit (John Foster, a one-handed potter – head of the art school – and his wife; very nice), south to Ann Arbor, where I stayed with Jim Plummer and his family – he knowing and being liked by my many friends in Japan. Again lectures, pottery parties and many very keen students. All the potters' problems acute here in this melting-pot.

'April 22nd.

To New York where I was called rather suddenly to give a lecture and receive the annually awarded Binns Medal for ceramics. I remember before I could finish the first sentence of my talk a lady in the audience interrupted with the question, "Say Mr. Leach, tell us where you got your tie." The tie was given to me by Phyllis Barron, the best printer of textiles in England and I still have it. The medal was the first I ever received and I was rather shy about it, although at Alfred I had been offered by the university an honorary Ph.D., which took me so much by surprise that I begged to be excused, for it was in philosophy! Perhaps belatedly I owe them an apology.

'April 24th.

9 p.m., by air to Minneapolis. I got in about midnight with two touchdowns en route. What a day! We are passing over Detroit once more – a marvellous sight with all its myriad lights and the neon colours in a lovely pattern of man-made starlight with the shadows of central skyscrapers looming, and winking signs – arterial roads reaching out to dark country areas.

'April 30th.

I left the MacKenzies – with whom I had stayed in their country home – at Minneapolis Airport at 10.30 and got to San Francisco at 6.30 – about 1,800 miles. The week at the twin cities of St. Paul and Minneapolis was very good.

'Now we have reached the Continental Divide – have left Denver, in Colorado, and are about to cross the Medicine Bowl Mountains, heading for Salt Lake City in the state of Utah. Altitude 18,000 feet. Snows below and blinding sun – 300 m.p.h. A rare roadway winds through treeless badlands, and on it we can just, and only just, see an occasional car. Erosion, escarpments, snow, cloud-fleece, and shadow-brown earth. 5 p.m. Sun westering – shadows of rocks – red sandstone – Salt Lake in sight – a vast, fifty-mile lake ringed with magnificent mountain-ranges – limpid blue air, and in it, two eagles circling amidst landing aircraft.

'Later – now over the Sierra Nevada and slanting down over rich lands to Sacramento, San Francisco and the Pacific.

'Pottery in San Francisco seemed to me tending towards exaggeration more than elsewhere. The nature background and the climate are so benign as to cause this evidence. Nevertheless a little south of San Francisco lived Tony Prieto, a nice Italianate American potter, who was selected for the national prize award at Wichita, and of course to the north in the redwoods were the Wildenhains, (of whom I write more later).

'May 12th.

From San Francisco to Seattle to spend two weeks with Mark Tobey. Within five minutes of leaving the airport on a lovely afternoon there was not a sign of man below us – no roads – no tracks on the hills. We ran into light clouds and flew at about 15,000 feet with the shadow of our plane clear on the starboard side. The cloud thinned and the shadow was gone, but no, there it was tiny on the white of a snow-capped peak: cloud again, then the ice-cap of that mountain less than 2,000 feet below, no bigger than a football field. White peak followed white peak, loop after loop – a succession of mountains, each comparable to Fuji. Sometimes a good port or starboard window – well placed, can provide incredible beauty. As a plane banks at night rounding a great city, one hardly knows if the starry firmament is above or below.

'Mark lived with a Scandinavian friend, Pehr, in quite a large house. He had cleared out half a bedroom for me, obviously with some effort and pride. But that was a man's house, full of Markenzian knick-knacks and rarities combined, endless coffee cups filled with butt-ends of cigarettes and half-hearted remnants of attempts by once-a-week women art students to clear up and sit down! Other women did not enter that domain, and the snarls between Mark and Pehr reminded one of the carnivorous area of the zoo. What a house! Still, Mark had an ambiance of loving friends; he is a unique person. Whatever his eccentricities he was at one and the same time a humble man, and one who knew his own value as an artist. He took me round, introduced me to friends, showed me his peculiar delights in the least expected combinations of shabby older buildings. His eyes roved; his forehead bulged and wrinkled with despair or laughter.

'One Friday he announced for the week-end a good hotel in Victoria over the Canadian border. On arrival the whole staff came towards him like moths to a lamp. We were fixed up in a luxurious bedroom with

comfortable beds from which we could discourse during the small hours and have vast, late breakfasts. On the Saturday he voiced his desire for a new suit, with a nice subtle yellow pullover. I had all the clothes I needed so was immune from his blandishments. The tailor, needless to say, was first-rate.

' "Now", said Mark afterwards, "I can take you round my circle of curio shops." We loitered from one to another, he picking up the oddest trifles, some well-worn wood off the foreshores, a native wood carving, an old V-shaped wine-glass: he growled at me, "Bernard, does nothing interest you?"

' "No, Mark, I have no handy dump here, and yours is full!"

'In, I think, the sixth shop, I found a collection of eleventh- to twelfth- century Chinese bowls and bought a beautifully engraved translucent Ying Ching example for £35. That, my single purchase, took the wind out of Mark's grumble – I bought it only because of a long suppressed desire for such a piece. We must have spent at least a couple of hours completing that circle, so when Mark, unaware that I was weary, commenced to re-start the round, I sat on the edge of the pavement on strike! He gave in.

'I sail from New York on June 19th with Warren and Alex MacKenzie, who are coming to work at the St. Ives Pottery.'

On the journey back to England I felt compelled to express my honest reactions.

'Mid-Atlantic, 1950.

After ten weeks' teaching, 12,000 miles of travel and upwards of a hundred talks and lectures – a week for retrospect here on this dividing ocean.

'For me it has been an intensely interesting and enjoyable experience: I have encountered generosity, warmth and enthusiasm everywhere, and my life has been enriched by many friendships. The tale is told and already outlines blur, but in the kaleidoscope of memory patterns begin to form.

'The new perception which came was a sense of thankfulness that I had been born in an old culture. For the first time I realized how much unconscious support it still gives to the modern craftsman. The sap

still flows from a tap-root deep in the soil of the past, guiding the sense of form, pattern and colour below the level of intellectualization.

'Modern art is inevitably eclectic. Abruptly in the unfolding tale of humanity, we have become the inheritors of all history and geography. The ancient barriers are down at last. North, South, East and West are ours and all the cultures of the world open their secret doors to us. Picasso – the Catalan – hurls banderillas of many patterns, Parisian or Peruvian, Primitive or Greek – a great acrobat that he is. I cannot however, call him a potter, and if a thousand young French potters ape his brilliance of invention and verve of draughtsmanship and colour, it is just unfortunate for them and for us. Would they have been any better able to find themselves in their quiet roots without him? There is the gist of the modern problem – *to find one's quiet root.*

'Americans have the disadvantage of having many roots, but no tap-root, which is almost the equivalent of no root at all – nothing but their own individual choice to depend upon. Hence their pots follow many undigested fashions and, in my opinion, no American potter has yet emerged really integrated and standing on his own two feet – not as much as Hamada in Japan, or Michael Cardew in England. Nor of painters such as Cézanne, Matisse, Braque, Rouault, nor even Americans such as Ryder and Whistler and the poets Whitman and Eliot. The poem, the painting, the pot, must be the real man. So far no evidence of such genius have I seen today. The Pueblo Indian uses his ages of traditional rightness, his own ancient confirmations. The problem we face today in this over-conscious, over-educated age, with all its added complexities, is the absence of confirmation. A few artists, a few potters, have been able to draw nourishment and power through their own pores from the streams that flow beneath the earth.

'The American Indians, of course, together with the "folk" anywhere do not proceed on individual choice, and the root in their case is the race-root. It is a humbling fact that so very few of our evolved, educated, self-conscious, even world-conscious potters, can stand the test of comparison. And yet a real judgement in pottery must be based upon the highest standards of the past constantly checked by the present, as in all art.

'It is for an acceptable criterion of beauty in pots that I have been most constantly asked – this seems to me the only possible yardstick. I have also been asked for tricks of the trade, and have tried hard to

place these questions in their subordinate place, for to pursue them as short cuts is futile, resulting in skilful attempts leading nowhere.

'That these humble, ordinary, unknown artisans of the past help to set us a standard is an encouragement, for it offers prospect as well as retrospect, art as part of normal life, not something separate or reserved for superior people. It tells of a buried potential in us, cut off from expression by our post-industrial way of life. But the overflowing life-force and sensibility of exceptional talent is not thereby excluded.

'After all, it was the music of the folk which provided great composers with melodies and healthy stimulus, just as the work of unknown peasant potters serves the same function for the best artist-potters today. Behind both lies the immeasurable background of creative nature of which we are at our best focal points. This is our belief at St. Ives, where co-operative craftsmanship serves a creative contribution to society by bringing the two forces together.

'American potters and students have also asked me for practical criticism of their work; there seem to be certain weaknesses which are widespread – handles which are obviously stuck on and do not grow from within as branches grow from a tree-trunk: jug lips which will not pour without dripping: tea-pot spouts which are goitrous: hollowed knobs on covered pots which contradict the formal rhythms of the rest of the shape, leaving the whole form with a question-mark instead of a full stop and conclusion. The major thrown forms often strike me as unarticulated and uncertain, from lack of breadth and speed and freedom of throwing. Many of the clays were poor in throwing quality, and the wheels were seldom satisfactory, particularly those to which one had to stand sideways. For them nothing can be said – they are a great hindrance to students.

'I am informed that there are some 70,000 non-industrial potters in the United States of one sort or another. Granting that the bulk of the work turned out is not worth serious discussion since it is little more than money-making enterprise of ceramic "novelties", the fact remains that there are hardly any serious potters who can make a living by pots alone in that rich country. It is much the same elsewhere and the individual potter has to have other sources of income, usually from part-time teaching.

'In Cornwall we believe through group-work we have found the

beginnings of a new way of life, motivated by common ideals, combining the individual with the people's need. Perhaps the nearest parallel would be a small orchestra under a willingly accepted composer-conductor. Group work requires leadership but not of a coercive, economic, or merely technical kind, nor will democratic committees, with low aesthetic compromise values, carry us far in any field of art.

'American potters seem to fight shy such venture, perhaps from an exaggerated importance attached to individualism and the absence of economic labour. Students seem to rush through a training as quickly as possible. Art schools tend to foster this fast personal progress, and exhibitionism and prize-money is attendant thereon. One cannot help wondering if prizes always go to the best work. *Who selects the selectors?* Art education is not simple; the best artists usually emerge despite it or without it.

'A potter should start with an intuitive concept – he thinks of a combination of shape, pattern and colour which will answer a given need of utility and beauty at one and the same time. God knows from what sources the mental image springs. He can analyse that later if necessary; he brings love and experience, knowledge of material and technique into play as shadow following light – intellect supporting intuition – and so carries the image into actuality.

'From the foregoing it may be seen that I connect pots very closely with life. When society is in confusion or decay the artist and the potter have to seek what truth and beauty they can find for themselves. Going a little further, with insight and experience, the qualities of the man may be seen in the pot. We are more accustomed to the idea in the unapplied arts. To the trained eye, decision or hesitation, sensibility or dullness, breadth or narrowness, tenderness or sentimentality, nobility or the commonplace, are all nakedly exposed. There are, as well, other more formal values of aesthetic composition which must be taken into consideration in judging pots such as proportion, symmetry and asymmetry, positives and negatives, but they all come back to the manner of application. The manner is the man, so all through I have laid stress on the humanist approach, and I hope I have been humanist enough not to give offence by frankness to all those who have done me honour and shown me a thousand kindnesses.

'As far as crafts are concerned, I believe that far and away the best

training is in the workshop of a good craftsman. There the slow transfer of concept and technique can take place under conditions of apprenticeship and reality. The precepts of a man who practises what he preaches carry weight, whether he be a genius or a traditionalist carrying forward the vitality of the countryside. If one integrated potter could be found and persuaded to carry on a workshop with the assistance of students, I believe it would do more to foster the making of fine pots in America than all other endeavours put together. There must be a conductor for the orchestra, and the nervous student need not fear obliteration of personality any more than the musician. If he has genuine originality it will emerge, if not, let him in Heaven's name love pots enough to emulate the modesty of the musician.

'This was the only answer which was found in the Japanese Mingei Movement, and those who organized it – my old friend Dr. Yanagi outstandingly, in the closest collaboration with the most creative craftsmen such as Hamada. The planning in the main emerged from an internal drive, not the other way about – hence its vitality.

'If I am right in my supposition that there is no American potter who has reached integration, then it would be best to invite one from abroad, preferably from the East. America is at the crossroads in art as in life. So, too, is Western civilization in its suicidal pursuit of the external, at the cost of internal, spiritual and artistic values. But, as I have pointed out, Europe has old cultural roots which America has not in the same organic sense. For that reason Americans have a freedom of choice greater than ours, an openness and a more insatiable hunger. Two World Wars have thrust upon her global authority and responsibility.

'I am writing about art and deliberately make the suggestion that, since it springs from life and often has a prophetic character, the answer to the problem of the American potter may contain the seed for which we are searching.

'Every modern artist, the potter included, has to find his own world-synthesis of thought and action. He has to choose between East and West or to discover out of his own deep perceptions how they can dovetail. It is a question of marriage, not prostitution. I have seen so many stoneware, or pseudo-stoneware, pots from coast to coast which are mixtures, "Bauhaus over Sung," free form – unintegrated. Can they integrate? Can the free geometry of the post-industrial era assimilate with organic humanism of the pre-industrial? Is it a *mésalliance*? Is this

241

the cause of the potter's indigestion? The problem being approached from outside instead of inside? I believe so.

'What then is In and what is Out?

'That is the kind of philosophic question I have raised on this tour and for which, somewhat to my surprise, I have been repeatedly thanked. What are the primary values in potters' minds? How can a good marriage result from uncertainty? Does not this question hold the American potter in thrall?'

A World Craft Conference and its Echoes

Interesting and illuminating as the first series of impressions of America may have been, my third visit in 1952 with Yanagi and Hamada, to carry the message of our Dartington Conference – the interchange of two hemispheres – to the pottery centres of the United States was the most significant.

This gathering at Dartington of potters and weavers from all over the world was the first of its kind. About a hundred and ten selected delegates from Europe, America, Asia and Africa, included two from Japan – Soetsu Yanagi and Shoji Hamada. My idea of an East and West meeting and interchange was supported and welcomed enthusiastically by friends like Leonard and Dorothy Elmhirst, Muriel Rose, George Wingfield Digby and Lady Sempill, who together selected both pots and textiles for the British section.

At Dartington practically the whole of the quadrangle, the arts division, and beyond the lawns, the ballet school, were allowed to be used. Well-arranged displays of twenty-five years of British hand-made pots, of corresponding textiles, of work by the chosen delegates and of Mexican folk-arts, were blessed with ten days of perfect weather in the beautiful background of the Elmhirsts' gardens. Intimate exchange was already taking place within a few hours; groups formed spontaneously, despite variety of language. There were constant lectures, films, and demonstrations of pottery and weaving. It was evident that a great need of intercommunication was being filled. This culminated in a celebration at the end of the week when the great hall was cleared and the whole company danced. I remember the Spanish potter, the late Señor Artigas, who knew no English, one morning in the courtyard

with his dark eyes gleaming and his right hand like a toreador's, pretending to stitch the thumb and fingers of his left together. He kept us all in fits of laughter, so good was his mime.

My belief was and is that the East, and particularly the furthest East, has a significance for us in the West of paramount importance, representing as it does the greatest divergence of feeling, thought and action at a period in history when barriers between cultures are dissolving, and the need of mutual understanding and interchange is already greater than at any previous time.

Of the recollections of that conference at Dartington which stand out in my mind, one was a lecture given by the Paris representative of UNESCO, John Bowers, when more than one African rose protesting that they did not want charity, even from such a source. They did want help, but with complete freedom to ask for it. The other was Michael Cardew's long, vigorous, and well-informed off-the-cuff talk about chemistry and geology, for potters in far-away places such as Nigeria, where he was chief pottery officer. Minerals were named and every 'i' dotted, but at the close he admitted ruefully that the Chinese never possessed scientific knowledge yet made such magnificent pots.

Another incident stands out: amongst those attending the conference was an eminent chemist-engineer, Edward Burke, who was also a weekend potter. Previously I had spent many hours with him looking at large-scale local maps of southern Cornwall for certain types of rocks, the analysis of which he had obtained from the Science Museum in South Kensington. We would go out by car in search of them. This enabled him to make useful suggestions at the potter's discussion group. He was even able to tell us of the highly plastic clay called bentonite which would make any clay sufficiently sticky, and enable the potter to throw more easily. He discovered that soft soap, commonly used as shampoo for washing hair, added tremendously to this plastic effect.

A Belgian potter dissolved some bentonite in water, left it for some hours, then mixed it with a not-too-plastic porcelain body, with which he threw a wide fifteen-inch bowl, turned the lip outward and then, wetting his hands, ran them up on both sides of that bowl and closed it into a vase with a tiny neck. A gasp went round the assembly of potters. Yet in contrast to this scientific knowledge, there is the advice and practice of Hamada, who avoids the use of rare materials for the sake

243

of their astonishing effects, preferring the more ordinary from near at hand, which yields a simpler, more natural beauty.

Apart from the general pleasure and enthusiasm of this unprecedented international conference, it produced widespread repercussions. The Arts Council sent the exhibition of twenty-five years of English studio pottery and textiles on tour in Great Britain. I arranged to travel across the United States with Hamada and Yanagi, lecturing, demonstrating, and discussing the problems raised at Dartington; everywhere we received the most generous hospitality. The Buddhist aesthetic expounded by Yanagi held audiences of craftsmen and craft lovers; this philosophy was demonstrated by Shoji Hamada without many words. The double presentation of thinker and maker lit the imagination of art lovers wherever we went. Here was the silent voice of an Oriental telling the West with fresh clarity the virtue of man doing work in harmony with nature as it should be done – with heart, head and hands; here was the example of a potter, far from being dominated by intellect, showing us how it could support intuition in work from day to day – a man balancing in right tension between the two extremes of individualism and non-individualism. There had been time to digest earlier experiences; moreover the companionship of two such remarkable Orientals carrying a Buddhist philosophy and aesthetic, was unique.

From Washington we travelled southward over the Blue Ridge Mountains to North Carolina and a beautifully situated college of progressive education, Black Mountain. Hillbillies were still about, and for them pottery flasks or bottles used to be fired in hog-back kilns to hold hooch, which they distilled hidden in the hills. The potter in charge was the representative of four generations of an English tradition – he made huge jars with great ease and speed. Beside him his son, aged no more than seven, threw merrily on a small wheel his father had probably made for him. In the college were two established potters teaching, who made way for us and gave help. I remember one night when a forest-fire started, some of the thirty students who came from afar for the 'seminar' went out to lend a hand fighting the flames.

Life was free and easy. We had our meals together and for the first day or two we three fended off the usual requests for glaze recipes for which some of the students had come a long way, hotfoot. We told them incessantly that secrecy about glazes was sheer nonsense and that

we had none, but if they would put first things first, we would tell them about the materials and the principles upon which they could put them together for themselves. We explained that most wood or vegetable ash would cause clays and powdered rocks to melt into a sort of glass: they were astonished and remarked, 'But how simple.'

'No', said Hamada, 'much more complex because the chemical composition of such raw materials including ashes varies with the locality and the season of gathering.'

We talked to them about *hakeme* Korean stoneware pots – a method of combining or brushing white slip over a grey body – of which they had seen photos – so they naturally wanted to learn how this was done. Walking to the canteen for lunch one day, Hamada gathered some coarse wayside grasses in seed, made a bunch out of the long stalks as we sauntered along, bound the butt ends with thin string, and said, 'I think that will do.' Then he took some half-dried bowls he had thrown the previous day, dipped either the inside or outside in white slip, put one at a time more or less accurately in the centre of the wheel, turned it slowly and combed the wet surface swiftly with the bunch of weeds. These American students were astonished by his close-to-nature, nonchalant treatment. Some smiled: Hamada looked up and said, 'Simple, but not simple.' They laughed outright. Those few seconds established a meeting-point between East and West in America.

It was here, at Black Mountain, that I danced one evening with Janet Darnell and found her mind alive and intelligent. She told me that when I talked about 'tradition' nobody understood what on earth I meant. To these young Americans tradition was not virtue – simply old fuddy-duddy habit. Before we left, Janet begged me to ask Hamada if he would accept her as a student, if she could manage to get out to Japan. I had no idea that this would eventually lead to our marriage.

Santa Fe, New Mexico, was a different experience; for the first time we contacted the American Indian. We were to lecture and demonstrate at a new museum of international contemporary crafts. Prior to this we were taken by a very kind American lady who loved the Indian people, to the Pueblo San Ildefenso, to find if possible a famous woman potter, Maria Martinez, and her son, Popovi Da. (See plate 17b.) Amongst the adobe huts which constituted the village stood the Catholic church. What struck us in its interior, as elsewhere in other Indian villages, was that the religious paintings and the *retablos* or holy

figure-carvings were a true and moving art of the people, Indian interpretations of Catholic origin – a very strange combination with an American Indian feeling. Crucifixes ran with painted red blood – from the piercing nails, from the Crown of Thorns, the side, and the broken knees. I felt the worship of the suffering of the death of Christ over and over again – even in the appalling pre-Christian habit of painting temples with fresh human blood. Perhaps it was one way of expressing the span of life between the two extremes of agony and ecstasy to be found in the carved stone or pottery faces of the ancient native arts right down the length of both Americas.

Maria and her son were out and we turned to go, but something made me pause to look around over snow and roofs: sure enough there was a trail of smoke rising behind an out-building and we found her poking a mound of ash, out in the open, with a piece of iron, turning over a large shining black surface of pottery in the grey background of cooling ash. Eventually she hooked it out, greeted our friend and then spoke to us. We stood and talked, then invited her and her son to come to our first lecture at the museum at Santa Fe.

On that night the hall was full of white people, all except those two Indians in the finery of their hand-spun, vegetable-dyed wools and solid silver, jet and turquoise jewellery. They were the only people there who looked as if they belonged to that high dry altitude of eroded lands and clear long distances with dotted pinyon trees. I told the story of East and West and of the first interchange at Dartington and introduced Hamada and Yanagi. When I left the stage I took a vacant seat next to Maria in the centre of the room. After a few moments when Hamada began to throw, she bent forward, her hand on my knee, with mouth open, eyes staring in amazement. 'Why did you not tell us? Come to us again – anything you want.' We did visit her again and she gave me a couple of her smooth, hard polishing stones. It was quiet in her room – all barriers of race were down. I cannot recollect Yanagi's talk that night, although I can say that his depth of Buddhist aesthetics arrested the thinking audience even if they may have smiled when he pronounced rice as 'lice'.

Oh the miles we drove to Lawrence's Taos and other pueblos in that eroded landscape! We ate hot Mexican food and tasted the difference between wheat, rice and Indian corn as 'staff of life'. (Plate 17b).

The Indians had no kilns, nor wheels, nor had any wheel been known

before Columbus. Maria made coils of clay rolled between her palms to the thinness of her little finger; she sat and coiled, patted and smoothed a bowl, dish, cup or vase as simply and swiftly as a good knitter making a pair of socks, talking gently. When the shapes were half-dry they were polished with stones such as Maria had given me. Popovi Da painted this surface with a sort of brush made by chewing and spitting out the pulp of a certain leaf, leaving only the tough parallel strands of fibre to be used as a brush, which was dragged rather than freely painted; but the lines were often of beautiful curvature or close, clean parallels. The juice of the pointed leaf would remove the polish. The effect was powerful – matt on shiny black, and the final black colour of the red clay was due to carbonization during the firing in a clamp of pots raised on broken shards and burned for two to three hours using thin sticks and dried cow-dung. The clamp was gradually covered with wood-ash until only a tiny orifice allowed the last smoke to escape, which kept the slow current of heat dense at not over 700°C.

Hamada, Yanagi and I made an excursion purely for sight-seeing to the Grand Canyon with its thin thread of the Rio Grande a mile below, as though the steel edge of a sword had fretted its way five thousand feet downward during a million years. Between us and it were buttresses, spires, a myriad formations of the almost horizontal strata with the various colours of earth, gravel and rock. One's eyes travelled miles over the levels of the surface above away to distant mountains and on returning plunged with incredulous awe down the deep canyon and then up the other side. I feebly attempted to draw this incredible perspective.

At our comfortable hotel-cum-museum, Yanagi became excited by many fine examples of Indian crafts, some of which he purchased. I whispered, 'Please include that magnificent Indian corn-basket in your total.' It cost me eight pounds. It is in the corner of this room as I write.

The following day we traversed the wild western cactus countryside by train, through Colorado towards Los Angeles, where we stayed with delightful friends at the Pacific Palisades beyond. (See plates 21a and 21b.) I walked the beaches and drew strange running birds. By day we visited Chinese and Japanese markets in that vast city, and brought our purchases back. One special day we planned a magnificent Japanese sukiyaki dinner. Everyone loved it. Another day we had a

picnic right on the bare top of the Santa Monica mountains above. I can still see Hamada resting against a large boulder, his eyes gazing far over the expanse of the Pacific towards his homeland five thousand miles away.

Our address and demonstration in Los Angeles with the Japanese Consul in the chair was publicized. We found ourselves facing a packed hall of a thousand people, mostly potters. The Consul was as surprised as we were, for there were also hundreds outside who could not get in. We carried on for ninety minutes and then I said to some students wilting against the walls, 'There is a little spare room up at this end.' We were almost swept off the stage!

After our first engagement with the Chouinard Institute, we were booked for a week at Scripps College, at least twenty miles inland, but still part of that enormous city. There the social standards of the young men and women students appeared to be somewhat better.

We were invited to spend a couple of nights high up on a mountain in a house built around a warmed swimming-pool. One could practically dive in from one's bed!

Towards the end of our visit in this unbelievable State of California, we stayed with the Japanese Consul, whose house overlooked the Golden Gate Bridge in San Francisco. This surely is one of the most beautiful as well as enormous suspension bridges in the world. Its two piers rise 750 feet above the water, and the curves of its suspension cables admirably fit the landscape. (See plate 13b.)

One day a party of us drove north over that bridge to visit the redwoods and to see the most ancient trees in the world, the *Sequoia gigantea*, upwards of 4,000 years old. If my memory fails me not, one of these gnarled and hollow trees, of which I made a drawing with Hamada standing in front, was twenty-nine feet in diameter at ground level. The cathedral silence of those red-brown, heavily barked redwoods rising to more than a hundred feet before any branch could be seen, left the most powerful impression: the light was dim, the mood sanctified. Their great age was due in part to the fact that the thick, close-grained bark resisted forest fires.

Eventually we emerged, making our way up the side of the valley to visit the Wildenhains, German potters attached to the Bauhaus of Weimar days. Margaret Wildenhain was very capable but too outspoken for American taste; even so, she wrote a good book. I recall her

248

complaint that the shallow expectation of American students to learn complex pottery in six weeks was ridiculous. She added that the only would-be applicant of whom she approved was a Chinese youth who had begged to work with her, saying he was ready to do any kind of hard work and if necessary to sleep under the table! In the afternoon we drove back along the coast – rather like ours at St. Ives; lovely walking country, but apparently unused.

Before leaving the mainland I would like to mention two of the many students we have had from both Canada and the United States. Warren MacKenzie and his wife Alex, who returned with me in 1950, during part of their stay lived with me in the Pottery cottage. A warm friendship began which has continued to this day. When they returned to America it was to a farmhouse some miles outside the twin cities of St. Paul and Minneapolis, where he was made a director of the pottery section of the university. Two girls were born of this happy marriage, and then Alex was told she had cancer and only a year to live. This blow was taken with a rare and splendid courage. The children were taught to accept the inevitable in a positive way, looking at the balance of joy and sorrow squarely in the face. Warren did everything for his wife and children single-handed during her sickness, and for the girls after her death. He retained his position, continued to run his own pottery, and has not remarried. I am sure he is a good teacher and that he and his wife were much loved and respected. In pottery he did not aim at competitive reputation or high prices. I remember once when I stayed with them: deep, crusty snow over the landscape; about eight o'clock one sunny morning some of his friends drove up to buy a batch of pots almost hot from the kiln. All were gone by mid-morning. This was their method of selling. His inexpensive pots are first and foremost for use.

John Reeve, a Canadian, came later: so different from Warren Mac-Kenzie in temperament, yet I think of them almost together, although there was a gap of quite some years between. Warren, as his surname suggests, was sandy and of Scots descent: persistent, tough, reliable – whereas John was of some darker breed: bald-headed, gentle, modest, lovable; there was a soul behind his searching eyes, a mixture of poet and priest. Men as well as women found friendship in him. Perhaps for these very poetic qualities it would not be wrong to add that there seemed to me to be a sort of wandering waywardness in his make-up,

but his lovable nature and ingenuity always brought forgiveness in its wake.

When I landed at Seattle for the second time, there he was with his lovely wife, Donna, and his Land Rover, eager to meet again and to find a nice motel on the banks of some wooded lake. Before leaving the built-up area of the city he had refused to look twice at any ordinary motel, so we drove for miles – cold miles – past winter-closed establishments in the freezing Land Rover. John's jaws were locked – he would not relinquish his dream world; he was short in speech to Donna. I caught her eye of pity for him and for me too. She was so cold, yet patient. I was freezing also, grim against complaint, but finally there on the opposite side of the road we came to the very first motel we had passed, and suddenly we all gave in. Soon we were in hot baths, melted, warm and hungry. We talked and talked for hours, knitting up the ravelled sleeve of time and care. I think it was the next day we parted, almost in tears. Was it not from John's that I flew on to Warren near St. Paul? My memory has become so blurred. Does it matter so much? I did introduce those two, Warren and John, by letter, and they became friends and John went and worked at St. Paul for some months. We still keep in touch by circulated cassette.

How favoured I have been in friendship, both with men and women – the best thing in my life!

From San Francisco we took wing to Honolulu. In the Hawaiian Islands – a Pacific playground of mixed races – life is easy-going. There is but little colour prejudice. We spent half a day on Waikiki beach, where I was even persuaded to mount a double surf-board and lie flat at one end whilst my host balanced the craft from the other, racing a hundred and fifty yards at least towards the shore on the white crest of a ten-foot wave. Others were on catamarans balanced beautifully on the surf crest, sometimes with one man on the shoulders of another, and when these were natives of the islands the flash in their smiles held pride of prowess as they passed us. When we reached shallower water I gashed my foot down on the coral. It was not a bad cut but reddened the blue sea, and of course I should have been warned. I have never in all my life seen such an array of coloured shirts as worn by the American visitors on the verandah of that hotel.

At first we stayed with the man in charge of the pottery section of Hawaii University, but friends of Yanagi and readers of his books

invited us to visit them – one a well-to-do Japanese doctor. We enjoyed the food, above all the fruit which grew so lavishly on those volcanic islands. The day started with papayas and tea on the verandah; papayas, with their black seeds, were the best possible food for that moment. There were bananas, of course – even Chinese lychees grown

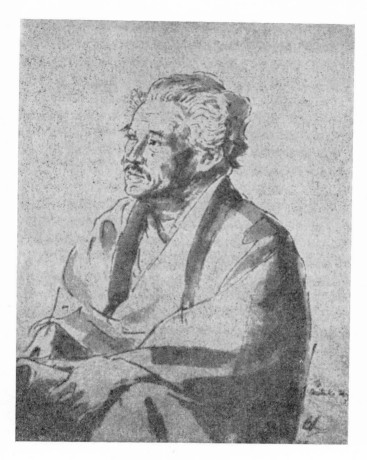

FIG. 14. Soetsu Yanagi

locally. Guavas choked the roads; we saw the cultivation of pineapples –bright green against an orange-red soil, ridged as I had not seen a plough ridge elsewhere, making marvellous patterns against the steeps behind, which were the grey cliffs of a once active volcano.

We drove slowly round the island enjoying the warm airs, seeing

the swaying grass skirts of the Hawaiian girls dancing in rhythm under coconut trees against the background of white Pacific rollers out at sea. I remember one day we made a circle to the other side of the island and round a pass through the steep slopes and back to the town. Here it was that the Queen had her palace. Here it was, I believe, that the struggle for their independence took place. Now Hawaii is an American state.

We visited the other, larger, island and drove high up to the lava lake. In the morning, eating our papaya on the hotel verandah, we looked out over the crackled expanse of the almost cool lava, and from it I saw that rare bird, the bosun's mate, emerge – no doubt it used the lava because there was enough warmth to incubate its eggs. We climbed to a height of seven or eight thousand feet up grassy slopes peopled with strange-shaped prickly-handed cacti with purple flowers and fruit.

When we finally reached Japan in the spring of 1953, the task of reporting our experiences in America and the Hawaiian Islands remained. In Japan, besides the main centres in Tokyo, Kyoto, Osaka and Kurashiki, there were by this time more rural museums and craft centres scattered from north to south to visit. We made an almost circular journey round the main island of Honshu. The whole of this sequence is reported in another book, *A Potter in Japan* (published by Faber and Faber) which has been widely used by travellers seeking little-known Japan. (See plates 15a, 15b and 18a, 18b.)

Chapter 18

LATER DEVELOPMENT AT THE POTTERY

After many months of reporting the Dartington Conference in different parts of Japan with Yanagi and Hamada, a second letter came from Janet Darnell, the student at Black Mountain College whom I remembered rather well from our recent American journey. I had noticed her unusual intelligence and had approved of her original application to become Hamada's pupil. We read her second letter and talked it over. 'I know she's a woman and there are no women potters in Japan, but I feel this student is exceptional', was his comment. I agreed. So eventually she crossed the Pacific and we met in Tokyo, and then I saw her off at Ueno Station en route to Hamada's.

We did not meet again for some time, but when I did get to Mashiko again, I found her living in one of the two rooms in the second long gateway between Hamada's old house and the workshop. She seemed very happy there, but was only participating in making moulded dishes, fettling, etc. as she had no wheel – she never did have one at Mashiko. Occasionally Hamada talked seriously with her, but it seemed to me that he was testing the strength of her intention in an endeavour to find out how much of a potential potter lay within her. She joined in the work whenever she could with Hamada, no doubt, keeping an eye on her. Later he began to discuss the possibility of going to a good traditional workshop elsewhere to help find her own expression. Finally Tamba was agreed upon, where Janet eventually went to live with the Ichino family.

During the first summer, Janet joined us at the Japanese Kazanso

Hotel, Matsumoto, armed with her typewriter, to help me with *A Potter in Japan*, the book I was engaged on. We used whatever time I could spare for this purpose. Living in Japan she had become accustomed to not pushing herself forward, because it was a man's country. She saw clearly that to get the best out of her experience, she would, as a foreigner, have to play a retiring role. I was surprised by her perceptiveness.

The proprietors of the hotel were old friends of Yanagi's, and with their staff treated us with the greatest kindness; during the hot months of July and August we had a wing to ourselves. Yanagi was hoping to gather from the conversation between Hamada, Kawai and myself, the material for a book on the beauty and techniques of pottery from all over the world. (See plate 20a.) Always as we discussed wheel, clay, texture, form, pattern, colour, kilns and their firing, a strange phenomenon showed itself – that our knowledge was by far the least regarding ceramics in Persia, which it is true lies in the East but nearer to the West, with a Mohammedan modality. The extent of earlier exchange has been surprising. This may clearly be seen by the influence of Sassanian silver on the earliest Chinese porcelains of the eighth and ninth centuries, but of Persian techniques we knew little. We must not forget, moreover, the percolation of Greek influence in the early Christian centuries, even as far as Japan, through Graeco-Buddhist sculpture owing its origin to camp-followers of Alexander the Great, left behind in India.

Yanagi made his notes at night from memory, and hoped to get that book finished during our two summers up there, but it was impossible for me to draw the necessary illustrations in the time, partly due to my absence when I was called away to attend an unexpected meeting of UNESCO in Tokyo. Thus, for the reasons given, Yanagi's book was never completed. After I returned to England he had a stroke and the opportunity was lost. Nevertheless, although partly paralysed, he lived on, able to write his aesthetic which I and others have during the last ten years translated into English which we are certain is faithful to his intention. *The Unknown Craftsman* (published by Kodansha) opens another gateway to the core of Eastern inner thought.

Each morning, rising from green tea drunk abed on the *tatami*, we washed, and looked down our side-valley over the mid-distant, castled, small city of Matsumoto, across to the snowy screen of the

Japanese Alps, twenty-five miles away. The eye travelled from one spearpoint (Yari) to the high moon riding its blue races. How many times I tried to draw this! (See plate 19b.) Some days, of course, we were shrouded in mist: on others, there were storms amongst the great hills away off, but always that valley two thousand feet above the sea and sixty miles long, its river and watershed going down to the Sea of Japan, lay across the main island. After working in the morning we occasionally made excursions, exploring the side-valleys and following the rivers towards their sources, passing villages, temples and mines. My companions always encouraged me, if so inclined, to stop and make brief drawings. We returned to hot baths and supper, often joined by craftsmen friends from the city.

One of the craftsmen in Matsumoto was a furniture-maker named Ikeda, whose wood-works employed eventually about sixty men (plate 14a). It was he more than anyone else who drove us about the neighbourhood; then he would come back to our hotel and stay for bath and supper, after which he would sometimes show me the full-scale drawings he had made from my sketches of chairs, tables, etc. Of course, I explained to him that I had never been trained in woodwork, but his reply was that I was a craftsman who had lived with European furniture, and therefore knew it with my body.

This remark reminds me of one made by Hamada to a group of his young men whose work he had asked us to criticize. I recollect him saying to them forthrightly, 'Here you all are making European furniture which is coming so much into vogue for modern Japanese use: how many of you have it in your own houses?' One only raised his hand. Hamada paused, then said, 'If you don't use furniture yourselves, sit on chairs and eat at tables, how can you know what is good – what fits the body?' Ikeda, who was a good friend of the musician, Shinichi Suzuki, was a very lively companion – we often had meals together.

One day we had an invitation from Suzuki, who had a small music school on the outskirts of the city of Matsumoto. I was first introduced to him by Yanagi's wife, Kaneko-san, herself for many years the finest contralto singer in Japan. We all went to see him conducting his children, whose ages ranged from three or four to thirteen years old. We wondered what sort of a cacophany they would make with their small fiddles, but not so! The parents who had brought them, country

folk – mountain people – sat around the room on bare chairs. Mr. Suzuki stood in shirtsleeves, fiddle under his chin, before the children and audience. He spoke in Japanese, but apologized, adding that he would come and talk to us as soon as he could. Turning to the children, he said gently: 'I think we'll have the youngest – you Tammy, come along here. Bring your fiddle – now stand – stand properly – so.' The child took his stance as a fiddler should, Suzuki bowed a single note, and Tammy knew exactly what to do with a simple melody of Bach, in perfect tune. I was astonished. Then Suzuki took the eldest of his girls who played up to good concert standard. I had never heard children play like this; it was their language and their life, and to me a miracle! Many of us had tears in our eyes. Despite the fact that it was not their own nation's music, one could see into those children.

Suzuki married a German, and I think his wife did not want to come out to the East, so he returned alone, very depressed. He decided against a career as a soloist, meditatively recollecting how he had learned his own spoken language, and commented to me, 'A complicated process, isn't it? An idea came to me. Could not the violin be learned in the same way? I began to look for children to teach. One or two brought to me were tone-deaf, but I recognized their immediate response. This resulted in others coming with a similar affliction, until my whole school was composed of tone-deaf pupils. You have just heard two of them.'

I report what he said at that time. How *did* he do it? How does one speak one's own language? It's a means of communication. May we not say the same of music as of all the arts? He told me later that Casals wept when in America he heard those children playing. The things Suzuki did were very strange, such as asking the children while still playing how many electric bulbs there were in the room, or to stand on one leg, etc., but I am not a musician, and though I can be moved I will not try to write too much about that which I know least. Suzuki is now a world figure. I asked him of the effect on the children's ordinary schooling, and he replied: 'Excellent', but added, 'I wish this same principle could be included all the way through their education – it would give them such extended life and confidence. As to why they play European music – for I do include some of our folk-songs – listen to this', and he played an old mountain air with them, then remarked, 'Is not all music one?' I was silent; we were deeply moved.

When we returned, quiet and impressed, I suggested we asked them to come over with their parents. This we discussed with the proprietors, and as the hotel was not full they delightedly agreed, and even went out of their way to make it an occasion. The children with their teacher gave two concerts – one before and one after the lovely meal which was provided. How those children adored him!

During those long weeks, I came to know Janet. I had found her a great help in typing my book and with delight discovered her sharing of the Japan I loved. My friends became her friends; in Kyoto, my brother potter, Tomimoto, made her welcome, and gave much of his leisure time to her. I thought of a shared life with Japan as a background and asked her to marry me. We began to plan a future somewhere in the neighbourhood of Kyoto where Tomimoto lived, and which she had come to know better than I did. I felt that we could be happy in that area of old Japanese culture.

Janet was now at Tamba living with the Ichino family. Here she had a wheel of her own, and an electrically heated cushion which kept her partially warm during the bitter winter months. For over a year she endured, but enjoyed, the hard life – washing her clothing in the one stream that runs down that twenty miles of valley, even in the winter when it was frozen over, and feeding on the same very limited diet. Every so often she would make an excursion via Osaka to Kyoto and stay a few days in a Zen monastery, eating well and recuperating – returning with stocks of Western food which she shared with the family. Janet did not speak much Japanese. I doubt if she had much more than a hundred words, but in spite of this she had an extraordinary capacity of understanding what was going on, and of making herself intelligible. She became really loved in that valley where the inhabitants were mainly potters. It required courage to live alone as an alien in a village of five hundred people. If she went for a walk, a son was always told to go after her, because it was not considered safe for a single woman to go out alone. The family with whom she lived provided an upstairs bedroom, and she joined them for meals. As is usual in Japan, she shared the daily communal bath, but it should be clearly understood that in that country the body is washed first before getting in; it is noteworthy that she insisted on taking her proper turn— last.

I had left my son David in charge of the St. Ives Pottery, but events

took place which necessitated my return, so I left Janet looking for a suitable place for us to work in, as well as a house and furniture, and returned to England in 1954 alone.

While back in St. Ives, my first wife, Muriel, became ill and was taken to hospital where she eventually died after an operation. Sometime later I received a letter from Japanese friends advising me not to establish a pottery at that time in Japan. This created an unexpected problem, for it meant that Janet might not wish to come to England. We had both hoped to make a fresh start in Japan; it was a hard decision for her to make.

It was a difficult period in which Janet arrived, by ship via Ireland, in a very cold winter fog. Early one freezing morning in 1955 I met her at Euston Station.

Coming from a dry climate, she has always felt our English dampness. I did not realize at first how profoundly her arrival would affect us all. I anticipated that she would come and work in the Pottery, but had not calculated on Janet's clear independence. She wanted to go on making her own pots as she did at Tamba, in freedom, and we had to overcome problems in organization and personnel. David, having rescued my finances and been my very good second-in-command for thirty years, decided to leave, and find himself, partly to get out of my shadow. He bought a good house at Bovey Tracey which already had a pottery. Michael sold the cottage I had given him – in which George Dunn used to live – and eventually followed suit. He bought a house and land in a village called Fremington, halfway between Bideford and Barnstaple on the North Devon coast and turned the ample garage buildings into a pottery. As well as a livelihood, this was home to their family and children.

Being intuitively far-sighted and a good organizer, Janet gradually took over the office. In the months that followed I began to perceive and recognize originality and force of character in her pots, which she has developed over the years.

It now seemed that a viable future policy was being achieved. I had often wondered what would happen if I became ill or died. The immediate question was how to preserve the tradition I had tried to establish whilst allowing for the further expansion of every member of a group. I had designed most of the pots myself, making drawings with measurements and weights, which were distributed amongst the

crew. The Pottery's illustrated catalogue of standard ware for daily use in the home enabled dealers and individual customers to order from us by post. This provided bread and butter throughout the year. The need of individual pots was always recognized; nevertheless pots with any tinge of self-consciousness were regarded with suspicion. As soon as they showed any capacity, we gave students the freedom of making their own pots out of working hours, choosing those we liked at prices I determined, and they received a percentage of the sale price. This helped to subsidize a comparatively low wage. After all, one should realize ours was in the nature of a postgraduate course, and part of their education, but the fact remained that very few had any money of their own and we had no official Government support.

As a result of my travels and lectures, I began receiving many applications from potters overseas. Janet and I decided not to pursue the prewar policy of taking Cornish apprentices and began taking these young students from England and overseas on a two-year work-trainee basis.

The last of the local Cornish lads was Kenneth Quick. He worked for twelve years at the Pottery and then started his own one-man workshop in St. Ives, followed by six months' teaching in America. Then I was given the hint that he would like to come back. Delightedly Janet and I took him. This changed him into a very happy lad. He had suffered from migraine and was suddenly cured. A desire to go to Japan and work with Hamada for a time developed, and, with this goal in mind, he saved up enough money for that purpose – we helped him. A month before he was due to return to England, he went with two friends to a nearby coastal village. While he was swimming with them, a warning was issued by the police that there might be dangerous currents owing to an approaching typhoon, so they began to come in. Kenneth was last seen in the water breast-high, laughing and waving his arms, but when his companions came ashore and turned to look again, he had gone. An alarm was given immediately and boats were put out, but owing to rough weather it was two days before his body was found two miles away in ten feet of water. This was a great shock to us all, and, most of all, to his widowed mother. Her one desire was to have his body brought back to Cornwall, but cremation was necessary, and his ashes were flown home. The local sergeant of police wrote her a very moving letter in English, saying, 'We do not

know how to express our sorrow – we can only mingle our tears with yours.' This moving note broke down the barriers of distance and nationality.

It took quite half the twenty years during which Janet has been helping me to establish the best way of handling the increasing number of students who came to work at St. Ives. For the sake of good personal relationships, we never wished the total to exceed a dozen, although this has often been suggested. I found the colour-slides of pots sent by students from all over the world curiously similar, which seemed to indicate the prevalent kind of education widely employed. This I found disturbing. Whenever possible we arranged a short trial period to gauge the quality of the applicant, but it was rather sad when we found it necessary to part company.

At this point I wish to make it clear how Janet has contributed to the further organization and development of the Pottery. David did a great deal in this respect in his earlier long period, but what my wife has done has been quite different. I think the best way I can convey this is to quote from an article she wrote published in *Ceramic Review* in November 1972:-

'The problem of the balance between individual development of the potter, individual pot-making, the necessary work routine and standard-ware throwing was almost a daily preoccupation. It is, even today. . . . Each potter must be allowed and encouraged to 'do his own thing', to develop his individual expression in pots alongside his development in throwing standard-ware. We feel that this balance is the most important thing of the Pottery . . . We can teach a young potter to throw a pre-determined shape and permit him a wide latitude for exploration within that shape. As his skill and perception develops, we can pay him a small wage for the pots he makes and he, at the same time, is growing. He must keep the image of making each batch of pots better than the batch before. . . . While the potter is making a hundred mugs, he must always remember that one person is going to buy and use one mug.'

Although David did so much for the Pottery, and has since proved himself a first-class craftsman and teacher, Janet has contributed to its further development and has supported my work with full

loyalty as a potter. Her best pots have always contained a reflection of her own true character. I do not admire every pot she makes any more than I expect her or others to admire mine because our characters are so different. It is my hope that she will continue to run our workshop at St. Ives in her own style and in her own name.

Chapter 19

WORLD TRAVEL

Scandinavia, 1949-1970

Three times I have visited this area of north-western Europe. The first occasion was in the spring of 1949 under the auspices of the British Council, and I travelled with my wife Laurie by steamer to Gothenburg in western Sweden where, as guests of the Craft Museum, we were treated in the most friendly manner. My main recollection of that crossing was sitting on an open deck at a small table with drinks before us like the other passengers, and unexpectedly seeing the ship tilt, with the slow descent of all the tables, drinks and passengers in one movement towards the starboard taffrail and ourselves. The ship rectified its level just in time, the landslide ceased at the critical moment before hitting us but my wife's dress received the contents of one cup of coffee! Another recollection of this voyage is that at one meal we were served the most delicious sweet of young spring rhubarb I have ever enjoyed – that semi-medical and so often over-tart, fibrous, vegetable.

At Gothenburg my exhibition, although successful, had a mixed reception in the Press: some critics grumbled of an invasion by British crafts, complaining in particular that many of the pots had a coarse texture. The director of the Art School, Kurt Ekholm, and others stoutly defended us. We enjoyed the fun of this battle.

From Gothenburg we travelled north to Leksand, Dalarna, where we were the guests for five days of the mother and stepfather of my

262

pupil Anne-Marie Backer. Then we visited Stockholm, met some of the leading potters, saw the famous new Town Hall and were impressed by it, as also by the Crown Prince's collection of pots. Unfortunately he was ill in bed. We arrived in Oslo at the end of March, where rooms at the Grand Hotel had been booked for us by the organizers of my exhibition.

Although the exhibition of my work went very well, I recognized a similar undercurrent of opposition to the nature of our stoneware. The expectation was of refined wares – it did not include standards born with the Chinese classics or with the Tea-rooms of Japan.

It was at Oslo I went to the Ship Museum devoted to the longboats with which those indomitable Norsemen invaded not only our islands but encircled Africa and made their way to America in about the tenth century. The forms of these ships were the most beautiful I have ever seen; one in black oak was complete, dug out of preserving mud. That shape, which was quite unforgettable, I often employed as a pattern on my tiles.

We heard many tales of the underground movement during the Nazi occupation; there was a brave gaiety which showed the quality of those Norwegians during the War. They enjoyed making fools of the Germans by slight alterations to public advertisements, which yet remained in the sphere of legality – full of disguised thrusts, with a double meaning. At one dinner-party, meat being available only once a month, we ate a splendid halibut, and the staff joined in the relating of exciting wartime stories. They had a united condemnation of Sweden's neutrality and consequent rich living, just across the border – we had found the standard of living there to be well above that of ours in England.

The extraordinary kindness and hospitality we received, not only from fellow craftsmen but also from great firms, was a confirmation of happier and more developed relationship between art and industry than exists at home. Industries here honour many of the best artist-craftsmen on terms of comparative freedom. My strongest impressions were at the Royal Copenhagen porcelain factory, the director of which was Christian Christenson. There we received a truly potters' welcome, for he assembled his staff, including their designers, engineers and chemists, gathered them outside the entrance and ran up the Union Jack alongside the national flag, then invited me to ask any technical

questions relating to glazes and kilns. This was of particular interest, as we fire our stoneware at the same temperature as theirs.

Not only did they tell us what we wanted to know, but in the largest gallery run by the craftsmen of Denmark, Den Permanente, we were given information which explained how their fine modern furniture had come into being. The training the Danes gave to their architects began with hand-work in stone, brick, metal, etc., involving practice before theory, in contrast to our English custom of theory before practice; thereby an understanding was reached of respective values of hand and machine and their characteristic products. It was because of this that Denmark took the lead in this field at our expense. Hamada and Yanagi, in their first visit to Scandinavia, reached the same conclusion.

I had been invited to include my work at the annual exhibition of the Royal Danish Craft Society to be opened by Queen Ingrid. I remember being somewhat tongue-tied when introduced to the granddaughter of Queen Victoria!

Towards the end of our Scandinavian visit the President of the Danish National Arts and Crafts Association invited us to a magnificent repast in a truly baronial hall, on the high walls of which were antlers such as I have never seen elswhere! Guests included representatives from Sweden. During dinner we ate, chatted and listened to speeches for something like six hours. This was certainly for me a record in Europe – in the matter of food, only to be beaten by a farewell dinner when we left Peking in 1916, which, thank God, was not six hours long! In Scandinavia to 'skol' is a varied art. I recollect that in Sweden one must not 'skol' one's host's wife. I can still see the red face of our host, who was nevertheless master of himself, whereas on the other side of my wife, Christian Christenson was amply toasting her! The next day we flew back to England.

When we visited Scandinavia again in 1960, I got the impression that the new movement in furniture had lost some impetus. This was later corroborated by my Japanese friends. We attributed this to some loss of vitality due to a remaining dominance of the industrial background over the freedom of the artist.

On our third and more recent visit in 1970 to Den Permanente for an exhibition of pots by my wife, Lucie Rie, Hans Coper, and myself – which we found beautifully arranged – I was invited to speak to the

assembled craftsmen, as before, but this time to be a severe critic. I was provided with a microphone and a comfortable armchair, and having been put at ease and feeling free, I asked first of all whether they could hear me at the back of the hall. I already knew that they would understand my English, so I said: 'Then we can do without the microphone, and I do not think I shall need the chair for at least half an hour.'

I added that although I had been asked to be severe, I preferred to speak to them not as an English visitor but simply as a contemporary potter facing in my own country and elsewhere many of the problems with which the modern potter has to contend. My information had been gathered not only by travel but also by the many colour photographs of would-be student's work sent from various countries, which gave me the disturbing impression that they might almost have all been trained in the same art school! I do not recollect just what I said, but I know that I felt free, walked about, and spoke from the heart, discussing our united problems. Then I asked for questions and sat down. An elderly lady, Fru Koch, who had been pointed out to me as having been the Danish Minister of Arts for the last fifteen years, stood several rows back and said as near as I can recollect: 'Mr. Leach, may I come and speak to my people from where you stand?'

I said I would be honoured – I had been impressed by her face. She stood for a few moments with her back to the majority of the audience, then quietly walked forward, put her hands behind her back and rested against the wall looking thoughtfully at her feet for a minute or two, and in complete silence said: 'My friends, I have been thinking of what I really wanted to say to you: it is very brief – tonight you have heard the truth.' Then she went to her place and sat down again. I was both astonished and moved. Two or three months later I heard of her death. She was referred to as the best speaker in that country's national assembly.

America, 1960

Prior to our second Scandinavian visit, I travelled for three months right across the United States, lecturing. A large Ford wagon bought for us by a friend awaited us on our arrival by ship. We carried our pots for exhibition in one half of the back, and put a mattress on the other, upon which I rested between each seminar. We stayed at motels

inexpensively. The whole journey was paid for (except for petrol) by the sale of the car when we left, but for brevity's sake I shall avoid a detailed description.

The ten-thousand mile journey by road was an experience in itself, and enabled us to see America from the level of the great highways, which was quite wonderful. Much of the fresh ground we covered was of great interest. We made a vast loop – Philadelphia, Washington down to Janet's Texas, New Orleans and the Gulf, passing through that sad *tech* country with its weeping Spanish trees; from there northwards eventually arriving at Minneapolis to visit the MacKenzies, late at night, after having been hauled off to the police station for speeding at ninety miles an hour on a perfectly empty highway! Then to Chicago, round Lake Michigan and right across the Canadian border highway, until we came to that fast, clear-running St. Lawrence River; then south down beautiful Vermont. I remember a signpost at one corner with the names of four old English towns. Thence to Boston and so back to New York and the journey home.

Japan, 1961-1962

This was written in England just after the death of Yanagi, which occurred in May 1961.

'One of my main objects in flying to Tokyo in the autumn of 1961 was to see my old friend and companion of fifty years, Soetsu Yanagi, once again. I am too late. He died on May 3rd of a third stroke. After I had cabled offering to postpone my journey, Hamada wrote, "Yanagi is gone, nevertheless his soul has no end. In fact the man whom we would most have wished to attend the funeral was you. Nothing else could truly make better for the repose of his soul than your personal call with the Guildhall pots he had, with great excitement, so looked forward to seeing. Some fifty thirteenth-century English mediaeval pots are now on their way to Japan, on loan, due to the courtesy of Mr. Norman Cooke of the Guildhall Museum in the City of London, to which they belong, and the British Council."

'A great man has gone, the father of the Japanese Craft Movement and founder and director of the incomparable Folk-Museums of Japan. The loss is not only theirs but ours too, for Soetsu Yanagi during his

life was the thinker and guide who provided an aesthetic philosophy for the craftsmen of the Orient, corresponding to some extent with that provided by Morris and Ruskin almost a century earlier for England and the Occident. It is not the same message, though it is akin. Yanagi's Buddhist aesthetic is deeply concerned with that aspect of truth and beauty described by such words as nakedness, humility and holy poverty, in the sense of St. Francis of Assisi. Non-egotistic art was his concern – there he spoke to the West as an antithetical Oriental. Despite politics, much has happened in a hundred years to shrink the world towards mutual understanding. My established belief is that East and West are the polarities of man's thought which we all, at long last, inherit. Hail and farewell to a man who, as much as any other, helped to break the barriers between.'

When I arrived in Japan at the end of August 1961, I found the Craft Movement suffering from the death of its founder and leader. Nevertheless it had grown in both size and influence far beyond any movement of our time, including that of William Morris. It has about 2,500 paying members, who own four museums, shops, restaurants, and at least one hotel. The work of traditional country craftsmen is combined with some of their best contemporary artist-craftsmen. (Since then the number of museums owned has more than doubled.)

Here are my impressions written during four months' travel all over central Japan, amongst potters and craftsmen, after an absence of seven years.

Wayside thoughts on revisiting Japan
'I awoke on my first morning, August 29th, to the cry of the cicadas in the old Iwasaki Garden of International House: I recalled Issa's poem:
> Listen, all you world of insects,
> That is the famous voice of the nightingale.

'New Tokyo: box on top of ferro-concrete box: enormous, over-crowded, ugly. Cars, telegraph-poles, and advertisements everywhere, but also quiet interiors where the heart is still fed through the senses and art is an essential part of living.

'My first supper at a "Sushiya" alone with Hamada. To watch a cook prepare raw fish is a feast in itself. Why is cooking not regarded as one of the arts? In Japan it is one – the heart is fed through the eyes as much as the stomach through the mouth.

'The ground trembles in a different way in Japan than it does in England. The earth must have a great deal of volcanic ash in it. Geologically it is new land. Japan is in the volcanic chain which circles the Pacific Ocean. We have no *shimo bashira* (frost-pillars, which may rise six inches above the ground overnight), nor any tree which leaps thirty feet into the air as the bamboo does in one spring month. Japan is nearly two thousand miles nearer the Equator than we are. In my county of Cornwall we live on an ancient core of granite. The earth is firm underfoot.

'In the Mingei Kan I burned incense before the ashes of my old friend, Soetsu Yanagi.
 'Fifty years of friendship!
 'I was too late to see you again but you are with me every day, wherever I travel, and I am trying to do that in which you and I believed.

'Mashiko once again. Round Hamada, the best balanced man and craftsman I have ever met. Those fine farmhouses and *nagae mon* (thatched gateways) which he collects, and his pots! The long refectory table weighed down with good food made by his wife, and which I enjoy as much as he does. His third son, Atsuya, back from three years of travel – two of them spent with us at St. Ives. He has strength and independence. I await his own good pots.

'Kuriyama, remote behind Chusenji. One evening we drove deep into the mountains of Tochigi Ken at dusk, mists winding amongst the rocky gorges and broken pines, and of a sudden, Sesshu, Tohaku and Mokkei came to life again: I almost wished I was born a painter of Sung and Ashikaga times.

'Takayama in Gifu where fans have been made for centuries, to Nagano and Matsumoto, winding through the great mountains where it seemed

impossible that roads should exist. Rough, narrow roads upon which none of my English friends would risk a car. My respect for the quick, nervous reaction of the Japanese driver is great.

'All waters run to the sea; Japanese water runs fast. Down from the steeps flashing like swords in the scabbards of the hills, tumbling white amongst the rocks, over dams, under bridges, under cables carrying the electric power of this mountainous land, hurrying down to the pebbly wastes and shining sea.

'Autumn. Mists wreathe amongst the conical, pine-clad peaks in the early sunlight of an autumn day, patient oxen ploughing, the rice crop hanging in ranks to dry, stubble-burning, blue smoke, ripe persimmons on bare branches and under thatched eaves, water running white. How I respect the Japanese farmer who works with nature; whose roofs match the hills in beauty, and who has learned to feed ninety millions with daily rice from an arable area no greater than England. To him, work is life.' (Plates 16a, 16b and 17a.)

From my diary
'At Tottori, in the Mingei Museum, forty Korean rice bowls of the Yi dynasty were laid out by Dr. Yoshida for me to see. All were good, some inexpressively beautiful with the gentle simplicity of a spring breeze. These were the unaffected products of normal man and of normal Korean society, easy and unlaboured. It is we who are difficult and out of balance.

'Matsue and Izumo. I was tired after Tottori and felt that my talk on the first evening at Matsue was halting. I tried to speak of difficult problems, but my limited vocabulary seemed to fail me. I dared to attack the prevalent use of the word *Mingei* to describe what is no longer folk-art but "*Mingei*-style" produced by educated modern Japanese who are not simple or religious-minded like their forebears. They can seldom reach out from their local background to the whole world of art and culture as the modern artist has to do, without suffering from indigestion. Their work is usually, therefore, without the virtue of either tradition or real artistry. Neither *tariki* nor *jiriki*. I suggested that Yanagi's concept of the meaning of *Mingei* was being

lost in the spread of his movement. What we can learn from those Korean bowls and their charmingly naïve makers is not to imitate them but to seek wholeness in ourselves and the resulting ease of heart, head and hand in our far more complex life and work. I cannot help feeling that there should be a counterbalance to the now widely used word *Mingei*, for the age of folk-arts is over – or almost over – everywhere. We have launched into another world of individualism, science and the machine, and we cannot go back. We must go forward into the next age which should combine both approaches. Some word, or expression, seems to me to be needed to indicate the responsibility of the individual towards self but also beyond self.

'Very few artists come to exhibitions of pottery. Are we such poor relations? It used not to be so in the period of Meiji, when university students came in thousands.

'October 25th.
Yesterday Tomimoto, Horiuchi and I were motored out through Nara to visit Tomi's old home in Ando Mura near Horyuji, about forty-five miles from Kyoto. There we were met by surviving members of his family. A niece travelled out in the same car, and she and Tomimoto talked of family matters. It was moving to revisit this background after so many years. The same old stones were in the garden; the same magnolia-trees stood beside the old *kura* (fireproof storehouse), the same sluggish moat outside the gate-house – fifty years rolled away.
'I first stayed with him in that country house, now dilapidated, as far back as 1912. The following year I came again with my first wife who brought our son, David. Tomimoto's mother and grandmother were there, and I still recall vividly their delight with our first baby. Tomi reminded me of their anxiety when my wife washed him and we were not particular to protect his ears from getting water into them, which is contrary to Japanese custom. The occasion of this visit was the national honour to be given to Tomimoto by the Emperor personally in a few days' time. He has just publicly stated that his greatest pleasure is that this has happened whilst I am in Japan.
'I, too, am glad, whilst at the same time feeling a certain anxiety: work is done for its own sake and we both know full well how dangerous both fame and honour are. They tend to separate one from simpli-

city and from other people. I was told of a woman weaver of Kyushu who was honoured in this way, and who became so impoverished by having to increase her prices because of it and then was not able to sell enough for a living, so in despair she committed suicide. I have also seen the ill effect on young artists of honours coming early in life, forcing them by social pressures into paths which twisted whatever genuine talents they possessed. Still, I am glad that Tomimoto has been honoured.

'Kurashiki – November 12th – 14th.

These two days at Kurashiki have been the culmination of my travels in Japan. I had very little idea what was planned by Mr Ohara beforehand. He has had old *kura* reconstructed and moved to form a square about 120 ft. wide to give permanent rooms for the exhibition of pots by Tomimoto, Hamada, Kawai and myself, textiles by the stenciller Serizawa and woodblock prints by Munakata. The two-storied buildings are beautiful outside and in, and somewhat resemble old English "half-timbered" construction. We each have a room or floor of well selected and arranged work. I know of no museum in the world which has given such generous and discriminating treatment to a handful of contemporary craftsmen. This has been the first occasion for years that Tomimoto has joined in with the leaders of the Mingei society on a public occasion.

'On the first evening there was a meeting of the local branch when the four of us spoke to a packed room of some two hundred people. We talked first about the mediaeval pots lent by the City of London, which were also on view. I had to lead off and spoke about the people who made them – simple uneducated workmen just like the Korean or Japanese peasants and farmers who made the pots the Tea Masters admired so much; the one in a background of Christianity, the other in Buddhism. The response to these old English jugs on the part of potters and pot-lovers here in Japan has been immediate. Their sharp eyes have placed them in the first rank. This, as I told the audience, will help towards a better appreciation of them in their land of birth. Of particular importance to Japan are the handles on these jugs or pitchers – so easy and broad and right, both to the hand and to the heart.

'Most of our talk was about brushes – the Far Eastern brush for

writing and painting, the hair it was made of, how it was made, and of its cultural importance. I was glad to note that in this age when every-one has become literate but so few still write well, that this audience at least responded warmly to what we had to say about the brush, for there is a danger following the War and the intense pursuit of every-thing foreign, at the expense of native culture, that Japan will come empty-handed into the society of nations.

'November 25th.
Time present – the train sliding away from Kyoto, round the shores of Lake Biwa, my friends dispersing from the station. Time past – the kaleidoscope of three months of faces and places and friendships – all hail and farewell, so brief. Time future – ? The autumn has lingered an extra month, the sun shines upon the flat-stubbled rice fields and the walls of hanging straw stretch like vast platoons "forming fours" below the canopies of pine-clad conical mountains. An occasional farmer ploughs the old stubble with an ox, women in white-spotted indigo bend to the rich brown soil.

'Yesterday I was up at 7 a.m. and reached Ryoanji and its rock-garden by 8, where I sat alone and meditated for half an hour in early sunlight in peace of mind. It was made by Soami, one of the great masters of Tea, over three hundred years ago and perfectly preserved; its sea of white sand is kept clean and raked round its stark island rocks enclosed on three sides by old plastered walls. It expresses the essence of Zen or *Mu* (being in not being) as perfectly as the Persimmon painting by Mokkei which I was shown by Abbot Kobori of the exquisite Ryukoin sub-temple of the Daitokuji two days before.

'These were two of the main art objectives for me in Japan, and I saw both under perfect conditions. The temple was not open to the public, but very much desiring to see these paintings I sought help from the Director of the Kyoto Museum who asked the Abbot Kobori if I might be privileged. He was good enough not only to fix a day and time but also said I might bring a few friends. There were four of us, one of whom was a wealthy American lady studying Oriental art. Abbot Kobori's Ryukoin temple, I later discovered, had been built by the Kouroda family by order of the ruler of Japan, Hideyoshi. It was to a descendant, Viscount Kouroda, that I was deeply in-debted, for he – a painter trained in Paris – had come to my assist-

ance after my pottery out in the country was burned down in 1919.

'We arrived in the beautifully-kept, quiet precincts, tile-capped walls, fine rocks, well-swept paths. I clapped my hands; a young priest opened the grille doorway. I said we were expected, would he inform the Roshi (Abbot) that we had come. He strode down the polished corridor and we, meanwhile, removed our footgear. Then the Abbot appeared clothed in white silk from head to foot. He was a man of about thirty-five, with a good, clean-cut face. We returned his bow of greeting, then he led the way to his own room where we settled on cushions, after which he clapped his hands sharply. The young priest came at once, prostrated himself before his master, who just said "Tea". On this occasion, in a Zen monastery, the high ceremony was dispensed with, and a bowl was brought in for each guest on a tray with a couple of simple sweetmeats, which provided contrast for the astringent flavour of frothed powder Tea. The contemporary black *tenmoku*-glazed standard bowls were of an ancient Chinese type of the T'ang dynasty, implying a recognition of equal spiritual potential amongst those present. (All men are equal before God.) Moreover the objective, even in the relaxation of monks, was never beauty at the expense of truth.

'After a minimum of small talk the Abbot said to me, "Mr. Leach, the two paintings you wished to see are hanging on the wall behind you." Bowing to him, I turned to look at them. After a pause he asked lightly, "Which do you like the best?"

'Although I was not so familiar with the second, of a branch of edible chestnuts, I replied: "I like both – both are good and by the same fine artist: the wind through the leaves and nuts and the persimmons sitting in still air."

'Whereupon he said with astringency, "Which do you like the *best?*" I sensed the tone of a Zen question, which cannot tolerate a rational answer, searching me out. At last, a real challenge. O God, how to reply?

'Turning to him, on impulse I said, "May I ask you a question, one which I have long wanted to put to a man of Zen?"

'He looked at me and replied, "Yes."

'Would you be kind enough to explain to me what the relationship is between you as a man of Zen seeking "satori" (enlightenment) compared with the intuition or inspiration sought by a genuine artist?"

'Immediately he replied: "There cannot be art without enlightenment." Moved, I bowed deeply. "Of course," he added, "a man dedicated to a life-long pursuit of enlightenment hopes to reach a more persistent state of 'satori', whilst the artist, as a rule, has only flashes of inspiration." No further questions were asked about the two paintings: we fell into easy converse, perhaps rather regardless of our companions, his eyes glancing over to them where, at the end of the row, the American lady was sitting sideways, obviously in discomfort. Then, with some consternation, speaking in excellent English he said, "I am sorry to have been thoughtless, please take more of these rather hard Japanese cushions." The spell was broken.

'On departing, Sohaku Kobori gave me a written poem:

"Amidst mountain peaks no place for measured time."

As we passed his study I saw the ink was wet on his stone.

'January 6th. Flying at 30,000 feet from Osaka to Tokyo.
We made a day's excursion by car to the hills of Tamba. It was so beautiful, through bamboo forests in green rustling shade with feather-carpets of dry leaves, lovely autumnal villages, thatched roofs emulating the lines of the hills all trying to be Mount Fujis; orange coloured persimmons hanging on bare branches and the serried ranks of drying rice-straw in hanging walls or conical little haystacks everywhere. I am finding the Japanese countryside so exquisite, and wish that I had time and skill to make a series of patterns of field life to express the farmer's year. Tomimoto said to me that he had the same desire, but from a background of English rural life. (See plates 16a ,16b and 17a.)
'In Kyoto I stayed with the Horiuchi family. I went there with Nami Ogata, Kenzan's daughter, to see the first Kenzan's pots which have recently been discovered and are in the possession of Mr. Isamu Morikawa. Tomimoto would not go, fearing the awkward position if, as he expected, the pots proved to be forgeries, so I went with Horiuchi and Nami. We met Mrs. Shirahata of the Kyoto Museum (very perceptive and well informed) and also the director and Mr. Hayashiya of the Tokyo Museum. When I saw the first group of pots I was astonished, for I was certain that they were all originals! As we were shown more and more – there were over a hundred – and also the three diary notebooks (by 1975 twenty-seven more) found in the

Sano area of Tochigi Ken, we all became more and more excited and enthusiastic.

'Many of the bowls – some for Tea, and numerous rectangular slab-built dishes – displayed the final freer and broader Kenzan, from the age of seventy-five years in his final maturity, to a degree hitherto unsuspected. These pots were all *raku* ware, employing a full range of black, reds, greens, yellow and blues with a quite unequalled mastery. I knew that a great discovery in the story of Japanese pottery had been made, and did not hesitate to say so, to the great delight of Mr. Mori-kawa and Mrs. Shirahata. I think that this is one of the most important finds in ceramic history, for instead of the gradual decline of a great artist potter in his old age, we are suddenly shown his final flowering in a glorious freedom of expression.

'The colouring was superb – on half a dozen pots was a bright red, beautifully used, which baffles me because it is not the red of iron oxide, even as employed in the brightest overglaze enamels, but almost a pure colour of tomato. I don't know what it can be, unless it is the red which I myself discovered a few years ago and use on stoneware – a mixture of red ball clay and nepheline-syenite. No such colour was known at that period as far as my experience goes. Moreover it appears to have been added as a glaze, much as mine is. In these *raku* pieces of Kenzan's it has been added in a third firing and in places the dark under-painting can be seen through it.

'Hitherto very little has been known about the latter days of this great and lovable man. Now, suddenly, a curtain has been drawn and it will soon become possible to look intimately into the mature life of one of the great artists of the Far East. (For those who would like to search into the life of this unknown Kenzan, the story is told in full in my book *Kenzan and his Tradition* (published by Faber and Faber in 1966). The argument in that book has not been contradicted over these nine years; in fact much investigation is still going on in defence of my thesis.)

'On almost every page of the notebooks as on many of the pots, there are brief, evocative, midget poems, crystallizing his reactions, nostalgic for the old capital of his youth, sad with the fray of his middle years, when for so long he was driven back to work to keep body and soul together and to pay his late brother's debts, until he was rescued by his friend, priest-Prince Kokan, who carried him off to the new

capital of the Tokugawas – Edo, at the age of sixty-nine. This patron died in 1738 and Kenzan returned from Sano where he had sojourned for some fifteen months. Very little is known of his last days except that they were in a descending scale of social and financial values. He died alone in his lodgings in Edo and was at first buried as a pauper.

'The following translations of Kenzan's *haiku* may preserve a little of the flavour of the originals:-

> The long night of kiln-firing, unsleeping,
> The voices of insects in the grass.

> When old men chatter about themselves
> It should be short and sharp
> Like a half closed fan.

> Men live in their hearts
> Their teachers the flowers of the four seasons.

> A priest sweeps pine-needles
> In cold autumn rain.'

Australia and New Zealand, 1962

From Japan I flew via Manila right across Australia, of which, being night-time, I caught no glimpse until my arrival at Sydney, where I was taken straight to a reception at the University of New South Wales. There I suffered the good-hearted handshakes of a multitude of people – my sympathy went out to the Royal Family!

Before flying on to New Zealand I spent a few days with friends and old students close to Botany Bay, and made a broadcast over the radio from which I have chosen the following extracts:

'One should be able to look at the pot for the man behind the pot, or the people behind the pot, or the good tradition of people behind the pots. What do we look for in people? We all know more or less what we really admire instinctively. Even if somebody walks along towards

you on the pavement, you size him up as a whole – do I like, or don't I like? Do I admire, or not? We know the virtues, they've been drilled into us; but behind the drilling we also know that truth, honesty, simplicity, lovability and all such are positive qualities insofar as they are of people. And of people not working on chain-production – working using self-control over their work, choosing their materials, patterns, shapes and so forth – loving them and loving us. And this is truest of all artist-craftsmen.

'I think the artist-potter is different from potters who have preceded him in time, because he is a man who inevitably inherits traditions of all arts from all periods in the world; the peasant country potter in Japan or elsewhere had a village-pump outlook – a narrow outlook but a very genuine one – he was a whole kind of person – whereas we are split. No wonder, because to digest ideas of shape, colour, pattern, glaze and methods of making pots from the background of all history is a vast undertaking. We do it under our own steam, as it were, rather cut off by a gap in time from any particular style. For centuries localized tradition has been handed down from father to son, generation after generation; far less individualized thought was called into play. Today machines have taken the place of the hand, but we must expand with an awareness our forefathers lacked.

'The potter today has been forced into the same position as the artist. During my lifetime something has happened, bringing about a new set of values – an expanding consciousness of what is true and beautiful in life. The task before us is to discover how to use this new perception.'

In Wellington I was met by Dr. Terry Barrow, the head of the Museum, and he kindly took me by car as far in the North Island as Auckland, visiting towns on the way where I gave lectures and met the potters – many more than I expected, and everywhere a real welcome! We had constant discussions of the problems raised at each city.

In Auckland I had a memorable meeting with Barry Brickell, who, together with Len Castle, I considered to be one of the two best potters in New Zealand. Barry very much wanted to get me out to his pottery at the coast across the sea with the lovely name Coromandel; there was not time to go by road, so he and his friends hired a small float aquaplane. It was quite an experience. I sat next to the pilot. At first I

doubted whether that swanlike canvas plane battering the waves could ever rise above them, but it did so, and we arrived in due course. The plane was flown back, and we were introduced to Barry's pet steam-engine as well as his pots! I don't know which he liked best. The engine was a miniature version of an English locomotive, and panted its way carrying heavy loads – coal, wood, big pots, and himself.

Time flew, and we had to return to the plane which was tootling for us on the sea. The tide was out so we took off our shoes and socks and ran across the wet sand, which was full of sharp sea shells on edge – painful! We reached a boat and jumped aboard, shoving at the same time, and managed to paddle to our canvas plane, which we boarded through a door in its side. Once more I sat next to the pilot – this time an older man. Again the batter, batter, batter, and a rise to a mere four hundred feet. Then, to my utter surprise, he put the joystick in my hand, gesticulating. I thought, 'My God, he is entrusting me with their lives!' I kept her steady for five minutes, and shook his hand warmly when we arrived safely.

We spent an afternoon and evening with Len Castle and his charming wife. Their house was on legs at tree-top level amid giant ferns and other strange formations.

From Auckland we flew to Dunedin in the Southern Island – very Scottish, as one might presuppose. At one gathering there I faced three hundred potters; the proportion of potters in a population of under three million was surprisingly large.

On the way to Christchurch, at a place called Timaru, I was met by Richard St. Barbe Baker, known all over the world as 'the Man of the Trees' and a fellow Bahá'í. He came down from his wife's great ranch in the high mountains.

Here I would like to tell the reader of the most characteristic sheep-land scenery of New Zealand – hundreds of miles which look like English chalk-downs, only twice as high. They used to be covered by fine semi-tropical trees and foliage; these have been replaced in a hundred years by British grass, which supports approximately thirty million sheep and cattle, as against under three million people. British and Maoris go to school together and there is very little race feeling. This seems to me to be a fine record. We saw no sign of poverty. The papers were more full of sports news than ours, but the external life explains this preponderance which will naturally be better balanced

as the cultural activities increase, and this is demonstrated by the amount of attention being paid to pottery and other crafts.

New Zealand potters are geographically remote but predominantly of British stock; they live on the volcanic fringe of the Pacific Basin, closer to the pottery traditions of China, Korea and Japan. Blood, they say, is thicker than water, and the natural process, I am convinced, is for the New Zealander to make a foundation of his cultural inheritance and broaden out from it to include whatever he can absorb or digest from this new situation.

The alternative, as I see it, is to be rootless. If I am right in believing that the basis of operations for the British emigrant is their taproot of culture, the reverse is the case for the Maori, who should also work outward from his native tradition.

The postwar growth and co-operative spirit of the contemporary pottery movement in this country took me by surprise. The level of the best pots made compares favourably with that in other Commonwealth countries. It was the strongest movement outside England, even if it had not, as yet, reached a definite character of its own. That, it seems to me, is not an objective to aim at consciously in this age of individualistic art – it is a by-product of communal periods of art and work. More important by far is the establishment of a standard, or criterion of good pots corresponding to that applied in other arts such as music or literature. The fact that many show in their pots the revelation of a new sort of beauty, out of the Far East, is a strong bond.

How best to develop the power to absorb and eliminate? William Blake, whom I have loved all my life, wrote, 'Drive your cart and horse over the bones of the dead.' He practised what he preached, and in our time and amongst potters no one has done so more consistently than has Shoji Hamada, and nobody admires the truth and beauty of the past more than does he. First he had his feet well planted on the soil of his own Oriental culture, then he entered into our life and our art over here. As a consequence upon his return he could see his Oriental inheritance with fresh eyes, reassessing the good and the bad. Since that time he has gradually and steadily put aside what he did not need from either East or West, – being born creative he was that much freer to digest and to produce new life in his pots.

Pots and all other artifacts serve the mind as well as the body. They are born of a marriage between use and beauty. They are not just

art for art's sake so much as art for life's sake. Whether less or more conscious they are extensions of people striving to make human products with as much wholeness and naturalness as a sea-shell or the wing of a butterfly: if human beings do not make peace with themselves as part of the whole of nature – how can they expect maturity either in themselves or in their pots?

Paris to South America, 1962-1966

In London again, the southern end of Sloane Street had been long familiar to me; I had had exhibitions there before the war at the Little Gallery run by Muriel Rose, followed after the war by a series at Primavera. It was when I went there one day to have a chat with the proprietor, Henry Rothschild, that I saw some unfamiliar pots in his window which attracted me: they were made in Paris by a French potter, Francine del Pierre. He was delighted that I liked them too, and said, 'She is coming to stay with me – you must come and meet her.' When she heard I was coming, she asked permission to cook a very simple French meal. It was excellent, and I recognized her evident versatility. Her English, though not quite fluent, was better than my French – enough to cement a new friendship.

When later in 1962 I received an invitation to participate in an international exhibition of pottery in the Louvre, arranged by the French Minister of Arts, André Malraux, I regretted being unable to go over and see it, for Hamada and I had been given the place of honour, and I rather suspected Francine might have had something to do with it. This was followed by a request to let her arrange an exhibition of our work in Paris, which eventually took place in 1963 at the Galerie de France and was a success.

That evening she held a wonderful party for pupils, friends, critics and poets. We received a real welcome, were put entirely at ease, and fed (amongst other delicacies) with no less than twenty-six French cheeses – which she knew I liked. I felt that those impregnable gates of Paris had opened, and in spite of my poor French we had a wonderful time. About 2 a.m. when the guests had departed, Francine, wanting to give me a further surprise asked, 'Do you know what a *coquillage* is?'

'No, what is it?' I questioned.

She replied, 'Shellfish.'

'At this hour?', I said.

She answered, 'Yes, most of the night.'

'Oh, lá, lá, c'est la France – let's go!', and off we went. We ate two kinds of oysters and I had my first taste of sea-urchins, which I had refused for years in Japan, but tried here under her persuasion and found them to be delicious. Of course, Hamada liked them as much as I did, remarking, 'And you with your English conservatism about food!'

'I think it's Francine's fault, she's a witch', I said. He nodded over his half-eaten sea-urchin.

The next day there was a strike of electricians, and some of the guests came round over *café au lait* to consult with us as to what we would like to do. 'Would you like to come out into the country? Your gallery won't be open.'

I raised an eyebrow at Hamada, and perceiving a slight nod said, 'I think Hamada would like to go to Chartres if possible, as would I.' This met with general approval, so off we went in two car loads, and had a wonderful French meal prior to entering the Cathedral. I remember walking slowly up the nave with Francine beside me. I said, 'Francine, would you mind my asking you to leave me alone for a few minutes?' The spirit of the place was upon me. After a quarter of an hour she came back and asked, "Is it all right now?'

I answered, 'Yes, I'll come with you.'

She said, 'There is something I would very much like to show you carved on one of the earliest of Gothic arches in the cloisters. At that time people could not read books, so they read from carved stone and painted glass.' Pointing upwards, she continued, 'They say that standing figure represents God contemplating the creation of man. Now what do you see in the next group towards the apex of the arch?'

'A wheel upon the ground.'

She said, 'A potter's wheel for the creation of man.'

As we made our way out, we passed the Virgin's chapel where several hundred people knelt in silent adoration, each holding a lighted candle of prayer – the only light to compete with the westering sun flooding across the great nave. I did not feel an alien to that Christianity. In later years I saw Lord Clark's film of Chartres, and talked with him

for an hour about the causation of this new birth in the first half of the eleventh century, after the Dark Ages.

My next contact with Francine and Fance – the potter friend with whom she shared a studio – was in 1966 in Venezuela, where Francine, Hamada and I had been given the first world exhibition in their National Gallery. This came about through Francine's friendship with Fina Gomez, granddaughter of a former President who unified Venezuela and ruled it in peace for more than twenty-five years. A very intelligent, as well as nice, woman, she had made it her life's work to introduce foreign art on the one hand and Venezuelan artists abroad on the other. Unfortunately Hamada was unable to come over from Japan, but from Colombia on the other side of South America came Signora Luz Valencia de Uruburu, who, in a similar manner, had arranged an exhibition of our work in her country, she herself had taken up pottery after reading my book. Luz was at the airport with a group of Bahá'ís.

From the airport we drove upwards some 5,000 feet, rising steeply on good broad roads and through tunnels, up to Caracas itself, on the eastern slopes of the Andes, and finally to our hotel.

The next morning I awoke early, got up at 7 a.m., ordered a magnificent papaya, and enjoyed a French breakfast with Francine, Fance, and Fina Gomez. Then we went for a drive in the country to the home of Alejandro Otero, an easy-mannered artist and craftsman who had studied under Francine in Paris and who was in charge of the art school in Caracas.

On another evening we visited friends who lived high up overlooking the city. I recall Francine's gay efforts to bridge the mixture of English, French and Spanish, and, as daylight faded after dinner when the city lights came on, we heard the music of tree-frogs accompanied by playing fountains.

The combined exhibition in Caracas was beautifully arranged by its director Miguel Arroyo, and practically everything was sold at once. Hamada was represented by thirty-seven pots; there must have been fully as many of Francine's, besides sensitive drawings of plants by her – studies for the delicate decoration of some of her pots. Infinite trouble was taken. Adjoining the main room was another containing the work of the artist-potters of Venezuela. It astonished me to find the influence of stoneware here too in South America. In the doorway between a large and small room hung a screen on which the B.B.C. film of my

pottery was projected from time to time quite discreetly. Light, colour, stands, screens, plants, pots, and drawings were all displayed in excellent relationship. In another area in an adjacent room, simple peasant red wares of the countryside were on view.

From my diary

'April 19th (1966).
Last night we were all invited by the Herrera family to a banquet in the oldest hacienda in Caracas. This splendid old house was built in 1560 and resisted the sacking of the city by the English under Sir Walter Raleigh! They say it is the best preserved and most constantly lived-in house of the early Spanish days in all America. The plan of what must have originally been great fortified farms, consisted of buildings surrounding an open space maybe sixty yards long and wide. Life was lived by day on very broad verandahs at ground level. I was able not only to compare its architecture with ours of equal dates, but also, as one of the guests of honour, to flavour the residue of old Spanish society.

'Most of the twenty or so guests spoke some English. Some had arrived on horseback, no doubt as in old times, but we did not see anything of the more private side of their life that night. It was a memorable evening: delicious food served on silver plate; deep verandahs, old flowering trees, space, old roofs, baroque proportions: Luz Valencia was there too, but in the hub of voices it was not easy to communicate. Sitting next to our hostess, Signora Herrera, who spoke English well, and who related the history of her hacienda to me, I remarked: "I hope you do not still harbour any ill feeling of that rough age against the English today?"
' "Of course not", she replied.

'April 25th.
How can I make time, even in "mañana" land? We eat well, talk in French, English and Spanish and I just hang on by my eyebrows. In Bogota there was a little uneasiness about the political situation, so for the sake of precaution I was housed in the army officers' quarters some miles out and given the suite which had previously been occupied

by Prince Philip. We were whisked away from those military bugles to a luncheon party with Luz Valencia and her friends, including the President, even further up the cultivated valley between the steep slopes of the Andes, to a lovely country house – the garden was ablaze with flowers, weeping willows overhung turf and ponds, warmed by volcanic heat. The gathering was friendly, informal and lasted for hours. After luncheon, at Luz's request, I was ushered to a delightful spot under those willows, with a chair, and fell asleep. Awaking to bird song, I dragged my chair back, apologized to a friendly-looking guest who spoke little English, but approved of my siesta; then someone came up and addressed him as "Excellency". I apologized again! He and others were amused. Then he took a diary from his pocket, tore out a page, and wrote a note to me which said that only after looking at our pots did one realize God's tenderness to mankind. Francine had a similar note from this President brother of Luz Valencia.

'April 26th.
We have just lifted off Bogota airfield in the President's private plane, and are flying along the valley, south, between the peaks of the Andes which rise hereabouts to a maximum of 15,000 feet; puffs of white cotton-wool clouds amongst the ranges. There are about twenty of Luz Valencia's pottery-loving friends coming for the three days in Popayan. Some of them were at the reception at the Palace last night, which reminded me of a Lord Mayor's dinner at the Mansion House. There must have been at least two hundred present including ambassadors – British, French, Japanese – and ministers, quite a sprinkling of artists and poets, and many friends of the Valencia family, also a group of Bahá'ís.

'For the warmth and hospitality we received I cannot find adequate words. Luz and her friends have worked for months in preparation for our coming. She is a fine person – quiet, intense, and obviously loved and respected. Her father was the national poet; theirs is an old family of culture. I stayed in her home – a simple, roomy old house beside the Cauca river, outside Popayan. This was where Luz made her pots.

'The hotels were full of potters and pot-lovers who have come to the opening of our show of pots and drawings (Francine's as well), and to her talk as well as mine, and to see my slides and film. The President was persistent in wanting our exhibition to be brought to

the capital after Popayan, but his sister was not in favour because there is political tension in the air, with armed soldiers and police everywhere, and with the Presidential election coming off in a week's time, she feared the loss of our exhibits following a change of government, or any possible disturbance. (The photographs did, however, go to Bogota.)

'Back at Bogota we saw the Colombian collection of old gold made by the Indian peoples before the Spaniards came. These seemed to indicate a state of culture like the early Irish, and not so much later in date. Here we parted company with Fance and Francine sadly; they returned to Caracas en route to Paris.

Kogo.

FIG. 15. Swallow pattern, 1934

'Before our departure I was asked to take as a present for Hamada a long tube of basketry, which contracts and expands. It is used in Colombia by the Indian people to fill with boiled manoic, or cassava root, to be hung on a peg or branch and pulled with both hands to squeeze the paste into a bowl. The residue is then baked to make a sort of bread. During my later travel at the airports, Americans were intrigued by this tube and questioned me about it. Eventually I told them it was the dried skin of a pet boa constrictor of mine, but I'm going to tell Hamada it has lost its tail!'

On my last evening some twenty Colombian Bahá'í gathered in my rooms and Luz Valencia came too. The next day I flew up the west

coast of the United States to a final seminar at Oregon University, before flying on to Honolulu and my seventh journey to Japan.

I saw Francine and Fance once again in 1967 when, with my wife, I joined them and their friends from Paris at an international exhibition to which we were invited at Hamburg. It was but a brief encounter. A few months after her return to Paris came the tragic news of Francine's death, in January 1968. The link with France was broken. A light went out. I wrote the following passage published in the Venezuelan exhibition catalogue in July 1966:

'Sometimes, but not often, a pot speaks in its own language; gentle, persuasively, looking one straight in the eyes. So Francine's pots first spoke to me some years ago. I recall the words of the Chinese sage, Confucius, "The wise man is he who in his maturity makes natural use of the gifts with which he was born." The pot, or any work of art, is the real man (or woman). What else shall I say about Francine? This indomitable little Frenchwoman who put her soul into her work in the face of long years of neglect and even sheer hunger; keeping intact, saying her piece.'

Chapter 20

DEPARTED FRIENDS

The tribute to Francine leads me on to a short chapter on other close friends who are gone.

Dr. and Mrs. Yoshida

On February 25th 1972 we heard that Dr. Yoshida of Tottori had joined his wife in that world beyond. Perhaps a few of their and my friends would like to read this short story, written now in memory of them:

I am not sure on which occasion it was when I was staying with them at their own hospital that Dr. Yoshida told me that his wife wanted me to teach her, and a few of her friends, how to make home-made English bread. I always enjoyed good food, of many countries, and liked to do amateur cooking myself, but it happened that I had never made bread! So I hesitated and explained, but they were very determined. I said the first thing needed was good whole wheat . . . 'I expect you can get that?'

'Oh yes,' he replied.

'And have it ground to a rough powder?'

'I feel sure,' he replied, 'and what else will you need?'

'Yeast. I know there is a bread-shop round the corner where they make the usual white, spongy, American type of Japanese bread – they must have *pandane* (yeast).'

'Ah yes,' said he, and reaching for paper and ink, wrote a note, clapped his hands to summon his messenger-lad, addressed the envelope and gave it to the boy to take to the baker.

Half an hour passed and the boy had not returned. Yoshida San said: 'That's very curious.' When he did return a little later, the doctor said: 'Why so long?'

The messenger lad scratched his head and hesitatingly replied: 'He said he could not sell the secret of his trade.' I laughed.

Dr. Yoshida put his head on one side, then seized his brush and paper and wrote another, briefer note, saying, 'Give him that.' In five minutes the boy returned with the yeast. I asked the doctor what he had put in the second note.

'Quite simple,' the town doctor replied, 'No yeast, no doctor!' I was very amused because to a Westerner secrecy about yeast is unheard of.

Then I did something more ridiculous. I told this very kind pair of friends more or less how to prepare the dough, but said nothing about allowing it to rise. The next day I was due to travel before the bread was attempted. They promised to send me samples of their progress by post. At my first port of call I received a cricket ball – at my next, a large baseball. After that, and my apologetic letters, something more like wholemeal loaves, football size, followed me!

Over the years they were good and kind friends, and I grieve that they are gone. He an enthusiastic supporter of craftsmen and of the Mingei Movement; she a good cook, especially of Chinese food. A crafts museum is there in Tottori as a memorial to them.

Dr. and Mrs. Yoshida, thank you for your friendship.

Daisetz Suzuki

Few men whom I have met have been so rich for death as Daisetz Suzuki. Nevertheless my heart sank when in autumn 1966 I heard the news that he had gone. I recollected the reproof which a certain Zen Master gave when a follower remonstrated with him on the sorrow and tears which the death of a friend caused him. The priest said what should bring more joy than the quiet answering of the great *koan* (Zen question)? Or more sorrow than the loss of a friend?

I met Dr. Suzuki and his wife over fifty years ago, but I have not talked with him more than half a dozen times, yet he and his friends Soetsu Yanagi and R. H. Blyth changed my outlook, and I do not forget the kind smile under his bushy eyebrows.

Once, in New York, he struck me hard with the Rod of Zen. Yanagi, Shoji Hamada and I spent some hours with him and Miss Okamura in his flat and I took the opportunity of thanking him for what I had learned through his books, then asked him to explain his earlier concentration on Zen and his later on Jodo Buddhism – the Road of the one and the Road of the many. He flashed back at me, 'If you think there is a division you have not begun to understand – there is no dualism in Buddhism.' Then, with that kindly smile, he explained that the problem was like that of a man determined to climb a rocky pinnacle, pathless. It was dangerous, he might fall, he might kill himself, but if he succeeded in reaching the peak he would find other people who had arrived there by a long established road on the other side of the mountain. The corollary, he added, was that the man of *Jirikido* (Self-Power road), the solitary artist for example, should never forget the men of *Tarikido* (Other-Power road) on the path of the many, and vice-versa.

On that same occasion in New York, we were all invited to a luncheon party in Greenwich Village by Mrs. John D. Rockefeller – a party of a dozen people. After the meal, she asked if we would care to visit the United Nations Building and see the river view from the top floor. I remember noticing little Dr. Suzuki glancing up the façade of that great glass box. We shot up in an elevator and stepped out on to the polished floor of a huge empty room and walked across it to look down. A silence fell on the party until, after a long pause, the thin, old voice of Dr. Suzuki said: 'And who cleans the windows?'

Two months before he died, I saw Dr. Suzuki in Tokyo and recalled this occasion; I showed him a cutting from an English newspaper illustrating a man hung on a sling on the outside of that glass façade wiping those windows. He chuckled.

A great and enlightened man has passed from our company.

It was in Dr. Suzuki's room that I first met Mihoko Okamura. I observed her devoted attention to that saintly old man. With her

parents' permission she became, at his request, his secretary, companion, and pupil, for the last fifteen of his ninety-six years of life. His death was due to an accident – otherwise he was still healthy, and able to climb the 140 steep steps to the ledge of rock next to the Buddhist library and garden, where he lived. The year before he had attended the World Conference of Philosophers at Honolulu.

Mihoko was born in Los Angeles of Japanese parents: not only was her English perfect, but she also had a profound understanding of Buddhism. I met her again in Tokyo with Suzuki before he died, and yet again after his death, when I took the opportunity of asking her what she was going to do. She explained that much of his work remained unfinished, such as his English translation of Shinran Shonin's work. 'More immediately?' I queried. 'I want to see my parents in New York,' she said. 'And after that?' I pursued. 'I am not sure – of course I'll have to come back here to do this work – he taught me everything.' Then I asked her if she had read my typescript of Yanagi's Buddhist aesthetic. She replied that she had, then asked me if I thought it was a correct translation – knowing that I could neither read nor write Japanese. 'You wrote a readable book but it was not a translation, for I often saw your thought instead of his.' 'I must start all over again. It *must* be accurate.' And then with a pause, 'Would you consider coming to England to help me for three months?' 'Yes, I would very much like to.' Thus began a wonderful friendship. Not only did she come once for three months, but twice, and helped me as much again in Japan where this book, *The Unknown Craftsman*, has eventually been published. Few readers will realize the difficulties of translating from Japanese religious text into English. Often we have no equivalent word, and there is a profound difference of modality. My memorial to one of the great friends of my lifetime is now, as I had hoped, acting as a leaven of thought in the world of crafts.

Reginald Turvey

Reg Turvey in his long life did three main types of painting. First of all, landscapes direct from nature, inspired by Constable and Cézanne. Secondly, animals from the background of South Africa where he was

born. Thirdly, and late in life, rhythmic abstract painting influenced by his friend, the American artist, Mark Tobey.

Reg knew South Africa intimately: the Drakensberg mountains appear in many of his landscapes; he also discovered the primitive art of the Bushmen. His last period followed Mark into an abstraction which changed Reggie's idiom considerably, but did not necessarily recall the appearances of nature. Occasionally there were mixtures of these successive styles, but I did not feel them to be his best work.

This artist loved painting in itself and was a born colourist. What we used to call tone in our student days was almost always clearly to be found in his strong brush-work. Touch sang to touch, tone to tone, tension to tension. Reggie was not clever, but something better – a man with a heart: a lovable person. He wasn't sufficiently practical to organize the steps towards making a living, and became too easily discouraged with a refusal of his work by selection committees. All his life Reg went on trusting people. He never lost integrity and bitterness never showed in his face. Sadness, yes. His kindness, moreover, bordered on gullibility, and he died a poor man.

His retrospective exhibition is touring South Africa as I write these lines. That a man, so persistent an artist and so honest a painter, should be neglected until the last chapter of his life when his painting years were over, has been a sorrow to me. It is hard to wait sixty years for the assurance from the informed and perceptive that all those years of search were not meaningless. It implies great modesty and steadfast loyalty to an inner vocation.

Major Tudor Pole

At this point I wish to tell the story as I recollect it told me by the late Major Tudor Pole, who was Intelligence Officer in the Near East under Lord Allenby during the first World War. Tudor Pole was also responsible for the welfare of Shoghi Effendi, the grandson of 'Abdu'l-Bahá – the Son of Bahá'u'lláh and Interpreter of His Word, when he was sent to Oxford to study, from whence he became Guardian upon the death of 'Abdu'l-Bahá.

I met Tudor Pole once at a supper party at the home of friends in Carbis Bay. I knew he had met 'Abdu'l-Bahá and in answer to my

question as to how this came about, he told me that as a young man he was the junior member of a family of grain merchants in Bristol and that his first important job for the firm was to go out to Haifa and the neighbourhood for a month or two to buy grain. Before starting off he was given a letter of introduction to 'Abdu'l-Bahá by a friend, with an earnest request to make use of it. Shortly after arriving he took the letter of introduction round to 'Abdu'l-Bahá's house and left it with his card, after which he received an invitation to come and meet Him. He spoke to Him through an interpreter and told me he was much impressed by his outgoing and deep spirituality. After some talk he said that 'Abdu'l-Bahá asked him if he would do Him a favour, and explained that there was a blind Persian Bahá'í in Paris to whom He wanted to send money – a bag of gold coins. Tudor Pole was returning via Paris and said he would be very glad to do this a month or so later. 'Abdu'l-Bahá replied calmly that he would return on the same ship, which was still lying at anchor a little offshore. Tudor Pole said nothing – he told me that was out of politeness, but when he was leaving and alone with the interpreter, he expostulated, saying that he had been sent out by his firm to do a job of work which would take weeks at least. The interpreter was unimpressed, and replied simply that if 'Abdu'l-Bahá said "the same ship" it would be the same ship. Young Tudor Pole went back to his hotel in some distress. He told me he always prayed when in difficulties and acted after prayer. Then he realized that if 'Abdu'l-Bahá again asked him to go back on board that ship, he would have to do so. On his farewell visit this is precisely what happened, and in a somewhat confused state of mind he re-booked, boarded the ship, and only when it was well at sea did he remember that he had not been given the address in Paris of the blind person. Arriving in Paris he went to the Persian Consulate, where the man had never been heard of, but Tudor Pole was advised of the pensions most frequented by Persians. Nowhere was his name known! In great distress Tudor Pole decided that he must go back to Bristol to face the consequences.

On the day prior to his departure however, whilst crossing the Seine near Notre Dame, he saw a man with a fez tapping his way along the pavement with a stick. He crossed the road and asked his name. It was the very man! He had only arrived in Paris that morning after three serious eye operations in Vienna, the results of which were

negative. Tudor Pole gave him the bag of gold, and they parted. He then went home to Bristol where, to his astonishment, something of a business nature which necessitated his presence had taken place, and instead of the wigging he expected, he found himself welcomed!

The sequel of this story is yet more strange. Some years afterwards, I related it to a Persian I met at a Bahá'í Summer School on the coast of Yorkshire. With excitement he asked: 'Do you know what happened to the blind man? I was in the Master's house when he arrived; he was taken upstairs to 'Abdu'l-Bahá who threw His arms around him and called for a glass of water to be brought, over which He prayed, then, after pouring a little into each of the eyes of the blind man, He told him to go and join the other amanuenses translating Persian texts by the high windows. This he did and I testify that I saw it. He was completely healed.'

Augustus John

Augustus John and Dorelia – both gone. Once he came over to St. Ives with her from Mousehole, where they were staying with his daughter-in-law. He asked me if I would make him a pitcher – presumably for beer. I said: 'Yes, with pleasure – I will do it for you now', and we went up to my room where I threw a good big one on my wheel, whilst they watched in silence.

Presently he wandered off round my studio looking at framed drawings attentively, then turning to me asked: 'Who did these?'

I replied: 'I did.'

'They're very good; I would like to buy one for Dorelia – it's her birthday.' Flushed with pleasure, I said I would be proud to give him anything.

'No, no, no – none of that,' he insisted, and paid me £4 for the one he chose. Then we sat down and looked at some of my other drawings. There were one or two I had copied years before when I was young, and signed 'After John'.

'You see', I said 'I owe you a very great debt.'

'They are good copies,' he commented. I told him that when I went out in 1909 to Japan, I had one good drawing of his of Dorelia which was reproduced in a Japanese magazine; it was so warmly

appreciated that thereafter any art paper which included a drawing of his doubled its sales. This astonished him.

Somewhat later on I saw an exhibition of portraits painted by his sister, Gwen, whom I never did meet. They were most sensitive and quite different from her brother's.

In his old age I found John receptive, warm and generous; it was a pleasure to watch his attention to that still beautiful, greyed woman by his side.

Kotaro Takamura

My first Japanese friend, Kotaro Takamura, comes back into my mind here. I still have some of his early letters.

'February 14th 1909 (Paris).
... Thank you for your kindness in sending me that beautiful re-production of John's drawing . . . His severe and sensitive line, and his feeling, are marvellous.'

'January 11th 1912 (Japan).
... Do you think it possible to buy an original drawing by Augustus John? Whenever I call on you, that drawing (of Dorelia) fascinates me so strongly that I wish I also have one . . .'

'December 18th 1917 (Japan).
... I have seen your works at the exhibition last night . . . Every one of them is you . . . I couldn't help to feel your presence everywhere . . . *Mountain gorge* is wonderful . . . Oh that road! Those symbolic houses! That geometry of earth up there. I am so glad you did draw that . . .'

I do not seem to possess any further letters of Takamura's. The reason may well be that after the death of his wife, he lived close to Lake Towada in the extreme north of Honshu. Nevertheless another incident concerning him has taken place as recently as 1973, when I was invited to a small intimate afternoon tea-party given by Crown Princess Chichibu who herself made pots, and was a patroness of art. There were only eight people present, and at one point she was talking to me

alone; incidentally, she said that she loved the poetry written by my old friend Takamura, and, astonished, I turned to her and said: 'He was my first Japanese friend in London when we were both students. I do not read Japanese as you know, but a couple of lines come to my mind:

> *Chichibu oroshi no samui kaze*
> *Konkororin to fuite koi.'*
> (Cold winds blow fierce
> From the wild mountains of Chichibu.
> Konkorin the sound of their voice.)

She turned to me in astonishment. I do not know who was more surprised. For once my memory was accurate, and how strange for Takamura to use the name of her Province – Chichibu.

Chapter 21

TEA AND FAREWELL

At this point I feel obliged to break the sequence of time with the memories of my visit to Japan in 1964, when the awareness came upon me that the work for which I went to the East had been fulfilled.

I was invited in the autumn to stay in a small Japanese hotel in the Geisha quarter of Kyoto called Gion as the guest of Mr. Isamu Morikawa, whom I had met in 1961 when I first saw the Sano Kenzan discoveries at his home. By this time I was engaged in writing my book *Kenzan and his Tradition*, in which the whole story of the Sano Kenzan pots and diaries is fully explained. I had not, at that time, met Isamu Morikawa's father, Kanichiro Morikawa – an old, retired, Master of Tea, and collector of art treasures. Almost every evening came a long distance call from him in Nagoya, begging me to come and meet him on my return journey to Tokyo. Eventually I agreed to do so, and travelled to Nagoya as his guest at a really beautiful purely Japanese hotel – the Hasho Kan.

I was taken first thing in the morning to old Mr. Morikawa's house, which my driver had difficulty in finding. Eventually I noticed a board outside a house entrance on which were two syllables, *Mori* and *Kawa* – meaning 'forest' and 'river'. On entering the outer gateway I heard an old man's voice across the garden calling in Japanese: 'Is that you, Mr. Leach? Don't trouble to go to the front door of my house, come to the verandah where I am sitting and let us meet without ceremony.' I did as he bade me; we bowed to each other and, taking off my shoes, I stepped on to the wooden verandah, which as usual was a foot or two above the ground.

Mr. Morikawa had an aquiline face, a high-domed skull and a long white beard almost to the waist, which he kept most of the time in a tidy white bag looped over his ears. I settled down on a cushion, and we began to talk. He said, I remember: 'There can be too much formality, although of course form *is* necessary, but the essence of Tea is to give pleasure.' At this point it would perhaps be kind to the reader to explain that Tea is a philosophy and way of life in which the drinking is but a part.

Whilst Mr. Morikawa busied himself preparing Tea, I looked round his room with great interest. Everything was plain, but good. I had been placed, as the guest, in front of the recess reserved for an object or two of art – a picture and an arrangement of flowers. The former was a *kakemono* of a spray of rice, drooping, by the thirteenth-century Chinese artist, Gassan; the latter a single camellia bud at the top of a green celadon bottle. As Mr. Morikawa returned to the room he saw my eyes resting upon a Tea-bowl on the *takanoma*. 'Do you like it?' he asked.

'Very much,' I replied.

Then he went on, 'Please pick it up and examine it freely.' I did so; then he asked whether I knew what it was. I said it was a bowl made by Koetsu.

'Ah!' he said, 'Do you know its name?' 'I cannot remember its name, but the word means the colour of the sky before a rainstorm breaks – indigo.'

He was obviously pleased. 'The name is *Shigare* meaning "approaching storm" – notice how the sides of the bowl are like metallic iron and only the bottom and the inside are covered with a thick black *raku* glaze.' Then, challenging me, 'Do you think the old man deliberately omitted the glaze or was it an accident?'

I replied with certainty, 'It was an accident – with the firing of *raku* ware, that kind of thing often happens.' This must have assured him, for he went on, 'Have you ever drunk *koi cha* (thick tea)?' I said that I had only done so once and was quite untrained in the ceremonies.

'That does not matter', he replied. 'It's the perception and enjoyment which are important. Will you drink *koi cha* with me to-morrow morning using this bowl?' I said I would be honoured.

He pressed me: 'Will you promise?' Somewhat surprised, I answered

297

'Yes.' Then, looking me in the eyes, he went on: 'Do you know the meaning of *koi cha*?'

'I think the word implies intimacy,' I said.

His face brightened. 'What you Europeans would call a kiss of friendship. We regard such a promise seriously. Once made it is carried out, unless prevented by sickness. Do you still promise?'

'Yes, I do.'

Thus began ten hours during the greater part of which he slowly, quietly, opened his treasures, bringing them one by one from an adjoining room. Tea-utensils, old calligraphy, painting, lacquer, textiles, etc., which he had gathered together with understanding and love. He commented and I listened, sometimes asking questions. In fact, the mood was quiet and of Buddhist source, but it occurred to me that this occasion resembled a Quaker meeting. Nearly all the objects were in beautifully made, inscribed boxes, some of them tied with high Japanese stylization. Occasionally an old woman, who looked after Mr. Morikawa, discreetly appeared. During that day we broke off twice; the first for a delicious cold lunch eaten from lacquer containers using chopsticks, which were thereafter discarded. The second was when he sent me ahead by taxi to my hotel. I had a lovely bath, changed; then he arrived finely attired to join me for supper, after which we continued talking into the night.

The next morning, as arranged, I visited his home once more and watched him go through the precise ritual of washing, wiping, and inspecting the implements in silence. There was no excess. He removed the ivory lid from the caddy, and using a bamboo-sliver spoon put at least eight times the usual helping of the green powder tea into that dark and severe bowl, then he poured half a ladleful of boiling water from the heavy iron kettle simmering on the fireplace set four-square in the matted floor, whisked the thick brew, and pushed the bowl towards me. During this process his old hand trembled a little and some tea fell on the taut green matting. Under his beard I heard him grumble, 'How clumsy one can be! So it is with old age.' I smiled inwardly. A little of the intensity had been relieved.

These two serious days in my life assured me that at least some of the objectives with which I had come to the Orient at the age of twenty-two, had been reached and recognized. I felt as if I had been given an accolade by this old man of Tea, who alone had demonstrated for me

the original meaning of Tea and the Tea-room as it was before the time of Sen no Rikyu and the decadence which set in during the seventeenth century. I had found what I had come to find fifty-four years ago – the art and life of this people.

Farewell Letter to Craftsmen in Japan

November 24th 1964.

My friends,

My sixth visit to Japan draws to a close. Once more I have travelled the whole length of Japan, and crossed the country from coast to coast thrice. Hamada has been with me most of the time and we have talked, publicly, privately, and searchingly. At the Kazanso hotel, near Matsumoto, Yanagi was sitting next to me in spirit for two months, whilst either Hiroshi Mizuo, my secretary, or Sonoe Asakawa, of the Mingei-kan, read his books to me from morn to nightfall and I wrote his thought down in English. For me this was a deep experience. (See plates 4a, 19a and 20a.)

I can think of only one creative critic of religion and art, of the East and of the West, with whom I can perhaps compare Yanagi, and that is Ananda Coomaraswamy, the well-known Indian critic, who died some years ago. Such men are rare and very important to the whole world, for they lead the way forward to the next stage of evolving human life. That is why I am attempting to present Yanagi's thought to the Western world.

My introduction to his book (*The Unknown Craftsman* (Kodansha)) describes his life and work broadly. I have translated selections from his writings so that foreign readers can get a general idea of that for which he stood. Both Mr. Hamada and I feel that had he lived longer there is one more book which he would surely have written, which I shall call *The Solitary Road of the Artist*. He has written so much and so well about the unknown, unnamed craftsman – the humble ordinary man who made O Ido Tea-bowls in the way of tradition; and he has told us who work alone, to cease to be alone and to lead towards the next age, but he has not written much about how we should do this, or, as craftsmen, escape from the imprisoning net of individualism. The remarkable experience I had with the Shussai Brotherhood in

Shimane Province on my last visit illustrates a meeting-point of these two approaches which I feel certain would have delighted Yanagi: something new happened – a pot was born alive – and the craftsmen knew it. It was not theirs, it was not mine – it was all of us together, and something more – it was the meeting of 'individual and community'. When the artist could forget his isolation and join in full co-operation with craftsmen who could and would unite for the sake of the object true and beautiful, a Power was automatically released – Life Itself.

I am taking this thought – this conviction – back to my workshop in Cornwall, and I am leaving it with you, my craftsmen friends in Japan. Hamada has told me how Yanagi founded his aesthetic on the basic religious thinking of the three great exponents of Buddhism – Honen who taught that the invocation of Amida was sufficient for salvation; Shinran who said that invocation was not essential, for the mercy of Amida covered all that we call sin; and Ippen Shonin, the last of the three, who bridged the apparent difference between Jodo and Zen Buddhism by insisting upon the principle of Immanence – man in Amida or God, and God or Amida in man. By doing so he gives us the basic solution of the artist and artisan's problem.

When the artist transcends individualism he arrives at the Round Table of Heavenly Beauty, beyond relativity and all measurement of above and below, but he arrives on a different plane from that of the artisan. He can see and understand with his intellect as well as his intuition, or feeling, and therefore he can lead. This is the artist at his truest. Yanagi asks us to do this and lead once more to a state of society in which co-operative work is the life-expression of all. My own feeling is that this is beyond the power of the artist, except on his own small scale, and requires Divine authority to focus the Divine element in man. This also explains my belief in the teachings of Bahá'u'lláh, which includes and relates all the great religions of mankind on a world scale.

These are thoughts which are in my mind as I am about to leave my second homeland at the age of seventy-seven, after seeing nearly all my old friends. Whether I can come once again, as I have been repeatedly asked, I cannot tell. Know well that I would like to, for I have loved Japan, and have felt the intimacy of its people deeply for over fifty years: it is with a heavy heart that I leave. (In fact I did go to to Japan again – six times altogether!)

Chapter 22

THE MOUNTAIN OF GOD

At Dartington Hall in the early thirties, Mark Tobey, Reg Turvey and I made a promise to meet, come what might, in 1963, on the centenary of the Declaration of Bahá'u'lláh's Prophethood. During the intervening years I often doubted such a possibility or likelihood; nevertheless it did come to pass. For five days representatives of the Bahá'í Faith from every corner of the earth met in the Albert Hall in London in an incredible unity, despite lack of a common language, demonstrating before our eyes the possibility of the meeting of all men in common faith and love. Speeches were instantaneously translated into four languages. There came a moment when Amatu'l-Bahá Rúhíyyih Khánum, the Canadian wife of the Guardian of the Bahá'í Faith, the late Shoghi Effendi, recalling her memories of him, broke down in tears, and the whole of that great hall became utterly silent. Slowly, spontaneously, the Africans seated in the centre began to sing gently in their rich voices 'Alláh-u-Abhá'; gradually the volume increased to include everybody present – all were one. Rúhíyyih Khánum, uplifted, continued her talk unperturbed. I recalled the Guardian's words to me, 'See the heart of humanity in the iris of the eye of the African.' At that moment came the conviction that we were passing through the end of one epoch into another – the beginning of the unity of mankind in adult maturity; the prophecies of a long past out of the Old and New Testament and the Qur'an of Muhammad were being fulfilled before our eyes.

I had come to know Rúhíyyih Khánum when I visited the World

Centre of the Bahá'í Faith at Haifa, on the way home from Japan in 1954. Every evening of my ten days' stay was spent with her and Shoghi Effendi, the great grandson of Bahá'u'lláh, who listened to my many questions with an open mind. One concerned Bahá'í architecture – the point I made being that it was not specifically Bahá'í, but either derived from the Near East or from Greece. His answer was of importance because it made clear that architecture, as well as other art-forms expressive of a new great religion, took centuries to blossom. Despite this, for the African temple to be erected in Kampala, he asked me to select the best architect I could recommend from England, with whom he communicated, but when I later saw the plans I found, as did Shoghi Effendi, that they were neither expressive of this new Faith nor, for that matter, good architecture. The spiritual wholeness of mankind was absent.

One evening an older Persian Bahá'í, Lutffúlláh Hakim, asked if he might show me the interior of the Holy Shrines, and I gladly assented. He unlocked a very large room covered with Persian carpets; one light was over that area where the remains of the Báb lie. He invited me to come nearer, but such a sense of awe overwhelmed me that, laying aside my shoes at the door, I knelt down and poured out my heart with irrepressible tears.

Later I climbed high up the steep slopes above and sat amongst the wild white-and-purple autumn crocuses, in meditation. I still have my written thoughts:

'I am sitting on a rock on Mount Carmel just above the tombs of the Báb and 'Abdu'l-Bahá. The sun is shining upon olives and cypresses and the golden dome of the Shrine, upon the town and harbour of Haifa six hundred feet below, upon the blue end of the Mediterranean and the prison fort of 'Akká (St. Jean d'Acre of the Crusades), where Bahá'u'lláh was imprisoned for so many years and from which He spread the Gospel of the Father – the unity of man and the maturity of the human race.

'For the second time I have entered that carpeted room with its bare walls and arches, and again been overcome and beaten down to my knees in tears, with my lips to the floor in adoration of God, through the power of that Young Man whose martyred remains lie below that red and central rug . . .

'This morning we drove with the Guardian up to the western pro-
montory of Mount Carmel, near the cave of Elijah, over which stands
the Carmelite church and monastery, to the acres of the crest where the
Bahá'í Temple is to be built; from of old these heights were known as
the "Mountain of God". We stood in the sun on the summit, and read
some prayers written by Bahá'u'lláh.

Rúḥíyyih <u>Kh</u>ánum one afternoon accompanied a group of us pilgrims
round the bay to the prison at 'Akká in which the Holy Family were
incarcerated. It was being used as an asylum for the insane. On one side
of the room occupied by Bahá'u'lláh a small window looked across the
bay to Haifa and Mount Carmel. From that window he was only per-
mitted to wave a handkerchief to pilgrims on the shore below, who had
come from Persia on foot.

The whole of this experience at the heart of a new world Faith was
a turning point in my life. This was Reality – no dream.

FIG. 16. The Oak

Chapter 23

THE STEPPING-STONES OF BELIEF

From time to time whilst writing this book, more particularly as it nears an end, I have been increasingly aware that in the background of my life there have been two vocations. The first began at the age of six when I became conscious of a persistent love for drawing, nor did I ever waver in my desire to become an artist. The second, from about the age of seventeen, after reading William Blake, was the search for truth, which grew stronger in the Buddhist background of Japan. There was even a question whether the latter might not swallow up its predecessor. Gradually this fear disappeared, and I discovered that instead of having to abandon one in favour of the other, it was simply an expansion of the search for a meaning of life, – of what the East terms enlightenment, which I have here called the stepping-stones towards belief.

In this final chapter my object is to summarize the conclusions arrived at during the footsteps of my life, at the deepest level of which I am capable. Who am I? Who are you? We are both 'fruits of one tree'. (Bahá'u'lláh.) 'I think, therefore I am'. (Descartes.) I am, therefore I think; I choose – both mind and matter. With five or more senses connected to a central brain, we seem to be at the apex of life on this planet. What then is life? What can we say of life itself but that it exists? We are part of it – it must contain all that is; in it we may choose. The night sky and the hedgerow seem to tell of Infinity, so does William Blake:-

To see a World in a Grain of Sand,
And a Heaven in a Wild Flower,
Hold Infinity in the palm of your hand,
And Eternity in an hour.

Infinity – with our minds can we reach it? With ever-growing expansion we desire it, but grasp it we cannot. As to our means of knowing, there seem to be two approaches – intellect and intuition. The first dualistic; the second direct and absolute. Both are at the root of our thought and consequent action from day to day. The one measures by inches and calipers, the other by instantaneous recognition of inherent truth. The genuine artist requires and uses both all the time, and finds that to place intellect above intuition is simply to misguide his footsteps: count your footsteps and you may fall down the stairs. Again Blake said: 'What is now proved was once only imagined', thereby indicating the precedence of intuition. Intellect is a very good servant but a very bad master.

'The word of God is the storehouse of all good, all power and wisdom. It awakens within us that brilliant intuition which makes us independent of all tuition, and endows us with an all-embracing power of spiritual understanding.' ('Abdu'l-Bahá.)

Where is the oil for the wheel of Life – love? What is love? Attraction, harmony, the great plus. By contrast its apparent opposite hate, is the minus which nevertheless makes this world possible, like shadow the light. Thus we learn the relation of these and all opposites, the right tension, strung as we are on a tightrope between agony and ecstasy: thus only are they harmonized. The scientist will tell you with faithfulness that nothing can be utterly destroyed. How then can we destroy the flower of living, or, if I may call it so, spirit – spirit over matter – eternal life? 'He made man in His own image and likeness' is written in the Bible. Thus, too, He is within us and we within Him, but we cannot contain Him: the whole cannot be less than the part, nor the part greater than the whole.

I hope that my readers will have from time to time noted that in the search for the meeting-place of aspirations between two hemispheres has lain the further unification of our concepts of truth and beauty.

I do not mind whether it is called philosophy or religion, but a growing feeling in later years has convinced me steadily of the need of communication and understanding as the ambience of a united world. A clearer comprehension between all peoples is essential, to raise a spiritual protection against disaster of a kind never hitherto experienced by man.

It is only a few years since that young American President John Kennedy, during a ghastly three weeks of tension, averted the possibility of a Russian attack with rockets from Cuba on the United States, which might have precipitated a World War. People just don't know what to do about it. The majority don't even dare to think about it, and yet there is an unrest all over the world, especially amongst the 'opt-out' young. By recent public acknowledgement there is now in two quarters of the globe stockpiling of atomic bombs sufficient to destroy all life on this earth. What have we learned from two World Wars? What have we learned but greater fear – now the only deterrent to the ending of life on earth? When did fear change the hearts of men? Ordinary human wisdom seems unequal to this task. Love on such a scale we have not hitherto conceived. From what other source should we receive assistance and guidance than from those Beings whom I have called inspired spiritual Geniuses? The only hope lies in the field of intuitive perception and understanding possessed alone in full measure by these Divine Mirrors of Truth. Is it possible that in this hour of greatest need such a Being should *not* be born to this end?

If ever the human race needed help it is now. It has barely begun to realize the responsibility of either achieving its own unity or of how to reach intelligent maturity on this planet. In Heaven's name why should we spend so much concentration on exploring outer space and at the same time as much or more on stockpiling of atomic weapons, when one-third of the human race has not enough food to live on and by far the greater part has no idea of its destiny? It is almost impossible to believe that in our own spiral nebula there are not far more developed intelligent beings than ourselves. What can they think of the antics of man on this obscure planet? If they have observed us during infinite time, no wonder they are not in any particular hurry to make our acquaintance – unless perchance through God's Manifestations.

The reader may well ask who then are the Manifestations of God? The Shepherds, the Healers who have led, who have enlightened mankind. Founders of the world's religions; interpreting God to man.

At no previous time in history has there been such a need of Divine guidance – of the great wisdom and insight of one of these Beings.

This time the call came out of ancient Persia, in the East where all great Prophets have been born, where the three continents meet in exchange and intercommunication. Bahá'u'lláh, who knew, and knew that He knew, taught unity as the fulfilment of creation and justice as its means and that the object of evolution is to glorify God, the Essence of Being, with one voice. With the discovery of instantaneous means of communication a bond of spiritual unity around the globe has become possible, love and understanding replacing hate and rejection.

The story of 'Alí Muhammad, the Báb, the Forerunner of Bahá'u'lláh, as told in close detail by Nabil in *The Dawnbreakers,* attracted me from the first days when in close contact with Mark Tobey at Dartington Hall. The lone figure of the Báb upholding both Jesus and Muhammad makes clear how Islam had fallen into decay as the Mosaic teaching had done at the time of Christ and as Christianity has done in our time. The similarities of Jesus and the Báb – their ages: (the Báb announced His mission at the age of twenty-four and He was killed after only six years' ministry); the common purpose of both to revivify the spiritual purpose of a new age. The complete and innate courage and authority of each shook me into acceptance and brought me to a first realization of the Oneness of all search for truth and beauty in human life. These were the footsteps in the line of Great Prophets called Adamic, which ushers in the long-awaited culmination of that One referred to by Jesus as the 'Son of Man' Who 'shall come in the glory of His Father', Whose Day has been described by Muhammad as the 'Day of God', the 'Day when mankind shall stand before the Lord of the world'.

The full implication had come upon me on Mount Carmel, that there had been in my lifetime a new revelation, a new leading forward, towards the unification of all men, in a single embracing ecumenical teaching. What else could heal our desperate need? Consider what saved the world after Roman Nero. With the memory of the slaughter of Christians in the Colosseum, who could have guessed the development of Christianity to its height through the clarity of Platonic Greek thought meeting with the heart of Christianity in that first great Gothic building of Chartres Cathedral, when Europe was afire with faith and Counts and Countesses worked alongside the villagers

pulling the carts of stones from the valley below? I stood there in 1929 with Hamada, Yanagi and our first American friend, Henry Bergen, gazing upwards – silent: twin towers and pointed arches: elongated figures reaching to Heaven, twelve of them carved by the genius Suger; flying buttresses; the Old and New Testament in glass and stone for the simple who could not read. Out of the quiet came Yanagi's voice: 'That is what you have lost . . . *You need a new Gospel.*'

Did Jesus Christ ever claim to be the only Son of God? He referred to prophecy continually, particularly to Moses, to the fulfilment of the scriptures and to His own return at the time of the end. He said: 'I have yet many things to say unto you but ye cannot bear them now. Howbeit when He the Spirit of Truth is come He will guide you into all truth.'

June 2nd 1974.
Now in old age when sight is leaving my eyes, there is no loss, only gain. This early morning I peeped into another world, comparing the expanding vision of the great Prophets – the ten commandments of Moses; Gautama the Buddha, 'There is no East, there is no West, where then are North and South?' (this is written on every Buddhist pilgrim's hat in Japan); Christ's sermon on the Mount and His prophecy: 'When He the Spirit of Truth is come He will guide you into all truth', in fulfilment of all previous prophecies; the whisper from the Upanishads 'That Thou art'; Muhammad's raising of the wild Arabs to the status of a great culture and its contribution to the development of European progress; the nineteenth-century words of Bahá'u'lláh 'Ye are the fruits of one tree'. Thus all roads meet on the Mountain of God. There all opposites are solved in perfect tension; there we are in the presence of the Master of Infinities; words fail, yet the ever-expanding Vision grows.

Where is journey's end? There is no end. What matters it to the Master of Infinities whether from above or below? In the West Christ reaches down from Heaven. In the East the perfected man Gautama Buddha reaches upwards to Heaven – Buddhists do not even speak of God. What is the difference between their 'Thusness' and the 'I am that I am' of the Bible? The barriers are down. The oneness of mankind *is* the Kingdom of God on earth, when man will meet man in happiness, joy and love from end to end of this our world. The time is about to

come. Bahá'u'lláh *was* the return Christ foretold for the completion of His work on earth.

Bahá'u'lláh wrote: 'The time foreordained unto the peoples and kindreds of the earth is now come. The promises of God, as recorded in the holy Scriptures, have all been fulfilled . . . This is the Day whereon the unseen world crieth out, "Great is thy blessedness O earth, for thou hast been made the foot-stool of thy God . . ." '

East and West.

I have seen a vision of the marriage of East and West, and far off down the Halls of Time I heard the echo of a child-like voice. How long? How long?

"Forebell"

B.

CHRONOLOGY

1887

5th January, born in Hong Kong. His mother dies and grandparents take him to Japan.

1890

Returns to Hong Kong when father remarries.

1894

Moves to Singapore, where his father is appointed High Court Judge.

1897

To school in England at Beaumont Jesuit College, near Windsor.

1903

Slade School of Art, studies drawing under Henry Tonks. Friendship with Reggie Turvey.

1904

November, father dies.

1905

Studies in Manchester for entry to Hong Kong and Shanghai Bank.

1908
London School of Art, studies etching under Frank Brangwyn.

1909
To Japan, builds house in Tokyo. Marries cousin Muriel Hoyle. Exhibits his etchings and proposes to teach this technique.

1910
Friendship with Kenkichi Tomimoto.

1911
Raku yaki decorating tea party. Meets members of Shirakaba Society. Friendship with Soetsu Yanagi. Exhibits work with Tomimoto and others and subsequently with Shirakaba Society. Meets potter Ogata Kenzan. Son David born.

1913
Son Michael born. Kenzan builds kiln at Leach house.

1914
A Review 1909–1914, his first publication, and first one-man show in Tokyo. Travels alone to Peking to meet Dr. Westharp.

1915
Family move to Peking. Daughter Eleanor born.

1916
Yanagi visits Leach in Peking. Family returns to Japan and Leach rebuilds Kenzan's kiln on Yanagi's property.

1918
Visits Korea with Yanagi.

1919
Meets Shoji Hamada. Workshop burns down. Exhibition in Tokyo.

1920
Final exhibition in Japan. Private publication, *An English Artist in*

Japan. Leaves for England with family and Hamada. Twin daughters, Betty and Jessamine, born in Cardiff. With Hamada establishes pottery at St. Ives, Cornwall, building first oriental climbing kiln in Europe.

1921
Exhibition, Artificer's Guild, London.

1922
First one-man exhibition in England, Cotswold Gallery, London. Matsubayashi comes to St. Ives, designs and rebuilds kiln.

1923
Michael Cardew comes to St. Ives as Leach's first student. Hamada returns to Japan. Exhibitions, Paterson's Gallery and Three Shields Gallery, London, and also in Japan.

1924
Katherine Pleydell-Bouverie joins St. Ives Pottery. Exhibitions, Japan.

1925
Norah Braden joins St. Ives Pottery. Exhibitions, Japan.

1927
Exhibition, Three Shields Gallery, London.

1928
A Potter's Outlook published. Exhibition, Beaux Arts Gallery, London.

1929
Yanagi and Hamada visit St. Ives Pottery.

1930
Son David joins pottery.

1931
Exhibition (with Tomimoto), Beaux Arts Gallery, London.

1932
Begins teaching at Dartington Hall, Devon. Meets painter Mark Tobey. Exhibition, the Little Gallery, London.

1933
Exhibition (with Tomimoto), Beaux Arts Gallery, London.

1934
Invited to Japan by National Craft Society. Travels in Japan with Yanagi and Hamada in search of country crafts. Works at seven potteries (including Hamada's, Tomimoto's, and Kawai's). Exhibitions, Matsuzakaya and Takashimaya. Makes slipware at Matsue.

1935
Visits Korea, returns to England.

1936
Resumes teaching at Dartington Hall in newly built pottery. Exhibition, the Little Gallery, London.

1937
End of slipware production at St. Ives. Change from wood to oil firing.

1938
William Marshall joins St. Ives Pottery.

1940
A Potter's Book published. Complete acceptance of the Báha'í Faith.

1944
Marries Laurie Cookes.

1946
The Leach Pottery 1920–1946 published in association with exhibition at the Berkeley Galleries, London.

1949
Exhibitions, Gothenburg (Sweden), Oslo (Norway), Copenhagen (Denmark). Guest of Danish Arts and Crafts Society.

1950
Tours U.S.A. for four months. Travelling exhibition organized by Institute of Contemporary Art, Washington. Awarded Binns Medal for 1950 by the American Ceramic Society.

1951
A Potter's Portfolio published.

1952
Exhibition (with Hamada), Beaux Arts Gallery, London. International Craft Conference, at Dartington Hall, Far East being represented by Yanagi and Hamada, who join Leach on American tour reporting conference and Yanagi's aesthetic.

1953
Trio continue tour in Japan. Leach lectures, works, exhibits.

1954
Returns to England, visiting Bahá'í World Centre at Haifa, Israel, en route.

1955
Sons David and Michael leave St. Ives to establish their own potteries.

1956
Marries Janet Darnell, who gradually takes over management of St. Ives Pottery.

1957
Exhibition, Liberty & Co., London.

1958
Exhibition, Primavera, London, and travelling exhibitions in U.S.A.

1960

A Potter in Japan published. *A Potter's World*, B.B.C. film of St. Ives Pottery. Made an Hon. D.A., Manchester College of Art. 10,000 mile tour of U.S.A. lecturing.

1961

Hon. D.Litt., Exeter. Yanagi dies. 'Fifty Years a Potter,' retrospective exhibition, Arts Council Gallery, London. Visits Japan in connection with exhibition of medieval English pottery and retrospective exhibition of own work in Osaka.

1962

Visits Australia, New Zealand, U.S.A. Returns to England. Made Commander of the Order of the British Empire (C.B.E.). Exhibitions, Primavera, London, and (with Hamada) Louvre, Paris.

1963

Tomimoto dies.

1964

Attends Japanese Folk Crafts meeting in Okinawa. Exhibitions, Tokyo and Primavera, London.

1966

Exhibitions, Primavera, London, and (with Hamada and Francine del Pierre) Museo de Bellas Artes, Caracas, Venezuela, and the National Museum, Papayan, Colombia; then visits Japan for retrospective exhibition in Tokyo. Receives Order of the Sacred Treasure, second class. *Kenzan and his Tradition* published.

1967

A Potter's Work published. Exhibitions, Crane Kalman Gallery, London; (with Hamada and Kawai) Osaka, Japan; and (with Hamada and Francine del Pierre) Museum für Kunst und Gewerbe, Hamburg.

1968

Exhibition (with Lucie Rie and Janet Leach), Primavera, London. Receives Freedom of the Borough of St. Ives.

1969
Visits Japan. Exhibition, Okinawa. *The Potter's Art*, Westward Television film, which, in 1970, received two major international awards.

1970
World Crafts Council honour at Dublin.

1971
Exhibition, Marjorie Parr Gallery, London; and retrospective show, Tenmaya, Okayama.

1972
Sight failing, stops potting. *The Unknown Craftsman* published.

1973
Visits Japan for exhibition at Tenmaya, Okayama. On return to England made Companion of Honour (C.H.). *Drawings, Verse and Belief* published.

1974
Given Japanese Foundation Cultural Award; N.H.K. Television film.

1975
Hamada: Potter published.

1976
A Potter's Challenge (British edition) published.

1977
March 3rd to May 8th, retrospective exhibition, Victoria and Albert Museum.

INDEX